THE
ART OF ETCHING

A COMPLETE & FULLY ILLUSTRATED DESCRIPTION OF
ETCHING, DRYPOINT, SOFT-GROUND ETCHING
AQUATINT & THEIR ALLIED ARTS, TOGETHER
WITH TECHNICAL NOTES UPON THEIR
OWN WORK BY MANY OF THE
LEADING ETCHERS OF THE
PRESENT TIME

BY

E. S. LUMSDEN

Late Associate of the Royal Scottish Academy

WITH 208 ILLUSTRATIONS

DOVER PUBLICATIONS, INC.
NEW YORK

Published in Canada by General Publishing Company, Ltd., 30 Lesmill Road, Don Mills, Toronto, Ontario.

Published in the United Kingdom by Constable and Company, Ltd., 10 Orange Street, London WC 2.

This new Dover edition, first published in 1962, is an unabridged and unaltered republication of the work first published by Seeley Service and Company Ltd. in 1924.

Standard Book Number: 486-20049-3

Library of Congress Catalog Card Number: 62-51399

Manufactured in the United States of America
Dover Publications, Inc.
180 Varick Street
New York, N.Y. 10014

TO
MY MOTHER

FOREWORD

WHEN, only a few months ago, I was asked whether I would contribute to this series a book upon Etching, I hardly treated the suggestion as practical. In the first place it seemed to me that everything there was to say upon the subject had already been said, and, in the second, the time which would necessarily be devoted to such a task appeared, in prospect, too great a sacrifice for one whose livelihood depends upon the practice of the craft.

But, in the endeavour to set my ideas upon the matter in some sort of order, I soon became so intensely interested in finding out what I really did believe, both concerning the art and its exponents, that I could think of nothing else and, for good or ill, the book had to be written. The digging up of the older authors upon the purely technical side, in order to discover the actual origin of many formulæ and recipes still in use, has also been extremely fascinating and the result should, I think, be of value—at least of interest—to the student.

I have many to thank for help. First Mr. E. L. Allhusen for his invaluable suggestions in the writing of the MS.; the loan of many books and catalogues, and, above all, for his generous encouragement. Amongst the officials of Public Museums I am indebted to Mr. Caw of the Scottish National Gallery for allowing me to search the folios not open to the public and to photograph the etching by Runciman; Mr. Campbell Dodgson, Keeper of the Prints at the British Museum, for the loan of several etchings from his private collection and for permission to reproduce many from the Museum itself; Mr. Martin Hardie for similar courtesy regarding prints in the Victoria and Albert Museum and for some important suggestions; and to Mr. Binyon, Mr. A. M. Hind and their Assistants for the ungrudging help during the weeks I worked in the British Museum Print Room, when Mr. Hind made me free of his notes upon various problems the solution of which is dubious, was always ready to discuss a technical point and to give me the benefit of his advice.

My most grateful thanks are also due to Dr. Alexander Scott, F.R.S., for being so kind as to revise my chapter dealing with his methods of research and for great assistance upon other problems of chemistry.

Amongst private collectors I wish to thank Mr. R. K. Blair, Mr. E. R. Boase, Mr. E. L. Allhusen and Dr. J. D. Pollock for lending their prints for reproduction, and Mrs. Strang, Mme Zorn and Mr. L. L. Legros for permission to include examples of the work of the late William Strang, Anders Zorn and Alphonse Legros respectively.

I deeply appreciate the courtesy of those artists who have not only given

me permission to use their work, but have greatly added to the value of the book for the student of the future by giving their personal technical notes.

Only two artists ignored my request and one refused to permit any reproduction, and these omissions I regret.

I have also to thank Messrs. Lefèvre and the Leicester Galleries, and the Fine Art Society for allowing me to reproduce plates by Messrs. Blampied and Strang respectively. A word also as to the selection of my own etchings. In every case my motive has been to find a plate which best illustrated the *technical* point in hand. To do this meant ruling out most of those which I consider my best, because I either cannot remember how they were done or their procedure was complicated by mixed methods which rendered them useless for the purpose.

E. S. LUMSDEN.

EDINBURGH,
August, 1924.

LIST OF CONTENTS

PART I

PART II

PART III

PART IV

LIST OF ILLUSTRATIONS

LIST OF TEXT ILLUSTRATIONS

16 LIST OF ILLUSTRATIONS

THE ART OF ETCHING

PART I

CHAPTER I

INTRODUCTORY

As this book is written professedly for the beginner first and foremost (although I hope that those more advanced may also find something of value in its pages) I intend to assume absolute ignorance on the part of the reader and to endeavour to describe as clearly as possible even the most elementary tools, contrivances and processes.

It is always better for the student to have an accurate knowledge of the ingredients composing the various compounds and solutions that he uses in any craft ; yet few people would advocate the making of things at home in a country where they can be readily purchased ; for example : the grinding of colours for the practice of oil-painting when one can buy them far better prepared by an experienced and reliable colour-maker.

This applies largely to the materials used for the various processes of engraving metal plates, though there are many appliances which can be made just as well at home, and at far less cost.

I well remember, when first trying my hand at this most fascinating art, how difficult I found it (living some distance from a great centre) to obtain any information as to where certain tools and materials might be bought. Consequently I had to fall back on the home-made articles in such matters as " ground " and printing-ink, until, eventually, I got into touch with a London firm.

Definition of Etching.—In the first place as to what constitutes an etching.

Our English word is derived from the Dutch *etzen* to eat ; therefore, in order to make an etching at all one must employ an eating-away, or as it is technically called, a *biting* process.

Any solid material which reacts to a mordant can yield an etching ; even glass, were it possible to print from it without danger of breaking.

Metals.—The earliest material known to us as having been employed to any extent was iron ; but nowadays there are but two metals commonly used, copper and zinc.

Brass has been tried, and so, very recently, have aluminium and pewter.

Steel was principally employed by the line-engravers who supplemented their graver work by more or less etching, but the invention of a process by which, with the aid of electricity, copper may be protected from wearing

during printing by an extremely fine coating of iron,[1] deposited upon the surface *after* the engraving has been completed, allows the artist the freedom of working upon the more tractable metal and yet to have confidence that his plate will yield a large edition of proofs.

In order to corrode these metal plates in certain places and, by so doing, to form a design, either by means of *lines*, as in etching proper ; *dots*, as in aquatint ; or whole, flat *spaces*, as in Blake's " relief " blocks, various acids are employed which will be dealt with in due course.

It is the *impression* which is printed from one of these plates on any suitable material such as paper, vellum, parchment or silk which is termed an " etching," not the etched metal itself. It follows that every impression or " proof " is equally an *original* etching. I mention this because a gentleman who was in charge of a post-war International Exhibition informed me, at its close, that so many " original etchings " had been sold and a further number of " copies " !

Relief and Intaglio Plates.—Both photogravure and " zinco " (line) blocks are strictly *etched*, though the print from the line-block is not called an " etching " because the term is only technically applied to a proof from a plate the *design* of which (that is the part which holds the ink) is bitten-in, while in the case of a " zinco " it is exactly the reverse ; i.e. the parts which are *not* required to print are corroded, and the proof is taken from the surface which remains standing, as in the case of a wood-block, or the above-mentioned relief-etchings of Blake.

Definition of Drypoint.—It will be seen, further, that " drypoint " though often spoken of as etching, is, in reality, no such thing, as the lines on the plate are not eaten away by means of acid, but are cut by a sharp instrument ; steel point, diamond, ruby or the like.

Although technically miscalled when spoken of as " etching," the intention in so naming it is to mark the more important fact that drypoint belongs to the same method as etching inasmuch as they are both printed from *intaglio* plates ; and this it is which places all kinds of " engraving " (including drypoint and mezzotint) and of " etching " (including aquatint, soft-ground and photogravure) in one group, as distinct from all " relief " or *cameo* methods whether engraved on wood or metal.

Printing.—No great pressure is required in printing from any relief-block as the ink lies entirely on the *surface*, and when a sheet of paper is placed upon this, even a moderate rubbing with the hand is sufficient to register the impression.

But, in the case of an incised or *intaglio* plate hardly any result can be obtained by direct pressure from above, even in a powerful press ; and in order to drive the paper down into the lines, and so take what is literally a *cast* of even the slightest irregularity of the plate's surface, a strong

[1] The deposit is usually termed " steel," but this is chemically incorrect ; as when steel is used in the bath to electrically deposit the one metal on the other, it loses its carbon and becomes a peculiarly hard iron.

roller-press is necessary with some elastic substance (the blan[ket]) between the paper on the plate and the upper roller.

Damp paper which has been placed upon an entirely uninked plate and passed through a powerful roller-press will shew every scratch of the work in relief if examined in a side light; so that an impression *is* taken, whether there is ink in the lines to make it more visible, or not.

Press.—It is the difficulty of providing a good press which probably prevents many from trying their hands at engraving plates by one method or another ; and the cost of a really first-rate article—even second-hand— is, to-day, prohibitive to the majority of students.

The more fortunate may live near an Art school where such a machine may be used by permission, or, at worst, for the price of joining the class : those that do not may be able to obtain the use of a commercial copper-plate printer's during off hours. Most towns boast at least one visiting-card printer whose press is serviceable enough, but in this case the etcher will be well advised to take along his own blankets. Such a printer usually works with one blanket, and that as hard as iron ; and I speak from experience when I say that to remove a proof from a plate which has passed through such an ordeal means scraping it off in pieces !

Failing this, a lithographic press will yield a very fair proof from an etched plate if carefully adjusted. Where the beginner is quite unable to get access to a press of any kind, the best thing to do is to send the plate to the nearest reliable etching-printer and to be as patient as possible in the interim ; but, unfortunately, the less experience the etcher has, the more necessary for him to see a proof from the plate upon which he is at work, in order to know exactly what his depth of line yields when printed ; while the old hand is able to judge pretty accurately how far he has succeeded by the look of the lines on the metal, especially if these are filled with some substance—ordinary plate-polish is as good as anything— which allows them to show up strongly against the shining, polished surface.

Substitutes for Press.—In Mr. Koehler's notes at the end of his transla-tion of Lalanne's treatise " On Etching " (1880) he suggests taking a cast in plaster of Paris. The lines are inked (see Chapter X) and the plaster mixed in a glass (one of water to two of plaster), and, when beginning to thicken, poured over the plate. In any case the result would be crude and only approximate. A much more serviceable idea was put forward in some work—I forget where—for obtaining a proof. This was the con-version of a good mangle into a temporary press, by the introduction of a drawing-board or other smooth plank between its rollers to serve as a travelling-bed. The principle of a mangle is that of an etching-press if the spring at the top (designed to prevent too great pressure when a button or other hard object passes through) be prevented from functioning ; and at least one well-known etcher has told us how he acted upon the hint in his early days. But to make a really workman-like machine which would

give sufficiently accurate results ought not to be beyond the powers of a good ironworker.

There is no delicate mechanism to adjust, all that is essential being that the rollers run true : and if by any chance a couple of iron cylinders could be procured, the rest should be comparatively easy. Failing iron, hard, wood rollers will serve. My own first press was obtained at an East-end auction room and was a most ancient affair. There was a travelling-bed several inches thick of iron-wood (*lignum-vitæ*) ; no regulating screws ; and, needless to say, no gearing. Nevertheless, though cumbersome, and by no means true compared with a modern all-iron machine, it answered my purpose well enough (all my early editions were pulled on it) till the day arrived that I could afford a better. This sort of difficulty will alway be met and overcome by the really keen student, and he is the only type worth bothering about. The youth (of either sex) who cannot begin until the most up-to-date appliances are provided will not go far !

The beginner should bear in mind that etching, though undoubtedly one of the most fascinating of all the graphic arts, is, at the same time, one of the most exacting. It is comparable to the playing of a difficult instrument, such as the violin or piano, in that it demands constant practice.

The first part of the process—the biting with acid—is a chemical experiment every time, and though this is one of the chief charms of the game, yet without practice one is hopelessly handicapped.

The principle of working is not at all difficult to grasp ; but to control the application of it in actual handling is always hazardous, and the element of luck makes the game all the more intensely absorbing.

This element of chance is always present to a certain extent, even if the etcher take all the scientific precautions now possible to utilize—thermometer, hydrometer and all the rest—without which Rembrandt got along somehow. The chief reason is the difficulty of seeing *directly* the result of the work, in the way that the draughtsman with pencil or brush can : watching the mark of his stroke, even as he makes it.

Need for Practice and some Qualifications.—Want of practice (lack of mere sleight-of-hand as well as forgetfulness) makes itself felt immediately in the final process of printing, also ; and my own experience in 1919 (when I had not touched a printer's rag for nearly four years) was that my hand had not only lost its cunning, but that I had forgotten how certain effects had been arrived at in the past, and had to experiment afresh.

Etching, therefore, is not a medium which can be taken up occasionally, at long intervals, without risk of finding that either one's memory or one's manual dexterity has gone.

Another point that the student should remember is that, though he may take as long as is desired over the *preparations* for an etching, he *must* have the idea, finally, complete—either set down in another medium or in his head—before beginning upon the actual plate. The more clearly he is able to visualize the desired result in imagination, the more chance

of the lines being put down with vigour and spontaneity : two of the most important qualities that a really fine plate should possess.

No one, therefore, need start working in this medium who finds it impossible to make up his or her mind as to what has to be done before beginning to do it ! This may sound absurd, but, after all, it is one of the most common failings. How many know what they really want to do ? Now, in oil-painting one may fumble away for months on one canvas, and yet arrive at something, without necessarily showing the traces of one's many tentative efforts. This at least is a common enough practice.

But in attacking a copper plate one cannot go to work in that manner. If one finds the initial planning to be wrong, it is far better to throw the plate away and (with added experience) start a second ; and (may be) after that, a third. But all this means that the mind is being made up on the copper when it might have been satisfied by working the matter out in another medium—a medium far less exasperating and decidedly more economical.

Another quality is essential—and if the student is without it, it must be acquired—Patience.

This may apply almost equally to every art, but is certainly a *sine qua non* in etching. One must be prepared to spoil plate after plate, not only as a tyro but *always ;* and, having spoiled one, not to give up in disgust (I know a very fine painter indeed who began etching, and gave up the whole thing after his first failure), but to begin *again ;* and to repeat this, when necessary, as long as one continues to etch !

One must never be afraid of *making mistakes,* but always of *giving up because of them.* The plates which do come off make it all well worth while. If the student thinks he has something definite to say in etching—having probably seen good work done by others in the medium, and feeling drawn towards it as sympathetic to the expression of what he himself sees—then by all means let him go ahead and try his hand. Only, let him go at it boldly, and, having made a mess of one plate, start making a mess of a second !

Although verbal advice from a master will probably save many blunders and disappointments at the outset, yet it is quite possible to learn what is essential from a textbook. I know this from personal experience ; and though it takes longer, what one teaches oneself (through one's mistakes, largely) *sticks,* in a way that no knowledge can which has been gained from a teacher who *prevents* one making those same mistakes.

The Art School.—One of the dangers of the modern Art school is that the students often have too much done for them ; and this is fatal when the course is over. I was once visiting one of the best-known schools, and asked one of the women students what strength of acid she was using. The astonishing answer was : " I don't know ; it's what we have given us ! " No doubt this was individual slackness on the part of the student, but if she had had to go out and buy, and afterwards mix, her acid, she *could* not have answered as she did.

To repeat what I said first of all : it is good to know how one's materials are made, and to be able to make them (at a pinch) ; but it is only waste of time for the student living within reach of a dealer to make up his own grounds, varnishes, etc., as the firms who manufacture such things can make them far better—being specialists, with the specialist's equipment—than the amateur ; and, in most cases, as cheaply.

This book, however, may fall into the hands of someone who lives out of reach of the dealer, and for that reason I have tried to combine in it my own experience with all the information I can gather from previous books on the subject and individual notes from several distinguished artists, together with the invaluable suggestions of two famous chemists.

CHAPTER II

ESSENTIALS

THE essential materials for the making of an etching are really very few. They are:—

 1. A metal plate.
 2. An acid-resisting ground.
 3. A point which will cut through the ground.
 4. Acid.
 5. Ink, paper and a press.

To execute a drypoint, Numbers 2 and 4 are not required.

These few materials and tools are the *necessities*, given which a perfectly good etching or drypoint can be wrought (see Dürer's prints, Chapter XX). In etching, the plate is covered very thinly and evenly with the ground, which the point serves merely to remove without scratching the surface of the metal.

When the drawing is completed the plate is submerged in a bath of acid, and this fixes the lines, their depth depending solely upon the length of time they are exposed to the action of the mordant.

The ground is then cleaned off and the face of the plate covered with printing-ink, which is so wiped away that, though the surface is polished, the ink is retained in the bitten lines.

The plate is now placed upon the bed of a press, damped paper laid upon it, blanketing over that, and the whole pulled between the rollers. Upon lifting the paper the ink from the lines will be found to have transferred itself from plate to proof.

In the case of a drypoint the instrument used for drawing must be strong enough and sufficiently sharp to cut into the metal, and besides this weapon two others are nearly always required, a " scraper " and a smoothing tool called a " burnisher," which often fills the place that india-rubber occupies in pencil drawing.

The scraper is used for removing the " burr," as the rough ridge is called which is thrown up at the edge of each line by the point, exactly as a furrow is flanked by its ridge after the passage of the plough.

These three instruments are all that are necessary (except for the correction of serious mistakes) in the whole working of a drypoint.

In order to explain the principal differences between these two mediums, I will use an analogy from another art.

I have always considered the difference between etching (including all bitten methods) and drypoint as essentially that between the organ and the piano. In organ playing, the sound is controlled solely by the *stops*,

and no matter how lightly or heavily the musician hits the keys—provided that he puts them down firmly enough to sound at all—the volume remains the same while any given stop is in use. In other words, the " colour," or " light and shade," is obtained by the skilful control of a mechanical device.

In piano playing, exactly the opposite is the case. Ignoring the *additional* contrivance of the modern " uni-corda " pedal, the volume of sound is dependent entirely upon the action of the hand upon the keyboard, an increase of volume corresponding to the added force with which the notes are struck, and consequently the piano is personal in " touch."

It will be seen that in etching, where a blunt instrument is employed to skate over the surface of the plate, removing the covering of the ground but not penetrating the metal below, there can be no emphasis from the action of the hand in drawing. Provided that the touch be firm enough to remove all the wax, so that the acid may reach the metal at all, the strength of line and " colour " is controlled entirely by the *mordant,* and contrast in depth depends upon the length of time that some parts are permitted to bite in relation to other parts. This is controlled as a rule by " stopping-out " those parts which have been sufficiently bitten, by covering them with an acid-proof varnish ; then continuing the biting of the unprotected parts and so on to the last and heaviest bitings of all.

In etching, therefore, there can be no " touch."

On the other hand, in drypoint the strength of the line depends entirely upon the force with which the *point* is driven into the metal, so that the " touch " is infinitely more variable than in any acid-controlled process. It is consequently more personal—more autographic—in every way except in the matter of *direction.*

Although the student will eventually find it necessary to possess a number of tools and materials other than those above mentioned if he is to do anything but the most elementary work—I mean technically elementary, as artistically first-rate etchings can be, and have been, produced with those only—yet the fewer with which he can manage the greater the control which he will gain over those few, and consequently the more expressive the work produced by their means.

In oil painting, the man who keeps fifty colours in his outfit will always be more worried, when selecting any for a given passage, than the man who has only six and knows, from constant practice, the capabilities of those six. Not needing to think about the colours themselves, he can concentrate all his energies on expressing what he sees in terms of his limited range.

So many tools have been invented by different practicians (and by firms catering for them) in recent years, that the beginner is very apt to be confused when confronted with the etching-dealer's catalogue ; and by far the wisest plan is to procure those which are indispensable ; make the best possible use of *them,* and gradually supplement this outfit as real need arises.

In the following chapters I intend to take these materials and their preparation and use individually, and though I may express a preference for one tool, or method, where several are given, it will only be after setting forth the reason for so doing as logically as possible ; and the reader who is of a sceptical nature—and the best students usually are, I think—had better try them all and choose for himself. What suits one may not suit another, and the more cautious and methodical may prefer (for instance) a slow-biting but safer acid ; while the student to whom patience only comes with effort will get on more happily with a mordant of rapid, though more dangerous, action.

I shall try to set down those ways of working which have descended to us from an honoured past, as they may be preferred to my own by some (that is, in those instances where the two are at variance) ; but in general the art has altered very little in practice, in spite of modern ingenuity, since the time of Rembrandt. We use a steel press where he relied upon a wooden one, but the principle is the same and the one is merely a little truer than the other ; and nothing that has been produced since his day has been in any way technically superior to the *work* of that great Dutchman.

CHAPTER III

THE PLATE

Of the two metals used most extensively to-day, copper and zinc, copper is the more expensive, but also the tougher and more capable of yielding both finer results and larger editions of good proofs.

Old *v*. Modern.—In the old days—indeed, the practice is probably still carried on here and there—plates were hammered by hand until their texture became extremely dense and fine, and free from open seams.

The cost of labour at the present time makes such a practice prohibitive, and most, if not all, modern etchers use machine-rolled copper, which, though much softer in texture, is generally very equal in consistency throughout.

Chemists tell us, however, that the purer a metal is—the freer it is from impurities—the less is it attacked by an acid ; and the old copper plates probably held a larger proportion of alloys, and in consequence may have been bitten more readily. But, after all, modern commercial copper is not so pure that it will cause any great anxiety on that account !

The plates are quite good if free from seams, which are, of course, readily detected if on the surface ; but unfortunately they occasionally appear after work has been begun, when the original face of the copper is scraped in order to make an alteration. This means that the seam was closed at its edges by the pressure of the machine rollers, but not filled up underneath. This need not worry the beginner as it is not of common occurrence, but it is well to scrutinize the surface carefully before buying.

The most marked difference between these commercial plates and the old hand-beaten ones will be found in the use of drypoint. Though very much easier to cut into, the new plates (principally manufactured for photogravure and similar processes) will not stand nearly so large an edition in the printing. Some time ago a friend gave me a parcel of old engraved plates which I had resurfaced. Upon one of these I did a drypoint head, and not only was it far more laborious to cut into, but I found the steel tool very quickly blunted, and not wishing to keep on stopping in order to sharpen it, a good deal of the work was executed with too blunt an instrument.

How to Buy.—The most economical way to buy plates is in whole sheets as they are sent out by the manufacturers, and to have these cut up into sizes most suitable for the purpose of the individual buyer ; always taking into consideration the outside measurements of the sheet in order to fit the aggregate length of the plates into the whole without wasting strips at the end, which, while too narrow to be of practical use, yet when

running across the whole width may mean an appreciable weight of metal to be paid for.

Thickness.—As copper and zinc are always sold by weight, it is well to avoid sheets of too great thickness. The most serviceable for medium-sized plates is 18 gauge. The sheets are standardized : the usual measurements about 25 × 20 inches. For small plates 19 gauge is quite thick enough, but not readily obtainable ; but very thin copper is sometimes a nuisance, as it is apt to curl up in the press, and though easily flattened by passing through longways or even upside down, this wastes time and puts one out. A curved plate is naturally difficult to wipe in printing. On the other hand, too thick a plate is liable to cause the paper to part (if at all brittle) at the plate-mark.

I once had one of Andrew Geddes's plates (a copy of a Rembrandt head) to print, which was so extraordinarily thick—obviously home-made, unlike others of his which I have handled—that there was the greatest difficulty in preventing any paper other than Japanese from bursting. There was no *cutting :* the edges of the plate, which only measured 3 × 2½ inches, were quite round and smooth ; but the depth was so great that the downward drive of the blankets simply pulled the fibre apart at the plate-mark. Japanese paper, having a longer fibre than European, and more elasticity in consequence, did not suffer. This is quite exceptional, but worth noting.

Edges.—There is no need to bother about the edges of a plate until the work has been bitten, or rather until the plate is ready to be proved for the first time ; because, while the acid is being used the edges are certain to be attacked more or less—even if protected by varnish to begin with, the manipulation of the copper is bound to remove it in places—and the filing will have to be done over again. The smoothing of edges is not merely for the sake of the appearance of the proof, but a matter of vital importance to the safety of both paper and blankets. A cut etching is at worst only one print spoiled ; but a cut blanket is a much more serious matter, as it is impossible to mend. A sharp plate-edge, under heavy pressure, will go right through the whole set of blankets, which means the placing of the lot permanently out of action. Another reason for deferring the filing of the edges is that the plate may be spoiled in the drawing or biting, and not worth proving at all !

Some middlemen dealers sell carefully bevelled plates and charge an exorbitant price for the extra labour involved—I have known considerably more than double the market rate of copper asked—and to purchase these is sheer waste of money, as a good file about 8 inches in length will soon do all the bevelling and smoothing necessary *after* the work is completed. It often happens that a plate is cut a little out of the square ; or, for the sake of composition, it may be better to remove ⅛ inch or so on one side or the other : in both cases the file, or possibly more than one —a coarser for cutting and a finer for smoothing—is essential, unless one is to trot round to the plate-cutter quite frequently.

For serious filing, such as the latter possibility entails, it is best to clamp the plate to a firm table—I use the iron travelling-bed of the press—for which purpose a small screw-vice is very handy. Care must be taken to pad the vice jaws to avoid scratching the surface, and an excellent preventive is an old, useless plate placed over the one to be worked on, with a sheet of blotting-paper between them, and then screwed down as firmly as possible (Fig. 1). Before beginning rule a fairly deep line with a cutting point where the new edge is to be ; otherwise it will be difficult to judge how far the work has gone, and whether it is being removed equally along the whole edge.

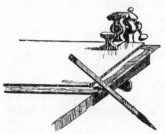

FIG. 1.

If much is to be taken off, begin by filing at a very acute angle, i.e. making a very broad bevel ; then turn the plate over, being careful to place a pad of soft paper beneath it, and work in the same way at the back. Push the file away from the body, using its edge almost as if it were a knife. This will shave off the thin bevel remarkably quickly and at the same time will prevent the edge curling downwards as it will if filed only on one side. In order to finish, the plate must be reversed once more, and this alternate bevelling, first on one side and then on the other, may be necessary more than once if the strip to be removed is broad.

Cutting up Sheets.—But where a large portion is to be cut away, filing would be much too tedious a process. In up-to-date workshops a steel guillotine is now used for cutting up all plates. It is a most useful and time-saving instrument, but naturally far too costly for the average etcher to indulge in, as well as taking up a lot of space.

To cut a plate in the absence of a guillotine by far the best plan is to make as deep a groove as possible with a steel point and ruler, and then to work up this line several times with the graver or burin. In order to prevent slipping, I find the method of clamping a second plate over the one to be cut, as above described, an excellent one. I place it about ⅛ inch from the line, so that the shoulder of the graver just touches its edge, which acts as a ruler. If there is a slip it also prevents damage to the new plate.

There is no need to cut completely through the copper, as after working three or four times along the line a sharp jerk or two will snap what is still unsevered.

A plate cut in this manner needs very little filing : far less than one cut in the more usual way with chisel and hammer, which leaves an extremely ragged edge.

After filing or cutting a worked-on plate it is very necessary to make sure that no metal filings remain in the lines. It is easy to sweep them off the surface, but a brush may be required to free the lines, and for this

purpose a stiff shaving brush—the cheapest kind is better because stiffer than a badger—answers admirably. On no account must they be allowed to get on to any of the rags in use for cleaning or printing, or horrible scratches will result and the work be ruined.

Zinc.—For open, free-line etchings and for aquatint, zinc is quite as good as copper. Some of Haden's best plates were of zinc, as he excelled in simple, straightforward, vigorously-bitten effects—indeed he has left it on record that he thought zinc more suited to the needs of an artist—but the student will be well advised not to change from one to the other at the beginning, as the acid—nitric particularly—acts rather differently upon the two metals.

Difference in Biting.—Supposing that two plates, one copper and the other zinc, were drawn upon in the same manner, the design including a closely worked passage of cross-hatching together with parts where the lines were widely separated from each other ; and that these plates were bitten in the same way (allowing a weaker acid for zinc) : would the results be identical ? Leaving aside the coarseness of grain belonging to the softer metal, one would be inclined to answer, Yes.

But they would not, for the following reason :

On the copper the tendency would be for the close-worked passages to become more strongly accentuated than the open lines ; while on the zinc all the lines would be found to bite equally.

This means that an etcher accustomed to the action of acid (I am referring principally to nitric throughout) on copper would take for granted that where a larger proportion of metal was exposed the attack would be correspondingly vigorous ; and, allowing for the same peculiarity in biting his zinc, would be disappointed at the *flatness* of the result.

In other words, the acid emphasizes the light and shade of the drawing, biting more rapidly where the lines are massed more closely on the one metal ; but, on the other, pays no attention to the amount of metal exposed, biting the lines literally as they are drawn. Consequently there is need for more careful stopping-out upon zinc if the relative light and shade is to be obtained.

Drawbacks of Zinc.—For very fine, close work, zinc is certainly inferior, being softer and coarser in grain, and more liable to " foul-bite," i.e. for the mordant to find its way through the protecting " ground " where no lines have been drawn. I fancy this is because the nature of the metal makes it more difficult for the wax to grip, there being a certain " greasiness "—absent from copper—which makes very thorough cleaning imperative.

Naturally its softness inclines it to be less suitable than copper for dry-point, and in any process the metal will wear more rapidly during printing. Zinc is also far more easily attacked by anything it may come in contact with when put away ; either by impurities—such as chlorine—in the paper it may be wrapped in, or in the atmosphere ; and the only safeguard is to cover the surface with wax. A fine aquatint plate may be ruined in a

very short time if wrapped up in a chemically-bleached white paper, or left exposed to the air.

"**Steeling.**"—Though copper can be "steeled," it is generally understood that zinc cannot ; but it is quite possible to "copper" it. I have made sufficient enquiries to be certain that the process of steel-facing zinc is not commonly known in this country.[1] Probably there is no commercial advantage (and, therefore, no incentive) in the proposition. Be this as it may, on page 73 of Lalanne's "On Etching" (1880) Mr. Koehler gives the following footnote : " Zinc plates *can* be steel-faced, but the facing cannot be renewed, as it cannot be removed.[2] The zinc plate on which Mr. Lansil's little etching . . . is executed, was steel-faced. It is feasible also, the electrotypers tell me, to deposit a thin coating of copper on the zinc first, and then to superimpose a coating of steel. In that case the steel facing can be renewed as long as the copper facing under it remains intact."

Surfacing.—Although plates are sold ready polished, it is necessary to know how to do the necessary work for oneself, as in any case the process will be required by everyone for making partial alterations later on.

"**Snakestone.**"—This is first of all employed to wear away the whole surface, and in order to do this evenly a sufficiently wide and heavy piece must be used ; say about the size of the ordinary Washita oil-stone, or 1½ inches in width, which is not too cumbersome for the hand.

The best stone I know is called "Water-of-Ayr" and can be bought

FIG. 2.

in a number of gradated sizes from ¼ inch upwards (Fig. 2). It is used with water, and care should be taken to push the stone with as steady a driving motion as possible, and to avoid jerks.

To grind down an old plate which is covered with fairly deep lines takes a lot of energy and time, but sometimes, when one is in great need of a plate, and cannot get one except by writing (entailing several days' wait), it may be worth doing.

Charcoal.—After the surface has been planed quite free from lines and scratches, charcoal is used to remove the roughness left by the stone (Fig. 3). Here again a broad piece is necessary for work upon a large area, and the sticks are sold in all sizes and of several degrees of toughness and cutting power.

FIG. 3.—Charcoal planing.

In the "History and Art of Engraving," 4th edition (1770), page 53, the unknown writer

[1] Mr. W. C. Kimber tells me that he undertakes to "steel" zinc.

[2] i.e. presumably an acid which will attack steel more quickly than zinc is not known.

advises the following treatment of charcoal for finishing-work after the use of, first, a piece of grinding-stone and water ; second, pumice-stone and water ; and third, a smooth hone[1] and water : " Then choose out a smooth charcoal, without any knots, or rough Grain, and put it in a well kindled fire : let it be there till you perceive it red-hot ; then take it out and quench it in water . . . pare off the outermost Rind and rub your plate with it and Water till all the small strokes of the hone are rubbed out."

The author hints, later, that charcoal, so treated, cuts better ; but I have never tried it, nor have I heard of anyone else doing so.

Willow is the most commonly used wood, and it is best to keep a coarse-grained piece for beginning, and a finer grained piece for finishing. Some use oil with the charcoal in final polishing. If this is done, the stick so used must be *reserved* for use with oil, as it will refuse to work with water afterwards. Oil kills the bite of the coal very largely, and personally I rarely use them together.

Oils.—The best oils for this work are *olive* and *sperm*, but ordinary machine-oil is quite satisfactory. It is not absolutely necessary to use any lubricant with charcoal, and when dry it tends to cut less and polish more.

One should be careful to remove any pieces of rough bark before using, as this is extremely hard and will scratch the surface badly, making matters worse instead of better. The angles of the end should then be rounded with a knife, or by rubbing against a rough surface, and felt with the hand to see that no sharp points remain jutting out. The stick should be cut to a bevel as in Fig. 3, and should be pushed with the heel of the hand in the same way as the snakestone ; always carrying the stroke through as in planing wood, and removing the pressure before stopping and drawing back.

Charcoal is not usually sufficiently fine to put a really good surface on the metal. If after the use of snakestone the plate were inked and cleaned off, the resultant proof would have a fairly heavy scratchy tone, held by the roughness of the surface. This tone after the action of charcoal on the plate would appear considerably lessened, but still too heavy and unequal, unequal, so that something smoother must be employed to finish the work.

Powder Polishes.—There are many polishing powders which can be used for this purpose, together with water or oil, and the choice may be left to personal preference with as much likelihood of each etcher selecting the best, as in the matter of choosing a tooth-paste.

Amongst these are pumice, crocus, putty, emery, slate and rotten-stone powders ; rouge, Tripoli or a paste made by crushing charcoal and mixing it with oil or vaseline.

Oil-rubber.—All are applied, in the time-honoured fashion, by means of what is termed an " oil-rubber " (Fig. 4). This is easily made by tightly rolling a piece of blanket, felt or " fronting " (the finest printing blanket)

[1] It is not clear what kind of hone he refers to.

and binding round and round with twine. The surplus material is then
cut off, smoothly, just above the place where the string stops, and the
tool (having been saturated with oil) held vertically—i.e. at right angles
to the plate—and the flat end employed to rub with. It may, of course,
be made of any diameter required. Solid felt pads attached to wooden

handles are also sold by the etcher's dealer, but are
only serviceable for polishing a large area ; neither has
the flat felt the grip possessed by the *coiled* material.
In using either pad or oil-rubber the surface should be
carefully examined in order to detect any grit which
may be clinging to it, and which would play havoc with
the plate.

Fig. 4.—Oil-rubber **Plate Polishes.**—Although, when I began to practise
for polishing. etching, I fashioned one of these implements, I soon
abandoned it, and all the dry powders, for the modern
plate-polish which is easily obtainable wherever one happens to be,
is already ground and mixed, and has several other advantages which
will be mentioned later on.

Probably the best of these was pre-war " Globe Polish," which was a
paste put up in round tins of convenient size ; but this went the way of
many good things during the war, being, I believe, of German manu-
facture. " Brasso " is my present polish ; but there are many probably
equally good spirit polishes based on some such powder as pumice.

By folding up a piece of soft rag into a pad an excellent surface can be
procured with the polish and a little elbow-grease.

The student should experiment with various polishes and choose that
which he finds answers his requirements ; but discretion is needed, because
some liquids sold have too drastic an action (containing possibly a per-
centage of some free acid) and are too dangerous for use upon an etched
plate.

It is of the least importance *how* a surface polish is obtained, so long as
it can be obtained at will and is suitable for printing from.

Burnishing.—Some etchers advocate burnishing the plate all over with
the steel tool (described later) before the final polishing. This is a difficult
proceeding if the usual small burnisher is used, as the work is apt to be
irregular ; but it tends to harden the surface and get rid of fine scratches
left by the charcoal. It is not ordinarily necessary.

After these three processes—(*a*) " Water of Ayr " stone, (*b*) willow
charcoal, with either water or water followed by oil, (*c*) oil-rubber and
powder or plate-polish—the plate should show a perfectly equal shining
surface, and should act as a perfect mirror. If one's reflection is distorted,
it means that the grinding has been done unequally and the surface
is wavy.

Re-surfacing.—This waviness occurs in plates which have been ground
down inexpertly on a buffing-machine. This machine is employed in
ordinary metal-workers' shops for making name-plates and in similar

commercial jobs, and these firms will sometimes undertake to re-surface old plates.

I had an experience of such a firm soon after the war which may serve as a warning to the unwary. I was informed that this firm used to do such work at a moderate charge, and taking a batch of old plates I asked the man in the shop what it would cost to have the *backs* replaned, as they were in fair condition and would entail less labour than the removing of etched lines. He could give no figure, but estimated that it would not be very expensive ; so I left them with the proviso that the work should not be undertaken if it were likely to cost as much as new copper. Imagine my feelings when the plates were returned with such wavy surfaces (to say nothing of pits) that they were practically useless, *plus* a bill for about thrice the value of new ones !

When I went to complain, the man who had taken my order had left, and no one in the workshop had any record of my instructions. The original surfaces had been planed—not the backs—and the British work-man's time had amounted to my modest bill !

With the present cost of labour, therefore, it is not usually worth while having plates re-surfaced in Great Britain, as it used to be before the war —at any rate, by the non-expert.

Selling Old Plates.—Old plates which are not wanted can be sold as " old copper " to any metal dealer, and the price, though relatively small, is better than nothing (about 6d. per lb.).

Cleaning.—Having either bought or prepared a plate for himself, the student next has to clean it thoroughly if it is to be etched upon.

This is by no means the religious rite which several textbooks tend to make of it. In fact, one might say that most treatises are enough to put any but the most determined students out of conceit with the idea of beginning at all, by over-emphasizing the need for spotless purity in the etcher's abode—that a speck of dust or a touch from a greasy finger means ruin to the work—and so on ! It is all nonsense ; and no artist who ever etched could live up to it.

Anything which will remove grease from the plate's surface without otherwise injuring it will do to clean with. My usual practice is to rub it first with a clean rag and turpentine ; and while the rag is moist to pass it over a large lump of whitening and rub the plate with the resulting paste. In a few moments this will become darkened and slightly greenish from its passage over the metal. The pad is then turned to present a clean dry face ; again rubbed on the whitening and then on the plate. I turn the rag as many times as is necessary until the plate is dry and free from the powder. One should remember to dust the *edges*, which being rough are inclined to hold the whitening, and also the *back*, as it is important to prevent any powder jumping up on to the surface again while the ground is being laid. Methylated spirits, alcohol, benzoline, benzine, petrol or any other volatile liquid of that nature will answer, and

are all less greasy than turpentine, but for use with whitening tend to evaporate rather too quickly.

A very good cleaning mixture which I found in use by the students at the Royal College, under Sir Frank Short, is whitening mixed with ammonia. This was kept in saucers, and after the plate had been rubbed with the mixture it was washed under the tap at the sink. It could be dried by means of a clean rag, blotting-paper or heating. But this use of water is a disadvantage, as it needs careful and rapid drying to avoid tarnish. The surface once clean should not be fingered before the ground is laid.

Tarnish.—A polished plate which has been left exposed or has been wrapped in a chemically bleached paper will often be very badly tarnished. This can easily be removed with plate-polish ; but if a bitten plate becomes darkened it is easier, and much safer, to remove the stains with the aid of a little household salt (sodium chloride) in acetic acid, or, failing that, vinegar. These are mixed just before use or even upon the plate (see Chapter VI). This removes any tarnish immediately, but should not be allowed to remain longer on a worked plate than necessary. This stain remover is particularly valuable in the case of a drypoint which must not be rubbed. Wash under the tap before drying.

CHAPTER IV

GROUNDS AND "GROUNDING" THE PLATE

THERE are many grounds in use, but most of them rely upon the same ingredients in varying proportions. A good ground must have the following properties:—

(a) It must be impervious to acid.

(b) It must be sufficiently hard to allow of being freely handled and to prevent adhesion to the needle as the drawing proceeds. When removed by the point it should be possible to blow it away in the form of dust.

(c) It must be elastic enough to permit the needle to move freely in any direction without chipping or "flying," especially where the lines are drawn closely together and cross-hatched. In very cold weather the best ground is liable to become brittle, unless specially prepared for such conditions.

A combination of wax, pitch or mastic and asphaltum meets all the above requirements. The following are some of the recipes which have come down to us:

Seventeenth Century.—The following is from the 3rd edition of Abraham Bosse's "De la Manière de Graver à l'eau forte," which contains much added by Cochin of great interest to the student. Bosse's 1st edition was issued in Paris in 1645 and was probably the first book on the subject, as he claims.[1] He had evidently known, or been in touch with, Callot, who had been dead ten years. Callot's *hard* ground:

Equal parts of *huile grasse*, made from the best linseed oil, and mastic, heated until mixed and melted. This was used with the mordant which will be given later (see Chapter VI). Both ground and mordant have been completely superseded by the *soft* grounds and stronger acids. The *soft* ground is our ordinary ground and must not be confused with ground mixed with tallow for "soft-ground etching," the *Vernis mou* of modern etching.

There is also a soft ground given as "from a Callot manuscript" which is an unnecessarily complicated mixture containing seven ingredients! This indicates, however, that Callot also worked with the stronger mordant.

The hard ground is of interest because it shows that the men who employed it thought of etching merely as a quicker means of imitating the strokes of the burin.

[1] See Chapter XIX, p. 172. The 2nd edition was edited by Le Clerc in 1701 and the 3rd enlarged in 1745.

The soft grounds in this book are numerous :—

(1)	Virgin wax	1½ ozs.
	Mastic (in drops)	1 oz.
	Asphaltum	½ oz.
(2)	Virgin wax	1 oz.
	Asphaltum, or Greek pitch	. . .	1 oz.
	Black pitch	½ oz.
	Burgundy pitch	¼ oz.
(3)	Virgin wax	2½ ozs.
	Asphaltum	2 ozs.
	Resin	½ oz.
	Burgundy pitch	3 ozs.
	Turpentine	*"un sol"*
			(halfpenny worth ?)
(4)	Virgin wax	2 ozs.
	Asphaltum	2 ozs.
	Black pitch	½ oz.
	Burgundy pitch	½ oz.

Perhaps the most interesting of all is the ground given as " Rimbrant's," which is almost identical with that left on record in England by Hollar, including the white lead and gum-water.[1] " In this manner Rimbrant varnished his plates ":—

Virgin wax	1 oz.
Mastic	½ oz.
Asphaltum, or amber	. . .	½ oz.

Pound the mastic and asphaltum in a mortar separately (from the wax). Melt the wax in a pot over the fire and pour in the others little by little, stirring until well mixed. Then pour the whole into water. In laying this ground do not heat the plate too much and do not smoke it. Spread over it when cool extremely finely ground white lead diluted with " *eau gommé.*" I do not know what sort of vehicle this last was precisely,[2] but many gums would answer.

I have never seen it stated in any textbook that Rembrandt used this whitened ground, but it was the tradition in those days in France.

Hamerton in the 1868 edition of " Etching and Etchers," mentions this ground, but does not finish the translation by adding the white lead and gum. Yet he calls it a " white " ground, which, if it contains asphaltum, it can hardly be, by itself !

[1] " A Description of the Works of Wenceslaus Hollar," by George Vertue, 1759 (2nd ed.), p. 133. Hollar employed a duck's wing feather for spreading on the ground and squirrel's tail brush for the white.

[2] For a similar recipe see Note by Frank Brangwyn, p. 345.

A true white ground is given in the "Ars Pictoria," by Alex. Browne, 1669. This is:—

Wax	1 oz.
Resin	2 ozs.
Venice Cerus	1 oz.

The first two are melted together and the finely ground Cerus added after.

Eighteenth Century.—From the "History and Art of Engraving," (?) edition (1747); 4th edition (1770). This anonymous book is practically a translation stolen almost word for word from the foregoing without acknowledgment :—

Hard ground.	Greek pitch or Burgundy pitch . .	5 ozs.
	Rosin of Tyre or Ordinary rosin . .	5 ozs.

Melt together in a glazed pot over a gentle fire, and when thoroughly mixed add :—

Nut oil 4 ozs.

(the original says " or linseed oil ").

Mix and boil well for half an hour until it will "rope" (when touched with a stick) like thick syrup. After laying, the plate must be heated to harden the ground. From the same :—

Soft ground.[1]	Virgin wax	2 ozs.
	Burgundy pitch . . .	$\frac{1}{2}$ oz.
	Common pitch . . .	$\frac{1}{2}$ oz.
	Asphaltum . . .	2 ozs.

The asphaltum is added last as in most recipes, stirring all the time over a fire. Care should be taken not to allow the mixture to boil over, as it may set the house on fire. When mixed thoroughly, pour into water and form into balls with the fingers. Warm water is advisable, as cold changes the temperature too suddenly.

Nineteenth Century.—Koehler gives the following in his introduction (p. xv) to Lalanne's treatise.

Peter Moran's ground.	Best natural asphaltum (Egyptian)	2 ozs.
	Best white virgin wax . . .	1$\frac{1}{2}$ ozs.
	Burgundy pitch	1 oz.

He adds : " Nearly all recipes order the wax to be melted first, but as the asphaltum requires greater heat to reduce it to a fluid condition, it is best to commence with the least tractable substance." Therefore the asphaltum is first melted, the wax added stirring all the time, and then

[1] This is Sir Frank Short's ground, an extra $\frac{1}{2}$ oz. of wax being added (as the book suggests for cold weather).

the pitch. The mixture should be allowed to boil up two or three times (with care) and then poured into tepid water.

Transparent Ground.—From the same book as last (p. 63). This is identical with Hamerton's[1] " white " ground (see " Etching and Etchers ").

White wax .	. .	5 parts by weight.
Gum mastic .	. .	3 „ „

The procedure is as before : the wax first melted, and then the powdered mastic stirred in gradually.

Drawing through a transparent ground is always unsatisfying to an artist because so little result is apparent after the line has been put down ; and cross-hatching where regular strokes have to be laid parallel, and very close to, each other, is particularly irritating. Free work is impossible when one cannot see properly. Not only is it more difficult to see the new lines, but also the old (already bitten) ones, as the light-coloured wax does not cause them to show up nearly so well as does ordinary dark ground, thinly laid. I always use ordinary ground myself for all purposes. When working *in the bath*, however, the lines show up at once on a transparent ground as they begin to bite instantaneously.

All vessels employed for mixing and heating should be scrupulously clean ; and for stirring, a glass rod is preferable, but this should be covered at the handle as it soon becomes very hot. I have found a damaged clinical thermometer very handy. It is advisable, in order to avoid burning, or cracking the vessel, to use a double saucepan, or to stand the pot in an old tin of water.

The great difficulty in making grounds is to obtain the right sort of asphaltum. The best is the true Dead Sea asphaltum, which may be bought from specialist dealers or perhaps from a good chemist. But there is a great number of varieties with different properties, obtained from various countries.

In two of the recipes are mentioned specifically " Syrian " and " Egyptian " asphaltums, and by these probably the Dead Sea variety is meant.

Twentieth Century.—The best ground I know of personally is Rhind's (see Chapter VII), and I can testify to its durability. I once drew on a plate in Benares which I considered of no account, and consequently left knocking about my etching room upon returning to Edinburgh for seven years. At the end of that time I bit it. And though (as was inevitable) there were several bad scratches—it had never been wrapped up for protection—the lines bit perfectly without giving way anywhere.

Mr. Joseph Pennell[2] gives his verdict in favour of an American maker, Weber and Co. (see Chapter VII), but of course the constituents of both these grounds are secrets of the trade. I have made ground in the old days and tried several others, but I have not found any so satisfactory

[1] See also McBey's note (p. 348).
[2] " Etchers and Etching," p. 205.

as Rhind's, though I have no doubt there are others just as good, and probably identical in recipe.

White Grounds.—Several white grounds have been invented in the past, and Mr. Hamerton described his method of working on white wax over a silvered plate. Mr. Kimber has advertised a white ground since the war ; but none of these attempts at making etching more *positive* in process are any great help to an etcher when once he has become accustomed to seeing his lines upon a copper, instead of a white, surface.

Laying the Ground.—The old method of grounding a plate, which is still as good[1] as any, is to heat the copper until the ball of ground will

FIG. 5.—Plate upon electric heater : negative plug withdrawn.

melt upon being rubbed gently on the margin (Fig. 5). In order to spread it equally over the entire surface as thinly and evenly as possible a " dabber " is necessary, which is made as follows :

The " Dabber."—A disc of cardboard rather less than 2 inches in diameter is cut ; a bunch of horsehair placed on this, and over all a wad of cotton-wool. A piece of soft kid—a white kid-glove is admirable—being placed over the wadding, the bunched ends are held firmly in the left hand and whipped with string, beginning next the fingers and working towards the card. This gradually strains the leather tighter and tighter over the cotton-wool (which must be worked into shape) so that no folds are left over the front surface of the pad (see Fig. 6). The whole operation should not take more than five minutes, and the result be like a lady's powder-puff or a fair-sized mushroom.

FIG. 6.—Dabber.

Action of Dabbing.—With this the melted wax upon the plate is spread as quickly as possible over the whole surface by a rocking motion and the film gradually equalized by a very *staccato*, rapid, dabbing action from the wrist.

A very little practice will enable the beginner to lay a perfectly workmanlike ground in a few minutes. The usual fault at first is to lay the wax too thickly, which prevents free needlework.

[1] See notes by Bauer and several others, Chap. XXVII.

Care must be taken to prevent the plate from becoming *too* hot. If the ground begins to bubble, the plate must be removed instantly from the heater, and it is easier, in any case, to obtain an even, textureless film as the plate cools. If the wax becomes too "tacky" to be moved easily before the surface is equalized the plate is re-heated. This may be done as often as required, provided the ground is never scorched.

After finishing with the dabber the cooling surface will have become dead-looking, and a final heating will still further smooth the ground by re-melting. It should be allowed to remain until the whole surface is shining brilliantly, but no longer, for fear of burning.

Scorching.—If scorched—there is no risk of this with ordinary care— the ground will turn dull and will be brittle under the needle. It will

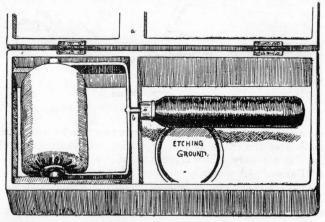

Fig. 7.—Roller in special box to prevent contact with leather surface.

also be permeable to the acid, and must be cleaned off and the work re-done.

Dust.—Too much is generally made of the dangers of dust, but it is hardly necessary to say that the operation should be performed where there is as little as possible. When the skin of the dabber becomes worn, or too hard from the wax penetrating to the wool beneath, it should be removed, a little fresh wadding added (as some will stick to the kid) and a new covering put on. A pair of lady's discarded long-sleeved gloves will provide sufficient kid for an etcher's lifetime.

The Roller.—A more modern implement for grounding is the roller. Its surface is covered with either leather or rubber; but rubber is liable to tarnish copper if used on the heated metal and, further, cannot be used with paste-ground, as it is affected by the oil-of-lavender.

Paste Ground.—Paste is made by dissolving ordinary ground in spike oil—oil-of-lavender—in the proportion of 1 of ground to 2 of oil. The

paste is first spread upon a second clean plate (or a sheet of glass) and taken up by the roller from this, in order to equalize the paste over its whole surface, and then rolled upon the plate to be grounded. This is done with cold plates, and the oil may be driven off by heating afterwards or left to evaporate—a slow business. I have never had any use for this method personally.

Ordinary Ground Rolled.—The roller can be used with ordinary ground —merely taking the place of the dabber—and this is as good a way of grounding as any, provided that the plate is flat ; but when small passages have to be re-grounded for working over old lines, and particularly where the surface has been lowered by scraping, it is useless. Naturally the roller cannot drive the ground into and thoroughly fill the old lines as the dabber can ; and I always prefer to use the implement which is equally suitable for all purposes.

Those who have given up the dabber as old-fashioned say it is a slow process, but this only means that they are not accustomed to its use. Fig. 7 shows a leather-covered roller in a box contrived to prevent the grounding surface from touching anything when not in use. The cross-bar (a) in the lid clamps down over (b) the socket (into which the handle fits) when the box is shut, and keeps all rigid.

Liquid Ground.—Still another method of grounding is by means of the same (ordinary ground) ingredients dissolved in chloroform or ether. This though a little more difficult to lay satisfactorily, makes by far the best ground to work upon. Rhind's is, again, the best I have tried ; but it is expensive, and so volatile that a good deal may be wasted if one is not very quick in its manipulation.

The best way is to place the plate—the back must be clean also in this case—in a porcelain tray (such as one requires for the acid bath) resting against the bottom and left side (Fig. 8). Place a second bottle ready with a funnel in its neck, and in this a tuft of cotton-wool to act as a

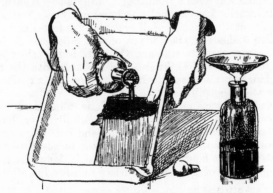

Fig. 8.—Coating plate with liquid ground

strainer for dust. Then remove the stopper from the ground-bottle ; tilt the tray up with the left hand and pour over the plate sufficient ground to cover the whole surface, always pouring from the top edge and with such force as will ensure the practically simultaneous flooding of the whole area. Immediately pour off the surplus liquid into the second bottle and replace the stopper of the first. The plate should remain tilted until the ground is almost dry in order to drain as much as possible to its edge, and also to prevent dust settling upon it while tacky.

Dust is a greater bugbear in laying this ground than in any of the previous methods, as a speck will sometimes divert the stream of liquid down the plate, and as the drying is so rapid there is no remedy. It is for this reason (apart from loss by evaporation) that the ground requires to be flooded over the plate with some force. The great disadvantage of liquids is that they are useless for re-grounding over bitten lines, as these are never properly filled in the sluicing of the surface.

There is (or was) a rather slower-drying ground made by Roberson and Co. which could be applied by means of a soft brush, and such a liquid is particularly valuable for making alterations in drawing on a plate. Mr. Pennell told me that he used it out of doors considerably. For many years I have used only the one solid ground and dabber for all purposes, but every etcher will choose for himself, and there can be no one way only for doing any of these things.

For making liquid ground Hamerton advises dissolving in ether, letting the solution stand for three weeks, and then decanting the clear upper portion for use.

Smoking.—The usual procedure when the plate is grounded and before it becomes quite còld (except in the last case, where no heat is required) is to smoke the surface in order to see the more clearly (when the needle lays bare the copper) against a blacker background. It may tend to strengthen[1] the ground to a small extent also, but, apart from this, I never could understand why such a troublesome, filthy business should be gone through. Personally I *never* smoke a plate for my own use, as Rhind's ground is quite dark enough in itself to enable one to see perfectly. But if the beginner wishes to do it, a bunch of wax tapers should be twisted up together—from three to six—and the plate being held upside-down the lighted torch is passed backwards and forwards with the tip of the flame just touching the ground. It must never remain stationary in any spot, or scorching will result.

When I had a class many years ago, in Paris, we used an ordinary oil lamp with the chimney removed. This, theoretically, gives too greasy a smoke, but we found it answer very well ; and it is much quicker and cheaper than using tapers. In this case one naturally passes the plate across the flame of the lamp. The students used a lamp also in my class at Edinburgh College of Art. If the surface remains dull after smoking,

[1] Carbon is not attacked by acid, but if the ground is good it should be *already* perfectly impervious !

the plate must be heated (from the back) until the wax absorbs the soot; but this often occurs during the smoking when a hot lamp is used. The carbon will rub off when the plate is cold if it has not been thoroughly incorporated with the ground, and a shining surface regained. Most etchers employ a hand-vice for holding the plate (Fig. 9), but it is not

FIG. 9.—Hand-vice.

necessary if the hand be protected by an old glove or even a rag. I have never owned a vice yet, and never feel the need for one, though I have provided them for students. If one is used, the jaws must be padded with card or paper, otherwise they will leave an ugly mark on the plate, which will print. One can see such marks on some of Whistler's later etchings—a bad one at the foot of the " Fruit Stall " of the second Venice set; but then Whistler, in spite of all that has been written to the contrary, was an extraordinarily careless craftsman in his later period, great artist notwithstanding.

While cooling, the plate should be stood against a wall or box, *face inwards*, to prevent any dust that may be in the air from settling upon it.

Stopping-out Varnishes.—For protecting the back of the plate, before placing it in the acid bath, and also for painting over lines which have been sufficiently bitten, a liquid ground of some sort must be used with a brush, and as the etching ground is far too costly for such a purpose, some other varnish must be found. By far the best I know, and the cheapest, is a straw-hat polish called " Tower-brand," which is made by Messrs. Hall and Dunbar, of Leith; but I have no doubt that there are other makes practically identical, and the bottles are cheap enough to buy for the sake of experiment.

It dries almost instantaneously; is thick enough not to spread up a line by capillary attraction (the danger of too thin a liquid), and is impervious to acid. Brunswick black has been suggested and various similar compounds; but the worst thing I know is the usual stopping-out varnish sold by dealers. It takes too long to dry, and is generally too thick and unmanageable.

Transparent Varnish.—For a transparent varnish, white resin dissolved in alcohol is good, but it is very difficult to see what one has stopped out.

Shellac and Pigment.—A stopping-out varnish recipe used by the " half tone " process etchers is as follows[1]:—

Shellac	4 ozs.
Methylated spirit	8 ozs.
Methyl-violet dye	2 drachms.

[1] The " Tower brand " is probably much the same. Shellac, methylated spirit and a black pigment.

(To this is added, if required, linseed oil ½ oz. to every pint of varnish. Also, for *still* slower drying, a little oil of lavender, in addition.)

Bitumen.—A more expensive varnish, used by photogravure process etchers, is:—

Bitumen (asphaltum) . . .	1 part.
Benzol	5 parts.

Shellac.—For backing plates the "half tone" etchers use :—

Methylated spirit and shellac . .	equal parts.

These last varnishes are generally used for resisting perchloride of iron. A similar commercial recipe is as follows :—

Mastic	2 parts.
Shellac	10 ,,
Turpentine	2 ,,
Spirits of wine . . .	60 ,,

An Early Recipe.—From the previously mentioned "History and Art of Engraving," one finds out what the old etchers had to use :—

Tallow	½ lb.
Olive oil	1 wineglass.
Lamp-black	1 spoonful.

Stir together over a fire until well incorporated with each other. Boil ten or twelve minutes. I should not advise this !

But if one can buy a bottle of hat-polish, which answers perfectly, there is no need to bother about such mixtures, and I doubt whether this last would resist a strong nitric bath, probably being used with the much milder mordants in vogue at that time.

Hamerton's.—In "Etching and Etchers," Hamerton suggests the following as the "most perfect stopping-out varnish yet invented" (1876) :—

A saturated solution of white-wax in ether. When the clear liquid remaining after the wax has settled has been decanted, one-sixth of its volume of Japan varnish is added, and well mixed.

This sounds very good, but then we are not told the constituents of the Japan varnish or its consistency ; and this varnish varies considerably.

CHAPTER V

POINTS, SCRAPERS, BURNISHERS AND GRAVERS

THE kind of needle a student should use is entirely a matter of his own choice. If he wishes to etch huge plates like Piranesi or Brangwyn, he will naturally select a somewhat larger instrument than were he endeavouring to copy an early head by Rembrandt ! There can be no law laid down on the subject : what suits one master is anathema to another.

Probably the oldest form of point, and one frequently used by several great moderns, is made by taking an unbending steel needle and jamming it into a wood holder—the handle of a pen or small brush—leaving ½ inch to ¾ inch projecting. Sealing-wax is then melted over the end of the holder and formed by the fingers into a smooth cone half-way up the

FIG. 10.—Needle in wood handle. FIG. 11.—Échoppe.

needle (Fig. 10). The earliest etchers largely used the *échoppe* (Fig. 11), the shape of the point (cut at a bevel) enabling them to make a line which swelled and tapered, thus imitating that of the burin.

Another form is the all-steel point preferred—possibly invented—by Whistler, which can be bought nowadays at any etchers' dealer (Fig. 12).

FIG. 12.—" Whistler."

Fig. 13 is a similar tool with a rectangular hand-grip, and one end rounded in order to act as a small burnisher.

FIG. 13.—Point combined with burnisher.

A more serviceable weapon than either (to my mind) is Fig. 14, which watchmakers and jewellers use. The great advantage of such a point is that it can be readily sharpened, as the shank is of equal diameter along its entire length ; whereas

FIG. 14.—Most serviceable type for etching.

Figs. 12 and 13 soon lose their acute angle when sharpened (unless the grindstone is used to wear away the whole shank) and become like Fig. 15. This happens still more rapidly when the drawing is done *in* the acid, which soon bites away the steel ; and a very obtuse-angled *needle* means a very broad *line*, unless the point is kept too sharp

FIG. 15.—Blunted point.

for perfect freedom. With a tool shaped such as Fig. 14, this broadening, as the point is pushed back, cannot take place at all.

Fig. 16 is another easily obtained tool used by engineers, and is sold with a sheath.

FIG. 16.

The form of point which I prefer personally, especially for carrying in the pocket, is another engineers' tool made by the L. S. Starrett Co., Athol, Mass., U.S.A. The same kind of instrument is probably made by various other firms in many countries (Fig. 17). It consists of a screw holder and loose steel point which is reversible when

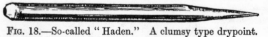

FIG. 17.—A perfect drypoint or etching needle.

not in use. As sold, the point is too long for drawing, but I succeeded in inducing Mr. Kimber to have shorter ones made, which he sells separately. The grip is excellent for drypoint. Several etchers utilize gramophone needles.[1]

Whether broad or fine, an etching needle should be blunt and perfectly round, so that the hand may move in any direction without the point catching in the metal.

After sharpening to the required size on a stone, the best way to ensure a smooth, rounded point is to take hold of the needle some way up the shank and describe circles with it upon some rough surface such as the slightly corrugated iron travelling-bed of the press, making the circumferences of the circles as wide as possible at first and gradually lessening them (by raising the hand) until the needle is nearly vertical and the circles very small. This wears off the irregular facets of the sharpened steel, and any degree of bluntness can be obtained without angularity.

Drypoints.—There is no need to keep a special type of tool for drypoint, as Fig. 17 is quite a perfect weapon for this purpose and various points may be fitted to the same holder. Several heavier and (I think) clumsier instruments are sold by dealers, however, such as the so-called " Haden " drypoint (Fig. 18),

FIG. 18.—So-called " Haden." A clumsy type drypoint.

which, as usually made, has no grip and is terrible to sharpen because of its enormous thickness. It can, of course, be whipped with twine to afford better hold for the fingers ; but why waste time supplying deficiencies which would not exist if the maker had exercised care ? The " Whistler " needle makes an excellent drypoint. The drypoint must be whetted to a *cutting* point, either round or flat ; but with the latter great care must be taken to hold the needle so that the edge is in line with the direction of the desired stroke, otherwise it will slide off at another angle, or else plough a broad shallow furrow.

The late William Strang invented a hooked point which he pulled

[1] See notes by McBey and Percy Smith, pp. 348 and 354.

instead of pushing like the graver, but the preference for such a weapon is very much a personal matter.

Jewel Points.—A very useful tool is the diamond or ruby point. Although the jewels are but small they are naturally expensive, but with care will last a lifetime. They are sold let into steel sockets which can be mounted as the buyer wishes, either in wooden or metal handles.

I use a modification of the tool (Fig. 17), which cannot be bought (so far as I know), but is easily made (Fig. 19). A thread is cut on the shank of the diamond socket (a)

FIG. 19.—The Author's diamond point—reversible.

and a corresponding one cut out of the inside of the holder (b), also a second thread cut on the point end of the socket (c). We then have a reversible point. The original screw of the holder opening at (d) is not in use at all, but can still be utilized if required with the ordinary steel point. This tool can also be carried safely in the pocket without fear of damaging the diamond.

The jewel is usually cut to a round point, either more or less obtuse, and the longer and more delicately shaped, the more liable to flake off if used carelessly on heavy lines.[1]

The chief value of these tools is their extraordinary freedom in comparison with steel. It is not very safe to employ one for throwing up as much " burr " as the metal point can readily do ; and the quality of line when the " burr " is removed approximates closely to that of etching.

In light passages, where great freedom is required, it will be found invaluable, as it can move quite as easily as the etching needle, and has an even pleasanter grip on the plate.

Before proceeding to the drawing and biting of the plate, it will be as well to break the logical sequence in order to describe the remaining steel tools which are of real importance.

The Scraper.—The scraper is used to pare off the surface of the plate when a correction has to be made ; and to remove the " burr " in drypoint where necessary. It is a three-sided stiletto, each face being hollowed except at the point. A good oil-stone is required to keep it sharp, and

FIG. 20.—Scraper, for making alterations and removing " burr."

each face must be held flat on the stone while rubbing. A long cork should be kept to protect the tip of the tool, with a suspicion of oil to prevent rusting (Fig. 20).

Rust.—None of these implements should be left exposed in a room where acid has been recently used, or much time will be wasted in removing rust.

[1] See note by Muirhead Bone, p. 332.

Action of Hand.—In scraping, one of the sides of the tool is placed flat upon the plate and then tilted just enough to shave off the metal when moved forward, with a slight downward pull. The grip is with the first and second fingers and thumb, the hand sliding on the nail of the little finger. This enables the angle of the hand, and consequently the angle of

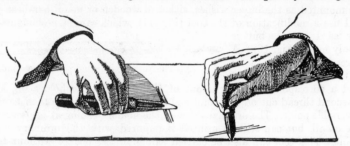

Fig. 21.—Finger grip in scraping.

the scraper, to be kept absolutely constant. All direction should be controlled entirely from the elbow (Fig. 21).

The Burnisher.—The burnisher is merely a highly polished, flat tool with rounded angles which is used with or without oil to remove roughness and

Fig. 22.—Burnisher—good pattern.

scratches. It is the india-rubber of the copper. The commonly made tool is straight and far less serviceable than the curved instrument (Fig. 22), which is made entirely of steel with differently shaped ends : one round, the other flattened. It will be seen at a glance why this is superior to the

Fig. 23.—Showing advantage of burnisher having bent handle.

straight wooden-handled affair which can never be placed flat on the plate except near one edge (Fig. 23).

The Graver.—The burin or graver is, properly, the line-engraver's weapon, but a very useful though not an essential tool for the etcher (Figs. 24, 25).

By its aid a line or two may be added here and there without the

necessity for re-grounding and re-biting; and the quality of this line combines far better with that of etching than does that produced by the dry point ; and is, besides, more durable, as the graver does not merely *displace* the metal in its passage, but *removes* it completely.

It is by no means every plate which will require its use, but as a reserve

FIG. 24.—Home-made Burin. 24 A.—Enlarged point.

tool it is very valuable. The accompanying figure (Fig. 24A) shows one type of point, enlarged, as seen from the under side, as well as a home-made burin which originally came from a " process " engraver.

Fig. 25 shows a modern design which balances well. In this case the

FIG. 25.—Well-balanced Burin.

diamond-shaped steel is cut straight through in sharpening with no bevelling of the lower angles.

Roulettes and similar mechanical dotted-line-making instruments are an abomination in etching, though they may be legitimately useful in mezzotint (see Chapter XIV, Fig. 49, C, D and E, p. 135).

CHAPTER VI

MORDANTS

Fifteenth Century.—From Mrs. Merrifield's translation of the MSS. of Jehan le Begue, 1431, in " The Original Treatises of the Arts of Painting " (1849) :—

(1) P. 76, par. 63—

" To make a water which corrodes iron : take 1 oz. of salammoniac, 1 oz. of roche alum, 1 oz. of sublimed silver (argento sublimato), 1 oz. of Roman vitriol. Pound them well.

" Take a glazed earthen vase ; pour into it equal parts of vinegar and water, then throw in the above-mentioned articles. Boil the whole until reduced to a cup or half a cup, and apply it to such parts of the iron as you may wish to corrode."

(2) Par. 64 (for the same purpose)—

" Take Roman vitriol and Euphorbia and distil them."

No. 1. Salammoniac = Ammonium chloride.
 Roche alum = Ordinary alum (sulphates of aluminium and potassium).
 Roman vitriol= Ferrous sulphate or proto-sulphate of iron.

Argento sublimato cannot be identified as no sublimate of silver is possible, but the presence of silver or of any of its compounds would undoubtedly set up an electrolytic action which would promote the attack of the metal by the mordant. This will certainly be a very weak one, and its action will be due to the acetic acid (vinegar) reinforced by small quantities of hydrochloric and sulphuric acids derived from the decomposition by water of the ammonium chloride on the one hand and the alum and iron sulphate on the other. The setting up of the electrolytic action by the silver will cause the iron to be much more rapidly attacked, however.

No. 2. The euphorbia (spurge) probably had nothing to do with the chemical result. Sulphate of iron being heated in a retort, Nordhausen sulphuric acid distils over. This would be quite enough to bite the plate.

Either of the foregoing mordants *may* have been used by Dürer in etching his iron plates. Nitric and sulphuric acids were known at least as far back as the eighth century in Europe ; and even if the armourers of Dürer's time did not use nitric, or know of hydrochloric, in all probability they obtained the aid of these acids (possibly without knowing it) by the addition to sulphuric of such salts as potassium nitrate (saltpetre) and sodium chloride (common salt), which would set free nitric and

hydrochloric acids respectively. (In Holland and Germany nitric is still called "saltpetre acid": the name used by Marius Bauer in writing to me of his mordant. See p. 326.)

Seventeenth Century.—The following is from the translation[1] of Bosse's treatise. I use the translation because it shows exactly what the British etchers were told at the time. In the original,[2] Bosse says that this was given to him by Callot:—

White-wine vinegar (distilled is better) . .	3 parts.[3]
Clear white salt armoniack	6 ozs.
Bay salt (original *sel commun*) . . .	6 ozs.
Vert de Griz	4 ozs.

Put them into a covered pot over a quick fire, and let the mixture boil up two or three times. Let it stand stopped a day or two before use. If too strong, pour into it a glass of the same vinegar.

Here the acetic acid and ammonium chloride are again present, and probably it is their action which largely constitutes the biting power.[4]

Bay salt indicates ordinary sea-salt which was obtained from the Bay of Biscay very largely, and in this case we have a definitely stated second chloride. It is therefore probable that in the older recipe the silver salt was also a chloride.

The mordant given by Bosse for use with the ordinary ground (his soft ground) is:—

Vitriol (sulphuric acid).
Saltpetre (nitrate of potassium).
Alum (*alun de roche*).

I only discovered this *after* a chemist had described the probability of an admixture of sulphuric acid with saltpetre being used in Dürer's day, and here we have actual evidence of it in Rembrandt's time, at any rate. Unfortunately, Bosse does not consider it necessary to give details of its preparation or proportions, as he says "it can be bought from the Refiners." It was called, he adds, *eau de départ*, being employed commonly by the refiners in separating gold from copper or silver. Bosse's third of water to the acid is condemned by his eighteenth-century editor, Cochin, as being too strong a mordant, and he advocates half water and half *eau forte*. This mixture was used in the modern manner by pouring on the plate, the edges of which were banked up with bordering-wax; whereas the weak vinegar-salammoniac bath was poured over the plate with a jug, the copper resting (nearly vertical) in a wooden trough on a sort of easel. At the bottom of this trough was a hole which allowed the

[1] "The History and Art of Engraving," 4th edition, 1770.
[2] "Traicté des manières de graver," 1645, (p. 9.)
[3] In the original, 3 *pints*, which makes all the difference.
[4] One theory is that it is the acetic acid which releases the hydrochloric acid in a small quantity from the chlorides, but only chemists can decide upon these points.

liquid to return to a basin below, from which it was again scooped up. A most tedious business ! This was to keep the weak mordant in motion, replacing spent acid by fresh.

Hollar, writing in England at about the same period, is still less explicit. His mordant is 2 parts wine-vinegar to 1 part aqua fortis at 3d. per oz.

Dutch Mordant.—The " Dutch Bath "[1] is as follows :—

Water	880 grammes.
Pure hydrochloric acid . .	100 ,,
Potassium chlorate . . .	20 ,,

The quickest method of making this up is to dissolve the chlorate in hot water in a saucepan, allowing it to cool sufficiently before pouring into the glass-stoppered bottle and adding the acid.

This is a very weak bath and is usually heated to about 80° Fahr., when it attacks much more quickly.

Smillie's Bath.—The following is the bath which I use. It is taken from the English edition (1880) of Lalanne's treatise. The proportions (given to Mr. Koehler by the American etcher J. D. Smillie) are easy to arrive at. I make up twelve times the amount in an 80-oz. bottle (say, 60, 12 and $2\frac{1}{2}$ ozs. respectively):—

Water	5 ozs.
Muriatic (hydrochloric) acid . .	1 oz.
Potassium chlorate	$\frac{1}{5}$ oz.

Smillie used even this bath heated to 80° or 90° Fahr. When cold it is very slow.

Action of Dutch Bath.—In this case the acid attacking the chlorate sets free chloric acid, but this chloric acid in the presence of free hydrochloric acid gives rise to chlorine and oxides of chlorine, which are the true biting agents, and attack the metal without the evolution of gas.

This is one of the important differences between this " compound " mordant and the single acid bath : nitric.

In the use of nitric acid, bubbles form in the lines as the gas is evolved, and unless constantly swept away (by means of a feather) will interrupt the action, and slightly broken or dotted lines result in the proof.

Lines Darkened.—Dutch mordant generally darkens the lines '(not always), but with an unsmoked ground they are quite easy to see. I believe this to be due to a slight sediment, as, if the bath be set in motion the lines begin to brighten. Also there is no permanent darkening of the metal.

Mr. Mortimer Menpes once told me that Whistler very frequently began biting with this acid (probably the Haden proportions, see below), and,

[1] This bath was possibly invented by Haden. He was certainly one of the first to use it. It was almost certainly unknown prior to 1850.

after the lines had been well started, went on with nitric. This is certainly a very sound method, as the slow-eating "Dutch" mordant attacks much more equally all widely spaced and delicate lines which are apt to be ignored by the more vigorous nitric. On the other hand, it is much more liable to cause foul-biting, as it penetrates, insidiously, the slightest flaw in the ground, and this cannot be detected until the wax is removed. In the case of nitric one can see the bubbles.

Reversing the above order, if one finds that the ground is in danger of breaking up under the widening effect of nitric it will be safer to carry on with the hydrochloric bath.

Haden's Mordants.—The following baths are given by Mr. Hamerton[1] as those which were used by Seymour Haden about 1880, and characterized as slow but safe :—

For Copper.

Nitrous acid	. .	33⅓
Water	. .	66⅔
		——
		100

Hydrochloric acid	.	20
Chlorate of potash	.	3
Water	. .	77
		——
		100

For Zinc.

Nitric acid	. .	25
Water	. .	75
		——
		100

Hydrochloric acid	.	10
Chlorate of potash	.	2
Water	. .	88
		——
		100

Nitrous and Nitric.—Nitrous acid is rather weaker than nitric, otherwise bites and is treated identically.

Nitric acid is used by myself with an equal quantity of water (equal volume, not weight) ; but many prefer a weaker bath, such as 3 parts acid to 5 parts water, or Haden's ⅓ acid to ⅔ water, quoted above.

For zinc a weaker acid is always advisable, but these strengths are varied by every etcher,[2] and it is largely a matter of temperament.

In preparing the mixture the water should not be poured into the acid, or the heat generated may conceivably crack the bottle. The water should be measured and first poured into the bottle, then the acid added. It should never be stoppered until the mixture has had time to cool ; neither should it be used until cold. The acid should be of about 40° strength on the French hydrometer, or of a specific gravity of 1.42, as bought. It is well to hold in reserve some of the neat acid for extra strong biting at the end of the work.

The mixture will be a little too vicious in its attack until it has

[1] In "Etching and Etchers," he describes the Dutch mordant as "recently discovered," but does not mention Haden's name, which he probably would have done if Haden had been its inventor.

[2] See Blampied's "Loading Sea-weed," p. 351; also notes by Bauer, McBey, etc., Chap. XXVII.

had some copper added to it, and filings or a fragment of the metal should be thrown in. After the first making some of the exhausted acid can always be mixed with the new : sufficient to colour it a pale green.

Iron Perchloride.—A mordant commonly used by process-etchers is perchloride of iron, which bites very sweetly and evenly. It also seemingly darkens the lines while biting, but they are not permanently discoloured. Its chief drawback when employed by artists is that its action causes a sediment (or deposit of iron oxide) to form at the bottom of the line, which interferes with the biting.

Process workers avoid this choking by usually biting the plates upside-down, when the sediment falls out of the lines, as formed ; but this implies working by time only, without the possibility of judging the depth by watching it in the bath. There is no evolution of gas perceptible.

Artists rarely use this bath, apparently, probably for the above reason.[1]

The solution kept by chemists (as medicine) is about 1 in 4, which is too weak for rapid etching ; but perchloride crystals may be bought and dissolved in water to any degree of strength desired. The process-etchers usually judge their strength by means of the hydrometer—the French *pèse-acide* (Fig. 26)—and a good biting strength should be between 25° and 30°, taking the saturated solution as 45°. The lines are moderately widened. It was suggested to me that an admixture of hydrochloric acid (say 10 per cent) would dissolve the iron oxide deposit and prevent fouling of the lines. I have tried this, but it needs a number of careful experiments to make sure in such a matter. It could in any case do no harm, and if this drawback were overcome, perchloride of iron would be a most excellent mordant.

Acetic Acid.—Another acid which is invaluable, and the use of which one does not find in textbooks, is acetic. Ordinary commercial acid is best—*not* " glacial," which is too strong—and it is used undiluted. The B.P. acetic acid (commercial) is about 30 per cent strength. Its function is to remove impurities—particularly those deposited by the moist hand in drawing on the plate—which may have collected in the lines, so forming a temporary " acid-resist " which will cause fatal irregularity in the biting.

Fig. 26.

Ordinary acetic acid has so little effect upon copper that one may leave the plate in the bath indefinitely, but five minutes or so should be fully long enough, unless the plate is in a bad mess.

After the treatment the acetic may be poured back into the bottle without removing the plate from the bath, and the mordant poured on instead. There is no need to wash the plate in between.

This freeing of the lines from the perspiration salts, etc., is particularly necessary when a plate has been worked upon for several days, as without the action of acetic the most recently drawn parts are almost certain to

[1] See note by McBey, p. 348, and by Benson, p. 328.

begin biting before those passages drawn earlier. This is especially fatal when an early-drawn piece of shading has been recrossed towards the close of the work, in which case these last lines will jump ahead of the rest of the tone they are part of ; as even when there has been no sweat from the hand, the slight oxidation from the atmosphere is sufficient to make a difference. The action of the acetic brightens up all the lines as if they had been only just drawn and permits the mordant to reach them all immediately, and, what is more important, simultaneously.

Vinegar and Salt.—Good vinegar should prove an efficient substitute, especially if a little common salt be added. I have recently learnt that this (rather with acetic acid) is precisely what " process " etchers use for cleaning the work before biting with perchloride of iron. It is what was advised earlier in the book for removing tarnish.

Bottles.—By far the best receptacle for acid is the French laboratory bottle. Other than my own, I have never seen one in this country, though I imagine that they must be employed in scientific workshops ; but they are certainly not known to the dealers, which is a pity. I bought my first in Paris in 1907 for seven francs, and another in 1922 for twelve francs, which, considering the then rate of exchange, was even cheaper (Fig. 27). This bottle has very great advantages : it pours exactly ; prevents any liquid which may remain on the lip from running down on to the table ; supplies its own funnel for returning liquid to the bottle ; and is air tight.

FIG. 27.—French bottle for acid —a great convenience.

The neck (*a*) is wide enough to form a funnel, and into its base fits a *movable* spout with a lip for exact pouring (*b*). At the base of this tube and at the opposite side to the lip is a *groove* (*c*) which allows any drops that run down from the lip in pouring to return to the bottle. Over all fits a glass cap (*d*) with ground sides. It is a remarkably ingenious contrivance, and saves much trouble.

Warnings which cannot be insisted upon too strongly may as well come here :—

1. Label all bottles legibly.
2. Keep acids and other poisons out of reach of children.

Whatever the shape, all acid bottles must be provided with glass-stoppers. In this country no druggist may sell acid in an ordinary white smooth-sided bottle. The law now insists upon a ribbed, blue bottle, so that both feel and colour may warn the user of the nature of the contents. But this blue glass is a nuisance for keeping mixed mordants, as it is very necessary to see the colour of the acid in order to judge of its strength.

The more copper taken up the deeper the green colour until, eventually, it becomes a rich peacock blue in the case of nitric.

When the colour becomes very dark, the biting force of the acid will be nearly exhausted—the result being under-bitten lines if the biting has been gauged by time—and most of it should be thrown away, keeping a little, as before mentioned, for taking the edge off the new acid.

The more concentrated the acid, the more quickly it attacks *and exhausts itself*. Pure nitric when placed on metal will boil furiously for a moment, when a blue-green salt will be formed and the action entirely cease ; while the same amount of acid mixed with an equal bulk of water will continue biting steadily for a long time. Within reason, therefore, the weaker the acid, the cleaner, smoother-sided line it will bite ; while the stronger the acid, the coarser, rougher-edged line will result.

Dutch and Nitric Lines Compared.—The action of strong *nitric* tends to push back the sides of the trench it is forming, undermining the ground which floats off into the bath. This means that, even if a delicate point be used in drawing in the first place, the strongly bitten line will be *broad* as well as deep.

The Dutch mordant, on the other hand, having no " boiling " action, does not break up the wax at the edges of the lines to the same extent, and only begins to eat sideways *after* penetrating beneath the surface.

Hence one obtains a comparatively narrow line with considerable weight of ink in the heavily bitten parts, as the trench is deeper in proportion to the width *at the orifice*. Allowing for considerable exaggeration, (a) and (b) in Fig. 28 illustrate the section of lightly and strongly bitten nitric lines ; while (c) and (d) the corresponding Dutch bath result. Perchloride widens the lines rather more than the Dutch mordant, if anything.

FIG. 28.—Nitric and "Dutch" lines in section.

Dishes.—The use of a tray during the biting for placing the plate in

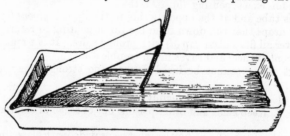

FIG. 29.—Method of lowering plate into acid.

bodily (instead of banking up the edges with green wax) probably dates from the very end of the seventeenth century. (See p. 66.)

For this purpose any kind of dish with a glazed or varnished surface, which is unaffected by acids, will serve. It is quite possible to make one

at home, with wood protected by stopping-out varnish, melted beeswax being first run into the joints. But the most suitable dishes are those used by photographers, of porcelain or *papier-mâché*, the latter being beautifully light but less durable. It is as well to buy one sufficiently large to take any plate one is likely to etch.

In order to avoid splashing when placing the plate in the bath, I use an old tooth-brush handle filed to a flat chisel-edge. The plate is placed against one wall of the tray on edge (Fig. 29) and the upper edge supported by the bone handle, which lowers it gently down into the acid.

Another method is to lower the plate into the bath by means of string under the upper end ; leaving this beneath while the work is going on, and using it in the same way for removing the plate (Fig. 30).

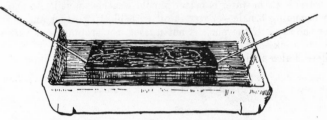

Fig. 30.—Lowering plate by means of string.

This is both more risky and messy. The string is rotted in time and may snap ; and if it does, everything near the bath will be splashed with corrosive. Also, the ends of the string, once saturated, are apt to carry the acid over on to the table by capillary attraction.

Ammonia.—It is well to have a bottle of liquid ammonia handy for application to any spots of acid which may get on to one's clothes.

Overalls.—If one uses an overall (on which spots do not matter), the sleeves should be either quite short or quite tight-fitting. Otherwise they will constantly interfere with one's work. It is quite possible, for instance, to dip one's sleeve in the acid without being aware of it, and then to rest the material upon an unprotected plate ! Also a full blouse sleeve will be always catching on the edge of the plate, especially in printing.

Acid on Clothes and Fingers.—Next to a strong alkali like ammonia, water is the best thing to counteract the effect of acid. If the hand begins to tickle violently, it should be dipped into water ; but for clothes an alkali is necessary to neutralize the acid instantaneously. This may save the colour of the cloth, if one is quick enough.

Rubber Gloves.—Nitric acid roughens and yellows the skin, but unless rubber gloves or finger-stalls are used this must be put up with ; and no genuine enthusiast ever minds such trifles.

Fumes from Acids.—Fumes from the hydrochloric and chloric acids are as nothing when compared with those from a strong nitric bath where a large area of metal is exposed. My present etching room is very small,

and the effect of these gases is very noticeable even at a distance from the bath ; but I shall never forget how near I was to suffocation from nitric fumes when I bit my first plate. This was because, in my anxiety to see what was happening, I leant right over the bath ; and the plate was being over-bitten to a hopeless extent. Once the fumes get down into the lungs it is no joke—probably similar to, though milder than, the mustard gas used in modern " civilized " warfare—and I strongly advise a beginner to avoid breathing in more than can be helped. Of course, it is only in *very* fierce bitings that real fumes are given off, but when they are—they can be seen readily enough, slightly orange in colour—look out ! If coughing begins, drink water,[1] and open the windows.

In order to stop the acid's action in biting, either plunge the plate bodily into water—warm water is better in cold weather, as it keeps the ground from becoming brittle—or dry it off with blotting-paper and then rinse under the tap. If the plate is not *washed*, the stopping-out varnish will refuse to stick to the ground properly.

There is also a slight danger of continued action in the lines.

[1] Better still. A little carbonate of soda in water, and breathe weak ammonia. In the case of chlorine gas, Hamerton cites milk as an antidote.

CHAPTER VII

The following list contains all the necessary implements for working in the several branches of etching and drypoint, together with many which are usually considered, but which are not, necessary :—

For Grinding and Polishing the Plate.

Snakestone (Water-of-Ayr).	Tool and instrument maker or etcher's dealer.
Charcoal (hard and soft).	Etcher's dealer.
Plate powders, choice of : Crocus, emery, putty, pumice, rotten-stone, rouge, slate, Tripoli, etc.	Tool and instrument maker or etcher's dealer.
Plate polishes: "Brasso," "Globe," etc.	Drysalter or grocer.
Oil-rubber.	Home-made.
Sand and emery papers, coarse and fine.	Drysalter.
Oils : Olive, sperm, machine.	Grocer, chemist, bicycle or sewing-machine shop.
Turpentine, pure.	Artists' colour-maker.
,, commercial	Drysalter or oil shop.
Methylated spirit	,,
Benzoline or naphtha	,,
Benzine (benzol)	Chemist.
Petrol	Motor garage.
Oilstone (Washita, Arkansas, Turkey).	Ironmonger or tool-maker.
Whitening, ordinary.	Drysalter.
,, fine.	Etcher's dealer or chemist.
Ammonia (liquid).	Chemist.
Caustic soda (for removing dried ink from lines).	,,
Hammer and anvil (for beating up)	Etcher's dealer or tool-maker.
Callipers (for same).	,, ,, ,,
Oil-can.	Cycle shop.
Vinegar and salt.	The home.
Files, coarse and fine (both flat).	Ironmonger.
Shaving-brush (cheap, not badger).	Hairdresser.

(Turpentine, commercial / Methylated spirit / Benzoline or naphtha / Benzine (benzol) / Petrol — choice of.)

59

Plates, copper or zinc.

Etcher's dealer. Any process-block maker will supply name of wholesale house if not able to sell, himself, direct.

For Grounding the Plate.

Ground : Black, transparent, liquid, „ Paste.

{ W. Y. Rhind, 69, Gloucester Road, Regent's Park, London, N.W. 1. F. Weber and Co., 1125, Chestnut Street, Philadelphia, U.S.A. Or etcher's dealer.

„ White.

W. C. Kimber, Tankerton Street Works, Cromer Street, London, W.C. 1.

Stopping-out varnish.
Straw-hat polish (black), Tower Brand.

{ Hall and Dunbar, Leith, Scotland, or similar make from ironmonger, etc.

Resin (white) for transparent varnish.

Drysalter or chemist.

Shellac.
Pitch : Burgundy or black.
Gum mastic.
Asphaltum (bitumen) (Dead Sea).

„ „
Chemist.
„
„ Messrs. Penrose, 109, Farringdon Road, London, E.C. 1, supply it.

Wax (white).
Tallow (for soft ground).
Alcohol, chloroform, ether (solvents).

„
„ Or drysalter.
„ (if reason for use can be shown).

Dabber (kid, cotton-wool, horsehair).

Home-made.

Dust-box (for aquatint ground).
Hand-vice.
Tapers (wax).

Etcher's dealer or home-made.
„. „ or tool-maker.
„ „

For Drawing and Working on the Plate.

Light-screen (wood frame and architect's tracing paper).

Home-made.

Points (steel).
Scraper and burnisher.
Graver (burin).
Diamond or ruby points.

Etcher's dealer or instrument maker
„ „ „ „
„ „ „ „
„ „ „ „

Tools specially made for mezzotint : scrapers, rocker, burnishers, etc.

} Etcher's dealer.

Hand-rest (for soft ground).

Home-made.

For Drawing and Working on the Plate.

Reversible engineer's pointers.	L. S. Starrett Co., Athol, Mass., U.S.A., or engineers' tool-maker.
Steel points (for same).	W. C. Kimber.
Transfer papers.	Stationer or artists' colourman.
Chinese white (in tube).	„ „ „
Brushes (camel-hair or fitch), several sizes.	„ „ „

For Biting the Plate.

Acids : Nitric or nitrous.

Hydrochloric (muriatic).

Perchloride of iron. } Chemist.

Acetic.

Baths (porcelain or lacquered).	Photographer's supplier.
Feathers (small and long).	Poulterer.
Funnel (glass or porcelain).	Chemical supply store.
Potassium chlorate (crystals).	Chemist.
An old toothbrush handle (a lifter).	The home.
Fountain-pen filler (for lifting acid on plate).	Stationer.

For Printing the Plate.

Press. Nothing smaller than 17-inch roller is advisable. No fixed-wheel (ungeared) action.

Zinc bed-plate for same (if desired).

} Second-hand, if possible, from a reliable source unless the beginner can obtain advice of an expert. W. C. Kimber, or makers such as Hughes and Kimber, of London.

Blankets (swan-cloth, fronting). } Etcher's dealer, or direct from factory through a draper.

Inks : Frankfurt black (*Noir sec*, No. 1, *pour Taille douce*).

French black (heavy and light) (*Bouju* is very good).

Burnt umber, raw umber, Sienna, etc.

} La Fleche fils, 12, Rue de Tournon, Paris ; or Messrs. Cornelissen and Sons, 22, Great Queen Street, London, W.C. 2.

Burnt oil (thick, medium and thin).	B. Winston and Sons, 100, Shoe Lane, London, E.C. 4.
Unburnt pure linseed (small bottle).	Chemist.
Ink ground and put up in collapsible tubes.	Etcher's dealer.
Ink slab (an old litho. stone is best).	Lithographer or printer.

For Printing the Plate.

Muller (marble or similar stone).	Etcher's dealer.
Heater (iron table with gas-ring attached).	,, ,, or blacksmith.
Heater electric (plate-warmer).	Electrician.
Jigger (smooth wooden box same height as heater).	Carpenter or home-made.
Muslins : Tarlatan (French or Swiss),	Draper (probably special order).
Book-muslin or Leno (coarse and fine).	,,
Soft (for retroussage).	,,
Palette knife—a long-bladed painting knife is best.	Artists' colourman.
Blotting-paper (without water-mark).	Wholesale stationer.
Clean rags.	The home.
Printing papers.	Etcher's dealer or wherever found. (Messrs. L. Cornelissen for Van Gelder ; *for Japanese see p. 143.*)
Gelatin (for sizing paper).	" Cox's leaf-gelatine " from grocers.
Alum (,, ,,).	Chemist.
Brush (,, ,,) (large flat).	Drysalter.

Steel-facing (both copper and zinc) is undertaken amongst many firms by W. C. Kimber.

PART II

CHAPTER VIII

PLAN OF AN ETCHING-ROOM

EVERY worker will, sooner or later, evolve some system of arrangement for his tools, press, drawing-table, etc., according to the type of room at his disposal ; and the following plan (Fig. 31) is merely a suggestion which may be modified to any extent. It is a purely personal arrangement (based on twenty years' experience) of a very small room, and it has its weak points : the chief being that when working from a very large drawing

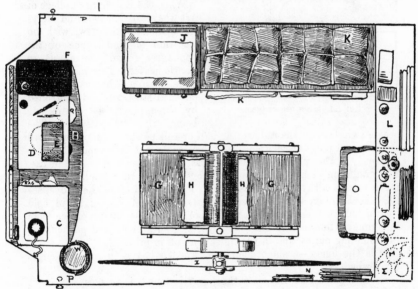

FIG. 31.—Plan of room.

(as sometimes happens) there is very little space for both drawing and plate if both are to be seen in a good light. Another drawback is the absence of a sink—a distinct inconvenience—but one can manage well enough by bringing in water in a bucket. Otherwise I find it answers excellently, and, in a small room, one never has to go far to fetch what is required !

A. In the window is the light-screen, made by stretching architects'

tracing-paper across a wooden frame—a canvas stretcher, for instance—which, by diffusing the light, prevents the metal of the plate from glittering too much. It is absolutely necessary when working upon a grounded plate indoors. Out of doors the light comes from all angles, and there is no glittering of the lines in one direction more than another. This is equally essential during printing operations.

B is a table filling the alcove of the window.

C. The heater on the table. In my own case merely a gas Bunsen-ring standing upon a wooden box, the top of which is protected by an iron sheet. Another sheet of iron is placed over the ring for certain purposes, but this is rarely necessary. The usual heater (Fig. 32) will probably be preferred by the student—at least, it is orthodox—and is merely a solid topped iron box with gas fixings or movable ring *at one end*, which allows a gradation of heat.

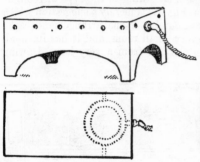

FIG 32.—Iron heater (gas).

When the Edinburgh College of Art was started in 1908 and everything was bought new, with no tradition to hinder, one of the appliances I had put in was an *electric*-heater. This was nothing more than a " hot-plate " with polished steel top and controlled by three plugs, the centre one being the " negative." The others switched on the radiator at half or full power. There were both radiator and plugs at each end, but they could not be employed simultaneously. This proved a great success as a heater and is still in use. The gradation of heat is perfect and constant, and in a small room it is much more healthy than a gas-heater. For illustration of the above, see Chapter IV, Fig. 5. The electric-heater does not back-light in cold weather like a Bunsen-burner, and there is also less danger of fire from inflammable liquids and old inky rags. The heater is used particularly in grounding plates, and in wiping the ink off in printing.

D is the jigger—a smooth-surfaced wooden box with rounded edges upon which is

E. The plate. In this case the jigger is longer than normally, as it serves for a table for drawing upon also. Underneath are kept the ink powders in tins, and the lump of whitening (Q).

F is the ink-slab (a litho. stone) with its marble muller. When the box is required for drawing upon this slab is transferred to the press opposite (G). About 18 inches above the heater is a large hook, from which the inking roller (described later) is suspended out of harm's way. The roller is never allowed to rest long upon its composition surface and so become flattened. If this happens it is almost impossible to convert it

to its original shape. This position (above the heater) also serves to keep it warm and, consequently, soft.

G is the travelling-bed of the press.

H. The blankets under the roller. They should never be left there long (see Chapter X).

I. The star-wheel, which takes up the least possible space next to the wall.

J is a table with drawer for holding etching tools, ground, dabber, etc., which can be reached without moving when working at the window table (B). A cupboard beneath the drawer holds spare blankets, muslin, etc. ; while on the table lies a sheet of plate-glass for use in damping paper, with a second against the wall ready to cover it.

KK are long shelves running the length of the wall and reaching nearly to the ceiling. These hold various parcels of printing-papers and plates, etc.

L is a shelf at the end of the room, very high up, upon which are kept oils, turpentine, spirits and other solvents ; with frames and old plates at the back.

M is a corner " what-not " with shelves widely spaced, to take acid-bottles, etc. Being in this corner no one is likely to brush against them in passing. This is underneath the long shelf running across the room.

N. Piles of plates, mostly finished with and " destroyed."

O. Reams of blotting-paper standing *on end*, with one open one (in use) laid across the others. It is far cheaper to buy at least five reams at once. If this is too large a quantity for one individual, it is a good plan for several to club together.

PP. Doors of the room, which both open outwards.

W. A bucket of water when required. (The door near it is then locked !)

Paper should never be kept on the ground ; and in a small room like this, where there is a large store of it, the floor should never be cleaned by *washing*. It is very liable to breed mildew if this is done.

Whatever the plan of the room it is very necessary to observe the old maxim, "A place for everything, and everything in its place," otherwise a lot of time will be wasted, and the work will not go well.

When artificial light is used, the globe must be screened even more carefully than daylight. An excellent plan, if one has the use of electricity, is to bring the lamp down behind the window screen, so that everything will be still in the same relation to the light as in the daytime.

In 1908 I had several open cubes of light wooden framework constructed for use at the College, over which was stretched the same tracing-paper. These were about 2 feet square with open tops into which the electric lamps were lowered as required. These screens, which stood on the benches, could be worked at on all sides by different students and gave a very good light. It is preferable to have a more powerful lamp than the usual reading light ; but with a really powerful globe one can see even more clearly in some respects than by daylight. I have often wondered how Rembrandt managed to work (as he presumably did) with the comparatively dim lamps in use at that period.

CHAPTER IX

METHODS OF BITING EXPLAINED AND COMPARED

We may now suppose that the student has fitted out his workshop with a selection of the necessary tools described in Part I.

Having laid a good ground, there are several different methods by which he may now proceed to draw upon and bite his plate, and they may be used either separately or in conjunction with one another.

A. **Biting in the Bath with Stopping-out.**—The whole of the drawing may be completed, as far as he can see his way to carry it, before any biting is done. Any mistakes[1] he has made must then be carefully painted out with stopping-out varnish, and the back covered also. The plate is then bodily submerged in the mordant and left for just so long as he judges necessary for the most delicate lines in the design to be bitten, and then removed, washed and dried with blotting-paper. The plate should have been previously treated with acetic acid as already described.

The delicate lines are then painted out ; the plate replaced and left long enough for the second lightest lines to etch ; removed again ; stopped out, and so on until the strongest lines of all alone remain. When these are being finished there is often a danger of the ground giving way and the lines coalescing, and if this happens the work must be stopped ; otherwise the mordant will merely lower the whole surface, and what is called a *crevé* be formed. The longer the biting is continued after this occurs the more the already bitten grooves are reduced to one (a lower) level, and the less ink will be held in printing. Therefore when the ground begins to break up, cease biting at once.

Bordering Wax.—A probably older[2] method for covering the plate completely with acid was to build up a wall of wax round the edges of the plate itself. To do this, wax is softened in hot water and then moulded on to the plate with the fingers when sufficiently pliable, fixing it firmly on the under side and bringing it up round the edges. It will soon harden as it cools. It is advisable to form a lip for pouring at the left-hand top corner.

Sometimes it is the only method possible, as in the case of a specially large plate. Extra sized baths are very costly.

When the plate is lying in the acetic bath is the best time to make sure that no scratches or small mistakes have been overlooked in painting out ; as when the surface is covered with liquid it is easier to see with certainty.

[1] e.g. the faint lines between the diagrams in Plate 1, which were painted out before biting began.

[2] The first mention of the bath appears in Le Clerc's additions to Bosse's book, i.e. in the 2nd edition, 1701.

Even in the best diffused light some lines always tend to shine more than others, and this is lessened by the liquid. If the needle has been well pointed so that it is not too sharp, these slips and alterations will take very little removing after the biting has been finished and the ground washed off ; but if forgotten and bitten in there will be a lot of trouble ahead. In using nitric the feather must not be forgotten and bubbles removed as they form on the lines.

B. **Biting out of the Bath, without Stopping-out.**—A second method is to complete the whole drawing as before, but, instead of placing the plate in a bath, to pour the acid upon it in various places, moving it here and there with the feather. This is rather tricky to handle properly and perhaps better avoided by the beginner, except in the case of final bitings on isolated spots, when it is far more convenient to paint round the passage for an inch or two and then pour the acid on, than to stop-out a much larger area for the sake of one or two small patches prior to replacing the whole plate in the bath.

The advantage of this method, when controlled skilfully, is that stopping-out is not necessary, or very little so ; and that more gradation may be obtained in a passage by playing the acid over it, little by little, with the feather. One can also see the whole effect right up to the end, and can better judge the values—delicate lines against heavy—when none is covered with stopping-out varnish. Joseph Pennell took this method from Whistler, who used it in his later period—that is during the time that Pennell knew him—and the pupil advocates it very strongly. Both he and McBey, who also employs it, say that the best way to prevent the acid running where it is not wanted—it will always try to get off the plate—is to spit on the part and form a little barricade of saliva (see note by McBey, p. 348).

It can be seen that this method is really only suitable for plates where the work is principally concentrated well inside the margin—otherwise the acid will tend to run off when pushed right up to the edge—and this is precisely the sort of design Whistler was drawing more and more.

Some of the last Dutch and Belgian etchings were a partial return to his earlier filling of the copper to the plate-mark—" The Embroidered Curtain," for instance—but such a design as " The Barrow, Brussels," is far more typical, and has not a line approaching within $\frac{1}{4}$ inch of the edge anywhere.

I think it is quite certain that the early French and Thames sets were entirely bitten in the bath (Method A), and, in fact, no plates worked thus solidly up to their plate-marks (e.g. " Black Lion Wharf " and " La Vieille aux Loques ") could have been executed in any other manner. In the last mentioned, if the margin be examined, foul-biting will be found running right up to the edge (including several finger-marks) where the ground was weakened during the plate's manipulation (Plate 115).

C. **Drawing and Biting Portions Alternately.**—There is a third method which presupposes a working-drawing or a very excellent memory ; unless

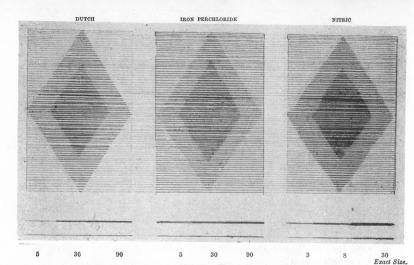

DUTCH IRON PERCHLORIDE NITRIC

| 5 | 30 | 90 | 5 | 30 | 90 | 3 | 8 | 30 |

Exact Size.

Plate 1. Figure A

ILLUSTRATING COMPARATIVE MORDANTS.

THE DUTCH WAS SMILLIE'S BATH, COLD.
THE PERCHLORIDE 30°, TAKING THE SATURATED SOLUTION AS 45°.
THE NITRIC WAS ½ & ½ WITH WATER.

TWO STOPPINGS ON EACH FIGURE. THE LINES WERE RULED RIGHT THROUGH EQUALLY. THE NITRIC WAS BITTEN BY POURING ON THE ACID; THE DUTCH BY PLACING THAT END IN THE BATH AFTER STOPPING-OUT BOTH CAREFULLY, THE COPPER WAS ENTIRELY SUBMERGED *upside down* IN THE PERCHLORIDE BATH.

| 2 | 10 | 25 | 10 | 70 | 190 | 10 | 70 | 190 |

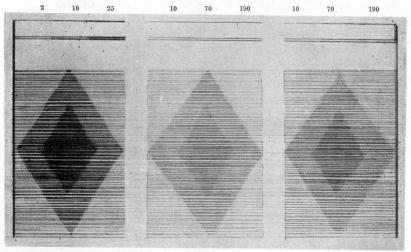

Exact Size.

NITRIC DUTCH IRON PERCHLORIDE

Plate 1. Figure B

ILLUSTRATING COMPARATIVE MORDANTS.

THE NITRIC WAS THE SAME AS THAT USED ABOVE, BUT WAS VERY FRESH.
THE DUTCH WAS SMILLIE'S BATH, VERY SPENT.
THE PERCHLORIDE WAS THE WEAK SOLUTION SOLD BY CHEMISTS.

ALL THREE WERE BITTEN BY ALLOWING THE ACID TO STAND ON THE DIAGRAM. HENCE MORE THAN DOUBLE THE TIME REQUIRED FOR ABOUT THE SAME RESULTS AS FIGURE A, WAS NEEDED FOR THE TWO WEAKER MORDANTS. THE TIMES ARE GIVEN IN MINUTES.

one can take the grounding apparatus to the subject or return several times to complete the work, as is possible in the case of a portrait, for example.

This is to draw one part of the design first, and, after biting this, reground the plate and finish the drawing, biting the second part in its turn.

D. A very similar method is to draw only the stronger parts of the design first, and having bitten these until the length of time which will be required to finish them corresponds with the period which will be sufficient to bite the more delicate passages, remove the plate from the bath, draw in the light parts and complete the biting of both together. By doing this no stopping-out is required, but a very nice judgment of biting !

Certain types of subject lend themselves to these two methods, and in employing the last, stopping-out can always be resorted to, if one's calculation of the time has proved faulty.

E. **Drawing during Biting.**—Still a fifth method is that invented (so far as we know) by Seymour Haden. Who actually was the first to use it is of no importance whatever : certainly Haden was the first who obtained such splendid results of gradated biting by its employment.

This is nothing less than drawing while the plate is actually in the bath. We can more easily understand why the Haden mordants (already given) are comparatively slow biting.

To do this one must have a very clear idea of one's composition and exactly where the *darkest* accent in the design (which must obviously be set down first of all) is to come ; as, directly the line is drawn, biting will begin, and however rapidly the subsequent lines may be put down those first started will keep their lead.

We are told that Haden used this process out of doors while drawing from Nature, but to do this requires extraordinary certainty and power of seeing the finished work in one's imagination before beginning.

A very complicated subject in which there are to be large areas of equal tone had better not be attempted by this means, at any rate by the beginner. A man who has used it successfully in the past, and still uses it in combination with Method B, is McBey ; but the treatment of his subjects suits such methods. This working in the acid naturally eats away the needle very rapidly, and, if a fine point, it soon snaps off, while a heavier one becomes too sharp and catches in the metal of the plate when turning.

Method A is illustrated by Plate 2. I have chosen this etching, although it was done as long ago as 1907, for several reasons. Firstly, being small and strongly bitten, it will reproduce well in detail. Secondly, it is one of the very few treated in this manner alone. And thirdly I have preserved the plate, from which I can judge of the bitings better than from a proof. Obviously I cannot give exact timing from memory, but in any case I have never worked by time, preferring to judge by the look and feel of the lines. The times given are therefore only approximate.

The ground used was Rhind's "liquid," and the whole of the work (as shown in this state—there is a final) done in one etching by a series of stoppings-out. The plate was bitten *in* the bath of half-and-half nitric acid.

1st stopping. The faintest lines of the receding scaffold-poles, with a very fine brush; after perhaps one minute or a little more.

2nd stopping. The distant lines of the building seen between the scaffold uprights and the sky, which being drawn with a single isolated line would bite less rapidly than those first stopped; after a further two minutes.

3rd stopping. The distant buildings, carefully avoiding the darker windows, and the lighter scaffolding in shadow; after a further five minutes.

4th stopping. The windows and the whole of the scaffolding except a few of the darkest places; after a few minutes more.

5th stopping. The closely worked darks under the scaffolding; after perhaps five minutes at the outside, probably less. These darks will now have had between fifteen and twenty minutes. In the proof these (to the left of and above the figures) appear quite as black as the horses and darker than the figures. This is because this interior passage was more *closely* drawn *and crossed* once at right angles. The *width* of these lines, in the plate, is *less* than that of the uncrossed lines of the men, but in the proof the effect is denser. The whole plate is now protected from the acid excepting the foreground with cart, horses and men. The cart and horses will already be ahead of the rest because crossed.

6th stopping. The foreground; after several minutes.

There was no need to replace the plate in the bath after this—the last—stopping. Taking up some acid with the feather, a few drops were placed upon the spots still unfinished, i.e. horses, cart and men. This was renewed every now and then. Finally, the horses, which had to be as black as possible, were treated with a drop of *pure* acid, and the action checked immediately with blotting-paper. (This may be repeated until the ground shows signs of breaking up, which will happen almost at once, and it is then time to cease all biting.) The horses would thus have been in the acid for fully twenty-five minutes.

It will be noted that passages in the foreground shadow are practically unbitten. This was due, not to stopping-out, but to faulty drawing. The needle had not properly cut through the ground, and consequently the acid hardly attacked those places at all. An alternative explanation is that the lines had been firmly drawn, but clogged afterwards by sweat from the hand. In those days I had not begun to use the acetic-acid bath preparatory to biting-in.

The stopping-out varnish is now cleaned off with methylated spirit, and the ground by application of turpentine or benzoline.

So many influences have to be taken into consideration in biting that to work to an exact schedule is not only foolish, but usually fatal; unless

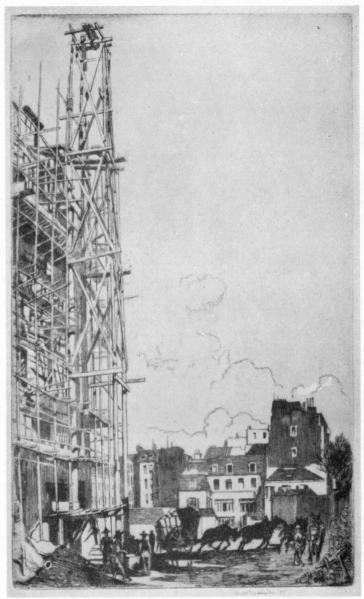

THE HORSES. The Author. *Etching.* 7⅛ × 4⅛

Plate 2

ILLUSTRATING COMPLETED DRAWING BITTEN IN THE BATH.

THE WORK (FROM A PENCIL DRAWING) WAS COMPLETELY DRAWN BEFORE BITING WITH NITRIC. USUAL
STOPPING-OUT TO OBTAIN VARIETY OF VALUE.

71

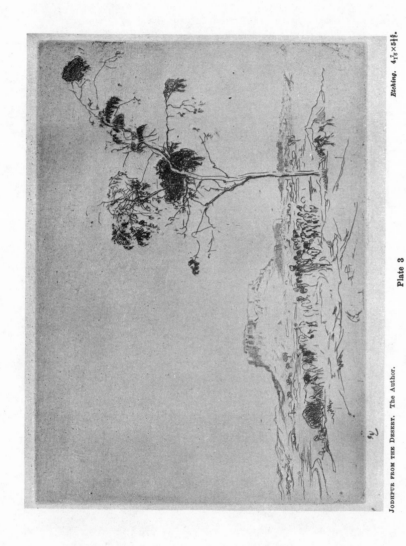

JODHPUR FROM THE DESERT. The Author.

Etching. 4⅟₁₆ × 5⅟₁₆.

Plate 3

ILLUSTRATING SINGLE DRAWING FROM NATURE.

THIS PLATE WAS BITTEN WITH NITRIC ACID MONTHS AFTER DRAWING. IT WAS NOT PLACED IN THE BATH, BUT ACID WAS POURED ON & CONTROLLED WITH A FEATHER.

one happens to have an exceptionally mathematical brain and employs both thermometer and hydrometer.

First. There is the temperature of the room. In hot weather (or in a heated room) the action is far brisker than in the winter.

Second. The strength of the bath. The amount of copper, or zinc, the acid has acted upon affects its biting-power.

Third. The density of the plate itself. Hard metal bites more swiftly than soft; and the amount of alloy in its composition also affects the speed. In fact, chemists say that the purer the copper the less is it affected by acid.

Fourth. The pressure exercised in drawing with the point also encourages or retards the action of the mordant in getting hold *at the beginning,* and one passage may easily—generally does—start ahead of another.

These four factors have to be considered upon every occasion, and not one of them can be ignored without risk. So that a time-schedule which works perfectly in the morning may be no guide at all in the afternoon, and the only safe plan is to watch the ebullition of the bubbles (if nitric is used) and the appearance of the lines, in all cases carefully examining them at short intervals by holding the plate almost level with the eyes and between them and the light, so that the shadows of the furrows cause these to appear as darks against the shiny, reflecting surface of the ground.

The lines should also be felt with a fine needle, and if neither method satisfies the beginner a small portion of the wax must be removed with a delicate brush dipped in turpentine (or other solvent) and the exposed passage examined. The part must then be covered with varnish and cannot, of course, be bitten further at that time, whether ready or no. A line or two which is not of the greatest importance will naturally be selected.

Method B.—This is illustrated by Plate 3, which being a small etching is reproduced almost full size. The *whole* of the work was drawn from nature upon a dabbed ground, and bitten some five or six months later, in Edinburgh, with the same half-and-half nitric. After the acid had been moved about on the surface for perhaps three minutes with a feather it was necessary to stop-out the line of distance where it passed behind the stem of the tree. When the sheep and goats had been bitten a little longer, a few more stoppings round the local patches of dark had to be made, as these were too small to permit drops of acid being placed upon them without overlapping the surrounding lines. There was no need for using any varnish in the case of the tree, as the spaces were larger, and indeed more variety was obtained by keeping the acid moving from one mass of foliage to another, and allowing longer for the central dark.

As previously noted, the design of such a plate, where no work runs up to the edges, lends itself to this kind of treatment; whereas the scaffolding of Plate 1 would have been almost, if not quite, impossible to bite in

THE SHRINE. The Author. *Etching.* 14⅞×10⅜.

Plate 4

ILLUSTRATING DRAWING BY STAGES:

THIS FIRST STATE SHOWS HOW LARGE PORTIONS WERE LEFT BLANK IN ORDER TO AVOID CONFUSION IN BITING SO
COMPLICATED A DESIGN. CLEAN WIPED.

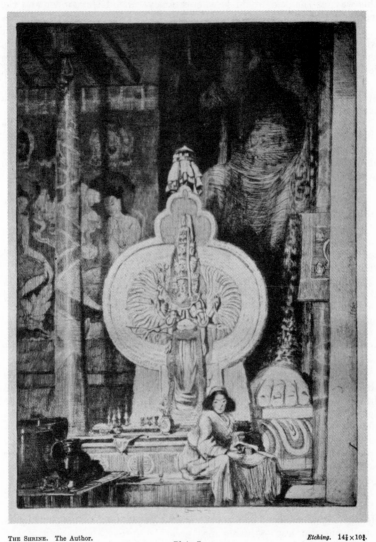

THE SHRINE. The Author. *Etching.* 14⅞ × 10⅞.

Plate 5

ILLUSTRATING DRAWING BY STAGES.

THIS STATE SHOWS HOW THE LEFT SIDE WAS NEXT COMPLETED. RAG WIPED.

this way, as the acid would have constantly run off the copper and the work been unequal.

Method C.—This is illustrated by proofs of an etching the drawing for which was made some years previously. Plate 4 is the first state, Plate 5 the second state and Plate 6 the final state. Between the two last were several states, but they are not required to show the method of working.

The work was executed upon ordinary dabbed ground and, after an acetic bath, was bitten for from five to ten minutes in rather weak Dutch mordant (i.e. Smillie's bath, which had become weakened by use).

Plate 4, *first drawing and biting.* It will be seen that the whole of one side (behind the pillar) was deliberately left blank. I had already etched one plate of this subject and found the work too complicated to control at one time in the bath ; and so determined, in the second attempt, to take one passage at a time.

The pillar upon the extreme right is also untouched.

After about ten minutes in hydrochloric the most delicate lines were stopped-out, e.g. those modelling the boy's face.

The biting was then continued with nitric, half-and-half.

There are some five or six stoppings-out in this state alone. Note the contrast of tone between the face, and the black lamb-wool head-dress and eyes, of the boy.

The longest biting was upon the foreground bowl and jug, etc., the lines of which were widely spaced in order to allow a considerable *broadening* before any risk of coalescing. This proof was wiped quite clean in order to show the *exact state* of the plate.

Plate 5.—The pillar to the right still remained untouched, but the whole of the wall behind that to the left was now drawn in and bitten (for re-working, see Chapter XI).

There was also a good deal of additional work strengthening those parts already drawn. Stopping-out was again necessary in order to obtain differentiation between the tones (representing colours in this case) of the figures, e.g. the blacks of the hair and the surrounding halos, but this was aided considerably by closeness and openness of shading and cross-hatching. As a general principle it is better to rely as little as possible upon stopping-out and as fully as may be on variety of line treatment (see Dürer, Plate 50, p. 204, where there was no interrupted biting at all).

Additional weight was also obtained by the method of printing.

We shall come to printing later on (Chapter X), but one may take as a general guiding principle that so far as is reasonably possible *every difference of tone should be in the lines* on the plate. The best—which is usually the simplest—printing may greatly improve the *quality* of the lines ; but no tricks of printing can convert a poorly drawn and etched plate into a good one, though Whistler himself sometimes attempted to make it do so, e.g. " Nocturne Palaces," 2nd Venice set.

In the final state there are several additions sufficiently noticeable to tell in a small reproduction. The pillar to the right is modelled, and the

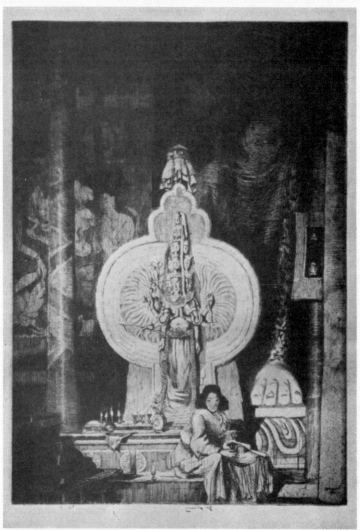

The Shrine. The Author. Etching. 14¼ × 10¾.

Plate 6

ILLUSTRATING DRAWING BY STAGES.

This represents the final state. The pillar on the right has been filled in. Considerable additional work elsewhere. e.g. centre of hanging banner on right, boy's cap, shadow on foot, etc. The printing is also fuller.

banner hanging upon the second pillar darkened by crossing vertically over the original horizontal lines. The shadows are strengthened further —noticeably over the great foot—partly by re-biting the old lines and partly by adding new ones.

When nitric acid is poured over a plate which has been begun with hydrochloric, it will be seen how immediate is the attack upon the lines so opened up ; while when nitric is used to start the work (especially if no acetic bath has been given), many of the lightly drawn and more widely spaced lines will remain untouched for some time ; and when they do at last begin, will do so irregularly. This irregularity is one of the most important things to guard against, both by drawing firmly, and by cleaning the lines with acetic acid ; and, further, for complicated passages, by beginning with a slow but sure mordant. I have said this already, I know, but it needs insisting upon.

Method D.—The method is illustrated by Plate 7, "A Note of Ronda," and is a compromise between Methods C and E. This particular etching was done specially, as I had no prints which were the result of this way of working only. In practice one generally employs several methods on the same plate.

Plate : Copper.

Ground : Rhind's, dabbed, unsmoked.

Acid : Dutch mordant (Smillie's bath), cold.

First the foreground—trees, cottages, etc.—were drawn and the plate placed in the bath for one hour. The plate was then withdrawn, dried and warmed slightly to soften the ground enough to prevent brittleness after the cold bath—merely a precaution—and the rest of the design completed.

The plate was then replaced in the bath and the whole bitten for twenty minutes, giving a total of one hour twenty minutes for the stronger foreground against twenty minutes for the distance.

There was no re-working, as I wished to provide an example of a plate bitten in two sections only without stopping-out.

For the édition de luxe of this book the plate was steel-faced and printed upon Japanese *Hosho* paper, clean wiped by the hand only.

By using this method lines which are required to be delicate may be crossed behind stronger ones in a way which is very difficult to achieve by drawing both together and using stopping-out.

Method E.—This is illustrated by Plate 8, which was drawn entirely in the Smillie bath. The ground used was that of a local maker and not sufficiently strong. Hence the foul-biting in the sky. The plate was altogether two hours in the cold Dutch bath, and was finally treated with nitric for about two minutes to widen the lines.

Although we are told that Haden used this process very largely, it is quite impossible to say with certainty that this or that plate was executed by this means. I have therefore chosen this example because I *do* know how it was done. The method is precisely that of the preceding one

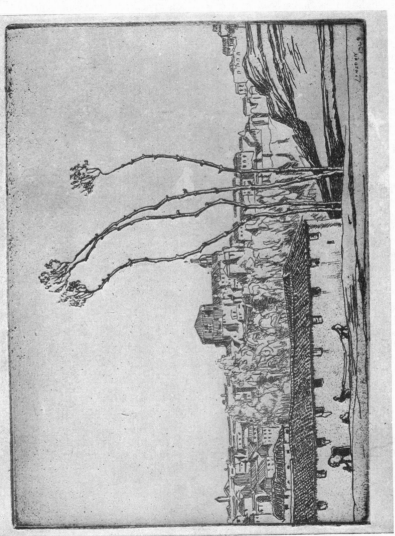

Exact Size.

A NOTE OF RONDA. The Author.

Plate 7

ILLUSTRATING ALTERNATE DRAWING & BITING.

DUTCH BATH.

THE FOREGROUND (TREES, COTTAGES, ETC.) WERE DRAWN FIRST & BITTEN FOR ONE HOUR. DISTANCE THEN ADDED & THE WHOLE THEN BITTEN A FURTHER TWENTY MINUTES. No STOPPING-OUT. CLEAN WIPED WITHOUT RETROUSSAGE.

79

except that there is no removal of the plate from the bath for the draw-
ing. Stopping-out is avoided altogether unless, by an error of judgment,
the lighter lines have been drawn too soon and so become sufficiently
bitten before the darker ones are ready. In this case there was none.[1]

If stopping *is* resorted to the *transparent* varnish will enable the operator
to continue to see his values—dark lines against light—the great advan-
tage of the method. In this manner of drawing while the biting is
progressing, it will be seen how easily delicate lines may be brought over
stronger ones in order to densen or strengthen a passage, and how much
more readily a gradation may be made than by the use of stopping-out,
where the mark of the brush is bound to leave a more or less definite
edge between tones.

Placing the Design on the Plate.—The majority of beginners (and indeed
of experienced etchers) find the putting down of the first lines on the
immaculate surface of the grounded plate the most terrifying part of any
process ; and it is particularly difficult in this case. One cannot make a
tracing, or draw with any metallic substance on the ground, because the
first thing the acid does is to remove any such marks. Only one resource
is open to the etcher who needs a guide : a drawing of some kind *beneath*
the wax, and a transparent ground.

Sometimes light drypoint is worked[2] over, but I generally use an
ordinary lead-pencil, both for this and for the other methods, unless
working out of doors. With the ordinary methods A and B there are
several other ways of helping the etcher over this initial difficulty, and
many advocate a tracing from a drawing of the exact size of the plate.
This is a tedious business, but for those who wish to practise it a piece
of sanguine tracing-paper must be procured and placed below the draw-
ing, which is then gone over with a fine point. It is advisable to turn the
edges over the back of the copper in order to prevent the paper moving.

A soft-pencil drawing will print off upon a grounded plate if run (not
too heavily) through the press, but naturally the impression will be in
reverse. If it is desired to have the *etching* the same way round as the
original drawing, this is so much the better. To complete the drawing,
in this case, a mirror will be necessary, placed facing the draughtsman,
and the drawing propped up so that he can see its reflection comfortably.
An alternative is to pin the drawing face outwards to the light-screen
(see Chapter VII), and if the paper is not exceptionally thick the design
will be seen quite well enough through the back ; well enough for main
facts, at least : details can be filled in by the aid of the glass. No one
bothers about this reversing unless obliged to do so. Even well-known
topographical views, and portraits in which the sitter is working with the
right hand, though they may look incongruous when reversed, in no way
affect the judgment of the real " amateur " on the look out for a work of

[1] But some added work '(by the same process) on a second ground bitten as
before. This did not alter the general effect.

[2] See McBey, note (p. 348).

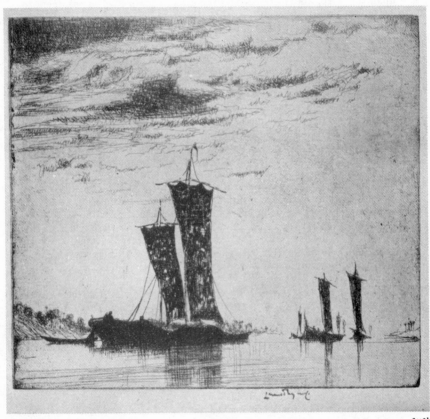

ON AN INDIAN RIVER. The Author. 6×6⅝.

Plate 8

DRAWING *IN* THE BATH.

THIS PLATE ILLUSTRATES HADEN'S "CONTINUOUS" PROCESS. IT WAS PLACED IN SMILLIE'S DUTCH BATH, THE LINES BEGINNING TO BITE
AS THEY WERE DRAWN. NATURALLY THE STRONGEST DARKS HAVE TO BE BEGUN FIRST. AFTER THE DRAWING WAS COMPLETE
THE LINES WERE STRENGTHENED BY A COUPLE OF MINUTES IN NITRIC. NO STOPPING-OUT NEEDED.

art. The use of tracing or preparatory work of any kind is not for the purpose of making a print " look right " in this sense. It is to aid the actual placing of the composition and to allow of clean, unhesitating draughtsmanship.

No work done from Nature (e.g. that of Whistler or Haden) can rely upon this help, and I always find it best when working out of doors to draw very lightly at first (so that the wax is not penetrated), thus indicating the plan of the whole design before beginning to set down the real lines which are intended to be bitten.

If this is objected to, the student can take some Chinese-white, moisten a brush with saliva and mark with this the main points of the composition. It is easily removed by using a wet finger as india-rubber.

When working at home with one's heater and tools at hand, I find a variant of the light-drawing method very useful when not employing the lead-pencil under the ground.

Drawing quite freely but as lightly as possible (using the *side* of the needle-point), and disregarding all mistakes until the whole arrangement is decided, the correct lines are gradually strengthened, leaving the rest telling less definitely. Then the plate is replaced upon the heater and left there until the lines have practically run together again. It will be found that the more definite ones will not disappear entirely, but they will have melted sufficiently for a film of wax to have formed over the metal. It is hardly necessary, however, in any case, to lay bare the surface of the plate in the light drawing, if the ground is of moderate thickness. A very thin ground would not " run " sufficiently to admit of this practice ; and I am not sure whether a smoked ground would either, but I never, under any circumstances, use smoke.

In working with the pencil on a polished plate there need be no fear that these lines will be deep enough to print. Here, in order to make alterations, a little plate-polish will act as india-rubber. It is hardly necessary to add that the plate should be cleaned beforehand and the hand kept off the surface as much as possible, because it obviously cannot be cleaned *after* the pencil-drawing has been made.

I use this method considerably and find it invaluable. One reason why these things are not advocated, probably, is that most previous writers insist upon smoking the plate,[1] and this, of course, is impossible to see through.

When the biting has been finished by one of the above methods, the varnish (both back and front) has to be cleaned off. The solvent necessary will depend upon the stopping-out varnish : methylated spirits for the hat-polish, and so on. After rubbing this off, a little turpentine will remove the ground itself. The backing may be scraped off with the long palette-knife, if preferred. It flakes off quite readily.

I generally clean the plate next with polish, partly because this allows me to see what the lines will look like in the proof, and partly to remove any drypoint marks where wrong lines had been stopped-out before biting.

[1] See McBey, note (p. 348).

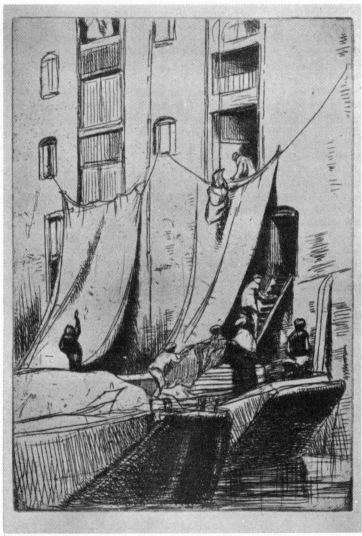

ETCHING. The Author. $5\frac{7}{16} \times 3\frac{15}{16}$.

Plate 9

ILLUSTRATING SINGLE BITING, IRON PERCHLORIDE.

THIS PLATE WAS BITTEN WITH PERCHLORIDE AT 30° (SATURATED SOLUTION 45°) FOR THIRTY MINUTES. IT WAS INVERTED IN THE BATH SO THAT THE DEPOSIT MIGHT FALL OUT & NOT CLOG THE LINES. NO STOPPING-OUT. BITTEN WITH THE SAME BATH AS DIAGRAM A, PLATE 1. THE GREATER STRENGTH MAY BE DUE TO SEVERAL THINGS: THE CROSSING OF THE LINES, MORE INITIAL EMPHASIS WITH A SHARPER POINT & PARTICULARLY FULLER PRINTING. RAG WIPED.

83

of these scratches are very strong (from an over-sharp point) it will be necessary to use the charcoal, or a burnisher, to get rid of them (Chap. XI).

Polish should be removed from the lines before leaving the plate. Otherwise it may harden and be difficult to remove later ; or (where its composition is unknown) it may contain a trace of free acid which will attack the lines.

Single Biting.—Plate 9 represents the simplest form of etching, i.e. with one biting without stopping-out. The plate is of copper on which was a very thin dabbed ground, and the mordant perchloride of iron at 30°.

The original drawing was done direct, but the ground was cleaned off before biting, as I considered the sketch too slight. When cleaned, however, the fine drypoint line which remained looked more interesting than I had thought, and in order to save it I re-grounded the copper and re-drew over the faint design. A little of this is still visible here and there. The new work has somewhat lost the spontaneity of a first drawing, but it will serve as an illustration.

The plate was bitten for thirty minutes *upside-down*, the sediment being quite visible at the bottom of the porcelain tray. In order to do this a small slip of wood was placed for the edges of the plate to rest upon at either side. *One* is quite sufficient to raise the copper off the tray. The plate was not touched afterwards, though several obvious mistakes call for remedy.

CHAPTER X

PRINTING

Part 1. *Wiping the Plate*

HAVING bitten the plate by one of the methods explained in the previous chapter, the etcher will be impatient to see the result of his *first state*.

Ink.—The first necessity is good ink.

Although more laborious, it is still worth while making up one's own ink, for the following reasons :—

(1) It can be made of any consistency—stiff or oily.
(2) It can be made of any strength, by means of strong, medium or thin oil.
(3) It can be varied in colour, by mixing more or less burnt umber with the black.

It is true that both black and coloured inks can be put up in collapsible tubes, of any degree of strength, but one still has to mix them for oneself for each plate's special requirements, and it is never possible to *thicken* their consistency, though easy to dilute it. No doubt this would be the ideal way of keeping ink *if* one could rely upon obtaining just what one asked for. That is, if one could test the blacks, umber and oils before giving them to a maker to be ground and put up !

Short of this I prefer to buy the individual ingredients and to make the ink up fresh as required. There is then no uncertainty ; no fear of tubes drying up ; or of being out of just the tube one needs ; neither will the ink be over-ground as it sometimes is by machinery, i.e. too fine to remain in the lines properly.

To mix the ink : take some Frankfurt-black of a good colour—some is very grey—or some French-black, which is sold in two qualities, light and

FIG. 33.—Powder colour ready for mixing.

heavy ; or a mixture of these powders, and add to it some powdered burnt umber. The best (French) umber (*c*) is usually sent out in pellets, and these must be crushed with the muller (*d*) on the slab (*a*) before mixing (Fig. 33). French-black will absorb much more umber than most Frank-

furt-blacks before becoming appreciably brown. French, especially *Bouju Heavy French*, is a very rich, dense, black powder. There is a curious difference between these powders in wiping the ink off the plate, the less dense Frankfurt-blacks coming away much more freely from the surface. A good ink is made by mixing some Heavy French with the Frankfurt. When the two (or three) powders are well mixed with the knife (*b*), looking rather browner than the colour required in the proof, form a crater in the cone of powder (*e*), and pour into it the burnt oil, mixing into a very stiff paste. Make it as *stiff as possible*, as in grinding it will become looser and looser. Push the muller on its edge at first—the near edge if going

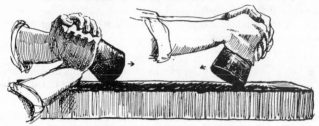

Fig. 34.—In starting to grind keep muller on edge.

away from the body, and the further edge when pulling towards the body (Fig. 34)—otherwise it will merely push the unground mass before it. Soft Frankfurt will not take much grinding ; but a hard powder like umber or French-black will need considerable patience and elbow-grease in order to ensure that no grit remains to scratch the plate. Under-ground ink is generally responsible for the scratches which are the curse of printing.

Another result of under-ground ink may be disintegration of the powder from its vehicle, the oil, in the future. As a test, rub the finger on the slab, and if there is any grittiness the grinding must be continued.

Fig. 35.—Ink ready to be taken up by roller.

When finished, scrape up the ink with the painting-knife and pile it at one end of the slab, whence it may be taken up by the roller (Fig. 35).

If printing a large batch of proofs—an edition—sufficient ink should be made up to last for the whole, and can be stored in a small pot which should be placed in a larger vessel of water, to keep the air from the ink.

It is always better (and easier) to mix and grind ink a day before using, as after standing overnight the oil and powder become more thoroughly incorporated ; and a final grinding before use in the morning will make it perfect.

If the consistency becomes too thin during grinding, more powder must be added ; and if the colour has been wrongly gauged it can be altered, taking care, in both cases, to re-grind sufficiently.

Oils.—For general purposes "thin" and "medium" oils only are required. Thin oil alone gives an ink without much grip or "tackiness," yielding a proof with considerable tone on the surface, but with a thin line.

Medium oil is the safest for a beginner to handle, as there is less likelihood of the lines being "wiped out" and so reduced in strength.

Ink made with pure unburnt linseed is very difficult to remove, leaving a heavy film over the surface (unless cleaned with whitening) and a correspondingly dense tone in the proof. But it is easy to drag it out of the lines. Delâtre, who printed for Meryon and for Whistler, is said to have employed it at times, and, though it can hardly be so lasting, as the oil has really no grip on the powder like burnt oil has, it certainly yields a peculiarly beautiful matt surface.

Burnt oil is practically a varnish. It is made by boiling and, when at a certain temperature, igniting ; the burning reducing it to a thicker and more siccative medium.

I once made some by throwing bread[1] into the boiling liquid, which has a somewhat similar result. If I remember rightly it was an old recipe, but I cannot recall who gave it to me.

But if one boils linseed-oil indoors one will soon wish it were outside, as the fumes given off are most painful to the eyes. That is why the old men used to boil it out in an open space, and a large quantity at a time. Nowadays I presume it is made in scientifically adapted retorts.

Strong oil if used alone would be almost impossible to move at all, but would yield a very powerful, varnishy line and, owing to its tremendous grip, a somewhat mottled or granulated tone on the surface, unless very thoroughly cleaned with whitening. The least irregularity in the plate's face would hold up the ink, and when one succeeded in getting it off it would be at the expense of all the tone, i.e. the proof, in that case, would be as clean as a visiting-card.

Etchings are never printed by cleaning so thoroughly that no tone at all is left. It gives a brutal, hard look to the proof ; and the delicate film over the whole surface of a well-printed etching is one of its chief beauties : a contrast to the purer white of its mount.

There is no real need for any beginner to provide strong oil. One modern etcher used it—I don't think he does still—for making a very powerful ink for working into lines prior to inking-up with a thin oil.

[1] It is probably the moisture in the bread which produces the result. It is practically the old method for obtaining what the modern scientist obtains by blowing steam through the oil to thicken it.

This allowed a greater body in the line with a fuller tone on the surface than could be obtained by the use of either alone. But I hardly think it was very satisfactory, and it can be very rarely necessary.

Dabber *v.* Roller.—The dabber is the old appliance for inking-up a plate ; but the roller, in my own opinion, is a very great improvement, though still comparatively rare in printers' workshops. The dabber is of the same shape as that described for use in grounding, but very much larger and made of solid cloth or other springy material. Printers usually cover them with part of an old stocking for the sake of the grip, and when not in use place them face down in a saucer of oil to prevent hardening.

The roller is superior because it does not wear the plate or scratch to the same extent. This is especially true in printing drypoints.

The usual tool is of composition ; mostly gelatine. This has a great disadvantage : it cannot stand much heat without melting and sticking to the plate. Rubber is equally bad because it affects the metal and causes tarnish. Leather is too hard : it does not give sufficiently to drive the ink into the lines. It is perfect for lithographic printing because that is all surface work.

Joseph Pennell describes a new American roller made up of layers of blanket which can be stripped off as they become hard.

My own roller, I think, combines the advantages without the defects of these others. Mr. Kimber made one or two for my friends, and I see he now advertises them. This is simply the composition roller covered with fine " fronting," i.e. printing blanket (Fig. 36). The composition gives continued elasticity : the fronting prevents melting, and also has a good nap which grips the ink well and can be cleaned thoroughly. Even when a little hardened with use, warming immediately softens the composition beneath, and the elasticity is retained, which is not the case when ink is allowed to harden over composition itself.

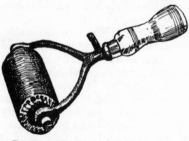

Fig. 36.—The Author's inking-roller.

When the blanket does eventually become too hard, all that is necessary is to strip it off—it does not tear away the composition—and sew on a new piece. This should be done with soft thread and the fronting brought well over the ends of the roller : otherwise the edges will become hard with ink and scratch the plate. After sewing the material as tightly as possible—drawing the two sides together so that they just meet without overlapping—the roller should be passed backwards and forwards over a well-heated plate with sufficient ink to cover its (the roller's) face and to fill up the seam. The superfluous ink is scraped off and the surface left to dry by hanging up so that nothing can touch it. If the weight of the roller rests upon the composition for long at a time it will cause

flattening (as has already been pointed out), and this is ruin (see Chap. VIII—F).

In rolling on the hot plate the heat will melt the composition sufficiently to make it adhere to the blanket, and when " set " thoroughly the thread of the seam can be filed away with emery paper. If this be allowed to remain, even though hardly noticeable to the touch of the hand, it will cause minute scratches on the plate when force is used to drive ink into deep lines.

If this is properly done the result is a perfect roller, and one cover will last for months or even years, according to the treatment it receives. The more often it is in use, the better the condition in which it remains, as the ink never has time really to harden.

Printing Muslins.—The ink is rolled on solidly all over the plate, and one should watch the deep lines in order to make certain that they are filled, rubbing with the finger or a rag if there is any doubt.

To wipe the ink off, several pieces of muslin of varying fineness of mesh are required ; the more open for beginning and the closer for finishing.

FIG. 37.—Wiping plate.

Muslin which is fairly stiff with dressing is best, as what is necessary is a flat pad a little larger than the palm of the hand with a firm, smooth face which will pick up the surface ink, but will *not* drive down into the lines and drag the ink out (see Fig. 37). In fact, the more one polishes the plate (with a circular motion) the more the ink should be driven *into* the lines, if the hand be kept flat and a scooping action avoided. What is called " leno," or book-muslin, is excellent and has a certain wooliness of mesh which helps the ink to cling to it ; but for leaving a fair tone over a plate—rag-wiping only—there is nothing to equal French (or Swiss) " Tarlatan," which is not so easily obtained in this country. Its mesh is absolutely " clean," with none of the fibrous wooliness which more or less blocks up the mesh of the book-muslins.

The old coarse " printer's canvas " is still used, but it has all the qualities which render it liable to reduce the amount of ink in the lines, and none of the qualities necessary for leaving full lines ! One professional printer told me, many years ago, that he never used it *except for reducing over bitten plates.*

I have never seen this coarse, woolly canvas, which will never lie really

flat, used by a French printer either in Paris or in London ; neither was it in use at Goulding's on the only day I worked there.

To obtain strong full lines it is necessary to have the rag well charged with ink. So, when a pad is used for the first time, it is unnecessary to change to a second piece for finishing, as there will be no more than sufficient ink in the rag at the end to clean the surface and leave the lines well charged. For the second proof the first rag may be used for removing the bulk of the ink, but enough allowed to remain to fill the pores of a second pad which will finish the wiping.

The second may (if desired) be of finer mesh, and when once in working order they should be kept at these degrees of inkiness as long as possible, as many as three pads being used in rotation. As each becomes over-charged, a new layer of muslin should be pulled from below over the old flat surface. This will settle well on the inky mass and remain firm and solid, already partially filled from underneath as the ink squeezes through the mesh. The pad should *not* be shaken out and re-made, but always a new layer brought up over the already used surface.

Rag-wiping.—Etchings are very often printed by wiping with the rag alone (see Plate 2), and this leaves a certain amount of ink hanging over the edge of each line, according to the direction in which the muslin has last passed. This fills the spaces between the lines where they are close together and gives a full effect. Such plates as Whistler's " Traghetto, No. 2 " or " Doorway and Vine " were printed in this way, and, although the lines are not very close-worked, the ink between binds them together and gives the appearance of much more line-work than there really is.

Hand-wiping.—The more orthodox and, in the majority of cases, I think, the more beautiful way of finishing is what is called " hand-wiping ": using the base of the palm for polishing the surface after the rag has taken off most of the tone. A large lump of whitening should be kept under the " jigger " (see Fig. 31 Q), the hand passed over this and then dusted free of the powder, upon one's overall, and finally brought sharply across the face of the copper. The whitening frees the skin from sweat, and the dusting action soon becomes almost automatic. The acid from a moist hand smearing the nearly finished surface removes every vestige of tone, and white streaks in the proof result.

The action of the hand drives the ink off the surface into the lines and clears their edges of the above-mentioned " overhang " left by the rag, yielding in the proof a simple visiting-card-like effect, but with an equal, delicate tone throughout. This tone can only be removed by application of a considerable amount of whitening and at the same time a probable weakening of the line unless great care is exercised. But (as pointed out) this is never required in the case of original etchings. For an example of this clean printing see Plate 4.

Retroussage.—To obviate the bare, rather cold look of this kind of printing the usual practice is to employ *retroussage* or " bringing up " the ink from the lines by playing a soft *clinging* muslin or other rag over those

parts which it is desired to print more richly. By this means (called also " dragging " or " pumping ") the ink is coaxed from the lines and spread over their edges—in this case *both* edges, while by the rag process only *one* side of each line is affected—the result being softer and stronger than in the " clean-wiped " impression.

It is easy to abuse this " dragging "—the result being dense and woolly —and the beginner should guard against any *reliance* upon it for obtaining strength from weak lines.

Well done, it is a great asset ; badly, an abomination.

A Combination.—A third variety of handling is very often most service-able. The plate is cleaned with the hand, and then once more gone over with the *fully-charged* stiff muslin, which drags the ink again from the lines as in rag-wiping alone, but the surface having been more fully polished previously, a much stronger and more brilliant proof is the result. Plates 5 and 6 were printed in this manner.

These several methods, combined with varying strength and consistency in the ink, afford an infinite range of possible proofs from any given plate ; and it is for the artist to choose—generally after experiment—which of them to employ for each new work he produces. This is at once the difficulty and the joy of printing, and the reason why every artist should do his own *proving* at least, even if he decides against pulling the whole edition.

It is only after great experience (and countless experimental failures) that he can realize the possibilities of any one plate seen for the first time. Not only this : the knowledge gained in printing affects his treatment of all the *previous* processes, as, after all, these are only preparatory stages in the production of a certain type of *proof.*

For instance, if Whistler had not had a great experience of *printing* he would never have had the requisite knowledge which allowed him to *draw* his open lines in the first place. His drawing, biting and printing were *all part of one process conceived from the beginning as a whole ;* and while the older I grow the less I tolerate over-elaborate wiping, no one but a fool would ignore the possibility of aiding the expression of the idea in the artist's mind (in which he may have partially failed through in-exact biting) by the use of every printing dodge of which he is possessed.

Part 2. *The Press*

Having now wiped the plate—preferably quite clean for a first pull— the next process is to pass it through the press (Fig. 38).

A good press, as I said in the very beginning, is essential, and should be at least 17 inches wide across the rollers and bed-plate.

Nearly all presses now are made with geared action ; either " double " or what is termed " wheel and spindle " in the trade, i.e. a single gearing. No fixed-wheel press should be purchased if there is any chance of obtaining one with the easier-working device. This is not merely a matter of labour-saving ; it implies less jarring and less liability to

crease or cause friction to the paper on the plate as they pass between the rollers.

Personally I am fond of the single-geared, spider-wheel press, as it enables one to feel exactly what is happening, without undue labour.

The small students' presses are useless for good work and should be avoided, as there is never sufficient pressure even for the smallest plate, and it should be realized that the finest lines need the most " pinch," as Mr. Goulding once wrote to me.

Blankets.—I generally use four blankets, sometimes five, but the fewer that will yield sufficient elasticity the better, and most etchers over-blanket the press. I find two of thick " swan-cloth " and two of fronting next the plate are usually quite enough.

Another point upon which I differ (with all diffidence) from everyone I have ever seen print is in the *length* of blanket. The ordinary practice is to employ lengths of 2 to $2\frac{1}{2}$ feet and to allow them to remain in position beneath the roller—first at one end and then at the other—while the printing continues. (No one leaves them there afterwards.)

This means that the several blankets are always in the same relation to each other ; and that the pressure, which means the hardening, happens time after time in much the same place, while the *rest of the material remains soft* and at a *different tension*. This causes wrinkles to appear, from the place where the pressure strikes, outwards, and is one of the fruitful sources of creasing on the proof.

My own practice is to cut the lengths *shorter* than their width, say about 14×16 inches (my press is 18 inches).

Instead of bringing all the blankets down over the plate in one lump, I place each separately and after passing through the press I sling them all over the upper rail. By doing this the pressure is never applied in the same relative position to all the blankets, and I also turn them about and reverse their order. Not only is the surface of each more equally acted upon, but being very little larger than the plate there is a very small area of margin remaining at a different tension, and consequently the minimum risk of creasing resulting from ripples of blanket being forced under the roller. Blankets of this shape are also far more easily washed out when hard, and, naturally, one needs to buy less by utilizing nearly the whole area instead of about one-third, as in the normal procedure.

Blankets should be rinsed in warm water[1] and Lux whenever they become at all hard. It is the fronting which bears the brunt of the pressure, or rather is much more quickly affected, because the close nature of the material allows it to become easily hardened and the moisture from the paper strikes the innermost pieces first. It may be softened a good deal by vigorous working between the hands between proofs if one is short of fresh pieces.

The Travelling-Bed.—Another point upon which I differ from accepted tradition is in placing the plate directly upon the travelling-bed. All

[1] Mr. Goulding once said " warm water only, without soap."

professionals and textbooks advocate this, but my own method is to back up the plate with a number of sheets of used blotting-paper.

Most printers also use a zinc sheet over the iron bed, which is supposed to give resilience. It probably does, but inappreciably, and there is nothing whatever *against* its use except its initial cost.

I find, at the time of writing, that there are fully twenty sheets of blotting-paper on the press almost welded together by constant pressure. The uppermost is changed every time to provide a clean resting-place for every proof, but the rest are left. This has several advantages, apart from resilience.

There is no pressure on the blankets beyond the pad, therefore no pulling of the blankets before the roller bites on the edge of the pad which almost coincides with the plate itself ; and there is no unnecessary labour. The slightest touch on the wheel brings the edge of the pad under the roller and—most important of all—there is no pressure upon the edges of the blankets while the plate is going through : they are free and do not drive before the roller in waves.

One can also " feel " the pressure far more easily when little but the plate is resisting : far more easily than when the roller is screwed down almost to the bed and a length of blanket is surging under it in the time-honoured fashion.

Pressure Regulation.—Another reason for using this backing is that by its means I keep the press regulated *without recourse to the regulating screws*.

Creasing.—The most common annoyance in printing is creasing, or a " printing-fold," and its occurrence in nine cases out of ten is due to *inequality* of pressure. When one side is tighter than the other the blanket or plate tends to slew round towards the tight side, and although not sufficient to make any appreciable difference to the lines it is enough to cause an extremely fine wrinkle in the paper which is flattened down as the plate passes beneath the roller. It may be so fine as to be extremely difficult to detect, but if the proof is stretched this fold pulls open and shows as a white line—white because the ink could not touch it—across the face of the etching. It is a very common fault in Whistler's later prints, and their value is considerably lessened in the eyes of a collector and the dealer who caters for him.

The best way to regulate the pressure is to take an old, uninked, etched plate of the same thickness as the one to be printed and pass it through with some blotting-paper. The examination of the two *sides* of the plate-mark and the cleanness and embossedness of the lines on the soft paper should tell the printer both if there is sufficient pressure and whether one side is bearing more heavily than the other.

If the plate-mark appears deeper on the left side, screw down the right, or (if too much pressure) loosen the left.

When once equalized, however, I rarely touch the screws, as with the paper backing it is the easiest thing in the world to add or remove one or more sheets without any risk of upsetting the balance. It is by no

means easy to obtain absolutely equal pressure ; and once obtained it is best left severely alone for as long as possible. I have seen printers changing the pressure between plates, or even proofs, by means of the screws, and I am quite sure that there was no certainty about the result. It is only when the blanket begins to harden and usually only with certain softish papers that creases occur, because the difference in pressure is extremely slight and the new blanket is often sufficient to counteract the effect of the pull. A sheet or two of paper is quite enough to add or subtract when an extra thick or thin plate is to be printed, or when the blankets swell in printing from damp or become slack from pressure. It is much easier, much quicker, and much more certain.

Pulling the Proof.—But to return to the novice awaiting his first trial proof. It is well first of all to examine the back of the plate in order to make sure that no stopping-out varnish, ink or other substance has stuck to it. Anything of the kind which caused a slight inequality on the back would be forced up, and raise a corresponding lump on the face of the plate after the first impression. This would become more polished than the rest of the surface in the next wiping and show up as a lighter patch in the subsequent proofs. It would then become necessary to hammer the plate flat again (see Chapter XI).

A rag, folded over the finger, should then be run round the edges, as the ink always collects there in wiping and may be squeezed up on to the surface in the press, spoiling an otherwise good impression.

After this the plate is replaced upon the heater for a moment (if quite cold), and when warm transferred to the bed of the press. It is better to print with the plate *across* the press, not end-ways. There is less danger of the paper moving and creasing and of the plate curling up.

Next, the damped paper (see Chapter XVI) is lifted from its pile under the glass and examined for any grit, hairs or other blemishes on the surface. If anything requires removal it can be done with a needle, small pliers or the shaving-brush kept for the purpose. When satisfactory it is taken up carefully by the corners and laid face downwards on the plate. Most papers when damp are sufficiently transparent for the plate to be seen quite clearly beneath, and if not lying squarely may, in the majority of cases, be moved freely without fear of the ink off-setting.

If there is any blemish in the paper which cannot be removed and is yet not serious enough to cause the sheet to be discarded, it should be so placed that the mark will fall in a heavily inked passage and so be hidden.

When in position two sheets of *new* blotting-paper are laid over it, and finally the two layers of fronting followed by the two (or three) thick blankets, and the whole pulled between the rollers.

Blotting-paper is far better and cheaper for this purpose than plate-paper, which is occasionally used, but most printers place only a sheet of tissue-paper between the printing-paper and the blankets. Blotting-paper is very important in my opinion, for the following reasons : it serves to dry the proof, and keeps it perfectly flat when removed from the press,

so that it can be examined at leisure without wrinkles. More important still : it serves to keep the moisture from the *blankets* and thus enables one to print far longer without changing them. Also it is, in itself, a form of fresh blanket for every proof, and protects very delicate paper in passing through the press ; in lifting from the plate ; and by keeping it flat afterwards until ready to be pressed, which must not be attempted for some days at least ; better some weeks (see Chapter XVI). Another advantage is that if a slight crease happens it often affects the upper blotting-paper only without spoiling the proof.

After the plate has been pulled (once only) through the press the blankets are lifted *en masse* and flung over the top bar of the machine and the blotting-paper gently raised from one corner. The proof will adhere firmly to its backing until forcibly removed, either at the moment, if desired, or some weeks later, which is my own usual practice.

If upon examination some of the lines appear white this means that the ink was not properly driven into them with the roller ; but wiping with a fully charged rag is sufficient in itself to fill most lines as a rule, even if they have been missed in the initial inking of the plate.

Used Blotting-paper.—Blotting-paper once used must *on no account* be employed a second time, as the tension in the centre (inside the plate-mark) will cause the sheet to buckle in passing through again and will almost invariably crease the proof.

Cut Proofs or Blankets.—If the paper is cut at the plate-mark it means, not that there is too much pressure, but that the edges of the plate are too sharp and need filing (see Chapter III). This should always be done after the plate has been bitten in any case.

When the blankets become hard with damp and pressure there is much more likelihood of the edges being severed ; and if a very sharp angle be left on the metal it may go through not only the paper but several thicknesses of blanket as well. This is no fairy story : I have known it happen in my class at Edinburgh ; and there is no mending a cut blanket. The join would mark the proof beneath every time.

Paper too Dry and too Damp.—If the paper is too dry it will not penetrate into the lines and the result will be a " rotten " quality, lacking depth and decision.

If on the other hand it is over-damp and " thin " oil is being used for the ink, this will " refuse " the water in the paper and tiny white spots or bubbles will appear on the surface tone of the proof. This is sometimes rather pleasing if it happen in the right place, but when too pronounced or in the wrong place, it is fatal. It, also, is common in Whistler etchings of the Venice period, and I remember in particular an impression of the " Long Venice " which was completely ruined by bands of such marks right across the water. With stiffer ink (made with " medium " oil) this rarely, if ever, occurs.

Colour of Ink.—It is well to remember in mixing inks that for a very heavily bitten plate a warm ink is not so suitable ; but for very delicate

etchings the ink may be very brown if desired, and is often most beautiful so. The reason is that a strong line is only weakened, and its *raison d'être* lost, by being printed in brown; while a delicate line is still more delicate when printed in a warm colour and its *raison d'être* emphasized.

I mention this because it is the usual practice to print very strong etchings (e.g. Haden's "Agamemnon") in a sienna-coloured ink, which destroys its whole meaning. This was not Haden's own intention, the prints I refer to being mostly posthumous, or at best printed when the artist was nearly blind with age, and could hardly see to sign them.

There is still another reason for not printing a plate which contains both very strong and delicate lines in too warm a colour.

Even when only a moderately brown ink is used the heavy lines are always blacker and *colder* than the shallow ones, the tone on the surface being naturally warmest of all. In an etching containing great contrasts of biting this is often so noticeable that I have many times been asked whether two inks had been employed. Sometimes two differently coloured inks *are* used on the same plate—never by me, but I have watched it being done in the case, I think, of Alfred East's large landscapes—but this is quite another thing, and is, I feel, a mistake because directly the realm of actual colour is entered one is committed to expressing something to which the whole medium of the bitten line is foreign and unsuitable. And one of the facts which justifies such a statement is that which has just been noted : that the *colour* of the ink changes in relation to the *depth* of the line from which it is squeezed.

Colour-etchings.—This is why coloured etchings have such a horrible "cheap" quality. For instance, a plate printed in blue would show a very light blue tint on the surface ; rather stronger, but obviously blue passages where the depth was shallow ; and practically black lines where the biting had been heavy. Attention is therefore attracted to the *colour* of the lines individually at the expense of their true function, which is the expression of form and light and shade.

Colour can only be printed with success from a "relief" block either of metal, such as the prints of Blake or William Giles, or of wood as used by the Japanese and the new English school, or of stone (not strictly "relief," but a flat surface), the results of which may be seen on the hoardings where some magnificent colour harmonies have often been shown.

Lithographic Press.—In the introductory chapter I spoke of the lithographic press as a substitute for the roller-action machine, and a fair impression from an *intaglio* plate may be obtained from this with careful regulation.

Instead of the rollers there is a "knife-edge" which can be adjusted at any height above the travelling-bed on which the plate lies. The latter is then pulled through against the pressure of the "knife-edge" which scrapes the whole surface as the plate passes, and the blankets are forced against the paper with considerable "nip." It is, of course, only a

substitute, but I know one student who managed to get quite satisfactory results in this way.

Counter-proofs.—Occasionally it may be found useful to see a proof in reverse while still working on the plate in order to correct or add with greater certainty. To do this a second damped sheet of paper is laid over the freshly proved impression and run through the press with not too much pressure. It is not easy to avoid creasing with a large etching because of the buckling tendency of an unflattened proof. To avoid this the margins of the first proof should be trimmed close up to the plate-mark, thus leaving a sheet of paper the whole of which is at the same tension.

Cleaning Plate after Printing.—It is very important to clean the ink out of the lines with turpentine or "naphtha" after printing—not after each proof, but when stopping for the day—as the ink soon sets hard in the lines, especially when there is much umber in its composition, which is very siccative, as painters should know. Otherwise when the plate is taken up again for more proofs the lines will be found to be clogged and thin proofs result. Heavy lines never yield all their ink; and what remains at the bottom is very easily removed while moist. The plate should be carefully examined—bending well over the lines—and any that are black must be cleaned until copper-coloured.

To Remove Dried Ink in Lines.—If, however, by accident a plate has been left until the ink is set, the remedy is to rub in caustic soda with a rag. A small bottle of this salt in a little water should be kept for emergencies, and a glass stopper is advisable as the cork is soon rotted away by the caustic.

If the ink prove stubborn the liquid must lie on the lines for a time; and in extreme cases, or where drypoint "burr" is in danger if the lines are rubbed, the plate must be placed in a boiling solution.

But all this trouble is avoided by a little forethought.

The Press.—Fig. 38 shows my own type of press, with "wheel and spindle" action.

A is the upper roller.
B. The lower roller.
C. The travelling-bed.
} 18-inch.

D. The pad of paper on which the plate rests.
E. The blankets when not in use.
F. The spider-wheel.
G. The outer gearing-wheel. Inside this (at the top) is the small cog-wheel, the teeth of which fit into those of the larger cog-wheel. The spindle of the smaller wheel is attached to the spider; and the spindle of the larger cog-wheel is attached to the upper roller. In order, therefore, to turn the small cog-wheel once (which means turning the upper roller once) the outer cog-wheel (which means also the spider) must be turned four times. By the length of the spokes of the spider one can thus obtain tremendous leverage, and by pulling these over quite slowly an extremely

slow even motion is maintained by the upper roller under enormous pressure.

HH are the metal blocks which give a certain elasticity, held down over the cups of gun-metal (which fit over the axles of the roller) by the regulating screws II.

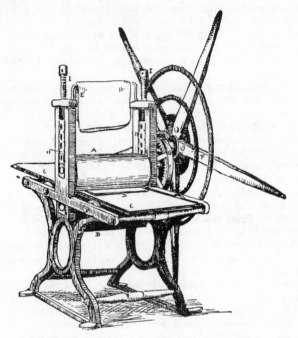

FIG. 38.—" Wheel and spindle " Press. 18-inch roller.

CHAPTER XI

I AM now going to ask the student to refer once more to trial proofs of my own from a definite plate, and to follow their evolution from the *first state* to that of the published etching, some five prints in all.

This plate, like all the preceding, was of copper, and the work executed from a pen drawing upon a dabbed ground, bitten in with the usual half-and-half nitric bath, and, though representing a well-known piece of architecture, was not reversed.

There is not a stroke of drypoint, except in the first three proofs, and then only the accidental marks where an alteration was made before biting (Plate 10). These are a few vertical lines at the top of the main buttress to the right (to left of the heavier patch of bitten ones). In the originals these lines appear much warmer in colour than the surrounding etched work, as they are very shallow, being drawn with a blunt point (see close of last chapter). The absence of these strokes in Plates 13 and 14 is quite visible in the reproductions.

The little ink held by these strokes is largely due to the " burr," which would wear off in the course of a few proofs ; but the treatment for such unwanted lines is burnishing. If this is not sufficient the passage must be scraped and then burnished, or charcoaled if there is no danger of greying surrounding parts by unavoidable overlapping. A few such marks will always need removal unless the draughtsman never makes a mistake !

Irregular Pressure in Drawing.—A really bad blunder which had to be repaired was the weakness of biting in the line of trees in the distance. When the plate was in the bath for the first time, it was noticeable that this passage had not been drawn firmly enough, or had become clogged by sweat from the hand (probably the former, as acetic was used), and in consequence was only beginning to be attacked long after the rest and very irregularly at that. The only thing to do was to remove the plate and stop-out the whole of that part, leaving till the next grounding its re-drawing and biting.

Another passage which failed badly was the water. To the left, the reflections (Plate 10) are too jumpy and " all-overish," while the vertical lines of that of the tree under the bridge are taking away from the effect of flatness which the water should possess.

Re-grounding.—The plate was therefore re-grounded with the dabber (Chapter IV), but in cleaning the surface no whitening was used because it would be likely to remain in the lines and so cause foul-biting. In this case only that part which included the arch and distance was covered, i.e. from an inch or so to the left of the arch to the right edge (of the proof).

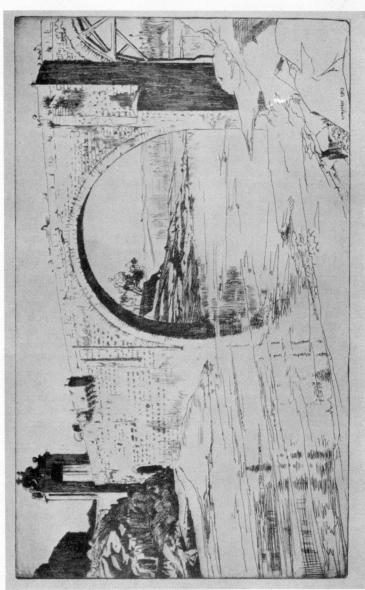

THE ALCANTARA BRIDGE. The Author.

Plate 10

ILLUSTRATING MISTAKES & THEIR REMEDY.

THIS SHOWS THE FIRST PROOF. NOTE PARTICULARLY THE UNDER-BITTEN DISTANCE.

Etching. 8¼ × 13¼.

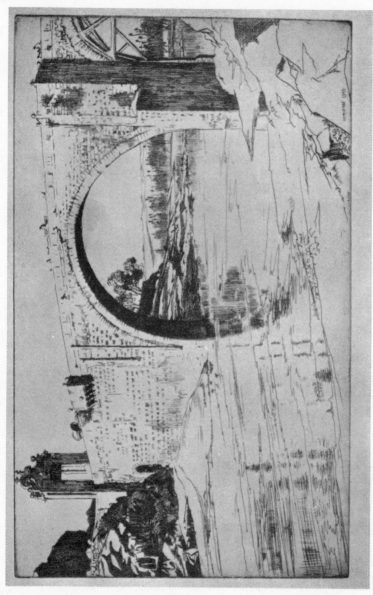

The Alcantara Bridge. The Author.

Etching. 8¼ × 13¼.

Plate 11

ILLUSTRATING MISTAKES & THEIR REMEDY.

HERE DISTANT TREES HAVE BEEN RE-DRAWN & BITTEN, & THE UNDER- (SHADOW) SIDE OF THE ARCH WIDENED.

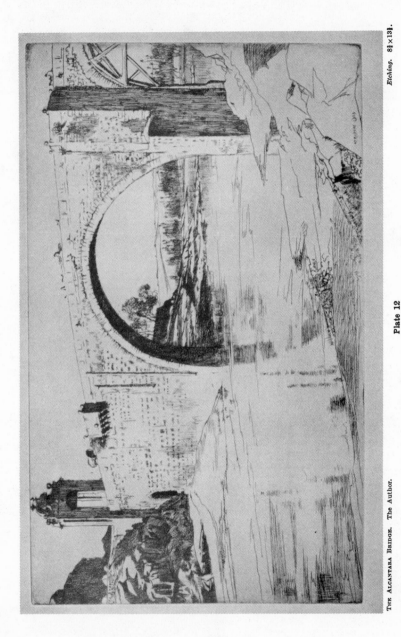

THE ALCANTARA BRIDGE. The Author.

Etching. 8¼×13½.

Plate 12

ILLUSTRATING MISTAKES & THEIR REMEDY.

THE WATER HAS NOW BEEN ENTIRELY PLANED DOWN & RE-DRAWN.

102

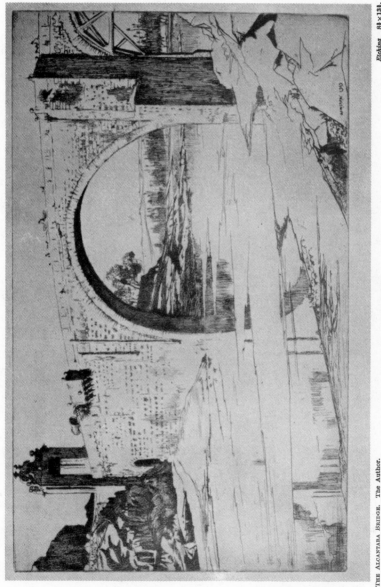

THE ALCANTARA BRIDGE. The Author.

Etching. 8¼×13½.

Plate 13

ILLUSTRATING MISTAKES & THEIR REMEDY.

THE LINES IN THE WATER HAVE AGAIN BEEN PLANED DOWN & REFLECTIONS DRAWN WITH *vertical* STROKES; ALSO THE TONE IN THE FOREGROUND REMOVED

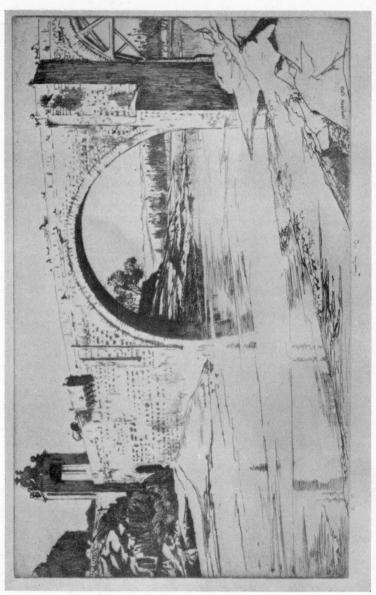

THE ALCANTARA BRIDGE. THE AUTHOR. *Etching.* 8¼×13¾.

Plate 14

ILLUSTRATING MISTAKES & THEIR REMEDY.

IN THIS FINAL STATE THE WATER HAS, FOR THE THIRD TIME, BEEN COMPLETELY CHANGED, THE VERTICAL REFLECTIONS BEING UNSATISFACTORY. NOTE: NO ALTERATIONS WERE MADE AT ANY TIME IN THE UPPER PART OF THE PLATE.

Except in the case of a small isolated spot in the centre of a plate where a few drops of acid are sufficient to bite—these can be absorbed by blotting-paper—some portion of the edge of the plate should always be included in re-grounding. This is to allow the acid to be poured off without passing over an unprotected area. The plate is placed upon the heater and some ground melted on that part where the deepest lines are (in this instance running the ball up and down the arch), and in order to make sure that these are filled I rock the dabber vigorously sideways before equalizing by dabbing. I generally hasten the cooling by placing the copper upon the iron bed of the press, and when practically cold it can be drawn upon. Even the most delicate lines of previous biting can be seen through the black ground if laid on thinly.

Having re-drawn the trees in the distance, I added lines to widen the arch on the inside, cross-hatching in order to join the new edge to the old work. These additions were now bitten by pouring on the nitric. The reflections of the distant trees having been sufficiently bitten, the mordant was allowed to flow off those lines. A little later, the trees themselves having become strong enough, the plate was again tilted to cause the liquid to collect only round the arch and large tree, the wall beneath which was also re-worked. When these were ready the ground was removed and the proof (Plate 11) pulled, showing the alterations so far carried out. These being satisfactory, the next thing to do was to cut out completely the whole passage of the river : drastic but necessary.

Planing-out.—A broad piece of " Water-of-Ayr " stone accomplished this with some labour, and the surface regained by the aid of charcoal and polish (Chapter III). After that the ground was laid over the lower half of the plate only, and the reflections re-drawn and bitten in the same way as before ; some new work being added to the bank in the foreground and some foul-biting helped and encouraged a little to left of the signature. The result of the last was a tone over the foreground which did not harmonize with the existing lines (Plate 12), and, although I thought at first that the water was more satisfactory, after a while I determined to try the effect of *vertical* lines for the reflections.

Re-planing.—Once more the surface had to be planed away. This was accordingly done, and the reflections drawn and bitten in the same way as before.

When the proof was seen it was disappointing and at once condemned (Plate 13). The only improvement was the passage of foreground which was simpler and better, having a few strong lines instead of many weak ones. Once more an interim of snakestone, charcoal and polishes—and by now I was rather tired of grinding—and the river was again blank. This time there was no need to remove the lines of the bank, as those had been " passed."

At last the reflections were more happily drawn and bitten and appeared as in the final state (Plate 14). Between this and Plate 13 there were, however, two intermediate states, but the additions were too slight to be

noticeable in a reproduction, and in any case would add nothing to the points already made.

It is worth noting that during the progress of the plate—seven states in all—the bridge itself (excepting the underneath of the arch) and the rock to its left remained exactly as first bitten.

It is important to think well before making changes—even slight ones may, and often do, ruin a plate—which may be found afterwards to have been greater mistakes than those they were designed to obviate. It is so easy to lose the original freshness and clean precision of a direct biting. Even in the case of the most successful additional work, where the old lines are crossed by new, there is invariably a loss of spontaneity—extremely slight, it may be, but none the less a loss—in spite of the fact that the work may gain as a whole.

This is one of the reasons for selecting the plate illustrated, as, if the last three states are compared, it will be seen how closely the first and third approach each other and how entirely off the track was the intermediate state.[1]

In many instances when one makes a blunder there is no going back : a new plate must be begun.

The " Crevé."—We will now suppose that a very deeply bitten passage covering only a very small area had to be removed and re-drawn (e.g. the small arch to left of the bridge in the last illustration). The cutting-out would proceed as before : first scraper, then stone, and finally charcoal. But the hollow thus formed would hold a certain amount of ink and remain untouched by the hand in wiping the plate, the result in the proof being a dirty tone less polished than the surrounding surface.

" Repoussage."—The remedy for this is what is termed in French technology *Repoussage*, or hammering-up from the back.

A smooth steel anvil or suitable substitute is necessary to hammer on ; a pair of curved compasses or callipers (Fig. 39) for marking the spot, and the small polished hammer itself (Fig. 40). It is useful to have a piece of chalk in that arm of the callipers which is placed to the back of the plate. The upper arm is placed on the spot to be hammered, the callipers closed so that the chalk marks the corresponding position on the back ; the plate turned face down on the anvil (care being taken to avoid scratching the surface) and the marked spot tapped smartly with the small end of

Fig. 39.—Callipers : upper of metal ; lower of wood.

[1] As an astonishing example of the same return to a previous state see Whistler's " Bridge," K 204, where there is only the slightest difference between the first and last (8th) states. Even the butterfly was removed and finally replaced almost in the exact spot, *but* less cleanly drawn. I saw a last state of this plate wrongly described as a 1st state some years ago in Glasgow.

the hammer. Examine the front between the strokes, and if by too much force the face is over-hammered it must be very gently tapped down again with the broad face of the hammer.

When level the charcoal will be required to equalize the surface, and this done, it can be worked over again or not, as desired.

Fig. 40.—Hammer for *Repoussage*.

Faking a Proof.—It is often possible to avoid hammering-up by using a little extra care in printing such a *crevé*, cleaning it out with the finger before finally wiping the surrounding surface. But it is far better to have the whole plate level, and to avoid " faking " in printing ; and this becomes doubly necessary if the plate is to be given out to a professional printer.

If the planing of a large area (as was necessary in the foregoing etching) is left out of count, the whole of the re-grounding and biting does not take long. There is no need to " allow the ground to stand 24 hours " or anything of that kind. If there were, one would lose all interest in the work before the third state !

I often work on the new ground while it is still warm if a small patch ; but the acid must always be carefully watched and some blotting-paper be ready to stop the action immediately if anything goes wrong.

Re-biting Original Lines.—Besides adding new lines *over* old, it is often required to re-bite the original furrows, and to lay a ground for this purpose one may use either the dabber or the roller. If the dabber is preferred, some ground must be melted on an adjacent part of the plate (or a second plate), and the amount upon the dabber having been reduced and equalized by striking it upon a clean area between the source of supply and the lines to be grounded until only a very thin film is left by it, the plate is allowed to cool a little to avoid possibility of the ground running down the edges of the lines and these cautiously dabbed over very delicately, borrowing ground as required from the supply. If it becomes too cool to move, the plate must be warmed again just enough to soften the wax. It is easier to burn a ground so thinly laid, and besides the fine lines will be filled by the melting.

It is advisable to allow some time for the ground to harden before biting, but, in any case, it is very liable to give way, being thinner than is safe. Heavier lines can, of course, be more easily re-grounded and with a thicker coating, but at all times the junctions of the lines (where crossing) will be rounded off and a certain crispness lost, and it is not a process to recommend when there is any alternative.

It is safer to use nitric (weaker than usual) for this purpose, as one can

see exactly what is taking place by the bubbles, and although the " Dutch" bath would appear to be less trying to the ground, it is much more insidious. If foul-biting begins, one must be able to detect it immediately to stop the action, but the slower mordant eats into the smallest hole and gives no warning till the damage is done.

Re-grounding Roller.—Re-grounding with the roller is more reliable than with the dabber in most hands, but I once knew an old-school engraver who was said to be able to dab a re-biting ground perfectly with absolute certainty. The plate must be flat if the roller is to be used. It is employed exactly as when grounding in the first place, the necessary thinness of film being obtained by rolling on a second plate, or, if the paste is used, upon glass (see Chapter IV).

The plate in this case must not be rolled up more than once or twice for fear of filling the lines, and the work must be done very delicately, and left unsmoked.

As for oil of lavender paste I cannot speak from experience, as (beyond once making some) I have never found the slightest use for anything of the sort. It is horribly slow drying, and cannot be heated to drive off the oil in this case for fear of the ground running into the lines.

Using ordinary black ground (or transparent, if preferred) is perfectly feasible, but the plate to be grounded should be almost cold, for the same reason as that given in the case of dabbed ground.

CHAPTER XII

SUPPOSING all the expedients for saving a badly drawn or bitten plate to have failed, as they very nearly did in the case of the Toledo etching described in the last chapter, there remains the possibility of doing better on a fresh copper. But in nearly every case there will be some passage on the original plate which one is loath to abandon. It is as right in drawing and biting as it can well be, and one feels that the probability is that in re-drawing this will be lost.

In order to save this drawing as much as possible there is a method of transferring the design from the old to a new plate, and it is a very useful one. It was practised by Whistler at least once, and then with great success ; the known instance (as described by an American[1] who was working with him in Venice) being that of the two "Traghetto" plates.

First of all ordinary flake-white (as used for painting) is rubbed into the lines and the plate cleaned off in the usual manner, the finishing being done with the hand in order to leave as little as possible upon the surface. The second plate, which has been grounded long enough to have become quite hard, is placed ready near the press, and the first proved on any thin paper one happens to have. Tissue-paper or soft brown paper is suitable, and it must be damped as usual (see Chapter XVI).

Full pressure is required for this, but before lifting the proof the press must be slackened. I do this simply by removing half my blotting-paper pad, or one of the blankets, which is much quicker than monkeying with the screws. When the press is ready put the new plate upon the bed (ground side up) and remove the proof from the first plate, placing this face down upon the grounded surface, great care being taken to adjust the corners, especially if the second plate is exactly the size of the first.

My experience is that, as the paper is already drying at the margins, it does not easily cling to the second surface and is inclined to jump forward a fraction of an inch when the pressure takes it. To avoid this it should be held in position until the blanket is placed over it and gripped by the roller. Otherwise the whole design will be found a fraction low (or high) upon the new ground and necessitate the work being done over again. There is no danger of hurting the ground any more than in the process of transferring a lead-pencil drawing as already described.

The plate's surface should not be rubbed after lifting the paper from it, as, though the most delicate lines will be found to have transferred per-

[1] I think Otto Bacher, but it is many years since I read the article.

fectly in greyish white upon the dark ground, yet the lead takes some time to dry and is easily smudged. If a piece of paper is used to protect the surface, little harm will be done by moving the hand over this.

The etcher now has the whole of his previously bitten work to guide him in re-drawing, and he can follow the old lines precisely, or disregard them in those parts where his first work went wrong.

Whistler's object in doing this in the case of his " Traghetto " was to *return to his earlier state.* That is, he had gone on working upon the first plate until the simplicity of its first state had been lost ; and in drawing the second time he wished to pick out the vital lines *which were still there,* but to disregard the later additions which destroyed the meaning of those lines. Needless to say, he *ended* by making an entirely different etching, but that was how he *began.*

Any passages or single lines which it is desired to remove (either after drawing through them or before) can be got rid of at once by a brush or feather dipped in acetic acid ; and when the plate is placed in the nitric bath all the lead remaining on the plate will disappear instantly, so that one cannot rely upon the tracing while the biting is in progress.

This process of transferring, which I have used for many years with the greatest benefit, caused me to experiment still further in the use of flake-white as an ink, in what I have termed (*faute de mieux*) " Negative " etching. I give it here for what interest it may have, and because the hint may be found of some use to someone for a particular purpose.

The idea is to print white lines on dark paper (Plate 15), and to do this it is necessary to etch lines on the plate which will interpret the *lights* in the proof instead of the darks. In certain subjects, such as a sunset behind a dark object, this might well lend itself to simple treatment with good results, but I have had no time to experiment very far.

As several people have remarked with regard to the etching here reproduced, its effect approximates to that more easily obtained on wood, and this may well be : otherwise I have little doubt the method would have been exploited long ago by others more inventive than I.[1]

The paper which I found print most happily with lead-white was of a soft surface ; dark grey (nearly black) in colour, and was probably sold for pastel work.

One must, of course, rely entirely upon the bitten line without any tone left upon the surface or other tricks of printing, just as in visiting-card wiping ; otherwise the dark of the paper will be spoiled by a film of grey. I have often thought this method might be used with success for the purpose of reproducing white-line drawings or diagrams in a sufficiently expensive publication where original work was needed.

Probably Baryta white would be more permanent than lead-white, as

[1] Since writing the above I have found a print in white by Hercules Seghers, but in this case the lines were not drawn in the first place with this in view. Seghers did not etch his lights ; merely printed his dark lines in white. Mr. Brangwyn has also told me that he made similar experiments, but cannot lay hands upon an example.

it is not discoloured by the presence of any impurities in the atmosphere ; neither does it become translucent with age. It would also be more easily wiped off the surface, if only it has sufficient grip to stay in the lines.

For transfer purposes it would also have the advantage of remaining visible during biting, as it is insoluble in nitric and hydrochloric acids.[1] This would enable one to bite a plate partially without losing the white design on the parts not yet drawn. Not having tried it, I cannot say whether it has sufficient binding power to stay in very fine lines when printing.

Of the etchers who have experimented on somewhat similar lines by far

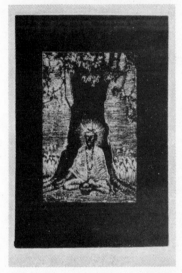

Exact Size

Plate 15

ILLUSTRATING NEGATIVE ETCHING.

HERE THOSE LINES WHICH ARE DESIRED TO PRINT WHITE ARE DRAWN & ETCHED ; THEN PRINTED IN WHITE ON BLACK PAPER. THE HALF TONE PROCESS CAN HARDLY SHOW THE CLEANNESS OF THE LINE.

the most interesting is William Blake. Judging by the proofs rather than by what has come down to us in writing, Blake must have used two rather similar but distinct methods to produce what have been termed " white-line etchings." The first is illustrated by the magnificent plate the germ of which was in a drawing by his brother Robert (Plate 97).

In this case Blake apparently drew black lines in some stopping-out varnish on the bare plate and then bit away the metal between them,

[1] " Chemistry of Paints and Painting," by Prof. A. H. Church (1901), p. 136.

afterwards printing in relief from the black lines which remained standing.

In the second example (Plate 98) he seems to have used an ordinary ground and removed this with the point in those parts and lines which he did not wish to print, afterwards biting this away, as in a *zinco*. In both methods the result is similar, and the proof is from the relief or *cameo* block, not like that of the etching proper as we understand the word. Like all Blake's work, they are most interesting and artistically fine.

CHAPTER XIII

SOFT GROUND AND AQUATINT AND THE PEN METHOD

We now come to three processes of etching, two of which are not so much used nowadays as they were a hundred years ago, while the third is but an amusement. Soft-ground (*vernis mou*) is nearly allied to etching proper and really stands half-way between it and aquatint. Therefore, and because it is more often employed as a preliminary guide to the last named, I will take soft-ground etching first.

The principle of working is a simple one in theory—more difficult in practice—and consists in laying a ground which has the property of sticking to whatever touches it, and can be readily removed from the plate by this means ; leaving the metal exposed to the action of a mordant in those places, but nowhere else.

The drawing is actually done upon a sheet of paper laid over the ground. The pressure of the point, heavy or light, upon this covering causes the wax to adhere more or less to its under surface. When the drawing is finished the paper is peeled off, and, wherever the point touched, the ground comes away with it.

Soft-ground Recipe.—To make a suitable ground, an equal quantity—in hot weather as little as one-third—of tallow is melted with ordinary etching-ground in a clean glazed pot, in the manner described (see Chap. IV) in making all grounds. The orthodox procedure is to wrap the balls so made in silk, but there is no need to do this nowadays if the mixture is free from impurities as good makers send it out. The wrapper is merely a safeguard against scratching the plate by these impurities.

Grounding.—The plate must be very thoroughly cleaned—ammonia and whitening is safer to use in this case—as there can be no removal of surface dirt or grease by a point as in etching proper.

The same dabber must not be employed for the two grounds, and as there is no *visible* difference between them it is advisable to mark them distinctly.

If hard-ground is adulterated with tallow it will naturally pick up when least desired to do so ; and if soft-ground has been laid with a dabber containing too large a proportion of wax it will refuse to come away where it should.

Very little heat is required, as tallow melts very easily, and the ground must not be laid too thickly. One is inclined to put as much on the plate as in laying ordinary ground, and this is not necessary and is apt to prevent the lines being laid open right down to the metal. There being less grip in the tallow than in the all-wax ground, the former is merely disturbed, when the plate is too hot, instead of being equalized, by the

H 113

dabber. But when laid as smoothly as possible a final heating will help the distribution by re-melting.

Smoking.—Textbooks advise smoking lightly before use : why, I do not know. The ground should be already quite impervious to acid, and one cannot see the surface when drawing. As for the darker colour enabling one to judge the lines better when biting, the contrary is the case, as the picked-up lines always appear dark from the beginning and grow still darker as bitten. Therefore they are far more easily seen upon a light ground.

In this respect, as in others where I suggest a method opposed to tradition, the student will of course decide for himself.

The grounded surface must not be handled after cooling, or it will stick to the fingers, but there is no harm done by laying the plate face downwards upon a sheet of paper in order to bring the edges over the back and fasten them with gum or stamp-paper. It is best to damp the paper so that in drying it will contract over the face and remain in close contact with the wax, but no *local* pressure must be applied anywhere.

Papers.—The paper may be of various grains according to the result desired in the proof, but it must have *some* texture. A very smooth surface will not work properly.

A very thin *laid* paper gives a most satisfactory result, and instead of being fastened at the back of the plate may be pinned over it as it rests on a board or table. The flatter the paper lies the better, as otherwise it will bulge when drawn upon and the continuity of contact be lost.

Hand-rest.—Unless the etcher can work firmly without resting his hand upon something, a support of some kind must be rigged up over the plate. If much work is to be done in the medium it is worth while to make this specially with a board under which

a cross-support has been glued at either end (Fig. 41). In the case of a narrow plate (up to 3 or 4 inches high) no rest is required, as the pencil will reach all over the surface quite easily.

Drawing on the Plate.—The drawing

FIG. 41.—Hand-rest for soft ground. is executed with an ordinary lead-pencil, or any other point which enables the artist to see what he is doing. If it were not for seeing his work, a steel point would answer just as well.

Biting.—The plate is now bitten in the usual way with certain fairly obvious precautions, such as not pressing too hardly on the blotting-paper in drying the surface and not applying too much force in brushing off bubbles with the feather, if nitric acid is used.

Stopping-out.—This may be employed if required, though in theory the width of line gives sufficiently marked distinctions of value when all are bitten to the one depth. This is accentuated by the fact previously noted that the more metal exposed the more rapid the attack.

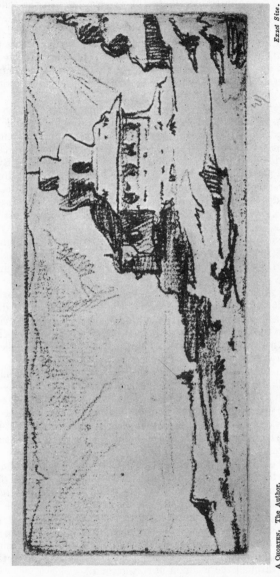

A CHORTEN. The Author.

Exact Size.

Plate 16

ILLUSTRATING SOFT-GROUND ETCHING.

ORDINARY GROUND IS MIXED WITH TALLOW, WHICH MAKES IT ADHESIVE. THE DRAWING IS MADE ON PAPER PLACED OVER THE GROUND, WHICH ADHERES TO THE
SHEET WHEN LIFTED, LEAVING THE LINES READY FOR BITING. THE PLATE WAS BITTEN FOR FIVE MINUTES IN NITRIC ACID.

The etching here illustrated (Plate 16) was executed in the following manner :—

Metal : Copper. Rhind's ground, thinly laid and unsmoked. The paper : thin " laid " ; an old fly-leaf which was too " foxed " to be useful for printing upon. This was merely held over the plate by the left hand.

Acid : Half-and-half nitric ; the biting—one only—taking five minutes. The plate was steel-faced (for the édition de luxe) and printed on Stacey-Wise paper of 1880—a blue " laid."

The whole process from grounding to proving did not take half an hour.

Re-working.—If additional working is necessary it is quite possible to re-ground and add lines, but a very transparent paper will be required to see the old lines. Tissue is serviceable if one is careful not to press too hardly or suddenly and not to sharpen the pencil too finely. By this means even a single line, or dot, can be added easily, and acid dropped on from the feather. Plate 17 shows two states of the same plate. The process was identical to that just described, tissue-paper being used for the second drawing. The result is not good, but serves as an illustration of the method.

Although with varying pressure in the use of the point stopping-out should not be required, it often happens that irregularity of touch will cause unequal biting, and in that case stopping-out is used in the ordinary way.

The biting without stopping-out where the lines vary principally in width and not in depth is comparable to the use of several needles of different size in etching proper and then biting to one depth. It is advisable to press rather too firmly in drawing than the reverse, as a line which will bite cleanly can always be controlled by stopping-out ; but a *too* delicately drawn one may not bite at all.

The line bitten by this method is a granulated or broken one resembling that of a chalk-drawing on a grained surface, and its quality lends itself extremely well to a combination between soft-ground and aquatint. That is why it was utilized more largely for the initial drawing upon a plate destined to be treated with aquatint tone than the ordinary clean, hard-ground line, which by its nature has no affinity with the granulation of the resin-process.

The quality obtained by the broken line is extremely pleasing and particularly suitable for the note or sketch, but lacks the decision of the needle-drawn method. It is naturally adapted for expressing *texture* in masses—variously grained papers may be used even upon the same plate by slipping them under an immovable upper paper upon which the drawing is made—and, in general, chalk or pencil studies which have been treated with a broad point (which would be unsuitable for expressing as etchings except in very free translations) lend themselves perfectly to interpretation through the medium of soft-ground.

Probably the greatest master of the method was J. S. Cotman, and he used it more than any other medium. His work will be spoken of again

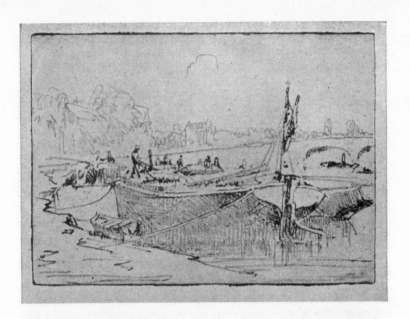

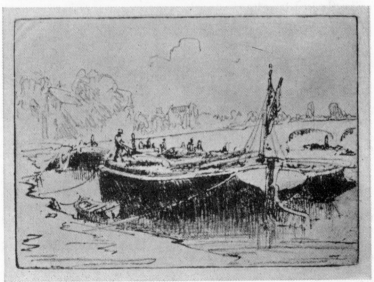

3¼×4⅛.

Plate 17
ILLUSTRATING SOFT-GROUND ETCHING.
RE-WORKING.

THESE TWO STATES SHOW THE POSSIBILITY OF RE-WORKING OVER UNDER-BITTEN PASSAGES A THIN TRANSPARENT PAPER MUST BE USED SO THAT THE OLD LINES MAY BE SEEN CLEARLY. IN THE SECOND STATE, ONLY THE BARGES WERE RE-WORKED. RE-BITING THE OLD LINES IS ALSO POSSIBLE.

117

in Chapter XXIII. Still earlier were the few incomparable plates by Gainsborough.

Aquatint

In aquatint we have a method for biting tones instead of lines, and in skilful hands it is capable of amazing depth and, at the same time, transparent delicacy. It differs from all methods so far touched upon in one important particular : that the ground laid does not entirely protect the metal from acid.

If the grounded plate were placed in the bath, the mordant would immediately attack the metal in a series of minute irregular dots which would form a tone of equal strength over the whole surface. This would be the result were the plate *entirely untouched* by stopping-out varnish.

Grounds.—Resin is the material most commonly employed for forming this equally porous ground. Asphaltum is also used, but I cannot speak of it from personal experience. There are two ways of getting the resin on to the plate : floating it by means of a solvent (spirits of wine) and dusting it on in its powdered, dry state.

The more certain method is the dust process, but still more delicacy can be obtained with the spirit preparation. Judging by the work of the old aquatinters of a hundred years ago the spirit grounds yielded extraordinarily delicate and perfect results, and they appear to have been able to control it with certainty. I have found it very treacherous in the little experience I have had, but I find most of the artists who have used it express the same verdict.

The method usually adopted for dusting a plate is to disturb the powdered resin in a confined space, allowing the particles to settle upon the surface of the metal.

The Dust-box.—There are several up-to-date "dust-boxes" sold by dealers for this purpose. Those which contain a revolving fan worked from without by a lever, and the clumsier contrivance which allows the whole box to rotate on an axis. When I was working at this medium I could not afford to buy such a thing, even had I known where to procure one, and my own box was made from a small sugar packing-case. A sliding tray was let in at one side near the bottom and a hole made to allow the insertion of the nozzle of an old-fashioned pair of fire-bellows. The powdered resin being placed on the floor and the tray—a grid—withdrawn, the bellows were brought into action until the inside of the box was filled with floating dust.

The plate, which had been thoroughly cleaned previously, was placed on the grid face up and the tray slid into the box.

If a very coarse ground is wanted, this should be done immediately after stopping the bellows, as the larger (heavier) particles of resin fall to the bottom first ; but for a finer ground sufficient time must be allowed for these to settle before pushing the tray into position. Experience in timing may easily be obtained, as the plate may be tested any number of times

before finally fixing the resin by heating. The plate must be very care-fully removed to the heater.

A breath will disturb the dust upon the cold plate, so it must be lifted very gently. If the plate has not been heavily enough coated it may be returned (after blowing up the dust again) for a second deposit before heating. The principle in all dust-boxes remains the same, however the dust may be agitated in the first place, and perfect results have been obtained recently by John Everett and (Mrs.) Laura Knight by simply dusting resin through muslin without a box at all.

The final heating slightly melts the resin and fixes it to the metal. It must not be given too much heat, however, or it will run together : just enough to cause the grains to yellow and darken.

Spirit-ground.—Mr. Robins[1] gives the following directions for preparing the spirit-ground :—

" Five ounces of finely-ground resin is dissolved in a pint of spirit of wine. The bottle is shaken several times during the day and then left for another twenty-four hours to allow the impurities to settle. The solution prepared will be much too strong, and a fresh bottle is used, and a mixture of one-third of the solution to two-thirds of the spirit of wine mixed together. If a very fine ground is wanted the second solution is again diluted ; for the stronger the solution of resin the larger will be the granulation and the coarser the ground."

Stapart's Ground.—Mr. A. M. Hind[2] gives the following :—

" Another method of obtaining a perforated ground was invented and described by Stapart (Paris, 1773), but it has been little used. He sifted sea-salt on to a thin coating of ordinary etching-ground, which was kept fluid by heat. The grains of salt sink on to the surface of the plate, and when the ground is hardened, these may be dissolved by application of water, leaving a porous ground ready for etching."

This method is in principle much the same as the " pen-process " of etching described later (see Plate 20).

Sand-grain Ground.—There is a commonly employed substitute aquatint ground which is prepared as follows :—

An ordinary etching-ground is laid and allowed to harden : the plate is placed upon the press bed, and over it a sheet of sand or emery paper. The pressure must be very slight when the plate is pulled through, otherwise the hard grains of the paper will be crushed right into the metal, but properly done the wax is merely cut through and the ground becomes porous. The position of the paper is changed or a new piece substituted several times, until the surface has been broken up into an intricate net-work of fine holes and equally permeable by acid all over. Any degree of coarseness or fineness may be obtained by the use of different sand or emery papers and by the number of times the plate is passed through the press.

[1] " Etching Craft," 1922, p. 194.
[2] " A Short History of Engraving and Etching," 1908, p. 12.

The underlying principle of all these grounds is identical, and the stopping-out and biting is the same for all.

Joseph Pennell used this last method with very great success : notably in his fine " Courtland Street Ferry," showing the lit-up windows of the tall sky-scrapers of New York.

Plate 18 is an example of this method.

"A Kashmir Bridge—Nocturne" (sand-grain aquatint).

Plate : Copper.

Ground : Rhind's, dabbed thinly, passed six times through press with coarse sand-paper (a fresh piece each time).

Acid : Nitric, half-and-half.

Stopping-out varnish : " Tower-brand " straw-hat polish.

Before biting : Light on right (stopped).

Timing :	$1\frac{1}{2}$ mins.	Sky and distant water (stopped).
	2 ,,	Upper water between bridge reflections (stopped).
	$\frac{1}{2}$,,	Distant shore on far bank (stopped).
	1 ,,	Buildings on right (stopped).
	2 ,,	Bridge (stopped).
	3 ,,	This completed the boat on right.

10 mins.

Whole re-grounded with dabber, leaving the dots open on undermentioned parts.

$\frac{1}{2}$ min:	Additional biting on distance to left (stopped).
$\frac{1}{2}$,,	,, ,, reflections of bridge (stopped).
1 ,,	,, ,, bridge and boat.

2 mins.

Total : 12 mins. on deepest darks.

The plate was steel-faced by Mr. W. C. Kimber, as were " A Chorten " and "A Note of Ronda." Printed on 1821 greenish paper, clean hand-wiped without *retroussage*, with Frankfurt and French-black and burnt umber, thin and a little medium oil. There is no preparatory line-work in this plate. It relies entirely upon the stopping-out brush-drawing. It is not easy to obtain sharp definition with sand-grain, as the pressure of the sand- or emery-paper raises a slight burr which breaks up the varnish when applied with the brush and softens each stroke. This is an *advantage* in treating such a subject as the present. This roughness must be removed after biting, with charcoal.

Etched Line as Guide.—Pure aquatint has no line-work at all, e.g. Goya's *Por que fue sensible;* but most etchers find it advisable to draw and etch —either in soft-ground or in the ordinary manner—an indication of the design on the plate preparatory to grounding it for the tone process.

A KASHMIR BRIDGE—NOCTURNE. The Author.

Plate 18

ILLUSTRATING SAND-GRAIN AQUATINT. (Copper.)

121

If this is done the bitten lines show sufficiently distinctly through the resin and serve as a guide to the stopping-out brush-work which follows. As already suggested, it is better to employ soft-ground if these lines are intended to show as an integral part of the composition.

Example of Usual Method.—We have seen that if the porous-grounded plate were placed in the bath, with no stopping-out, the biting would take place equally all over and its depth depend upon the duration of the action.

It follows that if a pure white is required in the proof the varnish must be applied *before* the first immersion.

In Plate 19 I have chosen a subject which could only be suitably etched by means of aquatint, depending, as it does, entirely upon *tone* for its effect. It will be seen that there are two pure white notes : the figures crossing the bridge. These were stopped-out before any biting, and, in order to be sure of the exact places, I had already etched a very faint outline of the main points in the composition. This can hardly be detected even in the original, because the aquatint tones were much stronger than the first guiding lines.

The plate was of zinc and the acid fairly strong nitric ; the ground resin dust. We can follow the successive baths easily, as this proof is the first pulled from the plate. I cannot give exact duration of bitings as the plate was etched many years ago.

When the varnish was dry on the figures the plate was submerged and removed almost at once, washed and dried. The resin being hard and firmly attached to the plate, there is no danger of moving it with blotting-paper, as in soft-ground. The lower part of the sky, its reflection in the water and the roofs to the left were then painted out, leaving crisp brush-marks, care being taken in going round the outlines of the jutting timbers against the sky, and the plate once more covered with acid. After another very short biting the process was repeated : this time the upper clouds in the sky and the top of the boat to the right (also a few other details) were stopped.

The next bath was shorter still, probably a few seconds. This was sufficient to differentiate between the tone of the clouds and upper sky ; the horizontal lines on the boat below and the rest of its cover in light ; the reflections of the same in the water, and so on, which were now painted out. Another half-minute or so and the main half-tone of the plate was strong enough, and this was treated in the same way.

The area to be bitten had now narrowed down to the smaller darks, and about three or four more immersions, working down to the deepest darks of all under the bridge, eaves of the houses, etc., finished the plate, which by this time was a mass of overlapping, black varnish-marks.

The tones of this first state were satisfactory excepting that of the recess to the right, immediately above the cover of the barge. This was too light, and in correcting it I made the blunder of which the beginner should take special note, as it probably happens to most users of the medium.

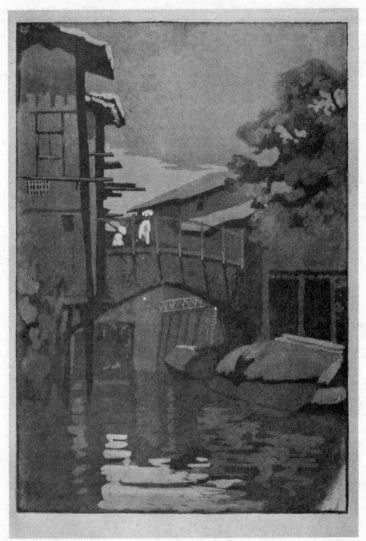

A KASHMIR CANAL. The Author. 8⅙×5⅛.

Plate 19

ILLUSTRATING AQUATINT, RESIN GROUND. (Zinc.)

THE WORK WAS EXECUTED UPON AN ORDINARY RESIN DUST-GROUND & BITTEN WITH NITRIC ACID. THIS IS A
FIRST PROOF AFTER THE FIRST GROUND WAS REMOVED. A TRACE OF THE ETCHED GUIDING LINES MAY BE SEEN
IN THE LIGHTEST REFLECTION AT THE FOOT OF THE PLATE.

Re-biting and its Dangers.—Upon re-grounding this portion, the particles of resin were too fine, and, instead of allowing the acid to eat a *deeper* series of dots, it permitted the already upstanding points of metal to be *levelled :* thus forming a wide shallow depression of roughened metal having no fine specks of the original surface left to give luminosity and no dots lower than the general plane to hold the ink. The result in the second state was, therefore, a light muddy half-tone. The remedy for this is the burnisher (or scraper and burnisher, if necessary), thereby forming a new, polished surface upon which a sufficiently coarse ground can be laid and an entirely new tone bitten. In re-grounding, therefore, the particles of resin should always be larger than those of the previous ground, otherwise this biting-away will take place. The best way would be to lay an ordinary etching re-biting ground with dabber or roller, leaving the original holes open as in Plate 18.

The differences in these three states are not sufficiently noticeable to make it worth while reproducing them, as in half-tone what little distinction there is would disappear.

This plate was drawn from an original by Fred. Parker, an artist who died in Kashmir, where the drawings (body-colour on toned paper) were executed ; and it was one of a set of three. I was first asked to etch them, but as this medium would have been entirely foreign to their nature, I finally chose aquatint ; and they are rather translations of colour than close reproductions.

Colour of Ink.—In printing this plate—which was handled in precisely the same way as a line-etching—I found that raw umber yielded a more beautiful colour with Frankfurt-black than burnt umber. The dark masses appeared too hot when warmed with the redder earth ; while the raw umber has a peculiar greenish quality singularly pleasing in tone subjects.

Interesting experiments have recently been made by John Everett, whose notes appear on pages 364 and 366. Besides using flake-white and colours *with resin* as a stopping-out medium—painting on the plate as if on a panel—after removing as much surplus oil as possible, he has latterly been biting through colours alone *without resin* and has found that every colour has its own granulation and resisting properties.

I have suggested that Baryta white would probably answer better than lead-white, which is of course attacked by nitric acid, and consequently must be loaded considerably in the high-lights. His records of exact timing will be found very instructive.

The Pen Method

A process which is somewhat akin to soft-ground is illustrated by Plate 20. I have never seen an actual etching produced in this way by anyone else, but it is described in Lalanne's treatise and elsewhere.

A pen-drawing is first executed upon the cleaned copper with ordinary ink—I imagine copying ink would be even better—and when dry a *thin* ordinary ground is laid over the ink lines.

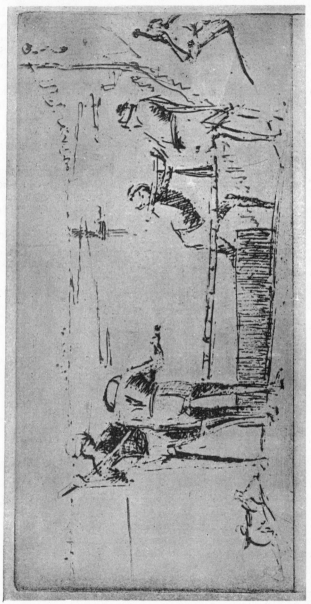

The Author.

Exact Size.

Plate 20

ILLUSTRATING THE PEN METHOD.

THE DRAWING IS DONE WITH PEN & INK ON THE BARE COPPER. WHEN DRY, A GROUND IS LAID. THE PLATE BEING SUBMERGED IN WATER, THE INK IS LOOSENED & THE GROUND ABOVE IT REMOVED. THE LINES CAN THEN BE BITTEN IN THE USUAL WAY. THE LIGHTLY BITTEN DISTANCE RETAINS MORE EXACTLY THE QUALITY OF THE PEN STROKE.

The plate is then submerged in water for half an hour or so, and by that time the ink will have become loosened—how the water penetrates the wax I don't know !—and can be gently rubbed away, the ground, naturally, being removed with it. The open lines can then be bitten in the usual manner, but they are so broad that they become almost *crevés* in places.

It will be noticed that the character of the pen disappears in the heavier biting : the lightly bitten lines reproducing the exact quality of the original drawing.

It is naturally a very unsympathetic surface to work upon—copper—as the ink sometimes refuses and sometimes blots, and probably a form of gum would answer better in this respect.[1]

Plate 20 was bitten in nitric half-and-half strength, and the distance stopped-out after five minutes in the bath ; the remainder being re-immersed for another ten minutes. No additions were made in any way after the first grounding, but it is easy to see that re-working would be perfectly simple.

[1] Since writing the above I have seen Mr. Everett's experiments in this medium. Instead of ink he uses a mixture of Gamboge and water. See also p. 197, Gainsborough's method.

CHAPTER XIV

DRYPOINT AND MEZZOTINT

FINALLY, we come to the processes which do not depend upon an auxiliary in the form of a mordant to do the actual spade-work.

I have already introduced the tools necessary for working in drypoint ; and, in the opening chapter, defined it as " engraving " rather than " etching."

The peculiar beauty of the medium is dependent upon its power of yielding a wonderful velvety richness in the proof. This is due, not to the groove which is cut below the surface, but to the " burr " or ridge thrown up by the passage of the tool under the lee of which the ink shelters from the rag, or hand, during the action of wiping the plate.

If the burr is removed with the scraper (see Fig. 21, page 48) or becomes worn off in the printing, the line below holds comparatively little ink, and the *distinctive* quality of the medium disappears. If this is done consistently throughout the work, the result is practically that of a very delicate engraving.

It is generally found to be expedient to retain the burr in heavy passages while removing it wholly or partially in delicate ones. This it is which gives drypoint its tremendous range in strength of line, far exceeding anything produced by etching. In such plates as Muirhead Bone's " Demolition of St. James's Hall—Interior " (Plate 132) this contrast of values obtained by leaving and scraping off the burr is seen to perfection ; while in Strang's " Legros " we have an example of pure line with practically no burr worth mentioning (Plate 122).

One great advantage over all etching methods possessed by our present medium is that plates can be worked directly from nature and *the result seen as the drawing progresses.* Further, there is no need to carry a chemist's shop about with one, nor is there any risk of spoiling unbitten plates by damaging the ground.

All that one requires is a bare plate, a point, scraper (and oil-stone), burnisher and a small tin of some greasy substance to rub into the lines as one works. I myself use a little ink (or dry black) mixed with vaseline. The vaseline prevents the ink drying ; can be moved about easily, and left in the lines for a long time without fear of setting hard. But every artist will have his own preference in this matter, and anything will serve which enables one to see the work clearly in black against the shining copper. A further advantage in an oily substance is that it prevents the metal glittering too much and allows one to see better, especially in artificial light.

Examples of Working.—I have often worked from the life by electric

or gas light without a screen, as, for instance, in the case of the head illustrated (Plate 21). This was drawn on the copper as it appears here except for a few minor additional strokes added as the edition was printed. A steel point was used throughout and very little burr removed. The plate lasted for about thirty impressions without retouching, and ten more after a little strengthening.

The second illustration shows the burr utilized to its utmost capacity for yielding solid blacks such as one might expect from mezzotint (Plate 22). In this case the back of an old plate which had plenty of foul-biting (acid having penetrated the varnish owing to friction while in the bath) was selected in order to hold a strong tone in printing. The snow on the wreaths was then burnished (after the drawing was made) to destroy locally this tone-holding roughness of surface.

In order to throw up as much burr as possible in the darks the steel (diamond would not answer so well) must be really sharp and held at rather an acute angle. If the point is nearly perpendicular very little burr will be raised, while, down to a certain angle, the more it is slanted the heavier the ridge thrown up on the opposite edge, and the more easily this wears off. Beyond this very acute angle, the point, especially if at all blunt, will cut a portion of metal right out of the line instead of pushing it up on one side as burr (see Fig. 44).

In printing a richly burred plate some of the looser particles invariably come away in the first proof and, generally, there is more difference between this and the immediately subsequent impressions than is noticeable between any two of the next twenty or more when the plate has "settled down." After this the ridges themselves, though not worn off, become polished on their crests, and as the hand cleans these there appear lighter centres in each originally solid-black line. This is when the proofs begin to look "tired," although the plate is by no means yet worn out, and in printing lines that have reached this condition a little *retroussage* may bring the ink over the crests of the ridges, thus hiding the worn appearance. But no dodges in printing can regain the velvety richness of an early impression.

Diamond-point.—As I have already stated in Chapter V, the diamond (or ruby) point has the advantage of steel in that it can move freely in any direction and at any angle. There is a danger of a finely pointed diamond flaking off if it is used too roughly over heavy lines, but on the virgin surface there is no need to fear.

In the third drypoint illustrated (Plate 23) the sky was entirely worked with a diamond cut to rather a blunt (round) point, and the free lines would hardly have been possible if steel had been used. The heavy crossed shadows in the foreground were steel worked : such straight strong lines being cut far better with the sharp metal point. Unfortunately, this fine diamond work (where the little burr thrown up is retained) wears most rapidly ; and obviously no re-working is possible, short of removing the whole passage and re-drawing. A certain amount of strengthening is

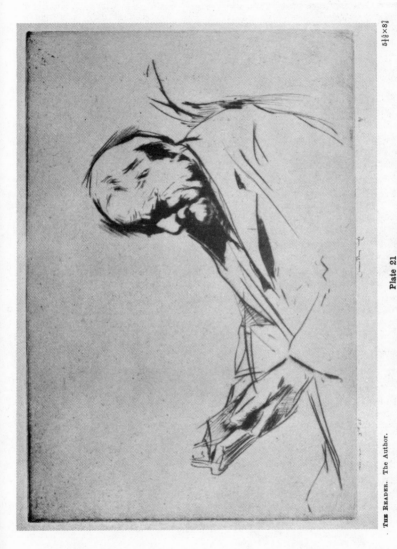

$5\frac{1}{10} \times 8\frac{3}{8}$

The Reader. The Author.

Plate 21

ILLUSTRATING DRYPOINT DIRECT FROM LIFE.

The work was done direct on the copper, in artificial light without a screen. A few touches only were added in the course of printing. It yielded thirty proofs & ten additional proofs after strengthening. The steel point was used.

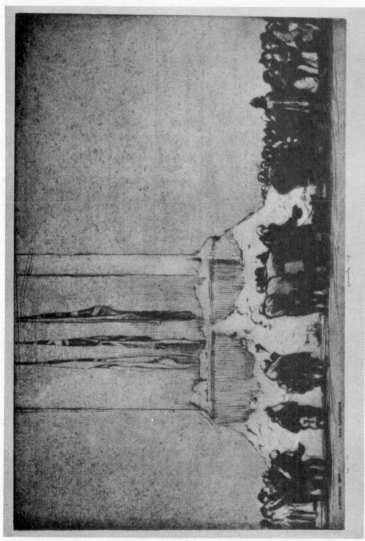

9¼×13½.

The Cenotaph. The Author.

Plate 22

ILLUSTRATING DRYPOINT & ROUGHENED SURFACE.

THE BACK OF A USED PLATE WAS EMPLOYED, WHICH YIELDS A TONE IN PRINTING. THE SNOW WAS BURNISHED.
IT IS AN EXAMPLE OF HEAVY BURR, UNSCRAPED.

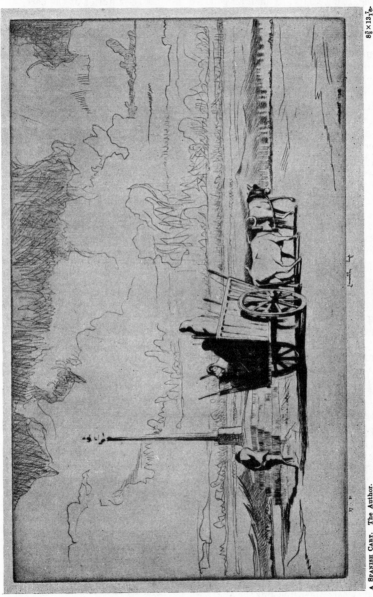

A SPANISH CART. The Author.

Plate 23

ILLUSTRATING DRYPOINT WITH DIAMOND.

HERE THE SKY SHOWS THE FREE LINE WHICH MAY BE OBTAINED BY MEANS OF THE DIAMOND. THE CART, & FOREGROUND GENERALLY, WAS WORKED WITH STEEL.
THE SKY WORE QUICKLY, YIELDING THIRTY-ONE PROOFS ONLY.

$8\frac{3}{8} \times 13\frac{7}{16}$

131

possible, if necessary, in such an isolated dark as the interior of the cart, or the figures in the previous illustration. This present plate only yielded thirty-one impressions.

All three drypoints were executed upon commercial copper.

Printing.—A drypoint is nearly always finished to advantage with the palm of the hand or fingers, and as there are no *deep* lines there is no need to cover the whole surface thickly in inking-up. In avoiding this sometimes the plate may be " nursed," as it follows that the less put on the less friction there will be in removing it again. A very little ink is enough to catch in the burr, and a wipe over the unworked portions with a soft rag will make sure that a tone will be left over the whole surface.

A proportion of ink must always be rubbed over the whole of a plate —however thin a film—between every proving : otherwise, if any area is left uninked, a white spot will show up in the print.

Any device which tends to nurse a drypoint is worth trying, and the inking roller *in good condition* is one of these.

The rocking motion of the old dabber, still so largely in use amongst professionals, must, in the nature of such an implement, help to rock off the burr. A *hard* roller, on the other hand, is worse than anything and will roll every raised line flat in no time ; hence the prejudice, probably, against using a roller at all.

A very stiff ink—i.e. made with strongish oil—is also very risky to use on drypoint plates, and " thin " oil with a touch of " medium " is quite strong enough to print heavy burr richly if not too liquid.

Lines Magnified.—Seen beneath a low-power microscope there is but little difference between the lines resulting from the use of steel and diamond-points, but *in ratio to pressure* the diamond yields a stronger and (unless very finely cut) broader mark. This is because it raises more burr on *both* sides of the line like blunt steel, but being of a light powdery nature this soon wears off.

In Fig. 42, A is the line made by the diamond; B by steel. In Fig. 43, A represents the line made by blunt steel ; B the jerky, burred line left by sharp steel in an attempt to draw freely; C the line left by a diamond under the same pressure as A. I have exaggerated the differences somewhat in all these diagrams, otherwise they would not tell sufficiently in reproduction.

Fig. 42.—Diamond and steel lines—relative " burr."

The blunt steel hardly raises a burr under light pressure : merely dents the metal. But it must be remembered that, with the steel, the *more pressure* applied the stronger line, but the *less freedom*.

Fig. 43.—Relative freedom.

In Fig. 44 we have the line cut by a blunt steel point at a very acute angle : a broad shallow trench from which the burr has been entirely cut, as in the case of a burin.

At a less acute angle a blunt tool will generally produce a "rotten" line in which the burr is broken into short lengths which are liable to come away soon in printing, and while they *do* stand, only print a broken

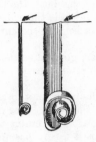
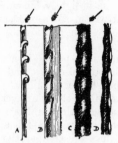

FIG. 44.—Loss of burr due to too acute an angle of blunt point.

FIG. 45.—Rotten lines due to blunt point.

line (Fig. 45). A and B show this line from two positions ; C and D the same *inked* from above and in profile ; B, C and D are greatly enlarged : drawn with the aid of the microscope.

It will be noticed that the top of the burr (as it curls over) presents a smooth surface to the rag or hand, and consequently shows as a series of light dots in the proof when polished (see C and D). It should also be

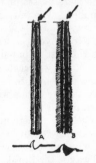

FIG. 46.—Good lines— acute point.

FIG. 47.—Good lines— vertical point.

noted that the burr curls inwards *towards* the point, *not* (as it is always drawn in textbook diagrams) outwards.

Fig. 46 shows a strong drypoint line as it should be when a burred line is required, the angle of the point being rather acute. A is the bare line ; B the same inked-up. Below are the same in section.

Fig. 47 represents a greatly enlarged line drawn with a nearly *vertical*

needle, the burr being raised on both sides almost equally. A is the line in good condition inked-up; B the same with burr worn or scraped down; C the same with burr entirely removed by the scraper. Their corresponding sections are below.

It will be seen in the last figure how greatly the burr adds to the *width* of the line. Without burr the groove corresponds to the size of the point which cut it, as in lightly bitten etching; but, plus burr, the line may be twice that width. As a matter of fact, I have made the width of the line itself too great in relation to that of the ink held by the burr in the case of a strong line.

All lines cut with a point—even a diamond—are grooved on their inside surfaces with parallel marks, and these help to retain the ink, although the trench may be very shallow.

Alterations.—Corrections are very easily made in drypoint, because, as we have seen, so little metal is *removed* from the surface, the strength depending principally upon the upturned ridges. This means that the sides of the lines are comparatively easily closed up by pushing them together with the burnisher. If the passage is to be re-worked with heavy strokes, there is no difficulty at all; but if the original surface has to be recovered in order to print a clean tone from it, there is often considerable labour to erase the scratches altogether, as under heavy pressure the faintest indications of a line will show up in the proof. With care and patience—using the methods described in Chapter III—anything can be done, and the freshness of the surface kept intact. It need hardly be added that no more pressure than is absolutely essential should be used in printing, as the burr is flattened every time the plate passes under the roller; and no unnecessary trial-proof should be pulled. The work should be carried as far as possible before proving.

I remember, a few years ago, when I took a plate to prove at a printer's how he exclaimed, "Do you mean to say that's the first impression?" "Certainly; why?" "But it's nearly finished!" He was accustomed to students from the etching schools, and his remarks seemed to indicate that it was really quite against the rules to carry a plate so far without a proof! But it is a very sound principle to work on.[1]

Mezzotint.—Mezzotint has nearly gone out altogether. There are still many collectors of the eighteenth- and early nineteenth-century schools, but few take any interest in it as a live art. The man who has carried on the tradition of the " great period " in the finest way is Sir Frank Short, but he is an isolated modern showing us that what the old mezzotinters did can still be done. Short's completion of the Turner " Liber Studiorum" plates was a splendid achievement, and the prints rank with those executed in Turner's own time. Though the etched line has hardly the vigour of biting given to it by Turner himself, the luminosity and richness of the mezzotint is fully equal to that of the master or his engravers.

The process is such a laborious one that few artists can summon the

courage or command the necessary staying power to carry it through. In principle the medium is reversed drypoint, the burr being first raised all over the plate so equally that a proof from the unworked plate would yield a solid black.

Everything which is required to print lighter than this black has to be scraped more or less strongly; until, in order to produce a pure white, the original smooth surface of the copper has been regained.

This at least is the orthodox method of setting about it, but some men have avoided part of the labour by only roughening the surface, to begin with, in those areas where it was necessary; working from light to dark instead of from dark to light.

In order to roughen the plate a tool called a " rocker " is used. This is a steel chisel having a curved edge serrated with very fine teeth, the handle springing from the centre of the curve (Fig. 48).

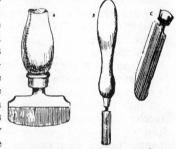

There is a contrivance which the student will find in dealers' illustrated catalogues in which the rocker is attached to a long shaft sliding backwards and forwards in a groove in the supporting table, which lightens the labour of using the tool—laborious even thus aided—with which the plate has to be covered across and across in many directions, each time taking a definite angle, until the face of the copper is cut up all over into a minutely dotted surface which holds the ink as does the burr of drypoint.

FIG. 48.—These rockers were drawn from those used by Thomas Lupton in engraving the Turner "Liber" plates. The tools are now in the Victoria and Albert Museum.

Whether this be done at the beginning, as a whole, or piecemeal as the work progresses, the principle remains the same, and good work can be, and has been, done in both ways.

To scrape away the burr where required a flatter scraper is generally used than that used by etchers (Fig. 49, A and B). The burnisher is the same kind of tool as already described, every craftsman probably having

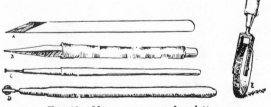

FIG. 49.—Mezzo scrapers and roulettes.

his own ideal design. To help out the work—to regain burr, for instance—variously toothed roulettes are employed. This instrument is shaped like the glass-cutter of a glazier : a small wheel running in a socket attached to a handle which leaves the indentations of its teeth upon the metal as it is rolled up and down the plate (Fig. 49, C, D and E). In C the small wheel runs transversely. E is an enlargement of the usual roulette shown at D.

Only unscraped drypoint can compare with mezzotint in the richness of its blacks, and it is a medium which might well repay the artist who has the patience to use it together with an understanding of subtle gradations of tone.

One of the few moderns who has practised it with some success in original work is Joseph Pennell, who did a few nocturnes from his studio window in Adelphi Terrace before leaving this country, which showed the great possibilities of the medium for effects of that nature. A much younger man who shows great promise in original work is R. C. Peter, e.g. in " Dawn " and " The Storm-wave," the quality in which is very individual.

Our interest in the process here is rather in its use as an auxiliary. It has been used in this way by several of the great etchers, as will be noted in at least two instances later.

A man who used it constantly with drypoint was Jacque (Plate 105). Another notable instance was in Andrew Geddes's " Mother " (Plate 92). Mezzotint, therefore, cannot be disregarded in a book of this nature, though there is no reason for examining the work of the reproductive engravers, which lies entirely outside its scope.

CHAPTER XV

THE finding of suitable paper upon which to print is one of the most urgent and difficult problems with which the modern etcher has to deal.

Till the nineteenth century—about 1820—when the adulteration which ended in making cheap paper by machinery began, a good quality article could be had for the ordering. Now it is a very different matter, as very few firms make really reliable paper at all, and still fewer make one which combines those qualities necessary for the printing from an *intaglio* plate.

This regrettable state of affairs—simply a matter of supply and demand—has caused artists to fall back upon the use of *old* paper. In itself it is a risky proceeding; but most consider it the lesser of two evils, preferring paper which will take an impression well and having the colour which only comes from age, to a stronger production more easily obtainable and freer from blemishes, yet which will not print so sympathetically.

The perfect paper should possess (1) Strength : that the proof may be handled without fear of tearing, and that it will not disintegrate in the course of a few decades as so many book-papers will. (2) Softness and pliability : that the damped fibre may be pressed easily into the lines and pick up the largest proportion of ink from them. (3) Beauty of texture and colour : which enhances the artistic value of the proof enormously. (4) Freedom from impurities and decay-germs which may begin to act upon the size or fibre after the mounting of the etching, causing discoloration and final ruin.

The best European papers have always been made principally of pure linen fibre (flax) strengthened by animal—sometimes vegetable—size. Various other fibres have been added (such as cotton, which gives softness), but it is generally conceded that flax makes the most durable article, and the practice has been to collect old linen rags. It is suggested that one of the modern manufacturers' difficulties is that linen which has not been subjected to chemical laundering is almost non-existent now, and this deteriorates the fibre to a great extent.

The first thing is the reduction of these rags to a very fine pulp, and a considerable degree of the permanence or otherwise is due to the care taken in this process.

In machine making the pulp goes through many cauldrons or vats of various chemicals in order to bleach it. The colouring matter is added and probably a certain percentage of size. The best hand-mades are usually guaranteed as *un*-bleached, and it is the use of bleaching powder which makes one suspicious of all machine-manufactured papers.[1] For

[1] There is always the danger of free chlorine remaining.

durability it is safer to have an excess of acid than alkali, though neither is desirable.

In making by hand the pulp is floated on to a flat tray having a fine wire-gauze bottom through which the water drains when the tray is raised, a thin film of fibre being left upon the mesh. This is turned out on to a sheet of felt. Upon this gauze are various designs which, being slightly raised, prevent the film of paper from being as thick in those parts, and when the paper is dry and held against the light these thinner portions (designs or lines) are seen to be more transparent, and are termed *water-marks*. For so-called *laid* paper this gauze is composed of fine, close, parallel wires crossed at right angles by stouter supports about one inch apart. The ridged texture thus obtained is preferred by many etchers, as it tends to give quality to those parts of the proof where there is no line-work. For *wove* paper the wire of the gauze is merely woven (as the name implies) and has no supporting lines, the resulting texture being an equally pitted surface such as that on which the majority of books are printed nowadays.

Now, in hand-making this surface texture and water-mark come entirely from the tray upon which the film of pulp settles. The character of these will therefore be identical upon both sides, though stronger on one than the other ; but on the machine where the pulp is passing—at first flowing —forward continually it is impressed upon *both* sides. The side upon which it lies first receives the impress of what takes the place of the " tray " in hand-making. This is a wire table continually revolving over a series of rollers, having usually a woven texture. It then, however, passes under a roller which impresses the water-marks and either *laid* or *wove* wire marks upon its *upper* surface, and this it is which distinguishes at a glance the normal machine-made from the paper made on the hand tray. I say "normal" because there are machine-mades which imitate very closely the hand-made *laid* paper without any apparent difference between the two faces. To imitate a *wove* paper is, of course, comparatively simple. The manufacture of the particular imitation I have seen is probably a trade secret, but paper-makers have told me that it is a very difficult thing to do, and probably entails much slower and more careful running of the mill.

After all, there is no reason whatever why machine-made paper should be inferior to the other provided sufficient care and trouble be taken. The beauty of hand-made is, of course, in its slight irregularity of surface and "deckle" edges.

Size.—Both kinds have to be sized and subjected to pressure. In the one case the continuous roll of paper passes through tubs of heated size in its progress along the machine, emerging sized, dried and pressed. In the other the sheets are dipped individually, having been piled—a felt between each—one on the other, in order to dry and set, and pressed.

The size is made from the hoofs and horns, etc., of animals, and makes the sheets of fibre less absorbent and much tougher and more durable.

According to the late Prof. Church,[1] wheat starch or gelatine are the safest sizes for paper, and sizing with leaf-gelatine will be described later.

It is this sizing which, though necessary for the durability of short-fibred paper (such as all European makes), tends to make the fibre less easily driven into the lines of an incised plate ; and it is because this size has decayed in old papers and the fibre, in consequence, regained its pliability, that these take an impression so much more sympathetically.

The usual drawing, and the few expressly made etching, papers have too much size to take the cast of the plate which is essential, and an attempt to overcome this difficulty has resulted in the making of *soft-sized* and *water-leaf* papers. The first is merely sized once instead of twice, as is usual, and the second is entirely unsized. *Soft-sized* paper is generally the best etching paper to be had, but there are several reasons for rejecting *water-leaf.* It is too easily torn, does not take the line as cleanly as the firmer-surfaced paper, the fibre of which is held together by size, and—most important—it is so absorbent that it is too easily affected by the atmospheric conditions, and a high percentage of moisture is one of the necessities for the germination of mildew spores which are always more or less present. The under-sized papers are very good, although never *quite* so sympathetic as those in which the gelatine has become semi-destroyed through age, and I can see no reason why a perfect paper should not be produced if the exact proportion of size were imparted to a first-class flax fibre with perhaps a small percentage of cotton for additional softness.

It would be absurd to imagine that the artists of Rembrandt's time used old paper—and if proof were necessary it is in the watermarks—and what was possible to manufacture in seventeenth-century Holland should be equally possible in the scientific twentieth, *if the demand were only sufficient.*

The stock of *good*, old paper—especially since the re-pulping of much during the war—is fast disappearing, and it must be remembered that as but little fine paper was made—in England, at least—during the greater part of the nineteenth century, and as age alone cannot turn bad fibre into good, in the course of the next generation etchers will be forced to rely upon modern produce.

Colour.—One of the chief qualities of old paper is its subtle colour, which is quite impossible to imitate by adding pigment to the pulp, because it comes from the rotting size having formed a warm film of colour by breaking up the original white surface irregularly. In nearly all modern Western papers the pigment employed is too crudely yellow. For beauty of colour one has to rely upon Japan. Let us be grateful that, though their art has been almost killed by Westernization, the Japanese still retain a part of their traditional sense of colour which in machine-ridden Europe has been completely lost.

An almost white paper has valuable qualities and is preferred by some men. It can yield a more brilliant proof than the tinted one (which is,

[1] "Chemistry of Paints and Painting," 1901, p. 10.

of necessity, lower in tone), especially when a warm ink is superimposed. For delicate, cleanly etched plates there is nothing more exquisite than the cold, almost greenish paper—resembling a duck's egg in colour—which was made by Whatman, Cowan and other firms at the end of the eighteenth century. It prints perfectly and has a certain lowness of *tone* which is very valuable and which modern makers endeavour to avoid. The colour of the paper is entirely a matter of personal preference, and will vary with the treatment of each plate.

Meryon's greenish paper, which he sometimes used for his sombre, strongly bitten, architectural subjects, was of great value to *him ;* while the brilliant warm Dutch paper which Whistler preferred was equally important in obtaining *his* effects. There can be no law ; and the search for the perfect combination between paper and ink for the given subject is one of the chief fascinations of the craft.

A few generalizations may be permitted nevertheless. When a positively bluish or greenish paper is selected, a warm ink will be more beautiful upon it, as the cold ground will be modified by the envelope of warm brown and yet show through it. The result will be subtler and less positive than that obtained in any other way. By reversing this one may obtain a rich, beautifully sombre effect in the use of a black ink upon warm golden paper. A proof from the same plate printed in warm ink upon white paper would be utterly different.

I have referred, on page 95, to the common practice of warming up the ink for very heavily bitten plates, and this cannot be too strongly condemned.

I have already spoken of the danger of bleaching agents. In many papers one finds also what is called *filling.* This is a dressing composed of various things such as china-clay, gypsum, whitening or chalk, and such adulterated papers should be avoided. One Chinese paper I had given me has such a heavy filling that one can smell the " earthiness " when the sheet is damped. It is, of course, useless.

Tinting Paper.—Many etchers in the past have tried to tint white paper for themselves. Coffee, tea, tobacco, etc., have been used, but probably the most satisfactory stain is *stout.* The beer is diluted with water according to the strength of tint desired.

Watermarks.—The watermarks in old papers are not usually so horribly obvious as they are made now. I suppose this is due to our tendency towards advertisement, but it is a great nuisance. Some of the Dutch papers offend very badly in this way. One must remember that such a mark is not only seen when held against the light but when the proof is flat on a mount. Being lower than the surrounding surface, its edge may cast a very faint yet perceptible shadow, sufficient to upset the values in that passage. I am thinking of a particular instance where the modelling of a forehead in the proof of a portrait seemed different from what I remembered in previous impressions. Upon looking closely I found that this was due to one of the letters of a huge watermarked name. This practice of

heavy-wire lettering began early in the nineteenth century, but it has been dropped by some of the better mills in this country recently, e.g. Messrs. Green,[1] who now use an unobtrusive little name at the foot of the sheet, quite sufficient for identification.

Some of the sixteenth- and seventeenth-century marks are very beautiful and have given their names to the size and shape of the sheets, such as " foolscap "—originally distinguished by the head of a jester. Many of the old Crown and other papers are worth collecting for the beauty of these marks alone, and if " foxed " there is no temptation to print on them !

India and Japanese.—We now come to the Eastern papers. Of these, Chinese and Japanese are the only ones we need consider.

The Chinese paper known as *India* (presumably because it was imported by the East India Company) is textureless and of a dull surface, but yields a very beautiful proof. Its disadvantage is extreme thinness, which caused printers to use it only in conjunction with a stouter backing—generally, and unfortunately, plate-paper—which enabled them to handle proofs more easily. It is a ridiculous practice and the source of endless trouble when such a proof has to be cleaned. In any case plate-paper is disastrous, as it is made of poor material and, being unsized, gives mildew germs all the encouragement possible by means of moisture. It is most rare to find one of these proofs of about the " sixties " (when it was largely used for woodcuts) that has escaped mildew when backed on plate-paper ; but I have many of that time upon unbacked *India* which show no trace of it.

Of Japanese papers there are many qualities ; some excellent and others worthless. They fall mainly under three headings :—

(1) The soft-surfaced, white *Hosho*, largely used by the European colour woodcut printers.

(2) The firm, textureless, thicker material (including the vellums), *Torinoko*.

(3) The thin, darker, harder-surfaced *Mino* or *Usumino* (meaning " thin ").

The first of these papers—possibly all, but I have been told that other fibres are used—is made from the bast-fibres of the Paper Mulberry, and is often called " Mulberry paper."

The first and last groups have very distinct wire marks running across the sheets at intervals of about $1\frac{1}{4}$ inches. In the cheaper qualities of the *Hosho* these are often far too pronounced ; and, besides, these modern papers are often heavily adulterated with " filling "—easily detected if the sheet be torn when it falls out in a shower of white dust—and this fact, in papers intended for the Western market, speaks for itself as to the durability of the fibre, and should be sufficient to warn etchers against its use. When of *good* quality this paper is probably as durable—certainly as strong—as any in the world, and its long silky fibre yields proofs of unrivalled quality for many types of etching.

[1] Makers of the " Head " papers.

None of these papers are sized, and though perfectly suitable for printing upon in that state, are extremely easily rubbed on the surface when carelessly handled, especially where there is little ink upon it. The ink in heavily etched passages helps to bind the fibre down, thus protecting it.

Being absorbent (though less so than unsized rag-paper), a proof from an identically wiped plate would be a little less brilliant than that printed upon a really soft rag-paper which had been sized. On the other hand, so yielding is the fibre, and so clinging, that it picks up more ink from both surface and line than any paper, with the possible exception of very old and good quality European makes, which are almost impossible to find.

It is far easier to obtain "all there is" from a plate with Japanese paper than with any *ordinary* rag-paper.

The colour-printers always size this paper (as do the Japanese) before using it, and so treated it will stand far rougher handling without the fibre lifting. The following is the method for doing this :—

Sizing Japanese Paper.—Five sheets of ordinary cooking gelatine (Cox's leaf-gelatine is reliable) are dissolved with as much alum as will lie on a

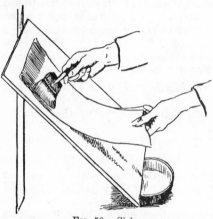

FIG. 50.—Sizing.

sixpence, in one pint and a half of water, using the double saucepan, or pot in an outside tin of boiling water, as suggested in Chapter IV.

The paper is then placed upon a board (Fig. 50) which slopes down to a vessel at its foot in which the superfluous liquid is collected, and, using as broad a brush as procurable —say 5 inch—the size (while hot) is brushed on from left to right, beginning at the top of the sheet and working downwards. The paper should be raised (with the left hand) at its foot while the brush passes across its upper portion and only lowered on to the board as the brush is about to pass over that particular section ; otherwise the air will get under the semi-wet parts—the board will be wet after the first sheet—and cause creasing when the brush arrives at the bubbles. It is the general practice to avoid wetting the two upper corners, so that when the sheet is pinned up on a line to dry the fibre at those spots will not give way, as sometimes happens when a pin is fastening the wet paper. The alum, besides hardening the gelatine when dry and acting as a preservative, causes its better liquefaction in the sizing,

but it is dangerous to have more in the paper than is absolutely needful.[1]

I have used this method with English water-leaf paper which I particularly wanted to print upon because it was of a peculiar colour (unobtainable otherwise), and quite successfully.

The second class of papers, being of so much firmer texture, have not the same need of a binding substance to prevent surface displacement.

The hard " vellums " have a shiny, smooth finish which makes them unsuitable for printing upon, besides a mottled appearance of texture which is anything but pleasing. They are extensively employed, however, for large plates, especially by the printers of Bauer's etchings, which is undoubtedly one of the reasons why his wonderful prints have been less popular than they merit in this country, where our better class of collector does at least know what good printing means.

But the best *Torinoko* paper has the strength of the " vellum " without its objectionable gloss and texture. Unlike the *Hosho* papers, this has no wire mark of any kind, being of close, even texture throughout and of much deeper colour. The darker shades—rich golden yellow—have great beauty, but have been said to bleach when exposed for some time to strong light, e.g. that of a shop window. I have never noticed this in an ordinary room where prints on this paper have hung for years.

It is relatively very much more expensive than the two other classes of paper—all " vellums " are—and at the time of writing (1924) at an almost prohibitive price when obtainable at all. Even before the terrible earthquake these papers were sold at a ridiculous figure, and no doubt it is true that stocks in the hands of middlemen were lost in Tokio, though, so far as I know, it is not manufactured to any extent in that district.

The only firm I know of who used to import this really good paper is that of Messrs. Crompton, of Queenhithe, Upper Thames Street, London ; but they had, I believe, practically given up supplying it before the disaster referred to above.

There can be no doubt whatever about the durability of this paper when not adulterated, and this particular make was said to be in use by the Japanese Government for important documents, though this may not have been the case. It was specially recommended to me by the late Mr. Littlejohn, of the British Museum Mounting Department, who employed it for backing valuable old work which had to be lined, etc. It has one peculiarity which is shared partially, but not completely, by several similar but inferior makes. That is its capability of being split into equal halves. All these papers are composed of more or less separate layers, but no other that I have tested will part as two complete sheets. In this case the two

[1] In the first issue (June, 1924) of the " Original Colour-Print Magazine," Mr. Urushibara describes his method and gives the following recipe : For *Hosho* Leaf-gelatin ½ oz., alum ¼ oz., water 35 ozs. For *Torinoko*, the gelatin and alum are cut down by half. According to Prof. Church this seems a dangerously large proportion of alum (see p. 14 of his book).

layers are readily separated. I have often done this when a plate was better suited by thin paper, as both sides can be used equally well. More : I have many times stripped the *back half from a spoiled print* and used this a second time, as the ink rarely penetrates to the under sheet ! One need not size this paper for printing etchings.

The third class, *Mino*, is very easily printed on, as its surface is much smoother than either of the preceding groups (excepting the " vellums ") and yet is silky and pliable. It is very thin, shiny and of a deeper yellow-brown colour, but appears less so when laid upon a white mount owing to its transparency. It is probably no more durable than the cheaper Mulberry papers and is usually full of flaws, bits of bark and dark fibre, showing that it has been carelessly made from unpicked material. For certain low-toned effects it lends an air of mystery and unity which the same etching on white paper would lack. It has no need of size, and can be handled without as much risk as either of the softer surfaced makes.

There is, of course, a great variety of all kinds of Japanese papers from very thick to tissue, but the chief distinction between all good qualities and European makes is in the length of fibre, which allows them a much greater strength while unsized (and therefore soft) than belongs to any of our own modern papers.

Rembrandt's Use of Japanese.—There has been so much outcry from collectors, dealers and artists in recent years against the use of all Japanese papers that the etcher and collector should bear in mind that *all* imported makes were not rubbish, and if treated with reasonable care—and unless a collector intends to do this he has no business to collect fine works at all—a proof on Japanese will last at least as long as one upon any other sort of paper : probably a good deal longer than on most.

That Rembrandt used it when he could get it, and that his proofs exist,[1] is sufficient evidence both that he considered the quality which it yielded him valuable—seeing that the paper he could obtain from the local mills was probably the finest and most sympathetic printing paper that Europe has produced—and of its durability.

Two men who have used Japanese papers most extensively in recent times are Muirhead Bone, who printed for a long time almost exclusively upon the *Hosho* Mulberry papers, and D. Y. Cameron, who employed the thin yellow *Mino* last mentioned. I have a proof by the former artist printed in 1906 upon *Hosho* which certainly is in as perfect condition now as ever it was—after many years (Plate 132).

Of genuine (skin) vellum and parchment there is no need to speak, as they have almost entirely gone out of use ; and though Rembrandt occasionally used vellum with effect, it is usually an unpleasant sootiness and heaviness that the printer obtains, and its contracting and wrinkling peculiarities make it a nuisance to the collector. No Japanese paper needs to be backed if the method of using blotting-paper described in Chapter X be followed, and there is *never* any necessity to damp the blotting-paper.

[1] There are many—especially of the large plates—in the British Museum.

Indeed, its chief function is to preserve the blankets from becoming wet and therefore hard.

Damping.—Papers take moisture very differently according to their composition and hardness of surface. In preparing them, therefore, for printing they must be treated accordingly. A firm-surfaced paper, old or modern, can be sponged as vigorously as possible without any danger of the fibre lifting ; but a soft paper, and particularly Japanese, cannot be touched directly with anything damp without being spoiled.

The aim in every case is the same : to make the paper as pliable as possible without excess moisture remaining on the surface. To do this it is best to damp down overnight. Longer is hardly necessary unless the paper is so hard that it is really unsuitable for intaglio printing, and to keep paper damp for longer than is essential is to encourage the development of mildew germs.

I use a couple of sheets of plate-glass, and usually sponge first one side of the paper and then the other ; finally turning once more, sponge it out flat on the glass. The reason for this is that most tough papers take some time to swell, and the second sponging is not usually enough. It is necessary to get out all the air bubbles and creases, because when other sheets are piled on the first the size of the swelling goes on increasing in ratio to the number added. Therefore I begin with the back, then the face, and finally swodge it down by rubbing the back where there is no harm done if the fibre begins to come up. With the very non-absorbent papers it will be better to sponge both sides and lay in a loose pile till all are done ; then turn the pile over and begin again, laying them face down on the glass, this time making sure that each is quite flat before superimposing the next. When the last is finished, place the second sheet of glass over all and weight down heavily with anything handy. I use a batch of old plates

By next day the whole mass should be equally permeated with moisture and stuck tightly together, perfectly flat. An easy way to get a crease in printing is to have the paper buckled when laying it over the plate.

Many people use zinc for this purpose instead of glass, but personally I prefer to see the flatness or otherwise of the paper through the glass.

For Japanese paper, the following is based upon the native method of preparing the pile of sheets for colour-printing :—

First count the number of sheets to be damped. Then, if a thick non-Mulberry paper is to be treated, take *half* that number of pieces of blotting-paper *and one more*. Divide this again and put the half (leaving aside the odd sheet) under the tap until entirely saturated throughout. This is now interleaved with the remaining dry blotting-papers and put under the glass and strong pressure. I use the same press—a copying press—that I employ for flattening proofs later on.

After this has stood, to become equalized all through—an hour or two is best—it is ready to receive the printing sheets. These are placed in

pairs between the moist damping-sheets, and the whole again put under pressure for the night.

The Japanese use the coarse outer wrappers which are used to protect the outside sheets of every ream, but blotting-paper is, I think, more suitable still.

For the thin papers—especially if unsized—less moisture is required, and therefore four or six printing sheets may be alternated with every damping sheet. The moisture naturally settles to the bottom of the pile to a certain extent, so it is as well to turn the whole pile upside down in the morning before beginning work ; but this is not necessary.

It is a good thing to print a large number at a time, if possible, because one sometimes—often—only gets into the trick of a plate's special requirements after a large batch has been pulled ; and when one is just " set " (to use a cricketing term) it is very annoying if one must stop work for the lack of paper or ink in just the right condition. Therefore it is better to damp a full number of sheets, always inspecting them carefully beforehand for flaws, and remembering that *some* are almost certain to be spoilt in the printing. If the etcher needs thirty, he is wise in allowing thirty-five sheets at least, and if he is exceptionally lucky the remainder can be kept damp for the next day or dried and re-damped another time.

There are days when the experienced printer does not spoil a single proof, but they are red-letter days and are offset by the periods when *nothing* will go right. But to have the paper in good order is at least the first step in making sure of a successful printing day on the morrow ; and the same with ink and blankets. If the paper shows moisture on the surface, it is too wet for printing with thin oil, and it is almost impossible to damp Japanese papers just before printing without leaving it too saturated. If this is done it can be dried by holding over the heater ; but it means uncertainty.

CHAPTER XVI

FLATTENING AND MOUNTING

Flattening.—We will now assume that a good series of proofs has been pulled and consider their subsequent treatment.

In the first place they must be flattened to allow them to be seen to the very best advantage and because, otherwise, they will be creased and the surface broken in supporting the weight of other prints or mounts in their buckled condition.

The ideal way to flatten would be to have a framework which clamped down upon the margin all round while the proof was still damp and held the edges during contraction (as in stretching with the edges pasted), but this is not practicable for large editions, and stretching with paste means the probable sacrifice of the deckle-edges by having to cut them away when the proof is removed.

This loss is of no real importance, especially when the proof is covered by a mount, but for some reason one likes to preserve the irregular deckle where possible. In any case, it takes too long for the etcher himself to undertake the stretching of a large edition.

So, after all, the only practical method is to employ pressure. If the proofs still remain upon the blotting-paper they are peeled off very carefully, or the surface will be cracked.

Unless the blankets in the press were very damp-hardened and had less elasticity than they should have possessed, most papers come apart without any effort, but in exceptional cases it is best to place the whole in a bath of water and sponge the blotting-paper away or rub it off with the finger-tips. This must be done when a make has been used in which the size is very soluble in cold water and the printing paper, being extremely sticky when printed upon, has stuck to the blotting-paper backing. Of course, if one knows of this peculiarity in time, the best thing is to remove the one from the other immediately after printing before the size has dried.

Some modern etching-papers are very bad in this respect, particularly one called by the name of a living etcher, though I believe this was produced by the same English mill that has turned out some very excellent printing-papers. As these have no makers' names it is not easy to find out by whom any given article was manufactured.

The proofs once free from the backing are well sponged from behind—no harm in gently damping the front as well—and the flatter they can be made to lie the less risk of creasing under pressure. In the case of Japanese paper they can be either sprayed with a fixing-spray or passed through the bath, when they instantly become fully saturated.

147

I interleave these wet sheets with old used blotting-paper which takes up the surface moisture, and when all are done I re-interleave them with new sheets instead, taking care to have at least three extra blotting-papers at either end of the pile. This is now placed between boards— three-ply is excellent—and the whole screwed down in a copying-press (Fig. 51), not too heavily for the first time, in case any prints crease.

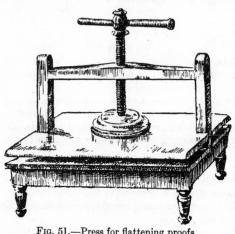

FIG. 51.—Press for flattening proofs.

Now follows the tedious process of changing the drying-sheets. The more quickly this can be got through the safer for the proofs, so far as mildew growth is concerned, and in no case should prints lie more than a day without being changed. I usually finish the whole drying in little more than twenty-four hours, sometimes in less than twelve.

Blotting - paper rapidly absorbs moisture from the proofs, and there is no point in leaving them together for a moment *after equaliza- tion has taken place.* At the first drying this takes place within a minute or two; the time after it takes longer, but at no time very long.

The important point to remember is that blotting-paper is never much, if any, drier than the atmosphere; and *that*, in this country, is rarely very dry! Therefore when the prints are, apparently, as dry as normal blotting-paper they will still contain enough moisture to cause them to buckle slightly on the surface when removed and exposed to drier air or air in motion. Buckling is fatal to any delicate etching, and, to guard against this, I always *heat* the blotting-paper before a gas fire till *steam no longer issues* from it previous to the *final* drying. This ensures the absolute dryness of the proof when removed and guarantees its remaining flat unless re-moistened.

This is where the professional mounter often fails. More: the pro- fessional cannot see the reason for it because he is not capable of seeing the slight change which takes place after a print is left, as he calls it, " dry." Nearly all these men, moreover, use hard " drying boards " instead of soft blotting-paper, and consequently crush the lines of the etching flat, so that the finger in passing across the face of the print can no longer feel the ridges.

As these are not solid ink, but largely caused by embossing from the back of the paper, very little is needed to press the raised parts back into

position, and even blotting-paper under heavy pressure must do this to some extent.

But plate-papers are far too hard for this purpose, and " drying-boards " (such as are expressly sold by dealers for the purpose) are damnation to the etched line.

If the etcher will try drying his blotting-paper before the last pressing, he will find that the proofs will remain dead flat in however short a time the work is done.

I was told recently that a whole night was not long enough for my informant—a professional mounter—to guarantee Japanese Mulberry-fibre proofs remaining flat ! This paper, being unsized, as already described, lies flatter of its own accord than any European paper except blotting-papers. More often than not it needs no flattening at all, because it is not firm enough in surface to retain the impress of the plate for very long.

I know something of these papers, as I have printed (and flattened) well over five thousand proofs on them alone, and I say unhesitatingly that the soft-fibre *Hosho* is the easiest paper to print on and to flatten that I have ever used : only, it is so easily rubbed in the cabinet ; and heaven help the proof which goes—unprotected even by tissue-paper—to the auction room, there to be handled, without regard for the damage inflicted, by anyone who cares to walk in before the sale and turn over the rough brown-paper folios ! Such paper can be guaranteed to remain flat after half an hour.

It is very important that the blotting-paper used for this purpose shall be free of watermark, as if there *is* one it will be liable to impress itself upon the surface of the etching while the latter is still soft from damping. Most makers will supply unmarked paper, especially if a large quantity is ordered, and there is no economy in stinting oneself in the use of good blotting-paper in any of the processes which together go to the making of a print.

Numbering.—When proofs have been flattened the etcher's own work is usually finished except for signing and numbering. With regard to numbering, I should like to suggest that the Continental method of recording the edition number as well as that of the individual print is by far the most satisfactory, and rarely carried out in this country.

Without an edition figure the number of the proof tells one nothing and is useless except for the fostering of a spirit of rivalry amongst the credulous who fondly imagine that because they own impressions marked No. 1 they therefore own the first proofs pulled ! How can the artist number the work as he goes along, and why should he if he could ?

The actual practice is something like this : the etcher prints so many more than he needs for his edition—at least, I do—and throws out the worst weeks afterwards when all are flattened.

Very often some of the remainder are still below standard, and more have to be printed and selected from. This may easily happen after the numbering has been done ; and in this case, supposing that No. 5 was

found not good enough, after all : out it would come and a substitute
pulled and numbered 5 when it might well be the 105th impression ! They
all get mixed up in flattening, anyhow, and are numbered just as they
happen.

What the collector wants to know in looking at the number is that from
a certain plate, in a certain state, so many were printed and that the one
in his hand is one of these—no more. It is of no importance to him whether
his proof were pulled first or last, so long as the artist has passed all as
good. The early proofs are by no manner of means always the best. On
the contrary, I once printed 150 impressions from a plate, and the edition
issued to the public was the last 50—numbered, naturally, 1–50. If the
rest were destroyed, what else could it have been numbered ? It is also
just as well to point out that no numbering is any guarantee that only
the stated issue was printed.

Even where both artist and dealer have genuinely believed no more
proofs to exist I have known definite cases where, when a plate has been
printed by someone other than the artist, other proofs have been pulled
by the printer for his own benefit ; or again where someone has been told
to destroy certain proofs and has not done so.

Neither does the destroyed plate aid the guarantee in any way except
by proving that no *more* will be printed. Where the artist prints himself
and is honest, there is no further guarantee possible or necessary. There-
fore what is of most interest is the edition, not the individual, number
recorded on each proof as *information,* not as a guarantee of probity to
those fools who will not buy anything unless it is rare.

FIG. 52.

Mounting.—There are two ways of cutting
a board (Figs. 52 and 53). If it be normally
thin for the cabinet, a fairly wide space should
be allowed between the mount A and the plate-
mark of the print C. This space (Fig. 52 B)
acts as a buffer between mount and proof, and
for normal sized work should be about ¼ inch
wide at top and sides, and ⅜ inch at the foot.

If, on the other hand, a very thick mount
(Fig. 53 A) is used, it should be bevelled at an
angle of at least 45° (B), allowing the bottom of the bevel to practically
touch the plate-mark (C). In this case the wide bevel acts as the buffer ;
as the space left does with a thin mount. The
difficulty of mounting in this style is in not being
able to show the signature in modern prints, unless
the mount is cut away specially, as is done by
some etchers.

Surely the principle is logical enough, and yet
so often (even in our greatest Museum) are the
two methods mixed and misapplied. Nothing
looks worse than a *thick* mount cut away back

FIG. 53.

from the plate-mark, except a *thin* mount cut close up to the edge of the print !

Another important point is that the mount should be at least as *cold* in colour as the tint of the proof. If a *little* colder it will be ideal ; but on no account should it be warmer or darker than the prevailing colour and tone of the print.

It is quite common—not in good-class firms—to see an etching which is printed upon a white paper mounted upon a cream board. The effect is abominable. The mount takes the life out of the etching, as the eye is always unconsciously attracted by colour and cannot disregard the mount as it should be able to do.

The etching should be positive ; the surrounding blank space negative. Again : to place dark mounts upon luminous warm-toned prints, as some people persist in doing, makes the warm paper appear cold and " chalky " and cheapens the whole effect.

These people imagine that a dark mount will make the luminosity of a sky, for instance, tell more—" show up " is the expression—but it doesn't ; it has precisely the opposite result.

Most wise collectors nowadays keep their prints in stock-sized mounts of two or three dimensions. A very usual and useful size is 22×16 inches, and many good firms keep to this size when possible. This prevents the solander cases or cabinet from containing any mounts that are loose, and allows a few frames to be utilized for the whole collection, which can thus be changed at will on the walls whenever the owner requires a new stimulus. I know one collector who re-hangs his drawing-room in this way every month or two and so really enjoys his whole collection. If the back-

Fig. 54.

board (in one piece) is fastened only by catches—either wood or brass—which fit into corresponding slots of the frame sides, this will greatly facilitate the hanging of a new exhibition at a moment's notice. It is not even necessary to unhang the frame if a picture-rail is used.

Another matter of importance to consider is the *proportion* of the mount's margin to be cut for a given etching.

Any print placed exactly in the centre between top and bottom will look as if the top margin were deeper than the bottom (see Fig. 54 A,

and Fig. 55 E). This illusion has to be counteracted by pushing the print up a little even if the effect of equality is desired. But it is better to make it *appear* to have more at the base, which means a still more liberal allowance (B and C in Fig. 54, and G in Fig. 55).

With a vertical subject on a 22×16 inch mount $1\frac{1}{2}$ inches will not be too great a difference between top and bottom; while horizontally $\frac{3}{4}$ inch may be allowed on an average. This naturally depends largely upon the proportions of the actual print and where the dark masses, within it, lie. It is best to keep the top and sides as equal as the whole proportions of proof to mount permit, especially in the case of an upright. What difference there may be should always be in favour of the top in vertical and the sides in horizontal—as they are termed "landscape"—subjects. Nothing looks worse than a tall print framed with less margin above than

FIG. 55.—Good and bad placing of proofs on mounts.

on each side (Fig. 54 D), or a long, narrow one with less at the sides than at the top (Fig. 55 H).

The only exception to this last is when, for the sake of uniformity on the wall or in the cabinet, the collector prefers to mount all prints on vertical boards (Fig. 55 I). In that case, all the works will not look equally well; but neither will they, even if mounted in both ways, so long as a uniform size of mount is used. That is to say, in whichever way it is done the individual proof must be sacrificed for the sake of uniformity, and, generally speaking, it is better to do this than to cut all the mounts to different sizes.

In Fig. 54, A, B and C show the same sized prints and mounts in different relations to each other.

A is the print placed with equal margins top and bottom. Whichever way it is turned, the margin looks deeper at the top.

B is an example of high mounting when the weight of tone (or interest) is entirely at the *base* of the design.

C is good proportion when the weight is at the *top*. It is set lower than B.

D is the print placed upon a board too short for it. The sides are wider than the top and even than the bottom. Even if the sides were cut down, though it would be better, too small a margin in relation to the print would still cramp the latter badly.

In Fig. 55 I there is an example of a horizontal print mounted upon a vertical board as described above. It is obviously the extreme limit of the mount's capacity, and this particular proof would look better mounted as at G.

E is again equally spaced top and bottom, but this is counter-balanced a little—not sufficiently—by being weighted at the top of the design.

F is mounted very high (like B, Fig. 54), in order to keep the weight at the base of the plate well up.

G is good normal proportion : a little more at the foot than the top.

H has less side margin than top, which looks very bad.

In all these diagrams the plate is as nearly the same size as possible.

Stretching.—A large etching being usually printed upon tough paper —even if it is upon soft—is very liable to buckle, and for this reason I strongly advocate stretching all such proofs : small ones also when they require it. A creased and wavy surface is most unfair to the artist who made the print. Buckling immediately destroys the illusion of any atmospheric reality the work may possess. No one knows this— no one can know it—better than the maker. He sees a proof in the first place, fresh from the press—absolutely flat—in its perfection. He strips it from its backing, and as it dries the illusion is dissipated. He still knows that the proof is a good one because he *saw* it before it became wrinkled, but even so he has the greatest difficulty in believing his memory trustworthy !

This same proof is flattened a week or two later, and once more it appears as a beautiful impression. The proof is sent out ; left in a damp atmosphere—say a London fog ; is then framed and hung near a fire or over hot pipes, and once more creases spring up as if by magic : once again it looks its worst. If the paper were stretched this could not occur : the print would remain looking its best.

I once saw one of the most sought-after modern etchings—worth, at the moment, the price of a good motor-car—the surface of which, as it hung in a collector's study, was a mass of radiating lines. It was hardly possible to recognize the plate. So heavy were these creases that they had become flattened, on the top of each, against the glass, and, as I warned the owner, would cause grey marks on the ink (the plate is a mass of black ink) which would be permanent and completely ruin the work. And yet this was a typical case where the collector preferred to have the work in this state rather than have it stretched !

It is just "fashion." There is not the slightest danger in stretching

if it be done properly—it should be done by an expert—and the paper not pulled so tightly that when dry it will be as taut as a drum. This, of course, may mean giving way at the plate-mark or bursting.

The advantage lies in the fact that, though a stretched proof will slacken in a very moist atmosphere, it will recover its flatness when dried again instead of being permanently buckled.

The edges are merely very slightly pasted to the mounting-board (which must be a firm one) and a sharp mounting-knife slipped underneath will easily part the proof from the mount if desired to unstretch it at any time.

I have heard many people who ought to know better say that they can make allowance for the look of a wavy surface, but they *can't*. No one can : even the man who knows them best—their maker—and if he cannot it is surely presumptuous for others to imagine they can ?

I admit that the practised and cultured critic may at times—indeed, not seldom—be the better judge of a work of art than the artist. Whistler's dictum on this matter was as wrong as many of his dogmatic utterances. A man may feel things to be right or wrong without having the power of expressing them—otherwise the artist would be a being apart from humanity instead of very much part of it indeed—and the artist is generally thinking along one groove only, to the momentary exclusion of all else.

On the other hand, in technical matters of this kind the knowledge of the critic is *nil* in comparison with that of the creator of the work, and in such a case, when the artist says he is unable to judge, the critic is mistaken when he affirms that he is quite able to do so. In Bernard Shaw's words, " He thinks he can, but he *can't.*"

Therefore let me.once more put forward a plea for keeping prints absolutely flat if their full meaning is to be appreciated—whether it be managed by stretching or by other means I care not—and I feel sure that once the necessity for this were fully realized, the foolish superstition that an etching should never be stretched would die a natural death.

Laying Down.—To lay a print down solidly by pasting the whole back is a very different thing, and not to be tolerated under any circumstances.

Air.—Prints kept in solander cases, etc., should be examined periodically and *aired*, if only for a short time. Airing is the greatest safeguard in warding off the incubation of mildew. If any decay is noticed, the patient should be at once segregated to prevent the spread of the germs to others.

Frames.—The collector should be guided by the tone (and colour) of his wall. My own belief is that a frame should be half-way (in tone) between the mount and the wall, supposing that there is any great difference between them.

A black frame on a grey wall is, however, very beautiful, provided that the frames are few and far between. In this case the wall is the half tone, and though the black frame lies perfectly upon the wall, the weak point is the too sudden contrast between frame and mount. This is apt to attract the eye at the expense of the print unless the latter is exceptionally strong.

Black, grey, gold and white mouldings are all beautiful if well hung, but they should have one point in common : their width. A frame for a 22 × 16 inch mount, for instance, should not exceed ½ inch. For larger works—etchings or mezzotints—¾ inch should be fully wide enough. Certainly no more than 1 inch for the largest and strongest plates, such as those of Bauer or Brangwyn.

There is in these exceptionally large frames the weight of the glass supported by the mortices to be taken into consideration.

A frame of which I am personally very fond is ½-inch oak, gilt directly upon the grain of the wood which shows through and keeps the surface matt. It has the advantage of suiting almost any coloured wall. But these things are very personal matters, and I have no wish to seem dogmatic on the subject.

Nevertheless I am convinced that a large proportion of the collecting public *and of the artists* never really consider the framing of their works at all seriously—often, indeed, leaving the choice of proportion and design to their frame-maker, who works on rule of thumb tradition.

As to the hanging of exhibitions of prints, so many of which are held everywhere, I should like to draw the attention of those concerned with the lighting and arranging of galleries, to the excellent chapter on the subject at the end of Mr. Pennell's " Etchers and Etching," quoted from several times in the course of this book. I have been informed on the best authority that this chapter was written many years before the book was published, and in it the author gives us the full benefit of a long and wide experience of the hanging of black-and-white.

Those who remember the splendid results of Mr. Pennell's hanging in the old days of the New Gallery " International " Exhibitions will agree that the artist knew his job. One of the most important features of such hanging was the use of the Velarium introduced by Whistler, and now unfortunately rarely seen.

Another matter of great importance was the hanging from a line at the *top* instead of from the *bottom*, as oils are hung, and the breaking of the line of prints into groups. In 1920 I hung the Whistler Exhibition held by the Scottish Print Club in this manner, and it was generally admitted that the prints looked unusually well. Yet it is hardly ever practised nowadays, and as an example of how monotonous exhibitions of etchings can be made to appear, one can think of those held by the Royal Society of Painter-Etchers in London, and yet several of the older members knew Whistler and many of them must remember Mr. Pennell's hanging of the New Gallery.

CHAPTER XVII

MILDEW AND RESTORING PRINTS

IT is but quite recently that any scientific research has been made into the question of mildew and its prevention and destruction with due safety to the print.

Dr. Alexander Scott, F.R.S., is still working at these and kindred subjects at the British Museum Laboratory, and his reports have been issued as pamphlets at intervals under the title of " The Cleaning and Restoration of Museum Exhibits," published by His Majesty's Stationery Office : the first being in 1921, Bulletin 5, price 2s., and the second in February, 1923, at the same price.

I should advise any collector who has a print of importance that shows signs of " foxing " or mildew spots to obtain and study these booklets, or to take his print to the Museum itself and ask for advice, always very courteously given. But whatever he decides to do, he will be well advised *not* to take his print to the usual cleaner and restorer, who is supposed to be at the beck and call of any print-seller.

I have seen enough ruin caused by unscientific professionals to know that even the best and most well-meaning firms cannot always rely upon the services of an expert who really knows his job. This can hardly be wondered at when an expert chemist of Dr. Scott's repute has put it on record that research along these lines is only in its infancy.

Mildew spores are presumably always present in paper, either from the time of manufacture or having been picked up from some infected object (not necessarily a print) which may have been in the same room at any time subsequently.

Conditions to Avoid.—But these spores will not germinate unless the conditions are favourable. One of these is moisture : particularly a warm, damp atmosphere such as one finds to perfection in southern sea-ports such as Calcutta and Singapore. Anyone taking prints to the East should be specially careful to give them air and light. A dark—especially an underground—warehouse, where the atmosphere is never disturbed, is an unusually likely mildew-breeding domicile.

In such a place as Calcutta I have known mildew spring up on one's boots in a single night during the rains ; but fortunately in Europe we have not those conditions to fight.

There is, naturally, less danger in treating etchings (the ink of which is composed of carbon in some form held in place by a linseed-oil varnish) than in cleaning coloured drawings or pictures ; nevertheless it is not at all difficult to ruin an etching, and in the great majority of cases the operator has no appreciation of the surface qualities of a

fine impression, and is therefore incapable of seeing when he has destroyed them.

I was shown a print, not long ago, where the incompetent to whom it was entrusted had actually ironed the back in order to flatten it out after " restoring," the result of the whole process being a surface like a newly polished piano-lid, combined with a friability of texture only equalled by an oat-cake ! Needless to say, that print no longer exists.

Chloride of lime is probably the most common bleaching agent used by restorers, and the great danger is that the chlorine will not be entirely washed out of the paper after use. It requires hours of soaking in constantly changed water to ensure that none remains.

Another chemical commonly employed for removing "foxing" is chloride of mercury—corrosive sublimate—a very dangerous poison and (Dr. Scott says) quite inadmissable for use upon works containing delicate colours (Bulletin 5, p. 5). I once had a foxed print sprayed[1] with a solution of this salt, but though the mildew was probably killed, the spots " came up " after a time and are there still.

Dr. Scott's Treatments.—The treatment for bleaching mildew stains advised in the above pamphlet is as follows :—

Two baths of bleaching powder and hydrochloric acid respectively are used alternately. The solution should always be very weak.

(1) 1 fluid oz. of concentrated hydrochloric acid in 1 quart of water.
(2) From $\frac{1}{4}$ to $\frac{1}{2}$ oz. of good bleaching powder in the same quantity (1 quart) of water (Bulletin 5, p. 4).

The mixture of bleaching powder and water need not be filtered. The print is first immersed in the acid bath for from ten to twenty minutes. Then, without being washed, placed in the second bath for an equal length of time. After this it is once more transferred to the acid bath. If this is not sufficient, the process can be repeated until no further improvement is noticeable. The print must then be washed thoroughly for some hours in water. To guard against any free chlorine remaining in the paper a *small* quantity of sodium sulphite may be added before the last washing.

In the second pamphlet (1923), p. 2, Dr. Scott mentions sodium hydro-sulphite, or "Hydros," as an agent for removing stains of an organic nature (in his case probably dyes contained in red ink), which resisted for many hours the treatment just described. " The stains were at once removed by applying a solution of sodium hydrosulphite, or by rubbing a little of the powder on the stain, then washing thoroughly and giving a single treatment of the bleaching agents followed by a thorough final washing." I have tried this with success.

" Instead of bleaching powder," Dr. Scott says in the first pamphlet, " the so-called *solution of chlorinated soda* may be used. This is sometimes too alkaline, and, if so, may render the paper dangerously soft and tender from the solution of the size in the paper."

[1] Spraying is not sufficient as small particles may easily escape saturation.

Danger of Bleaching.—In my experience this is the usual result of the chloride of lime treatment as commonly employed.

The mildew feeds chiefly on the size in the paper—generally gelatine or animal sizes, but starch and vegetable sizes are also liable to attack—and by the time the discoloration produced by the dead fungus has been removed the size has practically disappeared too, leaving the paper, to all intents and purposes, as soft and absorbent as blotting-paper.

A really good, strong-fibred paper will stand this; and I can see no reason why it should not be re-sized, but a poor fibre relying upon the size for its strength would naturally go to pieces at once. It follows, also, that papers so treated, being now easily affected (like blotting-paper) by the amount of moisture in the atmosphere, may become a danger to other papers or mounts with which they remain long in contact [1]; and though the absence of size in itself may make such papers less liable to the *growth* of mildew, the moisture they will contain will aid its germination.

It is not uncommon for a collector to notice mildew (recently started) upon taking a print from close confinement, either from the cabinet or a sealed-up frame,[2] and to be reassured upon finding that the marks have disappeared when the print has been exposed to dry air for a short time. Sunlight and even the dryness of an ordinary living-room will often check the continuance of growth, but the mildew *is not dead*. It is still in the paper, and will renew its activities at once if favourable conditions are restored.

Formalin.—To kill the spores, therefore, chemical treatment is essential. Even paper upon which there are as yet no signs of active mildew is better treated if there is reason to suspect contamination.

For this purpose, upon the advice of another distinguished chemist, I have used for some years a solution of formalin in spirits of wine or good methylated spirit : 5 per cent of formalin would probably be amply strong ; 10 per cent is certain to be.

Dr. Scott (1st pamphlet, p. 5) says : " Formaldehyde (formalin) would no doubt act, but, from its constitution and chemical activity, can hardly come under the category of undoubtedly ' safe ' reagents for this purpose until it has been very carefully tested. From the purely chemical point of view it may easily pass to formic acid, the presence of which may prove dangerous to many colours." But this need not worry the black-and-white collector. " Thymol," he adds, " and similar substances, aided by a gentle rise in temperature, seem to promise good results."[3]

There is no need to place the print in the formalin bath. A sponge or large brush applied to the back is all that is necessary. Formalin is, I

[1] Dr. Scott has queried this without actually contradicting it—on the ground that having absorbed the moisture from the atmosphere, the paper would retain it and not pass it on to another with which it was in contact.

[2] It is far wiser to leave frames unpapered at the backs, in order to permit air to penetrate.

[3] Dr. Scott tells me that his opinion of thymol has been since confirmed.

believe, inclined to harden the size in the paper, acting as a " tanning " agent, but this should be rather to the advantage of a print than otherwise.

Hydrogen Peroxide Method.—For the removal of " foxing," undoubtedly the safest method, but one entailing rather more trouble and care, is that which Dr. Scott has invented and advises in his first booklet, p. 5.

He casts a block of stucco (plaster of Paris) in an ordinary mould, larger than the size of the paper to be treated, and distributes over its surface (when dry) a small quantity of a concentrated solution of hydrogen peroxide, as uniformly as possible. By so doing an active surface is obtained, and the hydrogen peroxide is given off in the form of vapour and free from impurities. He then places the print face downwards $\frac{1}{8}$ inch above the surface and allows it to remain until the marks have disappeared. It will apparently require some hours to remove mildew stains in this way.

Pyridine.—To remove stains caused by oils and varnishes which have darkened with age, Dr. Scott advises the use of pyridine. It is applied by means of a soft glass-fibre brush, and the liquid removed with pure white blotting-paper. Several applications may be necessary. The pyridine, he says, evaporates very rapidly and leaves the paper undamaged in toughness.

Referring in the second pamphlet to the hydrogen peroxide method, he adds : " Some papers have become brittle and fragile under prolonged treatment, owing apparently to the size used in manufacture of the paper having been oxidized and destroyed. Most papers, but by no means all, seem to withstand the action of the hydrogen peroxide very well indeed."

He then goes on to say that in some cases writing inks (where the basis was an iron salt) have been bleached a faint yellow by this treatment. I presume, therefore, that where an ink signature or other work—such as retouches or dedication—is affixed to an etching care will have to be exercised and the written part, or added touches, protected if possible. It is possible, as Dr. Scott informs us, to restore the colour of ink so bleached by the use of certain salts, but in any case it would be unwise for the inexpert to try these delicate reactions which only the highly trained chemist would undertake.

In cases where it was inadvisable to submit the whole print to the moisture of the peroxide vapour (by reason of the unequal expansion of certain papers) a solution of this in ether was applied by means of a camel-hair brush to the parts requiring it.

Grease Spots.—For the removal of grease from prints, petrol may be used and the stain (if there is any) afterwards got rid of by the bleaching method. Fresh grease may be largely removed by placing blotting-paper on the spot and heating by passing a not too hot iron or other metal object over the blotting-paper very gently.

Printing-Folds.—For removing printing creases there is only one safe method of working. The print should be damped and stretched by an expert as tightly as may be without running the risk of bursting the paper. This will pull out the fold automatically, leaving the fine uninked line

telling as a white against the tone of the surface. The only remedy for this is to fill in very delicately with a fine brush. If the crease is across a passage of pale surface tone—and this is just where they happen most frequently, because there the paper is not gripped so well as in the heavily inked parts—it can best be filled in with water-colour mixed to the required tint and made as stiff as possible by admixture of a little gum of some kind. This will prevent the colour spreading beyond the line. If the crease crosses a heavily bitten passage it can be more easily filled by means of a needle dipped in the same printing-ink as was used for the etching in the first place.

In the case of Japanese paper, water-colour will be certain to spread unless the paper has been sized.

No *flattening* can ever hope to eradicate a printing-fold successfully, but it is the method almost invariably attempted. If the fold *is* worked out by this means it will only be at the expense of the surrounding surface, and moreover the tension of that part will be left unequal and the proof likely to buckle in consequence. By straining the fibre is pulled equally from the edges, and when de-stretched remains of more equal tension throughout. The great pressure required to *flatten* a crease will also destroy every vestige of an embossed line, whereas in stretching nothing of the kind happens.

CHAPTER XVIII

THE MEDIUM IN RELATION TO THE ARTIST'S IDEA

THE engraver in any medium is very strictly limited by the nature of that medium. In painting with oil or water-colours the artist is practically unlimited in his choice of subject. He can suggest the most delicate or the strongest differences of both tone and colour without ever straining the resources of his craft.

Leaving aside colour altogether, as we cannot here deal with relief methods which are alone suitable for colour-printing, the processes examined one by one in the previous chapters show that each is peculiarly adapted for yielding a certain quality of line or tone, which, in its turn, is most capable of being the medium of interpretation for certain modes of thought and their expression in black and white.

Etching can best express the thought of the artist when he is thinking in terms of definite form ; in other words, line.

Aquatint yields him of its best when he thinks in vaguer terms of tonal masses, which are yet definitely separated, each from each.

When he dreams of infinitely subtle and illusive gradations mezzotint is his medium ; and so it goes on, down to the less obviously distinctive qualities of soft-ground and drypoint.

It would be foolish (though not absolutely impossible) to endeavour to interpret a subtle nocturne with the needle, when the resources of mezzotint are available. Still more foolish, because impossible, to attempt to record in a few, swift, definite strokes the motion of an animal, in mezzotint ; though it might be done with the brush in aquatint.

The rough breadth of soft-ground lends itself to the rapid jotting down of a semi-tonal effect where true etching would fail ; while for broad, simple, flat washes of tone obviously aquatint is indicated.

These mediums are often combined, it is true ; and sometimes, though comparatively rarely, with success. Turner did it in the splendid *Liber Studiorum*, using combinations of at least four mediums (etching and soft-ground etching for his structure : aquatint and mezzotint for his tone), though probably rarely more than two of these upon any one plate.

Goya did it, also, in his amazing series of semi-etched, semi-aquatinted plates. That great experimenter Geddes often combined his mediums, and so subtly that it is extremely baffling to distinguish them (see Chap. XXIII). But for the student it is far better to master one medium at a time : to learn the strength of each and its limitations.

If the student, for instance, could gain such *technical* mastery as that achieved by the late W. Hole in his astonishing translations of Velasquez, Millet and others, he would be able to express himself in etching proper

with the greatest ease, supposing that he had anything in him worth expressing.

A student who is learning the resources of a medium is much more likely to be thinking *firstly* of his method of working, and only *secondly* of what he wishes to express by its means. This is as it should be ; but the result is that he will sally forth to find a subject only *after* he has made up his mind to produce an etching. By so doing he will, consciously or otherwise, reject every subject he meets with which is unsuitable for expression *in line*.

The converse of this is when the rarer, and usually older, artist is so enthralled by a *subject* that he casts about for a suitable medium in which to express it.

There are many artists, even of the first rank, who are temperamentally more interested in mediums than in expressing their manner of seeing Life ; although they have their moments when Life grips them so hard that they forget about the importance of the means for its own sake : otherwise they would never be classed as highly as they are.

As an example of a very great artist of whom this may be said I cite Whistler ; of the opposite type, Rembrandt, and I hope no one will misinterpret my meaning in contrasting these types, as no artist can have a more genuine appreciation of the work of the modern master than I.

If the student will take an illustrated catalogue of Whistler's etched work he will find that in hardly an instance did the artist attempt a subject that necessitated anything beyond *premier coup* methods, or that presupposed deliberate thinking out beforehand of the composition in order to express an idea—I mean a universal idea—beyond what he actually saw at the moment.

His composition was perfect within the limits of his art ; but this came from reducing what he actually saw to the essentials *requisite to the making of an etching*.

His amazing power of rapid selection in drawing on the spot—a power more *certain* even than Rembrandt's—allowed him to avoid subjects, or the parts of a subject, which were unsuitable for *expression in the medium*. In this Whistler was the supreme master ; and if art meant nothing more than the perfect handling of a medium, he would hold the place claimed for him by his extreme admirers.

If we now turn to a Rembrandt catalogue we shall see that the attitude of the Dutchman was very different. Some of his plates are perfection technically, but in others the technique went by the board because the greatest of all etchers was less interested in preserving its purity than in expressing the idea he had in mind.

That the medium, as such, interested him intensely, no one can doubt who has studied his work ; but that the expression of Life interested him still more is undeniable.

We know that, with few exceptions, the whole of Whistler's work was executed red-hot from nature, and this has certain obvious advantages.

The seizing of an action or an accidental arrangement of light and shade is more likely to be spontaneously and vigorously set down in this way, and, for individual figures or simple landscape, this advantage probably outweighs those which pertain to the studio. But for an elaborately designed plate such as the " Christ Healing the Sick," or one of Bauer's many-figured, carefully-balanced compositions, working in any way other than from deliberately planned drawings—or from one's memory if that be sufficiently accurate—is unthinkable.[1]

The great majority of modern etchers who have done work worthy of mention most certainly prefer to work finally upon the plate after having made studies, more or less elaborate, in another medium. The notable exceptions were Whistler and Haden.

That Meryon did preliminary work—we are told that he *did* work directly from nature,[2] working from a mirror—we have ample evidence in his pencil drawings. That the finest etching by far (in my opinion) produced by Zorn—the " Renan "—was done also in this way we again have the evidence of the original drawing, line for line almost identical with the plate. Cameron once told me that there was no doubt that nearly all the best men worked from drawings. Bone, we know, often, if not invariably, follows the same method. McBey told me years ago that he found working from nature directly on the plate much more confusing than helpful ; while Blampied said the same in almost identical words. Needless to say, such plates as Percy Smith's " Dance of Death " could hardly have been done in any way " on the spot," and of the living foreigners, Benson and Forain, the same may be said with certainty.

Of many other masters I have definite opinions on the same subject, but the student is as able to form his own as to read mine.

I began my own work by making drypoints from nature and generally etched them in reverse—i.e. from the print of the first plate—in the studio. After that I did most of the etching from pencil drawings, though some were drawn on the spot. I gradually worked more and more from nature, following Whistler's maxim, until the war. And yet, curiously enough, some of the best plates of those years were executed from drawings, though by no means all. Nearly all the first and second Indian sets were drawn on the plate from nature and bitten months afterwards in Scotland.

After the long break of the war I began gradually to feel that this method was no longer possible to me ; while in the last five years only portraits and a few small jottings have been done on the copper from nature, and, of these heads, all were drypoint.

I feel more and more convinced that for work other than the " note " or " sketch," planning out in another medium before touching the plate is by far the sounder policy ; and what is sacrificed by not being in definite

[1] Since writing the above I have had Mr. Bauer's letter confirming this (see note, p. 326).

[2] See Hamerton's " Etching and Etchers."

contact with nature at the moment is more than made up for by the opportunity for weighing the relative values of one composition against another, and in being unhurried in actual execution.

Great art can only be produced by analysing ; considering balance and rhythm, volume and line ; as well as by recapturing the heat of the emotion felt at a particular moment through the vehicle of one or other of the senses.

And this intellectual part of the work can be done far better in the calm of the studio, if one *can* only hold fast the memory of the past emotion.

PART III

CHAPTER XIX

For a large part of the information contained in the earlier part of this chapter I am indebted to two books in particular : Mr. S. R. Koehler's " Etching " (1885) and Mr. A. M. Hind's " A Short History of Engraving and Etching " (1908) (revised edition 1923), and the student who desires fuller details and the many intermediate names of those who fill the occasionally considerable gaps between men of outstanding merit who alone can have place here, will find those works invaluable for reference purposes.

The first names we have to mention are not those of etchers, but of a few obscure artists whose work was principally executed with the drypoint.

The Master of the Hausbuch (c. 1480).—The first of these (**Plate 24**) is the anonymous master, the largest collection of whose work is in the Amsterdam Cabinet. He flourished towards the close of the fifteenth century and was presumably a German of the middle Rhine. Mr. Hind finds an occasional influence of the great engraver Schöngauer in his plates, which are of great originality. Mr. Koehler mentions three Italians about whose work so little has been authenticated that it seems unnecessary for the student to be concerned with it.

No one seems yet to have discovered precisely when the process of etching designs upon metal objects—purely for ornament's sake—began first to be practised, but in all probability it was used by the armourers and jewellers long before the fifteenth century, when first we find any definite record of the art.

Jehan le Begue, to whom I have already referred in Chapter VI, left definite recipes for making two mordants for the practice of etching iron —presumably for decorative purposes only, but we cannot be sure of that —so far back as 1431 ; but nothing is authenticated in etching as we understand the term until the opening of the sixteenth century.

Daniel Hopfer (1493[1]–1536) is cited by Mr. Hind as having *probably* produced a portrait as early as 1503 or 1504, and Mr. Koehler's reasoning on the evidence seems very sound when he says : " There is other proof, however, to convince us that Daniel Hopfer was the earliest etcher so far known to have worked in Germany. In the year 1500 his name is found entered in the register of one of the guilds of Augsburg, and his profession is given in the same entry as that of ' Kupferstecher,' that is to say, an engraver on copper. . . . Hence we are perfectly justified in accepting

[1] This date would appear more than doubtful.

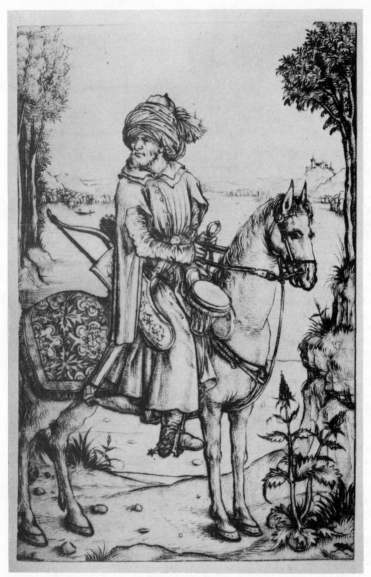

Drypoint. 6¼×4¼ Cut.

Plate 24

ORIENTAL HORSEMAN. THE MASTER OF THE HAUSBUCH.

THIS IS ONE OF THE EARLIEST DRYPOINTS KNOWN & THE ARTIST'S NAME HAS BEEN LOST.

From a proof in the British Museum.

166

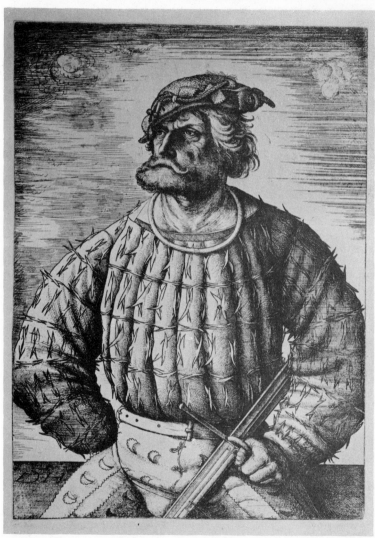

Etching. 11⅛ × 8¼.

Plate 25

KONRAD VON DER ROSEN. Daniel Hopfer.

Hopfer, who etched on iron, is probably the earliest worker in the medium whose prints have survived. He was already a known craftsman in 1500.

From a proof in the British Museum.

it as a proven fact that Daniel Hopfer, named as an engraver in 1500, and all of whose plates were executed by biting with a mordant, was engaged in producing printable plates by etching as far back as the date named." He points out that these plates (**Plate 25**) were etched on iron,[1] not on copper ; but that does not in any way upset his argument.

Urs Graf (c. 1485–1529).—1513 is the year of the first known print from a *dated* bitten plate. Urs Graf—probably a Swiss—was the author of it : the subject a woman bathing her feet (**Plate 26**), and only a single impression has been discovered.

Master of 1515.—At the same time, in Italy, was working another unidentified master, thought by reason of the character of his Gothic draughtsmanship to have been of northern origin also (**Plate 27**). He has been long recognized as one of the earliest artists to use the *drypoint*, but I am quite satisfied that his preliminary, structural contours were *bitten* and not graved. My reasons are : (1) distinct traces of foul-biting in some plates ; (2) the equality and continuity of the line ; (3) that it would seem much more logical for an artist to complete his shading with the drypoint, after having employed a single strong etching, than to change deliberately from the pushed burin to the down-stroke of the drypoint. If the latter were the method one might expect intermediate passages where both tools had been used (which is not the case) ; while if the contour were first bitten, there would be no going back after the wax was finally removed, all the subsequent shading being done in a different medium. We have no data, so far, to indicate whether 1515 which appears upon one of the plates was early or late in the artist's life, but there is little doubt that he was etching in Italy almost, if not quite, as early as any of the known Germans in the north. As his work was certainly executed upon copper he would also be the first known etcher of that metal. That etching or even engraving was derived from the Florentine goldsmiths' *Niello*[2] is now doubted, and our historians are inclined to place the birth of line-engraving as well as the bitten process in Germany.

Dürer (1471–1528).—The first great master who produced a few bitten and drypoint plates amongst his numerous engravings was Albrecht Dürer. His earliest attributed drypoint (1510) is disputed as a later forgery. Of the three authentic drypoints, two are dated 1512. His six bitten (iron) plates were executed between 1515–1518 (see Chapter XX).

Lucas v. Leyden (1494–1533).—Next comes the great Dutchman, Lucas, who was etching—probably inspired by Dürer—after 1520. Mr. Hind cites him as the first man of note to use copper, but, as I have just shown, the Master of 1515 has, almost certainly, a prior claim. I pass over these two men for the present because I shall return to them later on.

[1] Some of these iron plates are to be seen in the British Museum, where the student can see the pointed lines drawn with the *échoppe*.

[2] Niello (Lat., Nigellum) is the art of filling the engraved lines with a black (or coloured) composition in order to throw up the design strongly, as is done in so many forms of Eastern metal work, e.g. Kashmiri, Bidri, Muradabad.

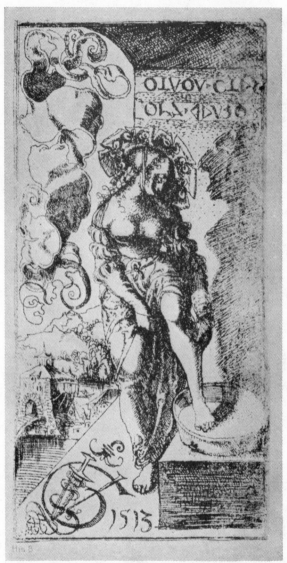

Etching. 5¼×2⅛.

Plate 26

WOMAN BATHING HER FEET. Urs Graf.

THIS ETCHING UPON IRON IS THE FIRST KNOWN TO CARRY A DATE, THOUGH THOSE OF HOPFER & THE MASTER OF 1515 ARE ALMOST CERTAINLY EARLIER.

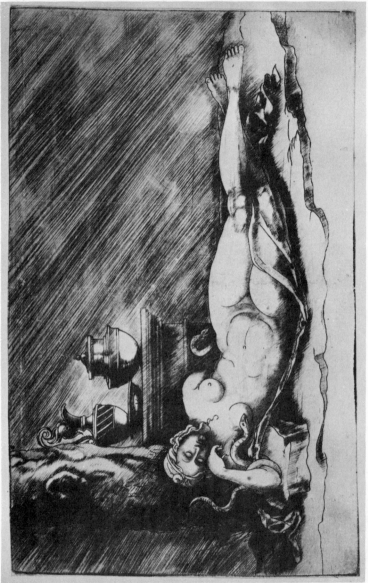

Etching & Drypoint.

6×9¼.

Plate 27

CLEOPATRA. THE MASTER OF 1515.

THE EARLIEST ARTIST TO USE THE BITTEN LINE KNOWN IN ITALY; PROBABLY A GERMAN. THE BACKGROUND & SHADING ARE DRYPOINT.

From a proof in the British Museum.

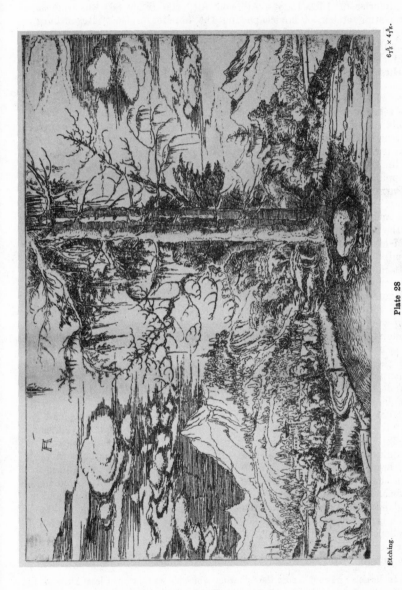

Etching.

6 5/16 × 4 7/16 in.

Plate 28

LANDSCAPE WITH LARCHES. ALTDORFER.

LIKE DÜRER, ALTDORFER, THE FIRST PURE LANDSCAPE ETCHER, USED A SINGLE, FLAT BITING. THE PLATES ARE VERY DECORATIVE.

From a proof in the British Museum.

171

Altdorfer (c. 1480–1538).—Albrecht Altdorfer (**Plate 28**) was a most interesting etcher of landscape and the founder of the "Regensburg school." His drawing of the drooping larch branches is very personal, though his plates have none of the incisive strength and definition of Dürer's, whose landscape drawing (e.g. "The Cannon") is magnificent.

Hirschvogel (1503–1553).—Another native of Nuremberg who made some very charming landscape plates (**Plate 29**) after the manner of Altdorfer was Aug. Hirschvogel. The "articulation" of the planes and the relationship of objects atmospherically are much more definitely felt, while the line is very economically used. Here we have the beginnings of true landscape etching. His great importance lies in the fact that he was perhaps the first to gain atmospheric perspective by varied strength of line : possibly by employing more than one needle rather than by stopping-out.

Parmigiano (c. 1503–1540).—To return to Italy : Francesco Mazzuoli, Lucas's contemporary, was etching after 1520 with an extraordinarily free and etcher-like line. It is so modern in feeling that one is reminded of the work of our Victorian woodcut school (**Plate 30**).

Meldolla (c. 1522–1582).—Andrea Schiavone was probably Parmigiano's pupil, and his work shows the influence of the master.

It must be remembered that we are here forced to disregard many greater men than the last named, merely because, though engravers, they did not employ acid or the drypoint.

We must now pass over a considerable period till we come to the first men who began to use etching for the sake of its own inherent qualities, though this might perhaps be claimed for the last four men I have spoken of, to a certain extent.

Seghers (1590–1645).—One Dutchman who deserves passing notice, principally because his rather wild landscapes were of interest to Rembrandt, is Hercules Seghers. He experimented considerably with printing in colour.

Callot (1592–1635).—Far greater was one who still had strong leanings towards the quality of the graver's line—Jacques Callot (**Plates 31, 32**). His is a most important figure in the history of etching because his influence descended side by side with that of his greater contemporary, Rembrandt, until our own day, as I think, has not been fully recognized.

In the seventeenth century his example (technically) was followed in France, Italy, Holland (where I am sure he influenced Rembrandt) and England. His great vogue, especially in the late seventeenth and eighteenth centuries, was probably largely due to two things apart from the excellence of much of the work. Firstly, his huge output ; and, secondly, that he was known to, and held up as worthy of imitation by, the first known writer on technical etching, Abraham Bosse,[1] through the

[1] In Bosse's foreword occurs the following, which shows that he at least knew of no previous work : "dont personne que je sache n'a traité par écrit public jusqu'à cette heure."

Etchings. 2¼ × 5¾.

Plate 29

LANDSCAPES. HIRSCHVOGEL.

THESE LANDSCAPES, PROBABLY ETCHED ON IRON, ARE VERY IMPORTANT AS SHOWING THE FIRST USE OF MORE THAN ONE
STRENGTH OF LINE IN THE SAME DESIGN. THIS MAY HAVE BEEN DUE TO STOPPING-OUT OR MERELY TO THE EMPLOY-
MENT OF DIFFERENT SIZED POINTS.

From a proof in the British Museum.

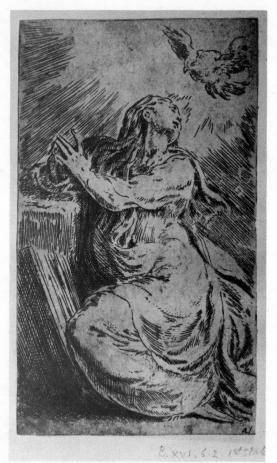

Etching.

B. XVI. 6. 2. 1st St. 6

4¼ × 2¼.

Plate 30

THE ANNUNCIATION. PARMIGIANO.

SHOWING THE FREEDOM & EMANCIPATION FROM THE DURIN INFLUENCE ALREADY
ATTAINED IN EARLY SIXTEENTH CENTURY ITALY.

From a proof in the British Museum.

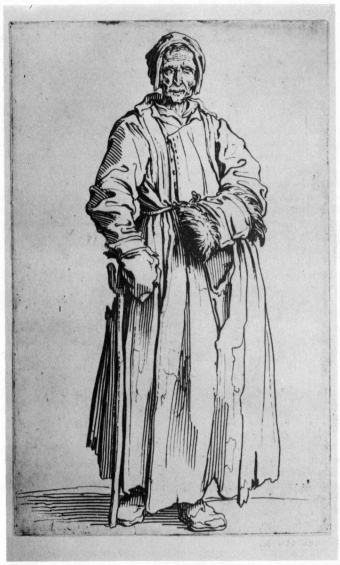

Etching. 5¼ × 3¼.

Plate 31
A BEGGAR. CALLOT.

A MAGNIFICENT EXAMPLE OF WORKING WITH THE ECHOPPE. NOTE THE POINTED ENDS OF MANY LINES
SHOWING STILL THE BURIN INFLUENCE.

From a proof in the British Museum

175

translation of whose book by Faithorne and the anonymous author of
the treatise quoted from in the early chapters of this book, his fame and
methods spread through Britain. Upon the title-page of Faithorne's " The
Art of Graveing and Etching " (1662) he is described as " that famous
Callot."

It was obviously his influence—in part through Claude and Zeeman—
which caused the first notable plates to be produced in Scotland (as I shall
endeavour to show later), and his influence which descended through
Zeeman to Meryon and the moderns. Callot was born at Nancy. He
spent most of his earlier life in Italy—largely at Rome—but returned to
his native town some fourteen years before his death.

Mr. Hind[1] makes a curious and ambiguous statement which I must
confess I am quite unable to accept under any interpretation.

" In the history of etching his work is a notable landmark, as it is among
the earliest in which the practice of a second (or further repeated) biting
was used to any extent. The varied tone of line achieved by this method
opens possibilities of treating atmosphere and distance which few even of
the greatest etchers have fully realized."

Whether Mr. Hind means by " second biting " the reopening of the
original lines and their re-biting, a continued biting after some passages
have been stopped-out, or the adding of *further* lines crossing the old by
means of re-grounding with the old lines filled up, is uncertain; but, in
any case, what follows seems to imply that few even of the greatest etchers
have fully realized how to exploit those processes !

Rembrandt himself was noted for his skill in the use of those operations,
and it would be difficult to find a single man of importance since that
time who has not *fully* understood and utilized either one or all of the
same methods.

I feel sure that Rembrandt must have been influenced very early by
Callot, but I have no evidence other than that of his prints—the beggars—
themselves. And with the fame that Callot appears to have won it seems
highly probable that some of his prints would have found their way to
Amsterdam, where the art was appreciated.[2]

The other influence, which I do not remember having seen suggested,
but which—direct or indirect—seems to me quite patent, is that of Callot's
figures upon the art of Meryon. Compare, for instance, Meryon's treat-
ment of his figures in " La Morgue " with any of the small groups in a
typical Callot, and I think the resemblance can hardly fail to strike the
student. It may be that the influence was only indirect—through
Zeeman—but it is worth while to draw attention to the probability of
the French tradition having definitely descended from the first great etcher
to the still greater etcher of two hundred years later.

Claude Gellée (1600–1682).—The next great artist, who was only inci-

[1] " A Short History, etc.," p. 159 (1st ed.).
[2] A very close copy of his " Misères de la Guerre " was published in Amsterdam
in Rembrandt's lifetime.

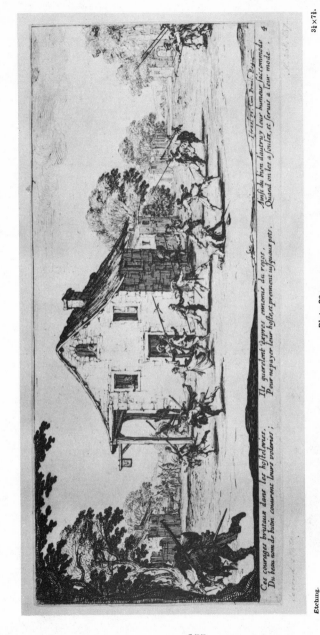

Etching.

$3\frac{1}{4} \times 7\frac{1}{2}$.

Plate 32

FROM "LES MISÈRES DE LA GUERRE," No. 4. CALLOT.

THIS PLATE IS TYPICAL OF ONE SIDE OF CALLOT'S ART. A STUDY OF THE HALF-LIT FIGURES WILL SHOW THE SOURCE OF INSPIRATION OF COUNTLESS ETCHERS.
INCLUDING CLAUDE, ZEEMAN, CLERK, RUNCIMAN, & MERYON.

From a proof in the British Museum.

177

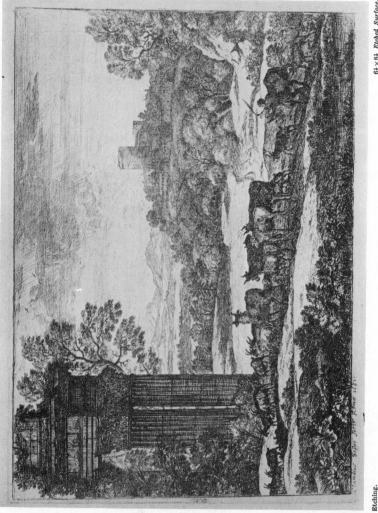

Etching.

Plate 33

CATTLE RETURNING IN STORMY WEATHER. CLAUDE LORRAIN.

CLAUDE, THOUGH HE PRODUCED FEW PLATES, HAS HAD WIDE INFLUENCE, ESPECIALLY IN ITALY WHERE HE LIVED.
OUR FIRST IMPORTANT SCOTTISH LANDSCAPE ETCHER, CLERK, OWED MUCH TO HIM.

From a proof in the British Museum.

6¼×8¼ *Etched Surface.*

dentally a great etcher, was also a Frenchman, and, like Callot, he absorbed the tradition in Rome. Claude outlived Callot by forty-seven years, though only some eight years his junior ; but while the older man produced at least one thousand plates at a modest estimate, Claude's whole output does not reach half a hundred ! His etched work occupied but a small part of his long life, but his plates are by no means bitten " engravings " like those of nearly all his predecessors. He employed a free, delicate, irregular line which unmistakably " belongs " to the medium, and that same feeling for luminosity which he imparted to his wonderful paintings also permeates the finest of his plates. I cannot agree with Sir Frederick Wedmore[1] in this instance when he ranks *Le bouvier* as the finest of these. It is a laboured plate containing some very poor draughtsmanship. Far finer, in my opinion, and showing an amazing sense of the peculiar qualities of etching, are such plates as the magnificent " Flock in stormy weather " (**Plate 33**), *La fuite en Egypte, L'apparition, La danse au bord de l'eau* and *Berger et Bergère*. " The dance by the water-side " is as true to nature as any of the contemporary Dutch landscapes except those of Rembrandt ; while Claude etched with greater force and contrasts of biting than even Rembrandt in the latter's outdoor work. This can easily be explained by the mere contrast of lighting found in their respective countries, Holland and Italy.

Although Claude does not approach the Dutchman in delicacy and profundity of draughtsmanship, yet he had absorbed from Italy a certain sense of bigness of *design* which is very satisfying and totally unlike the art of the North. In any case, Claude, like Rembrandt, was a pioneer, and a very great one ; a man who prepared the way for the great landscape etchers of England.

Van Dyck (1599–1641) and Rembrandt (1606–1669).—Born a little later, but both outlived by Claude, were the two men who were to change the whole development of etching : Van Dyck and Rembrandt. These men, both from the Low Countries—the Fleming who travelled extensively and left his mark directly upon our own artists, and the Dutchman who never left his own land, but whose work soon became still more sought after abroad—these two set a standard for portrait, figure and landscape etching which has remained generation after generation until the present day.

There is hardly a man who has come after Rembrandt but has been, directly or indirectly, influenced by his all-embracing genius.

No great artist of Rembrandt's calibre has time in the space of a working life to explore all the possibilities of even *one* medium, and though he may feel that in certain directions things might be accomplished, he can only hint at them and pass on along the main track which he has selected, or that circumstances have forced upon him.

These hints of what were but side-tracks on the road of the master are often followed up and carried further by his many followers, each working along a gradually diverging path, until, at the end, it is sometimes difficult

[1] " Etchings," 1911.

Bey Duren

W Hollar fecit, 1649. a Antwerp

Etching.

$3\frac{1}{4} \times 6$.

Plate 34

BEY DUREN, HOLLAR.

SHOWING HOLLAR'S GENUINE FEELING FOR THE LIE OF LANDSCAPE, THOUGH LACKING INTIMACY. NOTE THE CIRCULAR
TREATMENT OF DISTANT TREES AFTERWARDS USED BY CLERK OF ELDIN.

From a proof in the British Museum.

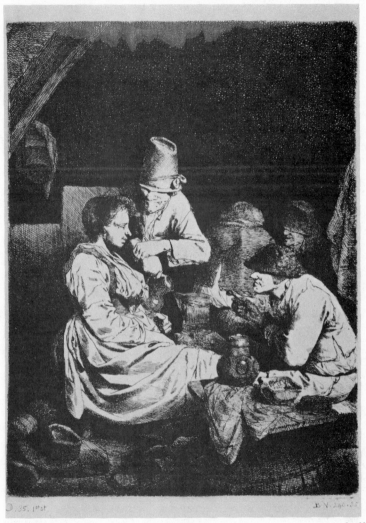

Etching.

8⅞×6⅜.

Plate 35

THE DOCTOR. BEGA.

FIRST STATE.

BEGA, WHO FOLLOWED REMBRANDT, HAD YET SOMETHING DEFINITE TO SAY FOR HIMSELF.

From a proof in the British Museum.

181

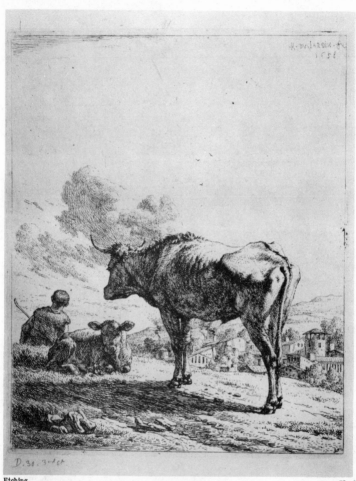

Etching. 7⅞×6¼.

Plate 36
CATTLE & HERD-BOY. DU JARDIN.

182

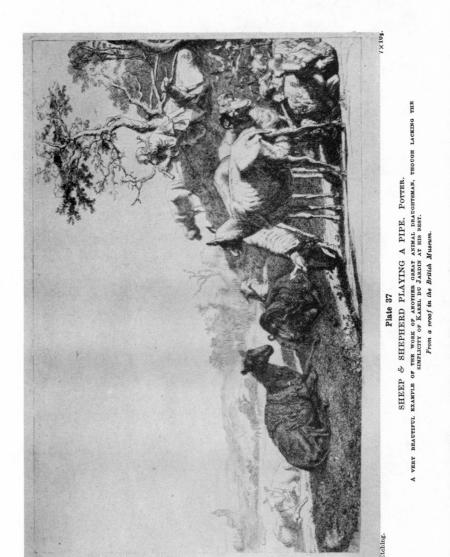

7 × 10¼.

Etching.

Plate 37

SHEEP & SHEPHERD PLAYING A PIPE. POTTER.

A VERY BEAUTIFUL EXAMPLE OF THE WORK OF ANOTHER GREAT ANIMAL DRAUGHTSMAN, THOUGH LACKING THE
SIMPLICITY OF KAREL DU JARDIN AT HIS BEST.

From a proof in the British Museum.

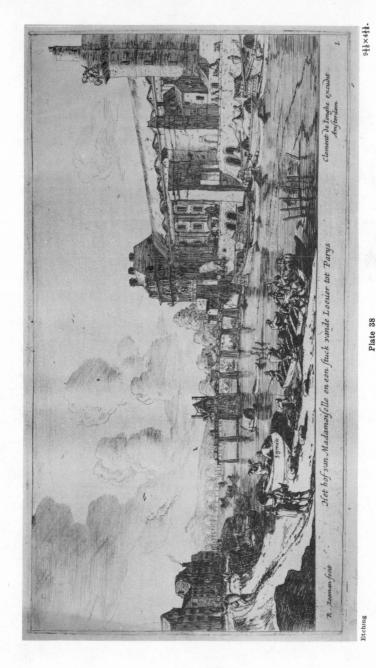

Etching

R. Zeeman fecit

Het hof van Madamoiselle en een stuck vande Loeuier tot Parys

Clement De Ionghe excudit
Amsterdam

9⅜×4⅛.

Plate 38

THE LOUVRE, PARIS. ZEEMAN.

THIS PLATE SHOWS THE MARKED INFLUENCE OF CALLOT & THE STARTING POINT OF MERYON. NOTE THAT THE PUBLISHER WAS
CLEMENT DE JONGHE, WHOSE PORTRAIT WAS ETCHED BY REMBRANDT.

From a proof in the British Museum.

184

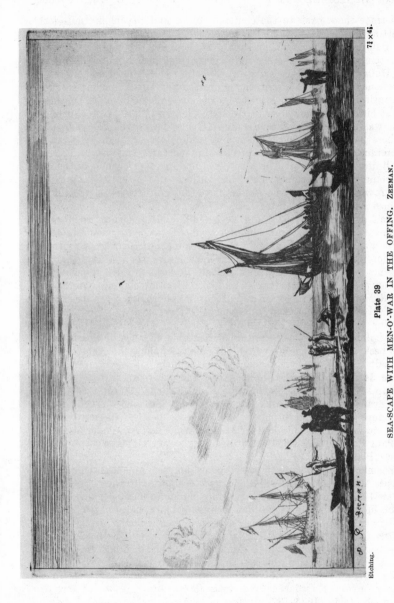

Etching. 7¼ × 4¾.

Plate 39

SEA-SCAPE WITH MEN-O'-WAR IN THE OFFING. ZEEMAN.

This plate shows the derivation from Callot in the figures. This or similar works must have had a profound
influence upon Clerk of Eldin & later upon Meryon.

From a proof in the British Museum.

185

to trace them back to the common source and the inspiration of their setting out.

Before dealing with these followers, however, we must note the one contemporary who remained uninfluenced by either Rembrandt or Callot.

Hollar (1607–1677).—Artistically, Wenzel Hollar need not interest the student to any great extent, though some of his small landscapes are very beautiful, and he had a great command over his medium, as, considering that his output numbered nearly three thousand plates, is not surprising. He was born in Prague and came to England with the Earl of Arundel, where he remained most of his life, and where he died. His etchings embrace a great variety of subject from landscape (**Plate 34**) to figure and still-life, drawn mostly in a hard, formal manner, which occasionally becomes very charming ; but his outlook was essentially that of an engraver. At one time he was employed by Faithorne at a wage of four-pence per hour !

van Ostade (1610–1685) and Bega (1620–1664).—One of Rembrandt's side-tracks which was immediately exploited was *genre ;* but van Ostade never, and his pupil Bega only rarely, approached their great prototype. I thoroughly agree with Sir Frederick Wedmore when he says that Bega has not yet had his day. His work (**Plate 35**) has a breadth of vision which far surpasses that of his master, and lacks Ostade's cloying " prettyness." Bold, simple (both in design and execution) and dramatic, it deserves the careful study of every serious student.

Nor, in portraiture, could Bol, Lievens and the rest in Holland, nor Castiglione in Italy, come within measurable distance of Rembrandt at his best, though I am convinced that many of the still accepted " Rembrandt " heads are by these and similar etchers.

du Jardin (1622–1678).—The eldest and perhaps the best of all the group who carried on the tradition by specializing almost exclusively in the drawing of animals was Karel du Jardin (**Plate 36**). There is a tremendous solidity and intimacy in his plates of cattle. Hamerton tells us that he was greatly admired by Haden, and I do not wonder at this.

Paul Potter (1625–1654) also did some powerful plates along similar lines (**Plate 37**).

Zeeman (1623–1663).—Reynier Nooms (his real name) did some fine sea-scapes which, as we shall see later, made a great impression upon Meryon (**Plate 38**). Callot's influence—possibly through Claude—is very marked in his figures, especially the silhouettes against an expanse of sea (**Plate 39**).

Naiwynx (1624–1654). } Although a few years senior to Jacob Ruysdael,
Ruysdael (c. 1628–1682). } H. Naiwynx is said to have been a follower of the better-known etcher. I think some of his etchings are quite as fine as, if not finer than, his master's. All these men followed up lavish hints thrown out by Rembrandt, with great success, each in his own groove. Ruysdael's landscapes foreshadowed those of our own [**A. v. de Velde (1635–1672).**] Norwich masters, while some of Adriaen van de Velde's cattle (**Plate 40**) are hardly surpassed in the whole history

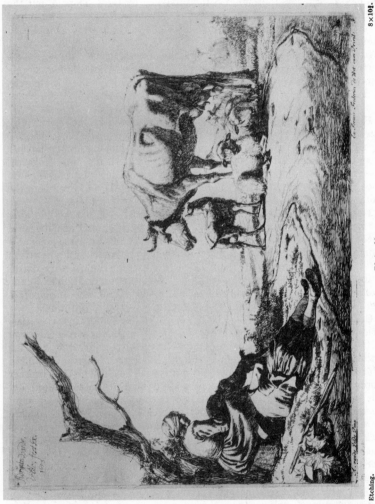

8 × 10¼.

Plate 40

TRAVELLERS RESTING. A VAN DE VELDE.

NOTE THE INTIMATE DRAUGHTSMANSHIP & THE LUMINOSITY OF THE SUNLIGHT.

From a proof in the British Museum.

187

of etching. They are wonderful in their truth and observation of accidental lighting.

G. B. Tiepolo (1696–1770).—Returning once more to Italy, we find, in the next century, real etchings being produced by G. B. Tiepolo, but the art has become weakened and prettyfied. Technically perfect and full of grace and charm, the prints do not move one in the least, accomplished though they are.

Canaletto (1697–1768).—Real feeling is expressed in the somewhat austere plates of that master painter, G. A. Canale, whose strong, simple line-work gives one intense pleasure, and may well have been the parent of much subsequent etching where brilliant effects of sunlight upon buildings has been the *motif*.

Hogarth (1697–1764).—In England the only etcher who merits any attention at this period is William Hogarth. He was one—the greatest—of a group of satirists and cartoonists who used etching amongst other mediums to express their comments on the life of their time. Hogarth, however, being a great portrait painter, produced a few plates of importance artistically, notably the "Lord Lovat" (**Plate 41**), but even here the work suggests the outlook of the engraver more than a little.

Piranesi (1720–1778).—Another Italian whose work has considerably influenced modern etchers is G. B. Piranesi. His actual architectural output as a whole is dull and lacking the insight of Canaletto ; but his outstanding performance with the needle is the imaginary series of prison torture-chambers known as the *Carceri* (**Plate 42**). Etched with extraordinary vigour and freedom, it is as much by their composition as by their treatment of line that the work of several moderns has been anticipated, e.g. Muirhead Bone's "Demolition of St. James's Hall" (interior).

G. D. Tiepolo (1727–1804).—The last of the Italians whose influence was, I think, probably very important is Domenico Tiepolo, the son of Giovanni Battista. He was born in Venice[1] and travelled considerably with his father and brother, producing his "Flight into Egypt" plates in 1753 in Würzburg. He arrived in Spain in 1761 with his father and brother Lorenzo, leaving for Venice again soon after the death of the older man. His work resembles that of his father in many ways, but is, in my opinion, far more powerful in its massing, and simpler in design. The blacks are bitten with great force, and though the delicacy of draughtsmanship is lacking, so is the prettyness or effeminacy which characterizes nearly all the father's work. I think it extremely probable that it was Domenico's work which influenced the young Goya so largely rather than that of the elder Tiepolo, as is usually supposed. His series of the "Flight into Egypt" (**Plate 43**) shows marked affinity with Goya's first known plate of the same subject, especially in the strong massing of the blacks. It is this plate which M. Loys Delteil says shows pre-Tiepolo characteristics. Pre-Battista, certainly ; but it has the very quality of a plate by Domenico.

[1] Mr. Hind says 1726 in Madrid, which could hardly be the case, as his father did not go to Spain till 1761 or 1762, and Madrid till 4th July, 1762.

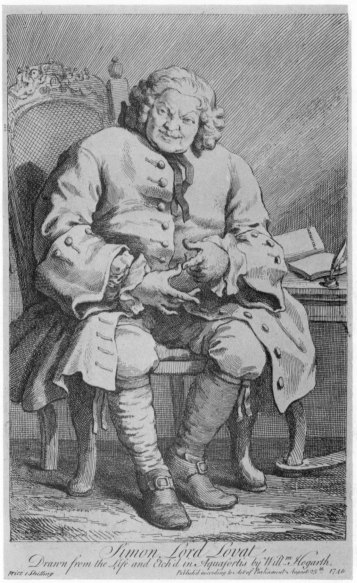

Simon, Lord Lovat.
Drawn from the Life and Etch'd in Aquafortis by Will^m Hogarth.
Price 1 Shilling Publish'd according to Act of Parliament. August 25^th 1746.

Etching. 13 × 8¼ *Etched Surface*

Plate 41

LORD LOVAT. HOGARTH.

ALTHOUGH ETCHED IN THE MANNER OF AN ENGRAVING THIS PLATE IS VERY EXPRESSIVE OF CHARACTER.

From a proof in the British Museum.

189

Etching.

Plate 42

ONE OF THE CARCERI SERIES. PIRANESI.

THIS SET OF IMAGINARY PRISONS & TORTURE CHAMBERS HAS HAD CONSIDERABLE INFLUENCE UPON THE WORK OF THE MODERNS.

From a proof in the British Museum.

16¼ × 21¼.

190

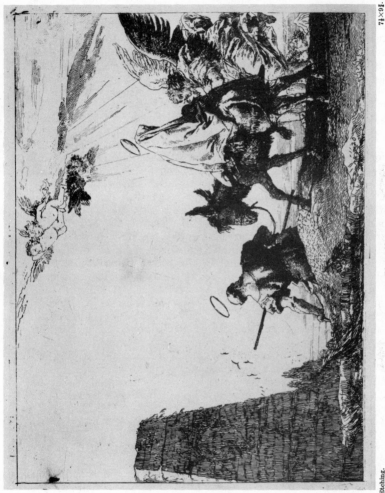

Etching.

7¼×9¼.

Plate 43

THE FLIGHT INTO EGYPT. G. D. TIEPOLO.

DOMENICO, THOUGH LESS KNOWN THAN HIS FATHER, SHOWED GREATER VITALITY & WAS PROBABLY THE REAL
INFLUENCE UPON THE YOUNG GOYA.

From a proof in the British Museum.

M. Delteil seems to forget that Goya might well have been in actual con-
tact with the Tiepolos before he left for Italy, so that, even if his supposi-
tion that Goya's first plate was executed before his journey be correct
(as is probable), it still does not affect the argument as to possible influence.
Goya went to Madrid first in 1763 or 1764, i.e. about two years after the
Italians' arrival ! (See Chapter XXII.)

The Runcimans : Alexander (1736-1785), John (1744-1768).—And now
we come to the beginnings of etching in Great Britain, where Hollar had
left a definite technical tradition which, however, seems to have been
merged into the art of the gravers once more. At any rate, the school
which, I hold, began with the men I am about to mention, had little in
common, either technically or artistically, with Hollar.

In Edinburgh were two brothers, Alexander and John Runciman, and
one of these produced (presumably in 1764) the notable " Nether-bow
port " **(Plate 44)**. I have found two proofs of this plate in the Scottish
National Gallery, both touched—the one with pen and the other with
wash—which bear no engraved signature ; but upon the former appear
what seem to be the initials A.R. upon the coat of arms over the gate-
way, in pen and ink ; while in the lower margin " J. Runciman " was
written in pencil, the J being subsequently altered to A.

In Bryan's " Dictionary of Painters " this plate is also attributed to
Alexander, of whom we know more than of his brother. He was the son
of an Edinburgh builder and architect, and was apprenticed to a painter,
John Norrie, at the age of fourteen. In 1766 both brothers went to Italy,
being sent by Sir James Clerk, of Penicuik, where in 1768, in Naples,
John died ; Alexander returning three years later.

Now there is a *second* etched plate done by a hack engraver (A. Cameron)
after the original under which is inscribed " drawn by John Runciman,"
and upon this it also states that the gate was demolished[1] in 1764, i.e.
two years before the Runcimans left for Italy. I have seen a number of
Alexander's etchings—all undated—which are of no artistic interest what-
ever, being carelessly drawn pseudo-classical scribbles, evidently inspired
by his Italian study. They have a certain vitality and freedom, but are
totally unlike the very deliberate and beautifully drawn figures in the
" Nether-bow Port."

There is very definite Callot influence in these figures ; and not only
this : the resemblance to Meryon's figures in the *Saint Etienne du Mont*
and *L'arche du Pont Notre Dame* is quite evident, showing, I can only
think, a common ancestry.

It is quite easy to imagine that the Runcimans may have had access
to Callot prints. We know that many foreign etchings were in Scotland
at that date (see p. 196), and as Callot was at the time one of the known
masters it is probable that his prints were amongst them. Scotland was
in very close touch with France—far closer just then than England—and
we have seen that Faithorne's book (probably the earliest on the subject

[1] In the etching it is shown in process of demolition.

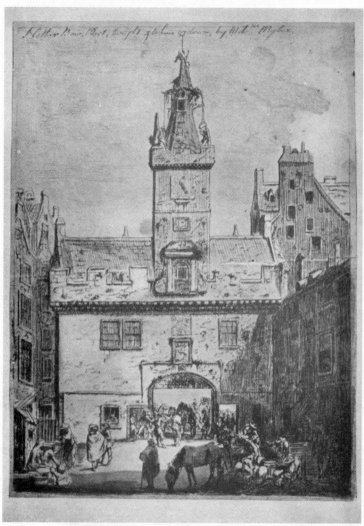

Etching. 8¼×6¼.

Plate 44
NETHER-BOW PORT, EDINBURGH, 1764. J. RUNCIMAN.
NOTE THE CALLOT FIGURES IN THIS EARLIEST OF SCOTS ETCHINGS OF REAL IMPORTANCE.
From a touched proof in the National Gallery of Scotland.

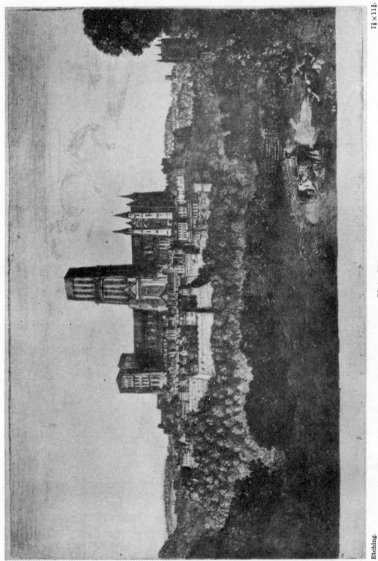

Etching. 7¼ × 11¼.

Plate 45

DURHAM. CLERK OF ELDIN.

FIRST STATE.

THIS MAGNIFICENT PLATE SHOWS HOW CLERK ANTICIPATED BOTH MERYON & BONE IN THE IMPRESSIVE DRAWING OF
ARCHITECTURE. CLAUDE & HOLLAR INFLUENCE IS EVIDENT.

From a proof in the collection of the author.

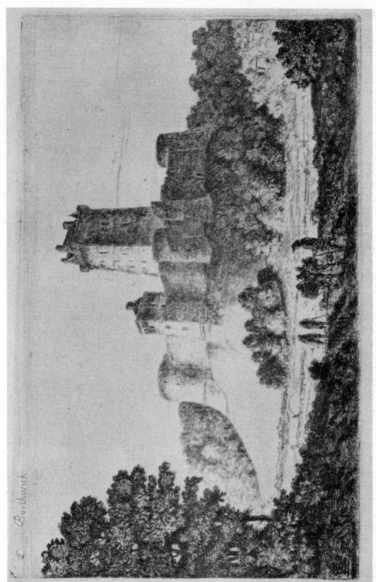

$4\frac{5}{16} \times 6\frac{3}{8}$.

Etching (Some Drypoint.)

Plate 46

BORTHWICK CASTLE. CLERK OF ELDIN.

THE CLAUDE INFLUENCE IS STILL STRONG, BUT THE ARTIST HAS DEVELOPED A STYLE OF HIS OWN.

From a proof in the collection of the author.

195

in this country) exalted Callot as worthy of all etchers' emulation. What more probable than that Runciman should model himself upon one of the best-known etchers at that time ?

Taking the known work of Alexander into account, together with the presumably contemporary attribution on the engraving, I am convinced that this fine plate was by his brother John,[1] who would have been twenty at the time. If so, Scotland lost a great etcher prematurely. There must be other equally good plates extant by John Runciman, as the certainty of technique makes it clear that he must have had considerable previous practice. In any case, I think that this plate, on its own merits, establishes a claim for Runciman as the first Scottish etcher (yet discovered) of any importance, and, in its scaffolding motif, anticipates both Meryon and the living Scotsmen.

Clerk of Eldin (1728-1812).—Another interesting Scot of this time was John Clerk, of Eldin, seventh son of Sir John (2nd Bart.) of Penicuik. He was brother to Alexander Runciman's patron, Sir James, and so may have known the Runcimans. Under some of his copies are written the names of Rembrandt, Weirotter and Claude ; men from three different countries. His original work proceeds from extreme amateurish bungling to very fine work indeed. There is a notably beautiful plate, which is probably one of the last executed by the artist, " Dalkeith from the North-West " **(Plate 48)**, splendidly designed and etched. It might well pass for a first state of Turner's *Liber Studiorum*. Another large and very personal plate, in spite of the strong Claude influence, is " Hill-head, near Lasswade" **(Plate 47)**. One sees Claude in the silhouette figures, but the arrangement and beautiful tree massing Clerk derived from his study of nature. It is not an Italianized scene. It is purely Scottish, and more than this, typically Lothian.

Paul Sandby (1725-1809) is said to have taught Clerk the technique of etching, and the influence of Hollar is plainly seen in such plates as the magnificent " Durham " **(Plate 45)** : not in the design, but the mannerism of describing distant tree-forms on a hillside (compare **Plate 34**). This is still more marked in many small plates in which Hollar's trick of inscribing the title in the sky is also imitated.

In his many seascapes Zeeman was obviously the model, and here again we have the silhouette figures derived (as in the case of Claude) from Callot. The first issue of Clerk's plates took place in 1825 to the members of the Bannatyne Club and consisted of only twenty-eight subjects. Later many of the smaller coppers were discovered by his son, Lord Eldin (whose mother was a younger sister of the famous Adam brothers), and a second book was issued by the Club in 1855 containing some eighty plates. They

[1] Since the above was written I have found a quite emphatic statement corroborating my view. This is in the " History of Art in Scotland," by R. Brydall, 1889, p. 165. The author here says that this plate was one of the few etched by John Runciman from his own pictures. The painting belonged to the Duke of Sutherland. Brydall deplores the loss to art in Runciman's early death.

are very crudely printed and give one no idea of the quality obtained from them by the artist. The " Durham," for instance, suffered greatly.

Clerk experimented with tone-biting and soft-ground ; but he did not understand the resin ground, apparently, and the attempt at aquatint was always a failure. He was also too fond of re-working both in etching and drypoint. His period of activity was extremely short—from 1770 to 1782—but in that time he executed at least 104 plates.

Many of these are quite small, but none the less beautiful and technically perfect.

Like Seymour Haden, he did not begin to etch till past his fortieth year ; he was an amateur, and he confined his work to subjects of the country he loved : and though hardly of the first rank—he was not a trained draughtsman—he showed the promise of what was coming in the next century, and his best plates are extraordinarily fine.[1]

Gainsborough (1727-1788).—The fame of Thomas Gainsborough as a painter has entirely overshadowed his very important work as an etcher. He is said to have executed only some twenty plates, the most vital of which are in soft-ground and aquatint. In their freedom, bold massing and subordination of detail they are totally unlike anything hitherto produced.

The actual dates of these plates is not known, but in all probability they were fairly mature works. We are told that he learnt his technique in London in his late teens—and no doubt the ordinary line etchings, which have no great merit, were produced early—but I should be surprised if the loosely handled aquatints were executed before the sixties. It seems probable that such a plate as the one reproduced (**Plate 48A**) was etched by means of a process now—I believe—no longer used. It is strictly analogous to the " pen method " (see Chapter XIII). When the ground has been laid the darks are painted with some mixture which is soluble in water. A coat of varnish is then spread over all and the plate immersed in water, which causes the parts so painted to come away, leaving the ground exposed for biting. In normal aquatint the *lighter* parts bear evidence of brushwork. In Gainsborough's case one can see that the *darks* show direct brushmarks. However they were done, these few works are extremely beautiful and place the artist as the pioneer of the true British landscape school.

[1] He had a curiously parallel etching career to that of Lord Aylesford, whose brilliant work in England has been described by Mr. Oppé in the " Print Collector's Quarterly " (October, 1924). Though born later (1751) the Earl began to etch in the same year as the Scot, and died in the same year. His plates are very beautiful.

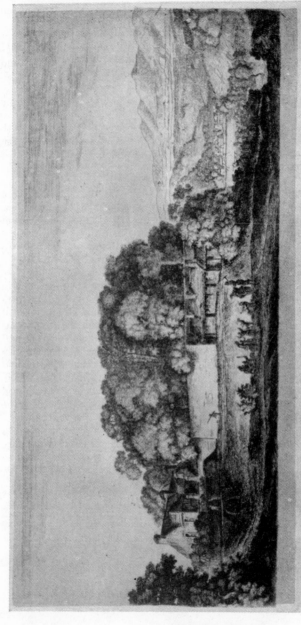

5⅞×12⅞

Etching.

Plate 47

HILL-HEAD, NEAR LASSWADE. CLERK OF ELDIN.

THIS BEAUTIFUL COMPOSITION OWES LITTLE TO CLAUDE—THE FIGURES EXCEPTED. IT IS TYPICAL OF THE LOTHIANS.

From a proof in the collection of the author.

198

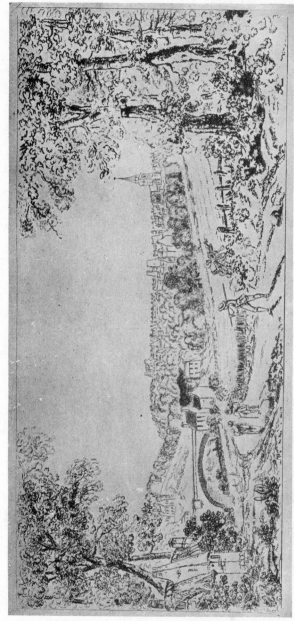

Etching.

5¼×11¼ *Etched Surface.*

Plate 48

DALKEITH FROM THE NORTH-WEST. CLERK OF ELDIN.

ONE OF THE FINEST & PROBABLY LATEST OF CLERK'S ETCHINGS. NOTE THE SUPERB (PRE-TURNER) DRAWING OF TREES.

From a proof in the collection of the author.

199

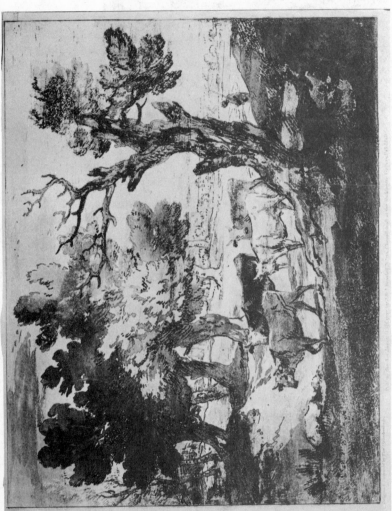

Soft Ground & Aquatint.

10¼×12¾ *Etched Surface.*

Plate 48A

DRIVEN CATTLE IN WOODED PASTURE. SECOND STATE. GAINSBOROUGH.

THIS BOLD, LOOSELY HANDLED PLATE IS, IN STYLE, NEARLY A HUNDRED YEARS AHEAD OF ITS PERIOD. IT MIGHT WELL BE BY ONE OF THE BARBIZON PAINTERS. GAINSBOROUGH, WHO EMPLOYED THE "PEN PROCESS" & SOFT GROUND, WAS ONE OF THE FIRST TO USE THE NEW "AQUATINTA," BUT HE DREW WITH IT RATHER THAN USED IT AS A TONE ADJUNCT TO LINE WORK.

From a proof in the British Museum.

CHAPTER XX

DÜRER AND LUCAS VAN LEYDEN

BEFORE continuing our survey into the nineteenth century we must return to look a little more fully into the work of a few of the supreme draughtsmen who happen to have expressed themselves with the bitten and drypoint line. Their work was only glanced at in the preceding chapter.

Firstly that of Albrecht Dürer.

Whoever actually *invented* etching, or working with the point on the bare metal, Dürer was an undoubted pioneer in both arts ; and to him will always belong the honour of being the first to produce really great works in both mediums.

Dürer was one of the men of " universal " genius concerning whose life (as in the cases of such as Rembrandt, Leonardo or Shakespeare) the smallest incidents have been the subject of controversy without end. I have no intention of trying my 'prentice hand at this game. It is an easy, a very dangerous and a most unprofitable one for the artist.

Dürer was one of the few men of his rank who have left authentic biographical details, and with them one cannot go far wrong. He was born in Nuremburg in 1471, the son of a Hungarian goldsmith immigrant who was for some years with the artists of the Netherlands before settling in Germany. His father therefore was obviously a man of wide knowledge in artistic matters, and the son had the advantage of learning his craft— the handling of the burin—while quite young. Later, Albrecht became apprenticed for three years to one Wolgemut.

The great engraver Schöngauer was never Dürer's master, but he certainly must have influenced him considerably. Jacopo de' Barbari was also a great influence on the young artist, and from him Dürer got the first hints for his " canon of proportion for the human figure," founded presumably upon the works of the great Greek sculptors. (As a model of what proportion in lettering should be, and for its grouping upon the page, could anything be more beautiful than the book of 1534 issued by his widow ?)

Without concerning ourselves with the disputed first journey to Venice, it is interesting to know that the artist did a considerable amount of travelling in his life, though always returning to Nuremburg. At least four years—from April, 1490, to May, 1494—were spent travelling : later he made a visit to Venice, and still later to the Low Countries, as well as working in other towns in Germany.

No matter to whom the honour of teaching him belongs, he was a born

draughtsman, and the extraordinary fidelity of his early self-portrait[1] when only thirteen years of age is truly astounding.

Being what he was, the greatest master of the burin (in my opinion) that the world has ever seen, it is quite natural that his few essays in the less known mediums of etching and drypoint should be strongly tinged with the spirit of that austere art. Freedom of line, as we understand it, was not Dürer's *affaire*, and whether or no he realized the *possibilities* of etching in that direction, he shows no sign of having done so. He laid his lines singly, firmly and deliberately, as was his manner in handling the graver, and as he employed no stopping-out, and presumably but one thickness of point, the comparatively flat effects this method obtained probably convinced him that etching as a medium was inferior to engraving either upon copper or upon wood. The small number of his bitten plates would seem to imply, at least, that this was the case.

Fine as the etchings and drypoints are, it goes against the instincts of an artist to separate them entirely from the whole of Dürer's noble series of engraved plates. Until I was asked to prepare this book I never thought of them in separate terms. Whether they are the work of the burin or the acid, or, as I sometimes suspect, of the two combined, does not seem important compared with the enjoyment and instruction obtainable by study of their composition—the splendid dignity of arrangement, balance, light and dark masses—and the intense feeling expressed in almost every one of them.

As split up they must be (since engraved plates do not come within our present scope), we find that both drypoints and etchings were looked upon by Dürer as requiring no very different treatment from engraving proper. This is less true of the three (or four) known drypoints, as the artist certainly made use of the burr, the distinctive characteristic of the medium, in that extraordinarily beautiful plate " St. Jerome " (**Plate 49**), wrought when its author was forty-one years of age.

All six of the bitten plates were of iron, and whether Dürer preferred this metal or simply used it because it was the tradition from the armourers to employ iron for working upon with acid, he produced magnificent results.

The first alleged drypoint (1510) is the " Saint Veronica with the Sudarium," of which only two proofs are known. After this come the " Man of Sorrows " and " St. Jerome " (1512), followed a little later by the " Holy Family." In 1515 were *etched* the second " Man of Sorrows " and " Christ in the Garden of Gethsemane " (**Plate 50**), and in the next year the " Angel with the Sudarium " and " Pluto and Proserpine." Undated is the so-called " Man in Despair," and last—his largest plate— " The Field-Serpent of Nuremburg," generally known as the Cannon, in 1518.

The most interesting thing to note in these etchings, from the technical point of view, is that, in them, Dürer shows what can be done by the simplest of all methods : the one drawing and biting-in without recourse

[1] I refer to a drawing—not a plate.

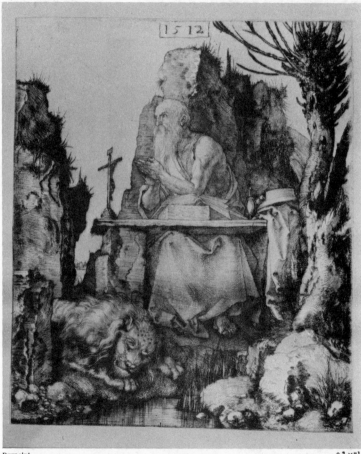

Drypoint. $8\frac{3}{16} \times 7\frac{1}{4}$.

Plate 49

SAINT JEROME. DÜRER.

UPON THE RARE OCCASIONS WHEN DÜRER WORKED IN DRYPOINT HE UTILIZED ITS DISTINCTIVE
QUALITY—THE BURR—WITH MAGNIFICENT EFFECT.

From a proof in the British Museum.

203

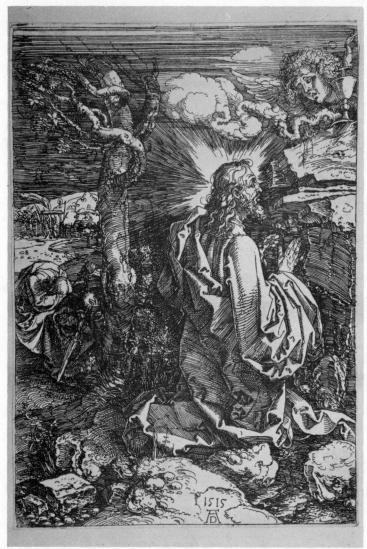

Etching. 8¾×6⅛

Plate 50

THE AGONY IN THE GARDEN. DÜRER.

DÜRER ETCHED UPON IRON & BIT ALL HIS LINES TO THE SAME DEPTH. THIS, THOUGH YIELDING A CERTAIN
FLATNESS OF EFFECT, DOES NOT DETRACT FROM THE WONDERFUL DESIGN & DRAUGHTSMANSHIP.

From a proof in the British Museum.

to stopping-out. If the reader will refer to Chapter II, he will realize that Dürer's work is the most remarkable illustration of what was meant when I wrote that great works of art *could* be produced with nothing more than the essentials : plate, ground, needle and acid. This apparently was the extent of his outfit ; and yet how many better-equipped etchers have made finer plates ?

The acids known in Dürer's time certainly included sulphuric and nitric, and for the actual mordant probably employed the student may refer to Chapter VI : Le Begue's MS.

The greatest engraver after Dürer who also used the bitten line at times was **Lucas van Leyden.** Unfortunately for our present purpose there is very little to be said of it, and still less seems to be known concerning himself. Many of his engravings are more or less etched, and I cannot help suspecting (by certain qualities of line) that Dürer himself used the acid upon his copper engravings. Those who have the leisure to study whatever trial proofs there may be in existence are in a better position to pronounce upon this point. We are on safer ground in affirming that Lucas was the first man of importance, in the North at least, to etch upon copper with no ulterior motive of engraving the bitten work. And this in itself forms a landmark in the survey of early etching, and shows Van Leyden as a pioneer in the art.

His sympathy with humanity and insight into human emotions are, I feel, as great as Dürer's own ; and his art is, in a way, a little less conscious. One can compare his magnificent " Adoration of the Magi " with Dürer's equally marvellous " Great Fortune " or " Melancholia," and wonder wherein lies the difference. They are all so intensely moving, and yet the work of the two men is so different ! But these are not etchings, and I have nothing to do with them here, except that, after all, both these men influenced countless etchers (including Rembrandt)[1] by work which was not etched ; and it is impossible to ignore their engraved plates merely because they were executed with a tool technically known as a *graver* instead of by means of a tool which equally graves the lines but which we choose to call a *drypoint*.

Of Lucas's etched plates the best known are " The Fool and the Girl," " St. Catherine " (**Plate 51**) and " David in Prayer." There is graver work in all, and it is extremely hazardous to offer a definite opinion on many passages. These early men drew with the *échoppe* (see Chapter V), and the result is a line which swells and tapers exactly like an engraved line even after it has been bitten-in.

On the other hand, there is a certain flatness in the whole effect of some plates which immediately suggests the acid without stopping-out ; while there are passages of tone upon the unworked parts of " The Fool and the Girl " which look very like foul-biting. Again, certain lines are hooked at their extremities, which is not a characteristic of the burin

[1] It is on record that Rembrandt strained his resources to the limit in order to procure a set of Lucas's prints.

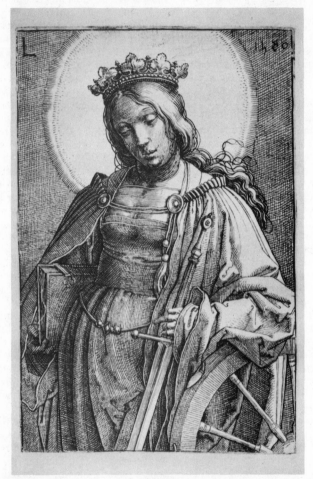

Etching & Graver. 4¼ × 3.

Plate 51

SAINT CATHERINE. LUCAS VAN LEYDEN.

LUCAS WAS PROBABLY THE FIRST NORTHERNER TO ETCH ON COPPER, BUT HIS LINE WAS STILL
THAT OF THE BURIN-WORKER. THE ADDITIONAL GRAVER LINES, THEREFORE, COMBINE PERFECTLY
WITH THE ETCHED WORK.

From a proof in the British Museum.

stroke, but is almost inevitable in drawing upon wax freely with a point.

I am inclined to think that the greater part of the Maximilian portrait —one of the finest plates—is etched ; parts being strengthened with the burin, and parts, such as the modelling of the cheek-bone, being *directly* graved. Here again many an individual line under the magnifying glass suggests engraving because of its pre-biting character, i.e. Lucas pressed much more heavily in the middle of the stroke and lifted his point with a flick upwards as if he were still employing his cutting tool. It is this habit—common to practically all the etchers till Rembrandt's time, and still advocated in the English eighteenth-century textbooks—which is so deceptive, especially when judging a proof which has been mishandled or one from a worn plate. From the nature of the *échoppe* it was easy, by turning it in the fingers during the stroke, to lay a line which began or ended (or both) in a fine point, but swelled out in the centre, thus counterfeiting that of the burin.

CHAPTER XXI

REMBRANDT AND VAN DYCK

FROM the death of Dürer, the greatest engraver, to the birth of Rembrandt, the greatest etcher the world has yet seen, we pass over nearly eighty years—from the sixteenth to the seventeenth century.

Van Dyck, it is true, was born a few years in advance of his greater contemporary, yet his art is so limited in comparison, that the Dutchman must come first.

Rembrandt (1606–1669).—Rembrandt Harmensz van Rijn was born at Leyden on July 15th, 1606, his father being a miller of that town.

There is no need to go into details of his life, as the books on the subject are legion, and we are here only concerned with his work upon the copper.

Like most of the greatest figures in the world's history, Rembrandt, except in his art, was apparently a perfectly normal individual. He was typical of his time and of his country : he was no recluse, no saint, no star-gazer, no self-satisfied egoist, no madman. He loved his work in particular, but he loved art in general and collected it in all forms, whenever possible. He loved the things of this world and painted them with a gusto which has never been excelled ; but he understood also the things of the spirit, and expressed them in such plates as " Christ Healing the Sick " in a manner which few have ever equalled.

I have already written (in Chapter XVIII) on the subject of his intense interest in life in all forms, and in humanity in particular. If to this is added an amazing executive skill and a prodigious aptitude for hard work, all the requisites for producing the greatest art are combined in his person.

The emotions that he felt from whatever life brought to him—and they were deep—joy and sorrow, exultation and dejection, this great man expressed in a continuous stream of noble paintings, drawings and etchings.

At the very outset he was successful with the public, but the more deeply he saw into character, and the more truly he expressed what he saw, the less was he appreciated ; so that, at the end, he died deeply in debt—an indebtedness partly brought about, it is true, by his extravagant collecting of pictures and *objets d'art*—largely because he was too great for his time.

So much has been written in praise of Rembrandt by so many far abler writers than I, that there is no need for me to say more than that I fully endorse all but that extravagant praise which endeavours to make of one of the most human—and consequently most lovable—personalities the world has produced in historical times, a god whom no man may love, but only worship.

I remember when I was once criticizing one of Rembrandt's bad plates

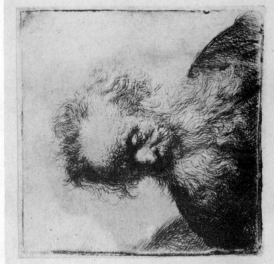

Etching. H. 1. $2\frac{8}{8} \times 2\frac{1}{4}$.

THE ARTIST'S MOTHER. REMBRANDT.

Etching. H. 48. $2\frac{8}{8} \times 2\frac{9}{16}$.

OLD MAN WITH A BEARD. REMBRANDT.

Plate 52

THESE PLATES, DATED 1628 & 1631, SHOW WHAT ASTONISHING DRAUGHTSMANSHIP & TECHNICAL SKILL WITH THE NEEDLE REMBRANDT HAD DEVELOPED IN HIS EARLY TWENTIES,

From proofs in the British Museum.

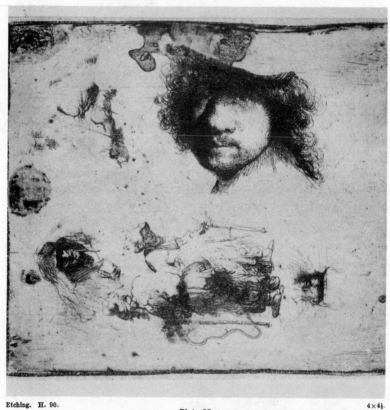

Etching. H. 90.

4×4¼.

Plate 53

SELF PORTRAIT & OTHER NOTES. REMBRANDT.

SHOWING HIS CONTINUAL STUDY OF CHARACTER.

From a proof in the British Museum.

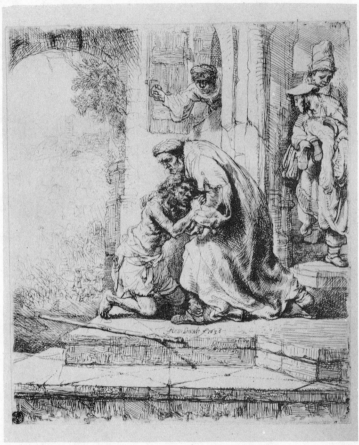

Etching. H. 147.

6¼×5¼.

Plate 54
THE RETURN OF THE PRODIGAL SON. REMBRANDT.
ONE OF THE MOST PERFECT COMPOSITIONS EXECUTED WITH THE PURE BITTEN LINE.
From a proof in the British Museum.

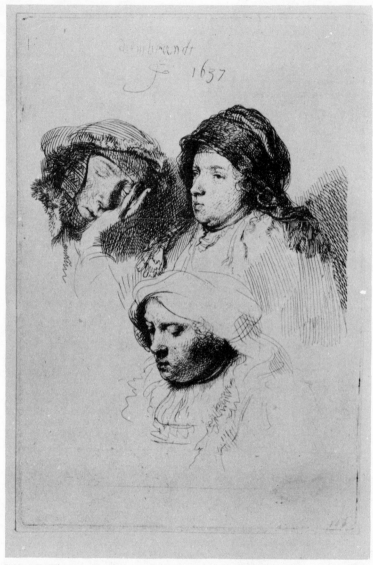

Etching. H. 152. 5½ × 3¾.

Plate 55
THREE HEADS OF WOMEN, ONE ASLEEP. Rembrandt.
Note how the treatment of the sleeping woman suggests that of the young Whistler
From a proof in the British Museum.

212

(if it is indeed by him) in the company of one of our official experts, how, with stern reproof, he remarked, " It is sufficient for us to know that Rembrandt did a thing, and therefore had good reason for doing it."

Such an attitude—and we have seen so much of it in Whistler's case—can only do harm by making the object of worship appear ridiculous. It is surely common knowledge that the supremacy attained by a man at his best does not make it impossible for him to produce bad work when at his worst. And Rembrandt was a man ; not a god.

The critics have laid it down that the etched work may be roughly divided into three periods. First : pure etching ; second : etching and drypoint ; third : pure drypoint. Like most arbitrary classifications, this is anything but accurate, but there is just sufficient truth in it to make it appear plausible.

The verdict that the work became finer and finer till the end is still more questionable. That his art in general—his painting and drawing—went on expanding till his death I unhesitatingly admit : the latest work in oils is unquestionably the greatest ; but not so in etching. In all probability this was very largely a matter of eyesight, but partly due to the fact that few old men can take much delight in processes and the overcoming of their peculiar difficulties. Therefore Rembrandt was often inclined to take up the drypoint when the etching-needle would have probably served his purpose better.

That the man's breadth of outlook continued to increase we are sure, and in certain plates—notably the " Three Crosses "—this almost overbalances the scale weighed down on its technical side by clumsy draughtsmanship and handling. It may be said to equalize matters, perhaps ; though I think no plate which is faulty in drawing and indifferent in execution can claim a supreme place upon the merits of its composition and nobility of *intention* alone.

The loftiness of conception reached in the fourth state of this plate (**Plate 71**) is quite awe-inspiring, yet how far short the execution falls in comparison with that of the " Christ Healing the Sick " (**Plate 66**).

That this Crucifixion and the magnificent " Christ presented to the People " (**Plate 76**) have been so hostilely criticized by the followers of Whistler only shows how amazingly narrow the vision of men working along one groove may become.

To return to Rembrandt's early work : the first plate in the Hind Catalogue—the little head supposed to be of his mother—is one of the most perfect expressions of character in the whole *œuvre* (see **Plate 52**), and in this its author—then only twenty-two—showed a marvellous sureness and freedom of line in one, not only very young, but who had had no access to work of similar vitality (in the medium), bequeathed to him by his forerunners.

In the two later portraits—" La mère au voile noir " (H 52), and particularly in the profile figure (H 51)—this deliberate, careful, yet free modelling was carried further on a larger scale, and they remain for ever

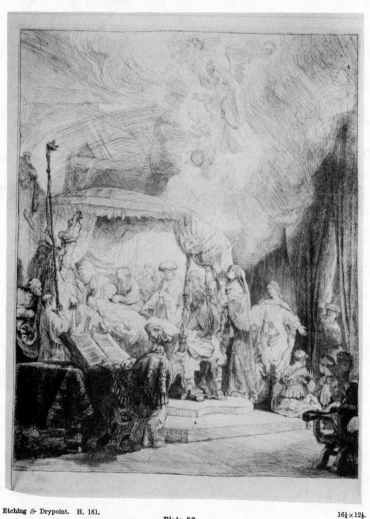

Plate 56

THE DEATH OF THE VIRGIN. REMBRANDT.

THE BEGINNING OF THE USE OF DRYPOINT AS AN ADJUNCT.

From a proof in the British Museum.

16¼ × 12¼.

214

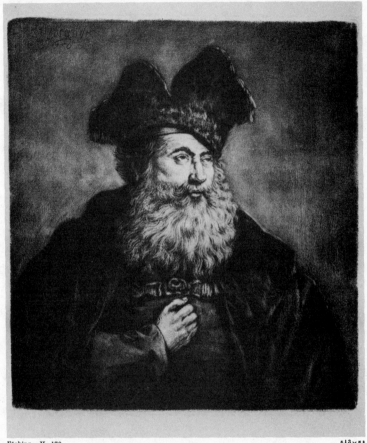

Etching. H. 170. 5⅛×5¼

Plate 57
MAN WITH A DIVIDED CAP. REMBRANDT.
ONE OF THE MOST INTIMATE, & AT THE SAME TIME, PERFECTLY BITTEN OF ALL THE PORTRAITS.
From a proof in the British Museum

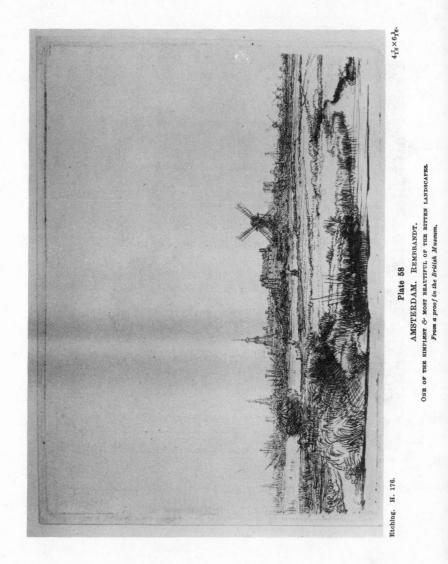

Etching. H. 176.

$4\frac{7}{10} \times 6\frac{1}{10}$.

Plate 58

AMSTERDAM. REMBRANDT.

ONE OF THE SIMPLEST & MOST BEAUTIFUL OF THE BITTEN LANDSCAPES.

From a proof in the British Museum.

216

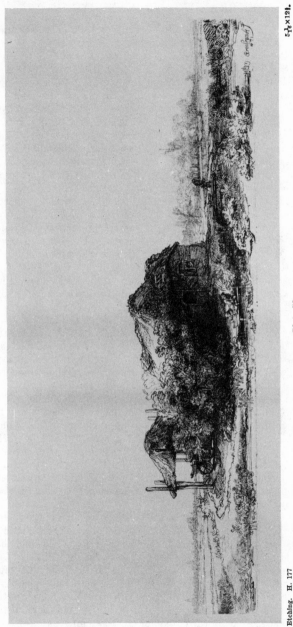

Etching. H. 177.

$5\frac{1}{16} \times 12\frac{1}{2}$.

Plate 59

COTTAGE & HAYBARN. REMBRANDT.

IN THIS & SIMILAR PLATES THE GREAT DUTCHMAN SET AN EXAMPLE WHICH HAS BEEN FOLLOWED EVER SINCE.

From a proof in the British Museum.

217

masterpieces of portraiture, in spite of the fact that H 52 was marred
in arrangement by the unfortunate addition of the table.

Five years later (1636) comes that eloquent rendering of "The Return of
the Prodigal Son"—perfect in composition and exquisite in line (**Plate 54**).

The year after produced the "Three Heads" (H 152), a plate which
in its first state—the single head of Saskia leaning on her hand—fore-
shadows so much modern work ; and then, after a further two years, came
the supreme work of this period, "The Death of the Virgin," in which
we find the beginning of Rembrandt's reliance upon drypoint as an adjunct
to his bitten line. It is one of the great masterworks (**Plate 56**).

After 1640 we find landscape taking a much more important place in
Rembrandt's work : the wonderful pure line of the "Amsterdam"
(**Plate 58**) and "Windmill," followed soon by the "Three Trees," and
then by a little plate which, in spite of all that has been written in its
dispraise, is most notable for its *placing*, "Six's Bridge."

At the same time as the "Amsterdam," was wrought that most exquisite
piece of draughtsmanship and intimate portrait "The Man with Divided
Cap" (**Plate 57**), than which I can imagine no purer example of bitten line,
and a few years later were etched "The Raising of Lazarus" and "Christ
Carried to the Tomb" (**Plate 62**), in the same clean, simple line. In my
own estimation such plates as these are quite unsurpassed by anything
Rembrandt did later (or by any other artist since), and so far as I remember
there is not a stroke of drypoint in any one of them.

In 1643 the master threw off one of his "suggestions" to the artists
of the future (see Chapter XVIII), none the less notable because a "side-
track." This was "The Hog" (**Plate 61**), an extraordinary piece of search-
ing realism, which has influenced countless animal draughtsmen from
van Ostade to Blampied.

Then, in 1647, we have the first astonishing example of delicate close-
etching and drypoint carried to its utmost limit—so far that it well-nigh
becomes mezzotint—in "Jan Six" standing reading at the window
(**Plate 63**). This is an amazing piece of craftsmanship, but as a work of
art it is (to me) infinitely lower in the scale than the immediately preceding
pure etchings. Then comes the portrait of himself drawing at a window
(1648), a wonderfully searching character study, but technically uninter-
esting. It suggests hesitation between the manner of the "Jan Six" and
a return to simpler methods (**Plate 64**).

1650 was a noted year among years which were all notable. In it
Rembrandt achieved two works—one a very small "side-track," and the
other the greatest (I think) of his black-and-white career—which have
formed models for emulation ever since : the "Shell" (**Plate 67**) and
"Christ Healing the Sick" (**Plate 66**). This last is surely a culmination
of the master's technical development, a masterpiece of masterpieces, and
in it he employs all the methods of etching, from the strong, simple outline
of the group to the left of Christ, to the most subtle gradations of tone
in the shadows suggested by the closest of cross-hatching.

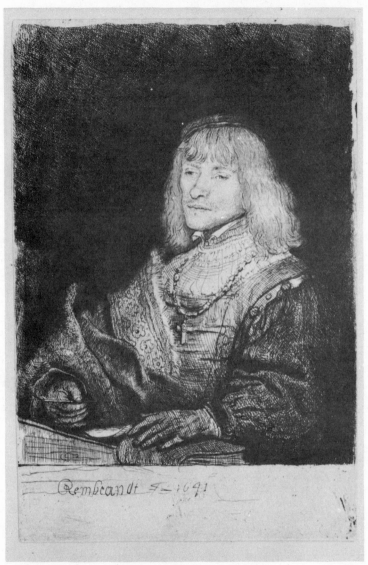

Etching. H. 189.

6 1/16 × 4.

Plate 60

YOUNG MAN AT A DESK. REMBRANDT.

THIS IS ONE OF THE PLATES IN WHICH THE MASTER'S POWER OF CHARACTERIZATION IS SHOWN AT ITS HIGHEST, BUT IN
WHICH THE TECHNIQUE IS BY NO MEANS PERFECT, ESPECIALLY IN THE LOWER HALF.

From a proof in the British Museum.

219

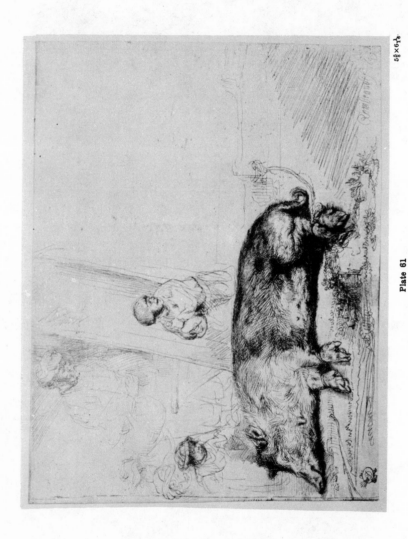

Plate 61

THE HOG. REMBRANDT.

An example of what I have described as one of Rembrandt's "side traits." Its delicacy was very cautiously...

5⅝ × 6¼.

220

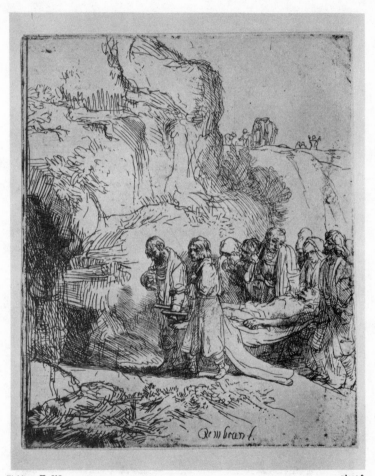

Etching. H. 215. 5⅛ × 4¹⁵⁄₁₆.

Plate 62
CHRIST CARRIED TO THE TOMB. REMBRANDT.

THE INFLUENCE OF THIS PERFECT PLATE IS SEEN TO-DAY MOST EASILY IN THE WORK OF BAUER & FORAIN.

From a proof in the British Museum.

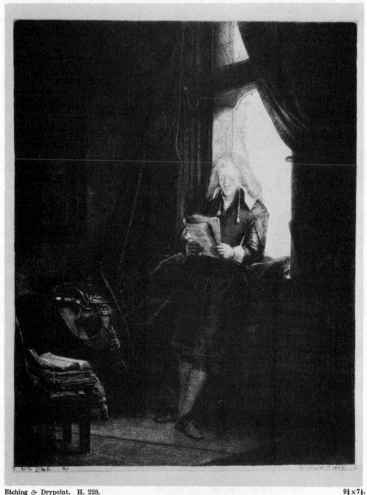

Etching & Drypoint. H. 228.

9¼×7¼.

Plate 63

JAN SIX. REMBRANDT.

The close drypoint work over etching, here, almost produces the quality of mezzotint; it has had many imitators, but is hardly one of the artist's great plates.

From a proof in the British Museum.

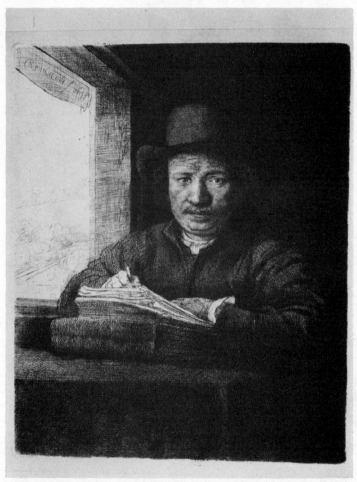

Etching & Drypoint. H. 229. 6⅝×5⅛

Plate 64

SELF PORTRAIT AT A WINDOW. REMBRANDT.

THIS TYPE OF PLATE HAS ALSO INFLUENCED MANY. IT HAS EXTRAORDINARY FIDELITY WITHOUT BEING
TECHNICALLY NOTABLE.

From a proof in the British Museum.

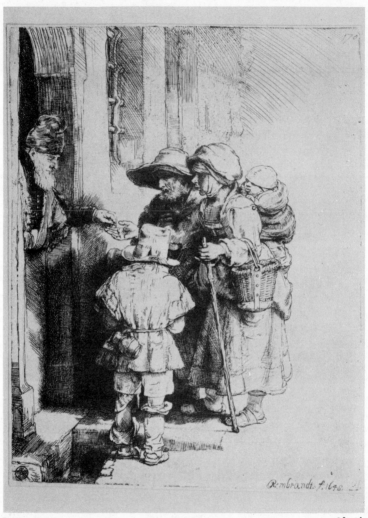

Etching. H. 233.

$6\frac{7}{8} \times 5\frac{1}{8}$.

Plate 65

BEGGARS. REMBRANDT.

THIS, NOT A GREAT PLATE, IS SHOWN FOR THE SAKE OF ITS INFLUENCE ON THE WORK OF SEVERAL LATER MEN
NOTABLY BEGA, MILLET, & STRANG

From a proof in the British Museum.

In the year following there was once more a return to the pure, open, bitten line in the plate which even Whistler praised to the point of exaggeration, " Clement de Jonghe " (**Plate 69**), and immediately after we find Rembrandt working out his most important " side-track " in the drypoint landscapes which have been the prototypes for countless moderns ; the "Landscape with Trees, Farm-buildings and Tower " (" Landscape with ruined Tower," Wedmore describes it) being one of the finest. The " Gold-weighers' Field " (**Plate 68**) is perhaps the best known of all these.

Then in the one year (1654) come the simply etched " Christ at Emmaus " (**Plate 75**) : a very perfect plate ; the " Entombment " (**Plates 73 and 74**) and " Descent from the Cross " (**Plate 72**), in both of which the artist carries further his experiments in leaving ink upon the surface in printing instead of carrying out the work in line (a method disastrous in its effect upon modern printers), by which he obtained some very beautiful and mysterious results. The same may be said of the "Adoration of the Shepherds," where the lantern alone approaches the colour of the paper (**Plate 70**).

Only two years later, however, Rembrandt returned to the close, careful, searching work of the " Lutma " and " Tholinx " portraits, the latter being one of his most perfect examples of fully realized drypoint over etching.

The use of free, slashing drypoint had culminated the previous year (as we noted at the beginning) in the great plates " The Three Crosses " (**Plate 71**) and " Christ presented to the People," 1655 (**Plate 76**), and after these and the portraits just mentioned there are few plates of importance.

As far as we know Rembrandt did no etchings during the last eight years of his life. Quite probably he found the medium too severe a tax upon his eyesight. The last known plate (and one of his best nudes) is " The Woman with an Arrow," 1661 (**Plate 77**).

Influence on Successors.—I append a list of some typical plates showing how vast a field was covered by this great man, and how even his " side-tracks " have suggested fields for exploitation to almost every etcher who came after.

I do not pretend, of course, that this includes nearly all the best prints ; neither do I suggest, for a moment, that the men whose names I have coupled with individual etchings plagiarized those works. In many cases I have no doubt they never even saw them. But their tradition was passed on and picked up here and there—no more than a hint sufficing, perhaps— where the genius of the successor was ready to receive and exploit it.

It should be understood that in selecting so small a proportion of Rembrandt's work it is only possible to suggest general influences, and the numbers being taken from a total of thirty-one, the words " or similar work " are implied in every case.

The chart which follows is divided into half-century periods from the first known print to the present day ; and in it there is no attempt to compile either a complete list of even the important etchers, or to indicate

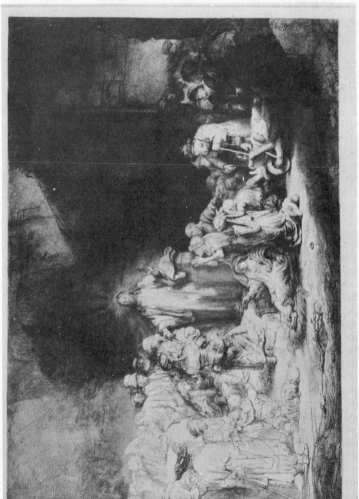

Etching & Drypoint. H. 236 ii. $10\frac{7}{16} \times 15\frac{5}{16}$

Plate 66

CHRIST HEALING THE SICK. REMBRANDT.

THIS IS OFTEN, WITH REASON, CONSIDERED THE MASTER'S GREATEST PLATE. IN COMPOSITION, CHARACTERIZATION & TECHNICAL
RESOURCE IT HAS NO RIVAL.

From a proof in the British Museum.

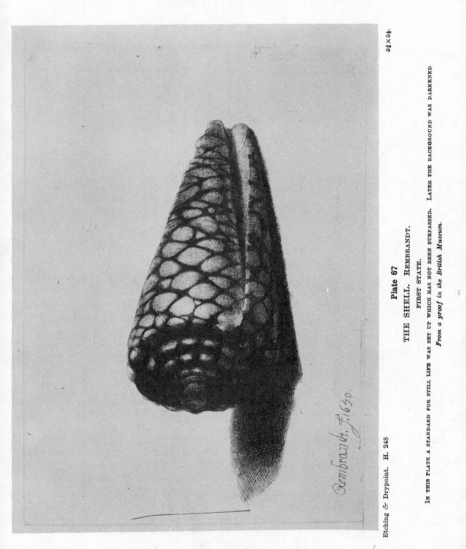

Rembrandt f. 1650.

Etching & Drypoint. H. 248

3¼×5¼.

Plate 67

THE SHELL. REMBRANDT.

FIRST STATE.

IN THIS PLATE A STANDARD FOR STILL LIFE WAS SET UP WHICH HAS NOT BEEN SURPASSED. LATER THE BACKGROUND WAS DARKENED

From a proof in the British Museum.

227

4¼×12¾

Plate 68

THE GOLDWEIGHERS' FIELD. REMBRANDT.

HERE WE HAVE ANOTHER & TOTALLY DIFFERENT TREATMENT OF LANDSCAPE, THE INFLUENCE OF WHICH HAS BEEN FELT FROM GEDDES TO LEGROS & BONE.

From a proof in the British Museum.

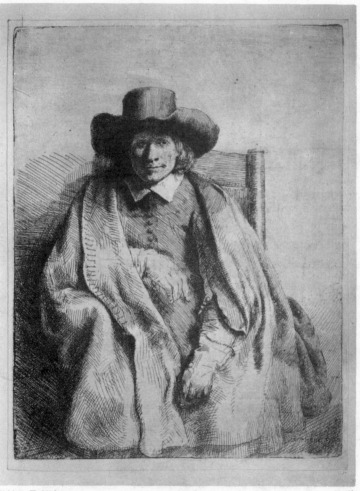

Plate 69
CLEMENT DE JONGHE. REMBRANDT.
THIS PORTRAIT HAS BEEN UNIVERSALLY ADMIRED, NOTABLY BY WHISTLER.
From a proof in the British Museum.

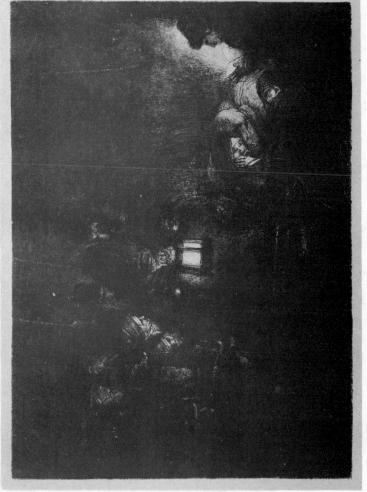

Etching. H. 255 iv.

5¼×6¼.

Plate 70

THE ADORATION OF THE SHEPHERDS. REMBRANDT.

THIS REPRESENTS STILL ANOTHER PHASE OF THE ARTIST'S GENIUS. IT MUST HAVE GREATLY INFLUENCED THE MODERN
PIONEER, JACQUE, & THROUGH HIM WHISTLER.

From a proof in the British Museum

230

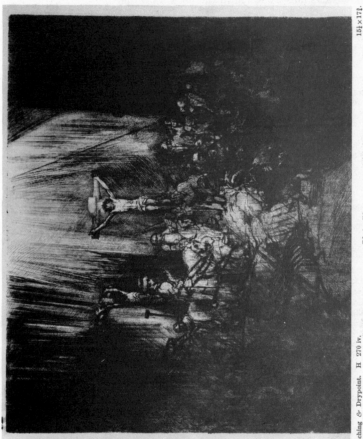

Etching & Drypoint. H 270 iv. 15¼×17¾.

Plate 71

THE THREE CROSSES. REMBRANDT.

In this final state of a plate several times revolutionized by means of the drypoint, Rembrandt was still searching for means to express his great conception But with all its faults of detail it remains one of his supreme utterances.

From a proof in the British Museum.

231

more than a few of the more obvious cross-influences. The names are placed in the positions corresponding to the period of the individual's important work, or rather its beginning, *not* corresponding to the date of birth, which in a few cases reverses the order, e.g. the relative positions of Bauer and Forain. Although Forain was born before Bauer, his significant plates only appeared in the present century.

TABLE SHOWING REMBRANDT'S GREAT RANGE, AND HIS
INFLUENCE ON SUCCEEDING ETCHERS.

(Nearly all the Rembrandts are here illustrated.)

1. Portrait of his Mother	H 1	1628	Bauer, 9, 15, 19, 27, 29
2. Old Man with a Beard	H 48	1631	Bega, 2, 4, 8, 16, 17, 18
3. Mother in Profile	H 51	1631	Blampied, 1, 2, 6, 7, 13, 14
4. Self-portrait	H 90	1632	Bone, 10, 11, 16, 17, 20, 22
5. Prodigal Son	H 147	1636	Bracquemond, 13, 21
6. Three Heads	H 152	1637	Brangwyn, 5, 18, 25, 26, 29
7. Death of the Virgin	H 161	1639	Cameron, 10, 11, 20, 22
8. Man with Divided Cap	H 170	1640	Castiglione, 2, 4, 6, 8
9. Triumph of Mordecai	H 172 c. 1640		Crome, 11, 20. Also " The Three Trees "
10. Amsterdam	H 176	1640	(through Ruysdael)
11. Landscape with Cottage and Haybarn	H 177		Forain, 15, 19, 25, 27, 29
12. Man at Desk wearing Cross	H 189	1641	Geddes, 1, 2, 3, 4, 11, 16, 20, 22
			Goya, through the Tiepolos
13. The Hog	H 204	1643	Haden, 10, 11, 14, 17, 20, 22
Also the Sleeping Dog	H 174 c. 1640		
14. Six's Bridge	H 209	1645	Jacque, 1, 2, 6, 13, 20, 24
15. Christ Carried to the Tomb	H 215	1645	Jacquemart, 21
			du Jardin, 13, 20
16 Jan Six	H 228	1647	John, 1, 2, 3, 4, 5, 6, 8, 12
17. Rembrandt Drawing	H 229	1648	Jongkind, 14
18. Beggars	H 233	1648	Legros, 5, 7, 10, 11, 12, 18, 19, 20, 22, 30
19. Christ Healing the Sick	H 236	1649	
20. Landscape with Trees and Farm-buildings	H 244	1650	McBey, 10, 11, 14, 15, 20
21. The Shell	H 248	1650	van Ostade, 13, 16, 17, 18
22. The Goldweighers' Field	H 249	1651	Potter, 13
23. Clement de Jonghe	H 251	1651	Strang, 4, 5, 11, 15, 17, 18, 19, 22, 28, 30
24. Adoration of Shepherds	H 255	1652	Tiepolo, G. B. and G. D., 2, 13, 18
25. The Three Crosses	H 270	1653	van de Velde (Adriaen), 13
26. Descent from Cross	H 280	1654	Whistler, 1, 2, 3, 4, 6, 8, 10, 12, 13, 14, 21, 23
27. The Entombment	H 281	1654	
28. Christ at Emmaus	H 282	1654	Zorn, 23, 30
29. Christ presented to the People	H 291	1655	
30. Woman with an Arrow	H 303	1661	

H refers to Mr. A. M. Hind's catalogue. The numbers after the names in the right-hand column refer to the Rembrandts (1–30). These figures are merely approximate, and with a larger selection of Rembrandts the student can easily find still closer affinities. I refer always to the *treatment* rather than to the *subject*.

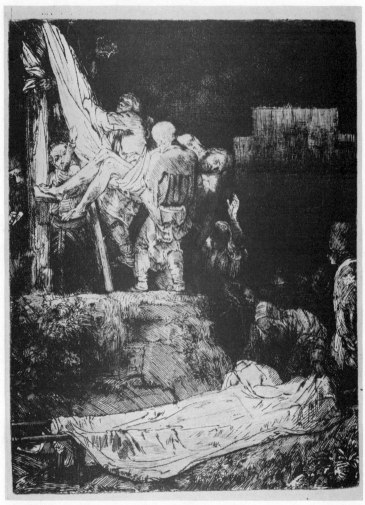

Etching. H. 280. 8¼×6⁵⁄₁₆.

Plate 72

THE DESCENT FROM THE CROSS. Rembrandt.

One of the most wonderfully arranged & drawn of all etchings. Note the balance obtained by the empty bier without detraction of interest from the drama above.

From a proof in the British Museum.

233

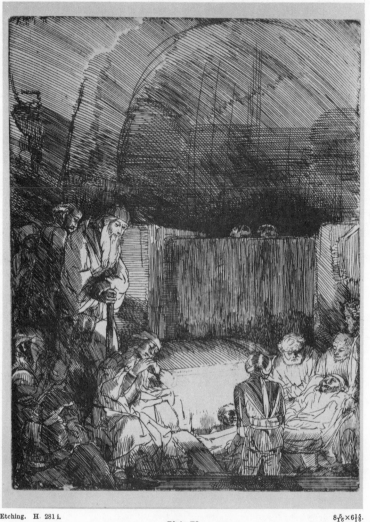

Etching. H. 281 i.

Plate 73

THE ENTOMBMENT. Rembrandt.

FIRST STATE.

Although there is considerable additional line work, the great difference

From proofs in the

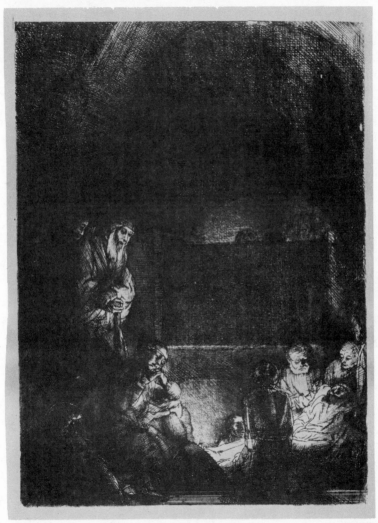

Etching. H. 281. $8\frac{A}{16} \times 6\frac{1}{8}$.

Plate 74

THE ENTOMBMENT. Rembrandt.

FINAL STATE.

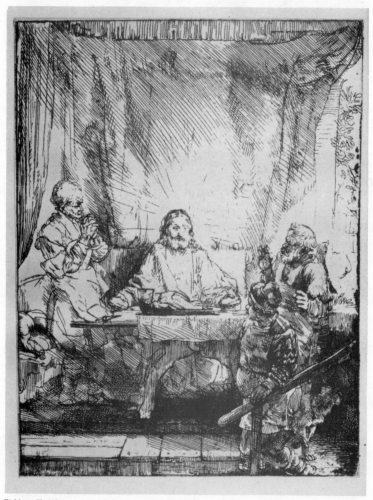

Plate 75

CHRIST AT EMMAUS. REMBRANDT.

SHOWING HOW REMBRANDT RETURNED TO CLEAN BITTEN LINE FOR SOME OF HIS FINEST LATER PLATES

From a proof in the British Museum

Etching & Drypoint. H. 271 ii.

14×17¼.

Plate 76

CHRIST PRESENTED TO THE PEOPLE. REMBRANDT.

ANOTHER DESIGN WHICH WAS NOT SUFFICIENTLY WORKED OUT BEFORE-HAND. WHEN, LATER, THE FOREGROUND GROUP WAS ERASED, THE COMPOSITION BECAME TOO SYMMETRICAL, THOUGH GAINING SIMPLICITY. (NEVERTHELESS, INTERESTING IN BOTH STATES.)

From a proof in the British Museum.

237

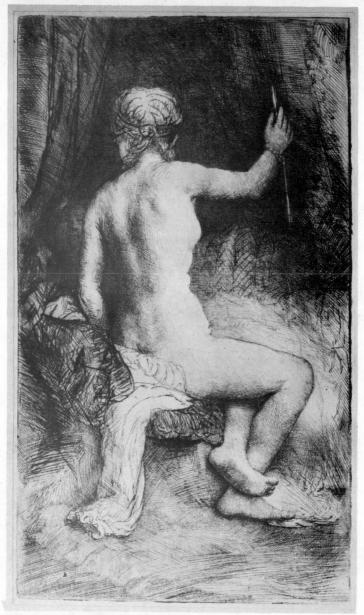

Etching & Drypoint. H. 303 i.

Plate 77
WOMAN WITH AN ARROW. REMBRANDT.

THERE IS BREADTH OF VISION HERE, BUT TECHNICAL DETERIORATION ; POSSIBLY A MATTER OF EYESIGHT.
IT IS THE LAST KNOWN PLATE

From a proof in the British Museum.

238

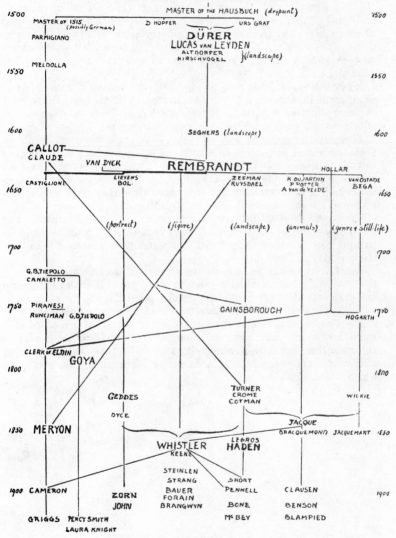

CHART

GERMAN AND ITALIAN LINE-ENGRAVERS

| 1500 | | MASTER OF THE HAUSBUCH (drypoint) | | 1500 |

MASTER OF 1515 (possibly German) D HOPFER URS GRAF

PARMIGIANO

DÜRER
LUCAS van LEYDEN
ALTDORFER
HIRSCHVOGEL } (landscape)

1550 MELDOLLA 1550

1600 SEGHERS (landscape) 1600

CALLOT
CLAUDE
VAN DYCK **REMBRANDT** HOLLAR
CASTIGLIONE LIEVENS ZEEMAN K OUJARDIN VAN OSTADE
BOL. RUYSDAEL P POTTER BEGA
1650 A van de VELDE 1650

(portrait) (figure) (landscape) (animals) (genre & still-life)

1700 1700

G.B.TIEPOLO
CANALETTO

1750 PIRANESI GAINSBOROUGH 1750
RUNCIMAN G.D.TIEPOLO
HOGARTH

CLERK of ELDIN
1800 **GOYA** 1800

TURNER
GEDDES CROME WILKIE
DYCE COTMAN

1850 **MERYON** JACQUE 1850
BRACQUEMOND JACQUEMART

WHISTLER LEGROS
KEENE **HADEN**

STEINLEN
STRANG SHORT
1900 CAMERON ZORN BAUER PENNELL CLAUSEN 1900
JOHN FORAIN BONE BENSON
BRANGWYN McBEY BLAMPIED

GRIGGS PERCY SMITH
LAURA KNIGHT

Plate 78

THIS CHART SERVES A DUAL PURPOSE. IT ENABLES THE STUDENT TO FIND AT ONCE THE PERIODS OF MOST OF THE IMPORTANT ETCHERS. IT SHOWS HOW WIDESPREAD IS THE INFLUENCE OF REMBRANDT. VERY FEW CROSS-INFLUENCES ARE INDICATED.

239

Van Dyck (1599–1641).—Of Sir Anthony van Dyck there is much less to be written. He was essentially a man who said one thing only, but that wonderfully well. He etched little more than a score of portraits, and most of these were afterwards worked over with the burin in part or altogether. Mr. Hind says that probably all, or nearly all, were produced during the six years between his return from Italy to his native city—Antwerp—and his settling in England as court painter, i.e. between 1626 and 1632.

When the student has seen one head by the master there is no great need, as in Rembrandt's case, to go on looking at the rest. Some may prefer one particular portrait, but it is much more likely to be the subject which appeals than any great difference of treatment.

To study the prints as Van Dyck left them, it is necessary to obtain them in the first, or at least an early state, before the hack engraver filled in the accessories and ruined everything. Until the nineteenth century these splendid, simply stated, magnificently drawn plates were not considered of any importance, but since that time they have exercised a profound influence upon the modern portraitists.

There is little of subtlety in the expression of the deeper character of his sitters—men of importance all—but it is entirely probable that his patrons were far more pleased with the portraits as likenesses than were the majority of Rembrandt's.

Van Dyck's nature was utterly unlike that of the Dutchman—indeed, the two typify their countries—and he was incapable of searching into and comprehending the hidden depths of a personality to the extent that was not only possible to, but characteristic of, his great contemporary.

The Fleming was essentially a courtier and carried this *into* his art; while the Leyden miller's son was bourgeois in everything *except* his art, and even there his taste was sometimes execrable; but he was a seeker after truth, and what he sought he found. Therein lay his greatness, which will endure.

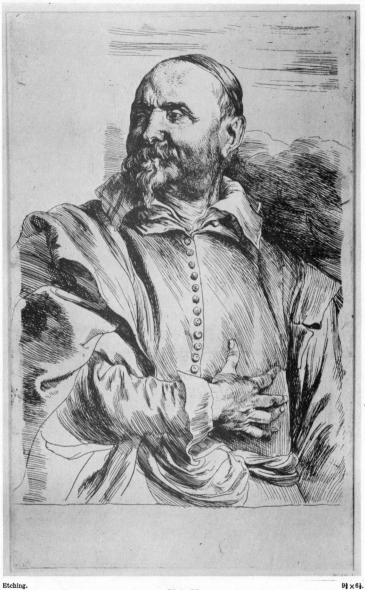

Plate 79
JAN SNELLINX. Van Dyck.
FIRST STATE.
A TYPICAL EXAMPLE OF THE ARTIST'S STRAIGHTFORWARD, CLEAN LINE-WORK.
From a proof in the British Museum.

9¼ × 6¼.

CHAPTER XXII

GOYA, 1746–1828

ONE hundred and forty years after Rembrandt's birth, and, curiously enough, in a country which had so far failed to produce any etcher of importance, appeared one of the greatest etchers the world has yet seen : Francisco Jose de Goya y Lucientes, who was born at Fuendetodos in the province of Saragossa in 1746.

When scarcely twelve years old Goya was sent to study under J. L. Martinez at Saragossa, where he remained five or six years. From there the artist first visited Madrid for a short time, but, as the result of a quarrel, he was obliged to fly to Italy to avoid arrest by the Inquisition. This incident was in a way typical of his after career. Upon returning to Madrid, in 1775, he married.

Early Plates.—M. Loys Delteil (to whose *catalogue raisonné*, 1922, I am indebted for most of the details which are here given) states, as his opinion, that the first plate known, *La fuite en Egypte* (L.D. 1), belongs to a period (*c.* 1770) prior to Goya's Italian visit. It is certainly a very telling composition, showing no apparent trace of the influence of the elder Tiepolo, but, as I have pointed out in Chapter XIX, it *does* show possible influence of the Italian's son Domenico. As the Tiepolo family were already settled in Madrid when Goya arrived, it seems to me certain that it was a direct influence, probably of both father and son, but principally of the son, upon the young Spaniard.

It often happens that the earliest efforts of an original artist show his personality more than those of an intermediate period when he is temporarily led away by enthusiasm for some particular quality in the works of others less great than himself. In this way the earliest often anticipates the mature later work, and in this instance the impetuous spirit of Goya was more in sympathy with Domenico Tiepolo's work than with the more accomplished but less interesting etchings of the father.

However this may be, some of the earliest plates after Goya's return show a certain technical timidity in his attempts to translate the canvases of Velasquez into black-and-white, quite unlike the bold massing of the *Fuite*. Then follow[1]—undated—some of the most interesting of the whole *œuvre*, in my opinion. The wonderful draughtsmanship and conception of *Le Garrotté* (L.D. 21) is as fine as anything Goya did (**Plate 80**). A most original composition in aquatint is the " Waterfall " (L.D. 23), and equally so the set of " Prisoner " plates (L.D. 31–34), three of a man and one of

[1] I do not know whether M. Delteil considers all these works chronologically placed, as several previous cataloguers have put them at the end instead of the beginning.

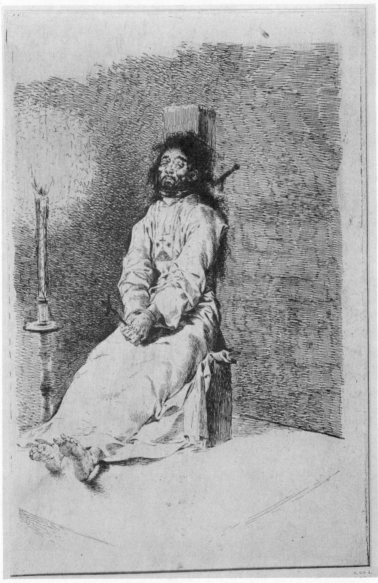

Etching.

12⅛ × 8¼.

Plate 80

GAROTTED. GOYA.

THE TREATMENT OF THE BACKGROUND PARTICULARLY SHOWS TIEPOLO INFLUENCE ; BUT HOW MUCH
GREATER IS THE DRAUGHTSMANSHIP & IMAGINATION !

From a proof in the British Museum.

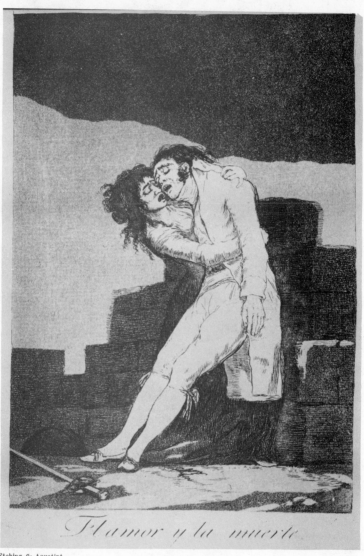

El amor y la muerte

Etching & Aquatint.

7½ × 5¼.

Plate 81

LOVE & DEATH. GOYA.

THERE IS HERE CONSIDERABLE LINE WORK UNDER THE SIMPLE, FLAT MASSES OF TONE. NOTE THE
ABSENCE OF UNESSENTIALS.

From a proof in the British Museum.

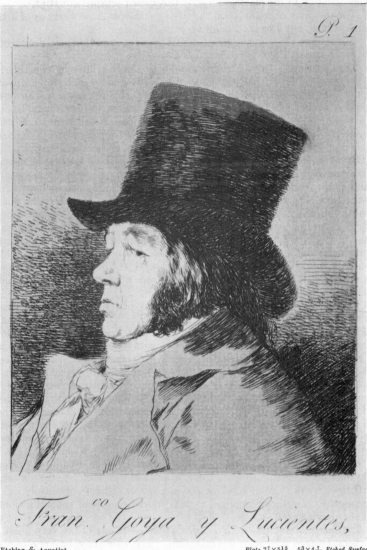

𝒫. 1

Fran.ᶜᵒ Goya y Lucientes,

Etching & Aquatint

Plate 7⅞×5⅛. 5⅜×4⁷⁄₁₆ _Etched Surface._

Plate 82

SELF PORTRAIT. GOYA.

A MAGNIFICENT EXAMPLE OF INCISIVE DRAUGHTSMANSHIP.

From a proof in the British Museum.

245

a woman. Last is the powerful " Colossus " (L.D. 35), one of the most successful of all his plates, and in it Goya used scraped aquatint.

The majority of critics seem to have passed over these works as of little importance, but I cannot at all agree with them.

Next comes the amazing series of biting satires upon the social decadence of the Spanish life of his time : *Los Caprichos*.

Los Caprichos.—Goya had become official Court-painter by this time— they were produced between 1793 and 1798—and so had ample oppor- tunity for observation. These prints—some in pure line, a few in pure aquatint ; but most in a combination of the two—are of great significance in the history of the bitten plate. It is impossible to name even the majority of fine plates of this series, but a few of the very best are *El amor y la muerte*, L.D. 47 (Love and Death) (**Plate 81**) ; *A caza de dientes*, L.D. 49 (On the hunt for teeth) ; *Por que fue sensible*, L.D. 69 (Because she was frail, or Because she was sensitive ; the meaning is very ambiguous) ; and *Mala Noche*, L.D. 73 (A dirty night). The original drawing repro- duced by M. Delteil for *Por que fue sensible* seems finer and far more subtle—in fact, *sensible* in its literal sense—than the plate. In this work there is no line-work at all. The combination of tone with etching was not new—it had been experimented with as far back as Claude—but a satisfactory ground had only recently been invented,[1] and Goya's whole outlook, as well as his treatment, was absolutely his own, and has had some—will, I think, have far more—influence upon the art of succeeding schools.

Self Portrait.—One of the most important plates of all is the frontis- piece of the *Caprichos :* the portrait of the artist himself in a tall hat (**Plate 82**). It is a most memorable work, and I am not sure that it is not the finest individual plate of the whole eighty. Perhaps not, but it is a relief to come upon an actual fact imaginatively rendered—a portrait— though the basic ideas behind the others are (unfortunately) just as factual.

Los Desastres de la Guerra.—Next—begun in 1810 or thereabouts— comes that truly terrible series illustrative of the most disgusting episodes of war-time : " The Disasters of War." They are, in my estimation, the high-water mark of Goya's dramatic draughtsmanship, especially when seen—as, alas ! few of us will be able to see them—in their early states, as reproduced in the catalogue.

So far as I know, nothing approaching them in sheer, undiluted horror has ever been done on copper. And, in spite of this, the compositions are artistically vital. Some of these plates make one almost physically sick, so intensely are they visualized : quite unlike the broad generalizations of the previous set.

The first plate of all—a kind of frontispiece—is one of the very finest : *Tristes Presentimientos*, etc. (L.D. 120). The title may be very freely translated as " The shadow of coming events." So tragic is the expres-

[1] By Le Prince in the latter half of the eighteenth century. This is, I believe, disputed.

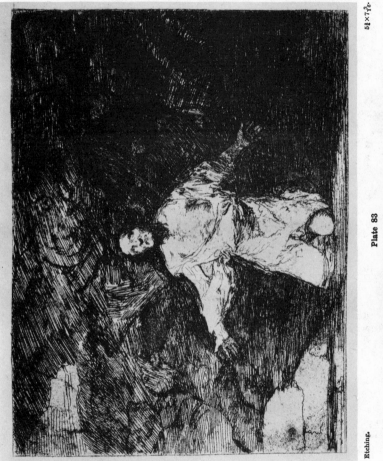

Etching.

Plate 83

TRISTES PRESENTIMIENTOS DE LO QUE HA DE ACONTECER. GOYA.

THUS, THE FRONTISPIECE TO THE "HORRORS OF WAR," IS ONE OF GOYA'S MOST DRAMATIC PLATES, & CONTAINS NO AQUATINT.

From a proof in the British Museum.

$5\frac{1}{4} \times 7\frac{3}{16}$.

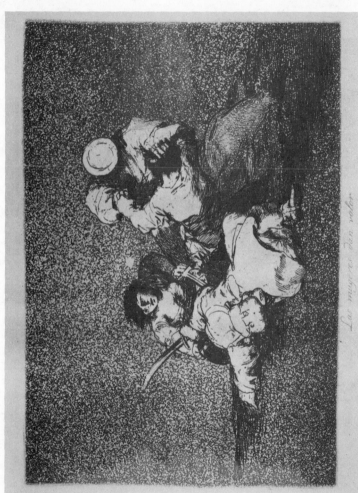

Etching & Aquatint.

Las mugeres den valor.

5 5/16 × 7 1/4.

Plate 84

LAS MUGERES DAN VALOR. GOYA.

NOTE HOW THE SENSE OF DRAMA IS INTENSIFIED BY THE CRUDE CONTRASTS OF LIGHTING.

From a proof in the British Museum.

sion of the solitary kneeling figure that it might well be called the "Agony in the Garden " **(Plate 83)**.

To mention a few others of the best in a series where nearly all are good ; none uninteresting : *Las Mugeres dan Valor*, L.D. 123 **(Plate 84)** (The women encourage . . .) ; *Duro es el Paso*, L.D. 133 (Hard is the Way) ; *Y no hai Remedio*, L.D. 134 (And there is no help, or There is no more to be done) ; *Enterrar y Callar*, L.D. 137 (Bury them and be silent) ; *Al Cementerio* and *De que sirve Una Taza* (Of what use one cup ?) **(Plates 85 and 86)**. What amazing compositions of tumbled bodies in poses of agony, despair, fear and death !

Nothing that the last war has caused to be produced has come within measurable distance of these things, with the possible exception of Percy Smith's " Dance of Death," and even these lack the wonderful draughts-manship of Goya.

The sixty-five plates were created while the Peninsular War was still fresh in the artist's memory, and they remain—probably will continue to do so—the most trenchant commentary on the bestiality and hideousness of warfare, when lust and cruelty are released from the restraint imposed in normal times.

The remaining seventeen of the eighty-two plates are, as M. Delteil points out, a return to the style of the *Caprichos*.

Los Disparates.—The eighteen "Absurdities " which follow are not of any great merit. They have been generally and wrongly entitled " Proverbs," and, according to Mr. Hind, Goya called them *Sueños* (dreams), but he gives us no text.

Suggestions as to the date of this series, by different cataloguers, have covered a period of nine years, 1810–1819 ; but nothing is certainly known on the subject. Only one of the set approaches the quality of dramatic draughtsmanship sustained so well in the " Disasters." This is the sixth : *Disparate Furioso* (L.D. 207), which in its first (pure line) state illustrated in the catalogue, shows Goya at his very best. It might indeed have be-longed to the previous series, as there is none of that fantastic exaggeration characteristic of the "Absurdities."

Tauromaquia.—Goya's last set of aquatints is the *Tauromaquia* (" Bull fighting "), which was executed—at least, several plates are so dated—in 1815 and at first comprised thirty-three plates. It is quite possible that the *Disparates* were contemporary with, or even later than, this series ; but, in any case, there is a very great falling off in power, both of observa-tion and draughtsmanship, in some of these dramatic incidents in the " sport " of his country.

The drawing of both horses and bulls in many of the plates is positively feeble—No. 13 (L.D. 236) being unrecognizable as Goya in this respect—while it is significant that the original drawings are (in all cases illustrated) incomparably finer. I imagine that the drawings had been done, in many cases, earlier. This is particularly noticeable in No. 32 (L.D. 255), where the drawing shows the artist at his very best in composition, perspective

Etching.

Al cementerio

$5\frac{5}{16} \times 7\frac{1}{4}$.

Plate 85

AL CEMENTERIO. GOYA.

NOTE THE SIMPLICITY & CERTAINTY OF THE MAGNIFICENT DRAUGHTSMANSHIP; THE SENSE OF WEIGHT IN THE LIFTED FIGURE, &c.

From a proof in the British Museum.

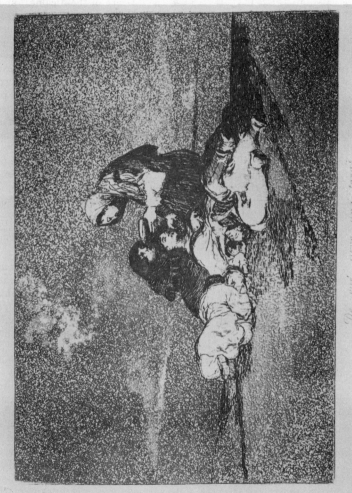

Etching & Aquatint.

5×7 7/16.

Plate 86

DE QUE SIRVE UNA TAZA? GOYA.

NOTE THE BEAUTY OF THE PYRAMIDAL COMPOSITION. ALSO THE CONCENTRATION OF EVERYTHING UPON THE ONE CUP OF WATER.

From a proof in the British Museum.

and sense of action. The shock of bull and horse and the movement of
the men is amazing. No. 21 (L.D. 244) reaches supreme rank, and it is
noteworthy because in this splendid plate the scene represented is outside
the actual arena (**Plate 87**). It is called the "Death of the Alcalde," and
has the reality of life apart from the unnatural conditions of a theatre.
In it the bull has apparently leapt the barrier, and the callous spectators
have for once the knowledge of how death appears at close quarters. The
drawing of the bull here is that of a real, savage animal which might have
broken loose from an English meadow ; not that of the semi-heraldic beast
prancing in the ring, represented in too many of the plates. The last two
of the series, Nos. 39 and 40 (L.D. 262, 263), and No. 26 (L.D. 249) are
amongst the really fine plates : very notable for their beautiful arrange-
ment of light and shade, and perhaps No. 39 is the greatest of all. It is
peculiarly beautiful in the way in which the lighting is concentrated on
the drama in the centre of the plate.

Retirement.—Late in life, having held his Court post (at the expense of
his loyalty) through the abolition and restoration of the Hapsburg mon-
archy, Goya received permission to retire to Bordeaux, where he produced
his last important work—no longer in our present medium—the litho-
graphs.

I feel I cannot do better than quote Wedmore again here, and the
following passage is taken from his graphic picture of Goya's life in
" Etchings " (p. 121) :—

" Painter of church frescoes, which were fuller than even the religious
pictures of the Venetians . . . of secular appeal ; painter of portraits in
which something of the grace of Gainsborough seems not incompatible
with something of the relentless insight of Balzac, the imagination of Goya
and his unfailing observation, his sense of terror and of comedy, come,
all together, to the front in his performances upon the copper—in his
several hundred prints."

I have allotted Goya a special chapter because he is, in a way, unique
and stands outside the main line of the evolution of etching. This is
partly because his personal *ensemble* was of the rarest, and few feel impelled
to express similar ideas in any medium ; and partly because he chose, as
a means for expressing his intensely passionate denunciations of what he
felt to be rotten and decadent, a medium which few find sympathetic—
aquatint.

More : his actual technique is in itself not at all remarkable. It was
not of superlative excellence, like that of Rembrandt, which caused crafts-
men who had nothing to say to emulate it, purely *as* craftsmanship, so
keeping it before the artistic world until the next great creator came along
to use it. He did not leave a tail of little Goyas petering-out down the
century, as is generally the case with a technical comet of the first
magnitude.

There is another reason for his failure to win a wider approval from
artists and so from the collecting public. It is one of the tragedies of the

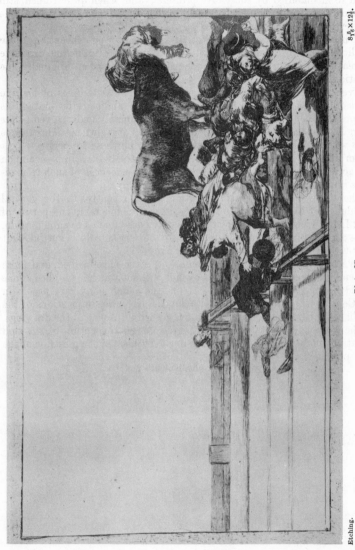

Etching.

Plate 87

THE DEATH OF THE ALCALDE. GOYA.

FIRST STATE.

NOTE THE MAGNIFICENT DRAWING OF THE MOMENTARILY STATIC BULL & DEAD BODY IN CONTRAST WITH THE FLYING CROWD.

From a proof in the British Museum.

$8\frac{5}{8} \times 12\frac{1}{4}$.

history of etching that these powerful and original plates should have been so mishandled by successive printers ; and, when quite ruined, still printed from in such numbers that only exceedingly rarely is a fine impression found.

It has given the average connoisseur a totally wrong conception of the quality of the work, and, with the best will in the world, no one can have a great affection for an utterly inadequate rendering of an originally fine creation.

Even the modern textbooks reproduce worn-out examples of his fine works in which the values have totally changed, and since beginning this chapter I have heard that a number of the presumably undestroyed plates from Madrid have just been dispersed by their last owner. This means that we have not yet seen the final printing from these coppers.

For all these reasons, Goya has had comparatively little influence upon the actual making of bitten plates, though his own art is of such tremendous importance, and has told in many other ways.

There has been a notable exception, quite recently, to the general avoidance of his special use of the medium (by etchers) in the person of Mrs. Laura Knight, whose aquatints, mostly based upon a line foundation, are extremely interesting and technically and artistically beautiful.[1] It may well be that others will follow her example.

To see Goya's work in other mediums one must go to Madrid, and more especially to see the studies and drawings without which his etched *œuvre* would not have been possible. But one may find many rare proofs in the Continental galleries, and, in England, fairly early impressions of the published sets in the British Museum, together with some of the drawings.

The average later state, however, gives one no conception of the rich aquatint tonality of the early impressions ; still less of the pure line of the trial proofs.

[1] See page 360 for Mrs. Knight's methods.

CHAPTER XXIII

BRITISH ETCHERS OF THE NINETEENTH CENTURY

I HAVE already spoken of the beginnings of etching in England and Scotland in the eighteenth century; and though the great work in both countries was not produced till the beginning of the nineteenth, nearly all the men whom we now have to consider were born in the preceding century.

In both countries the artists who made their mark in the medium were better known as painters. Geddes, Dyce and Wilkie as portrait and *genre* painters; and the three great Englishmen as landscapists.

Turner (1775–1851).—The first of these is J. M. W. Turner, who was already working upon the copper in 1807. Most of his etchings were in more or less severe outline intended as the basis of full-tone plates carried further with either aquatint or mezzotint; but it is in these rare early states, showing the line only **(Plate 88)**, that one can study his extraordinary mastery over form and composition.

In a few cases Turner completed the tonal work with his own hand **(Plate 89)**, but in the majority of the series—the wonderful *Liber Studiorum* —the work was delegated to one of the expert engravers of his time.

Of the hundred subjects originally designed by him to form the set, only seventy were issued in his lifetime; some twenty more being completed wholly or in part; while some (if not all) of the remainder were engraved—in one or two cases the work was actually drawn upon the ground by Turner, though unbitten—by Sir Frank Short, several generations later.

Crome (1768–1821).—John Crome, of Norwich, was the first Englishman of note—excepting Gainsborough—to take up etching (both ordinary and soft-ground) for its own sake. His plates in both mediums—there are not many altogether—show him to have had a real understanding of their peculiar qualities, and very considerable technical grasp. Many of the coppers were entirely ruined by some hack re-working his delicate, free lines with mechanical "improvements," after the death of the artist, and, as they were reissued in that state, the student should be careful to study the early impressions left by Crome himself. Unfortunately these are scarce.

"Mousehold Heath," which, in my opinion, is by far the finest of his pure etchings, is a typical case. In its second state (as completed by Crome) it is magnificent **(Plate 90)**; in its last (fourth) state it is worthless. The whole sky was changed and machine-ruled! In its fine state this plate shows the spirit of true landscape-etching in a way that none of the Dutchmen could equal, with the exception of Rembrandt.

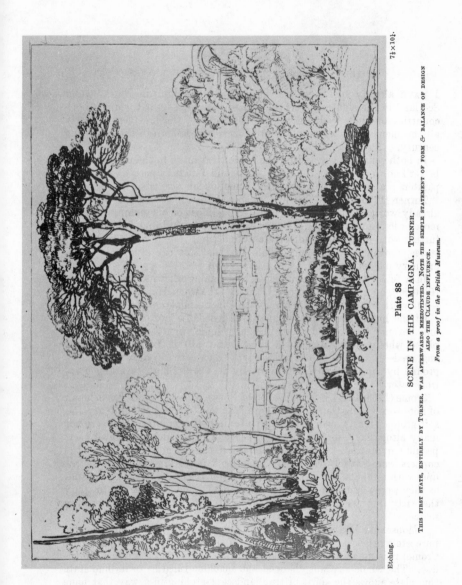

Etching.

7¾×10¼.

Plate 88

SCENE IN THE CAMPAGNA. TURNER.

THIS FIRST STATE, ENTIRELY BY TURNER, WAS AFTERWARDS MEZZOTINTED. NOTE THE SIMPLE STATEMENT OF FORM & BALANCE OF DESIGN
ALSO THE CLAUDE INFLUENCE.

From a proof in the British Museum.

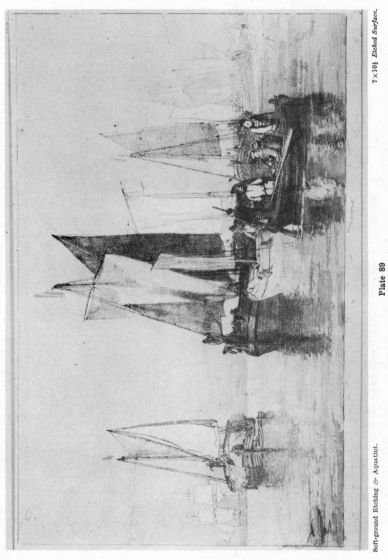

Soft-ground Etching & Aquatint. 7 × 10¼ *Etched Surface.*

Plate 89

CALM. TURNER.

This state was entirely executed by Turner. It was later completely re-worked in mezzotint under the artist's supervision.

From a proof in the British Museum.

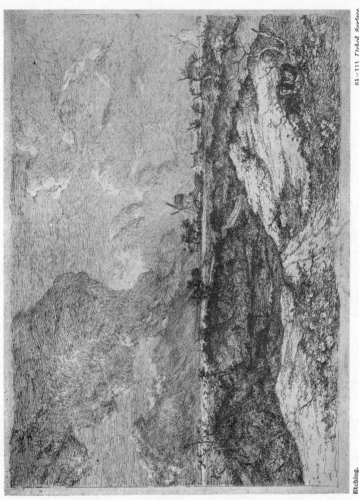

Etching.

$8\frac{1}{4} \times 11\frac{1}{4}$ *Etch'd Surface.*

Plate 90

MOUSEHOLD HEATH. CROME.

SECOND STATE.

THIS IS THE BEST STATE, AS THE ARTIST LEFT THE PLATE. THE FINAL ONES ARE BY ANOTHER HAND. IT HAS GREAT BREADTH
OF VISION COMBINED WITH DETAIL & SUPERB DESIGN.

From a proof in the collection of the author

258

Crome used soft-ground considerably, and with some success, in his studies of trees, etc., and his plates, numbering less than fifty, were executed between 1809 and 1813 ; that is to say, towards the end of his life. For this reason I have placed him after Turner, whose early work preceded his by two years.

Cotman (1782–1842).—John Sell Cotman, whose magnificent pictures in oil and water-colour have hardly yet received their full recognition at the hands of the public, confined his work on the copper very largely to soft-ground etching **(Plate 91)**. He was by far the most prolific of the earlier men. The prints are a pure delight in their sure draughtsmanship, and are perfectly controlled technically, as was to be expected from an artist of such genius who practised so extensively in the medium. The bulk of these beautiful plates were published in book form under the title of *Liber Studiorum*, a volume of which may be picked up occasionally for quite a moderate sum, and should be well worth buying for the sake of study.

It is hardly to be wondered at that Cotman's prints, so seldom seen, should be still unknown to the majority, seeing that it is only recently that he has received anything approaching his due in the appreciation of his pictures.

Geddes (1783–1844).—We now come to a man, little known until recent times outside Scotland[1] (and not even yet known to the public), whose few plates showed a remarkable understanding of all the mediums except soft-ground ; an altogether extraordinary command of drypoint in particular, and an appreciation of its peculiar qualities second to no one save Rembrandt, upon whom he founded his technique—Andrew Geddes. He was completely master of the technique of etching, also, though rarely using it entirely alone.

Geddes in his own time was overshadowed by the extreme virtuosity of Raeburn, but in the opinion of many most competent to judge he was a painter of far deeper insight into character than the popular man of the day, and with a less showy but more subtle power of modelling. This same quality shows throughout his plates. The methods he employed varied with almost every one : he was ever experimenting and copying prints or pictures of the masters, including Rembrandt and Van Dyck.

The most important of his plates—I think all will agree—is that of his mother, after the painting in the Scottish National Gallery **(Plate 92)**. It is a wonderful study, full of intimate draughtsmanship and appreciation of character, in which respects one may say that Geddes stood in relation to Raeburn in precisely the position occupied by Rembrandt relative to Van Dyck. The technical procedure in this plate was as follows : begun in drypoint ; continued in mezzotint ; and completed with etching, the graver and more drypoint. It is certainly by no means a pure drypoint. There is evidence of foul-biting all over the plate, and the background is obviously more than half bitten-line, as well as much of the dress.

[1] Although he lived a great deal in London.

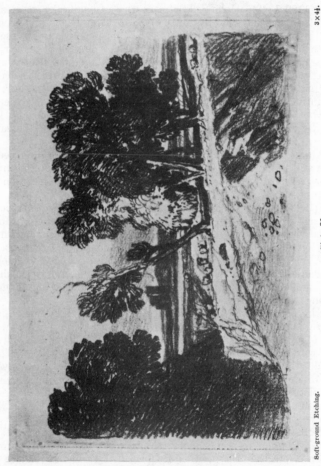

Soft-ground Etching.

$3 \times 4\frac{1}{2}$.

Plate 91

STUDY OF TREES. COTMAN.

THIS LITTLE PLATE IS TYPICAL OF COTMAN'S FREEDOM OF WORKING & BIGNESS IN DESIGN.

From a proof in the British Museum.

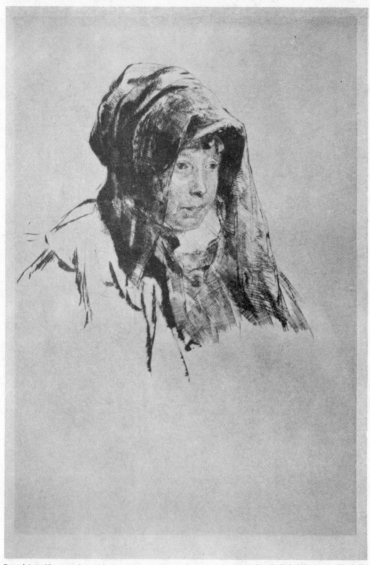

Drypoint & Mezzo. rocker. $6\frac{1}{2} \times 4\frac{1}{2}$ *Etched Surface.* (*Final St*)

Plate 92

THE ARTIST'S MOTHER. GEDDES.

SECOND STATE.

IN THIS EARLY PROOF THE MARGIN IS MASKED. DRESS & HAND AFTERWARDS ADDED & COMPLETED
WITH DRYPOINT, ETCHING & GRAVER. THE ROCKER WORK IS PLAINLY SEEN IN THE VEIL.

From a proof in the collection of R. K. Blair, Esq.

261

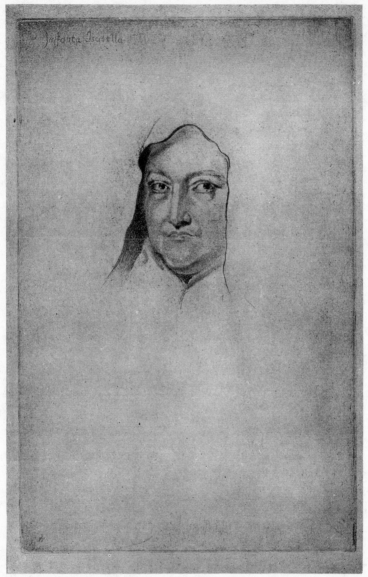

Etching, Drypoint & Graver-work. 8⅛⅝×5⅛⅝.

Plate 93

INFANTA ISABELLA. Geddes.

AFTER VAN DYCK.

The methods employed in this beautiful head are very hard to identify (see text

From a proof printed by the author & in his own collection.

I have examined carefully (and printed from) some half-dozen of Geddes's plates (including the " Mother "), and it is extremely difficult, even with the aid of a low-power microscope, to determine with which medium many of the lines were wrought. The plate—again after one of his own paintings —of a youth named Henry Broadwood in fancy dress is one of the few *pure* drypoints. It is a most delicate and expressive piece of drawing.[1]

The head entitled " Infanta Isabella," after Van Dyck **(Plate 93)**, is an extraordinary technical performance, and how executed I cannot determine precisely. I am of the opinion that it was first drawn very slightly in drypoint : the plate then covered with a very thin and broken ground, and either this allowed Geddes to use foul-biting on purpose for modelling the face, or the acid broke through by accident and was then controlled by painting out the lights with varnish. Whichever it was, it is pretty evident that he first went over a large part of the face with the *point* of the needle and bit-in this stippled work. It is quite likely that foul-biting began while he was etching this dot-work, and the artist recognized that it would combine effectively with the latter. That it was not entirely intentional, as in aquatint proper, is also obvious from the fact that the bitten tone extends beyond the head on to the unworked background. The deeper strokes suggest the burin. It is, in any case, a most interesting, subtle and beautiful piece of modelling.[1]

To the student another equally interesting plate is " Dull Reading " **(Plate 94)**, which anticipates Whistler's " Music Room." It is practically pure etching, but the surface has been roughened in some way in order to throw up the lights on the woman's face and collar of the man. I used to think this was a matter of printing, as in the Whistler, but, after comparing different impressions, I am sure that a definite tone was bitten on the copper. It is probably spirit-ground aquatint, as one can see but little granulation. However executed, the contrasts were shockingly overdone ; but it is none the less instructive to see Geddes trying these tricks of reinforcement of the etched line.

" Peckham Rye " is one of his simple and quite beautiful drypoint landscapes, but even in this case the love of experiment shows itself to the detriment of the later states, where an entirely foreign medium—aquatint —is introduced in the sky. The early proofs before this was added are far finer. There is a state (unknown to Mr. Dodgson) in which this aquatint was lightly etched, and this is particularly beautiful.

The " Halliford on Thames "[1] is a completely successful *etching* anticipating Haden ; while the " View on the Thames," of which I have only seen the reproduction in Laing's publication (No. 38)—presumably the plate was destroyed or lost—is a very fine drypoint, done under the Rembrandt influence.[2] The little still-life of a bronze boy holding up a

[1] The plate is in my possession.

[2] Mr. Dodgson tells me that this plate is almost certainly not by Geddes but by Burnet (1784–1868), as a proof has recently been discovered in a collection of the latter's work.

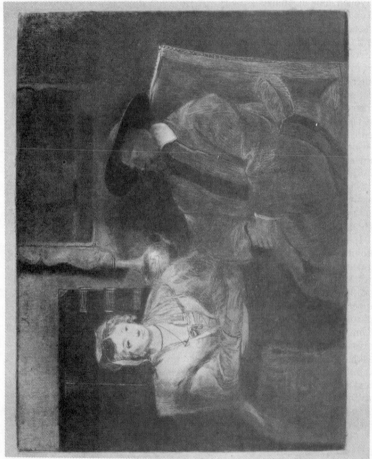

Etching & Aquatint. 5¼ × 6⅞

Plate 94

DULL READING. GEDDES.

A TONE SEEMS TO HAVE BEEN BITTEN OVER THE ETCHING & THE LIGHTS THEN BURNISHED. THE PLATE CURIOUSLY ANTICIPATES
WHISTLER'S "MUSIC ROOM."

From a proof in the collection of the author.

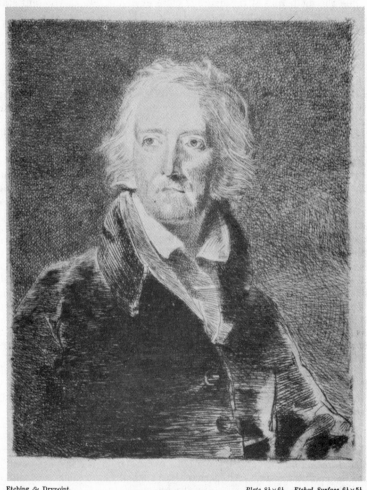

Etching & Drypoint. Plate 8¼×6¼. Etched Surface 6¼×5¼.

Plate 95

ARCHIBALD SKIRVING, ESQ. GEDDES.

ONE OF THE ARTIST'S MOST BEAUTIFUL PORTRAITS. THE DELICACY OF MODELLING IN THE FACE HAS SUFFERED IN
REPRODUCTION, BUT THE BRILLIANT LIGHTING REMAINS. THERE IS DRYPOINT IN THE RICH BLACKS OF THE COAT.

From a proof in the collection of the author.

watch is a curious mixture of very deep etching and drypoint. The chain and seals hanging from the watch are purely bitten and very heavily; while the modelling of the figure is close drypoint. In the present state of the plate the burr has disappeared from this, and the contrast is very marked.

One of his very finest plates—etching with a little added drypoint—is the "Archibald Skirving" (**Plate 95**).

Geddes was emphatically a pioneer—though not one of the first in Scotland, as I have shown in Chapter XIX—and a great experimenter. Just as his (and Dyce's) portraits anticipated Whistler, his landscapes anticipate Legros and Haden, and in the use of drypoint he is the artistic progenitor of Bone.

Wilkie (1785–1841).—Of Sir David Wilkie there is much less to be said. He used (with some skill) both etching and drypoint, but his fame rests principally upon one plate : the "Receipt" or "Man at a Bureau"—it has various titles—which is, I believe, pure drypoint. I once found that one of his little etchings was executed upon the back of his own visiting-card plate. Wilkie is not one of the interesting etchers.

Dyce (1806–1864).—William Dyce, on the other hand, was a real artist of the copper, and so far I have never seen his name mentioned in a textbook. He did a number of illustrations for books or magazines in the medium, and very good they are. I think Sir George Reid must have founded his style of pen illustration upon these. In the Scottish National Gallery hang two of his works (other than illustration) which are extremely fine. One—a girl seated at a window holding a flower—is pure etching, and might be mistaken for a Chas. Keene or even a Whistler. The other is pure drypoint of even finer quality. It is called "The Young Angler" (**Plate 96**), and is a most charming piece of drawing, with rich burr on the free line-work and is dated 1834, i.e. the year of Whistler's birth !

Another plate, of which I have only seen a very poor proof, is a "Holy Family." The drawing of the nude Infant, over whom the mother is stooping, is superb ; and the relations of woman, child and father in the background are perfect.

A fourth plate is a portrait (on a bigger scale than the others) of an old woman, reminding one a little of the Rembrandt oil of the London National Gallery. Only the face and the gnarled hands below are completed, rather tentatively, in the proof I have seen ; but it is quite possible that later states exist.[1] Altogether Dyce's etchings are much more interesting than the one or two paintings known to me. He was a genuine etcher : far more so than the better-known Wilkie, and deserves wider recognition.

Girtin (1775–1802) and Bonington (1801–1828).—There are two other Englishmen who might have left more important etched work : Girtin,

[1] I have since seen what I believe is a later state (still unfinished) in the British Museum, printed by Muirhead Bone.

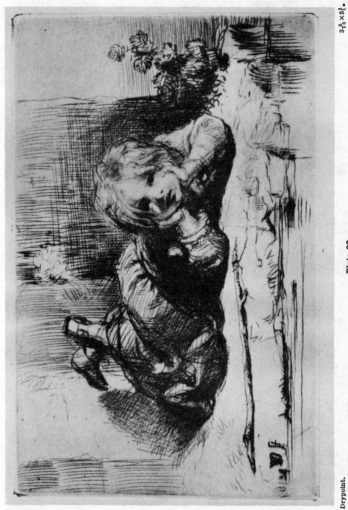

Drypoint.

Plate 96

THE YOUNG ANGLER. DYCE.

THIS PLATE SHOWS HOW WELL THE ARTIST UNDERSTOOD THE RIGHT USE OF THE MEDIUM.

From a proof (printed by Muirhead Bone) in the British Museum.

$3\frac{5}{16} \times 5\frac{1}{4}.$

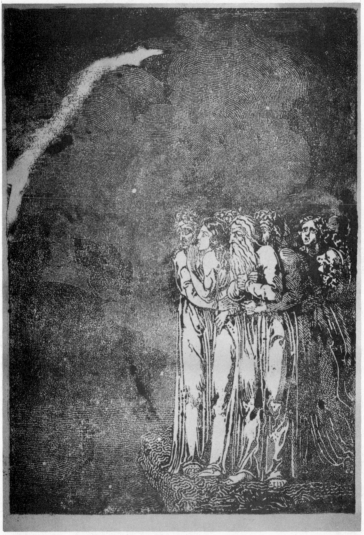

Relief Etching. 11¼×8¼

Plate 97

AN AGITATED GROUP GAZING INTO SPACE. William Blake.

After the drawing by Robert Blake.

IN THIS PLATE THE BLACKS ARE PROBABLY DRAWN ON THE BARE METAL IN VARNISH & THE LIGHTS
THEN BITTEN AWAY.

From a proof in the British Museum.

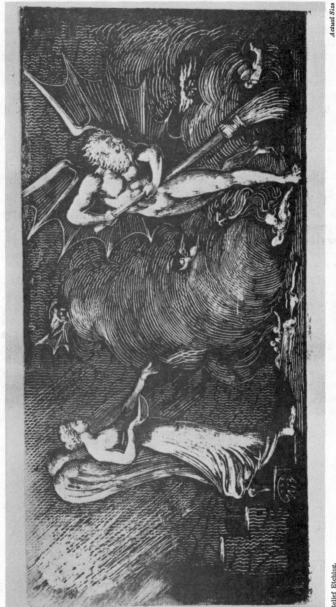

Relief Etching.

Actual Size

Plate 98

SWEEPING THE INTERPRETER'S PARLOUR. WILLIAM BLAKE.

IN THIS PLATE THE WHITES WERE OBVIOUSLY DRAWN (THROUGH AN ORDINARY GROUND) & BITTEN AWAY. THE RESULT IS EXACTLY
THAT OF A MODERN "ZINCO" PROCESS BLOCK.

From a proof in the British Museum.

269

who used soft-ground for the same purpose[1] as Turner etched ; and Bonington, whose one plate, reproduced in Mr. Salaman's " The Graphic Arts of Great Britain " (1917), is pure line etching, and hardly finished at the premature death of the gifted artist. Bonington also used soft-ground occasionally.

Of all these pioneers, however, I think Geddes alone can take permanent rank among the greatest *etchers* (and that in spite of his very limited output) by virtue of the great sympathy with, and understanding of, humanity which he was able to express in his few plates.

I would not dispute that several hold a still higher place on the strength of their work in other mediums, but here we are dealing only with that on the copper.

A word must be said of two men, both interesting, but neither true etchers in the accepted sense of the term.

Blake (1757–1827).—The first of these is William Blake, who used the acid to form his relief blocks (see Chapter XII), but preferred the graver for executing his wonderful line plates (**Plates 97** and 98).

Palmer (1805–1881).—The second is Samuel Palmer, who lived entirely in the world of the past and yet chose the freer method to create what, to me, are essentially fine original engravings.

Keene (1823–1891).—Neither must one forget that magnificent draughtsman, Charles Keene. His prints are very few compared with his drawings, but both in figure-subjects and in landscape he showed a genuine feeling for the capabilities of the medium. His print of the boats drawn up on a beach is exquisite in its line ; and the study of a girl holding a book, in the small hat and widely billowing skirt of the period, is a masterpiece (**Plate 99**). It is also interesting to us technically because Keene—evidently for his future guidance—noted the durations of his bitings on the margin of the plate : " 1st bite 20 mins. ; 2nd bite 15." His acid cannot have been as strong as half-and-half nitric. The rich blacks, the luminosity and the poise of the delicate head are beyond praise.

[1] " Picturesque Views of Paris and its Environs," 1802.

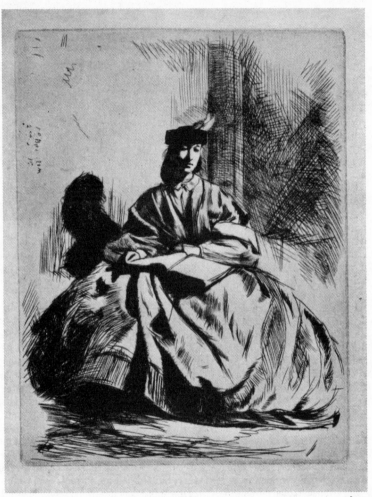

Etching. $6\frac{6}{16} \times 5.$

Plate 99

GIRL WITH A BOOK. KEENE.

THIS BRILLIANT PLATE, WHICH HOLDS ITS OWN IN ANY COMPANY, MAKES ONE WISH THAT THE
GREAT DRAUGHTSMAN HAD LEFT US MORE ETCHINGS.

From a proof in the collection of the author.

271

Meryon (1821–1868).—At the very time that Geddes was producing his few but splendid plates, the year of Crome's death, when Turner still had thirty years of work ahead of him and—how extraordinary it seems !—Seymour Haden was already three years old, there was born in a private hospital at the Batignolles in Paris the greatest etcher after Rembrandt the world had seen. I am not at all sure that it has yet seen a greater.

Charles Meryon probably stands alone in the history of etching more than any other man, with the exception of Goya.

Artistic Descent.—He made so few tentative efforts before reaching his mature style that it is difficult at first to see into what the roots of his art were struck ; but when the early plates are examined they yield at least the secret of his technique, being copies and translations of the works of various later Dutchmen—Karel du Jardin, Loutherbourg and particularly Zeeman, whose etchings of old Paris must have appealed to such a lover of the city.

I have already suggested the influence—possibly through the medium of Zeeman—of Callot. I note these points because with Meryon's great plates only before us it appears as if he sprang fully armed from the head of Zeus. I need not go into full details of his unhappy life. The greater and more widely known the artist, the easier it is for the curious student to obtain a biography ; and much has been written concerning Meryon of late. It is strange that this man, who we are told felt the stigma of illegitimacy very keenly, should have yet taken his English father's name —the accent over the " e " was a posthumous addition—but so he did upon entering the French navy.

Influences of Birth.—Sir Frederick Wedmore—to whom Meryon owes much for the recognition of his genius—thought that from his mother, a Parisian *danseuse*, the artist received his passionate nature, while his romanticism descended from his father, but this is pure supposition, though interesting. Probably the tendency towards madness which ended his own life so disastrously was inherited from his French parent, who herself died insane. But it must be insisted upon that the dozen or so plates upon which Meryon's fame rests were executed when their author was as sane as Bracquemond or any other of his friends.

Madness cannot produce great art ; though the temperament which is capable of producing it may tend, unless carefully held in check, to the production of madness also.

The few cases in which this has actually occurred have been so dwelt

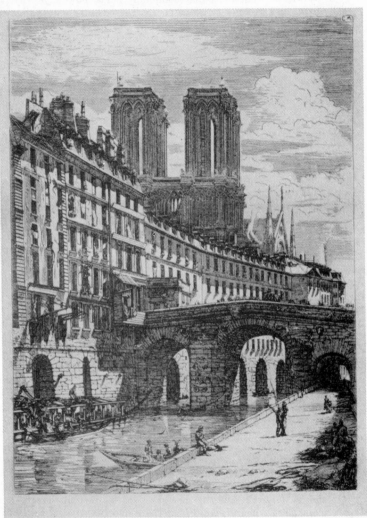

$10\frac{1}{4}\times7\frac{1}{2}$.

Plate 100
LE PETIT PONT. Meryon.

One of the most satisfyingly complete & monumental plates ever produced. It was the first
of Meryon's great series.

From a proof in the Victoria & Albert Museum.

273

upon by writers, that the public commonly holds, nowadays, that to be
really great an artist must also be mad. There is no greater fallacy.

Schumann's case is a very close parallel to that of Meryon. But were
Beethoven, Bach, Brahms or Wagner even approaching madness ? Were
Shakespeare, Milton or Goethe ; Rembrandt, Dürer or Goya ?

The very fact that so little concerning our greatest dramatist has come
down to us is proof of his normality—in other words, of his "sanity"—
because it caused no remark amongst his contemporaries. Let us believe
that Meryon therefore did his great work in spite of, not because of, his
madness.

Naval Career.—About the time his mother died he entered the Naval
College at Brest, going to sea two years later (in 1839). After several
voyages, including a visit to the South Sea Islands, he abandoned the Navy
in 1846 in order to become an artist. Upon realizing that he was colour-
blind—this does not imply any lack of ability to distinguish the most
subtle relations of tone ; rather the reverse—Meryon was forced back
upon black-and-white, and began to study and copy the men referred to
above. He was for six months a pupil of Eugène Bléry.

First Etching.—Mr. Dodgson, in "The Etchings of Charles Meryon"
(1921), says that the first etching was a head of Christ founded upon a
miniature of P. de Champagne, but only one impression is known.

In 1850 his first masterpiece was produced, *Le Petit Pont* (**Plate 100**), and
with the possible exception of *La Morgue* and *La Galerie*, nothing he did
later, in my opinion, surpassed it.

His Methods.—There is a certain amount of conflicting evidence con-
cerning Meryon's actual methods of working. Mr. Hamerton, who, if he
did not know the man himself, must have gathered information from
Meryon's friends who watched him, says, definitely, that he worked from
nature with a mirror, "laying" his lines with astonishing certainty. Mr.
Pennell, in his attempts to belittle Meryon because Whistler did not care
for his work, scoffs at this for some reason known only to himself. But it
is not at all an unlikely story. He also affirms that Meryon was no artist
because he did not make a sufficient number of mistakes !

"And in this plate (*La Morgue*) there are no mistakes, erasures, foul-
biting, none of those qualities found in all spontaneous, vital etching—
Meryon is perfunctory, perfect, pathetic."[1]

Compare this with Meryon's own letter to Jules Andrieu : "For often
I must patch my plate so much that I am more Tinker than Etcher."[2]

It shows Meryon's amazing mastery over his medium that he could
produce a plate which *appears* as if there had been no mistakes to Mr.
Pennell, in spite of his patching. In fact, he did to perfection that which
Whistler proclaimed all through his life to be the greatest technical
achievement possible : he concealed the art which produced Art.

Against the theory that Meryon worked directly upon the plate we have

[1] "Etchers and Etching," p. 40.
[2] "Etchings," by Sir Fred. Wedmore, p. 44.

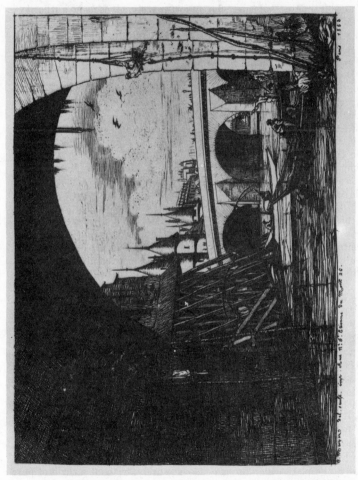

Etching.

Plate 101

L'ARCHE DU PONT NOTRE DAME. MERYON.

A MOST BEAUTIFUL DESIGN, WHICH WAS MUCH MORE DARINGLY ORIGINAL THEN THAN IT APPEARS NOW. COMPARE
THE MOTIF IN THE HANGING FIGURE WITH THAT IN RUNGMAN'S PLATE (PL. 44).

From a proof in the Victoria & Albert Museum.

$6 \times 7\frac{1}{4}$. $4\frac{1}{8} \times 6\frac{1}{2}$ *Etched Surface.*

the evidence of the original drawings. In all probability he made use of both methods, the drawings being supplemented by additional final work from nature. Or both methods may have been employed, but on different plates : why not ?

To quote from Mr. Dodgson, who, unfortunately, gives us no authority : " . . . Meryon seldom made a complete drawing on the spot. He would go every day at the same hour and make minutely finished studies of details on small bits of paper, which he either stuck together or made another drawing from them."[1]

Mr. Dodgson also adds that Meryon began his drawings of both architecture and figures at the *ground* and worked upwards. This, though a mere personal fad, was logical enough, and, I believe, the same was said of Blake, who had much of Meryon's abnormality.

Le Petit Pont (Plate 100) was a compilation from two different points of view, and is interesting in that respect as showing that Meryon fully realized that art was not a mere copying of nature.

Among moderns who have both achieved fine results from similar "liberties " with topography one may cite Bone's " South Coast, No. 2," and McBey's " Lion Brewery." I believe Whistler did the same thing in the " Long Venice," but I do not personally know that city.

The brilliance, strength and dignity of Meryon's first great plate— doubly wonderful when one remembers that he was the pioneer in treating architecture in such a manner : a manner which suggests the very soul of a building—have rarely, if ever, been equalled even by the splendid draughtsmen who have founded themselves upon their great forerunner.

Following this noble plate came, in quick succession, *Le Tour de l'Horloge*, equally brilliant but less finely composed, and *La Pompe Notre Dame*, in which Meryon, using his first scaffolding *motif*, showed the way to Bone and the rest of us who have, and will continue to, come after. Last, but by far the finest of this year (1852), was the exquisite *Saint Etienne du Mont*, the church near which the artist must have lived.

In 1853 appeared *Le Stryge*, a subject which has also been plagiarized *ad nauseam*, but in one instance forgivably : that of Cameron's " Chimera of Amiens," a plate which is, I think, more perfect than its prototype, though lacking the mystery of the latter. In the same year were also *Le Pont Neuf*, a very beautiful study of light falling athwart the old piers of the bridge, and *L'Arche du Pont Notre Dame* (**Plate 101**), one of the most perfect plates when seen in an early state. But this reservation applies to most " Meryons."

Finally, the plate which no one can see, surely, without a thrill of pure joy, *La Galerie Notre Dame* (**Plate 102**). This, we hear, was Victor Hugo's favourite, and I do not wonder at it.

The next year—only four from his beginning !—brought Meryon to his climax. In it came *La Rue des Mauvais Garçons :* again a prototype for countless etchings ; *L'Abside de Notre Dame*, a wonderful presentment of

[1] " The Etchings of Charles Meryon," 1921, p. 6.

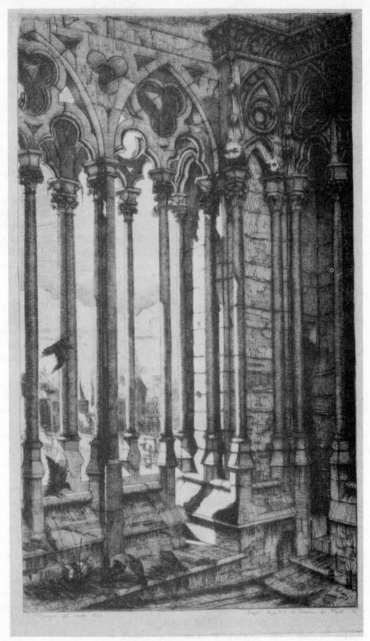

Etching.

Plate 102

LA GALERIE. Meryon.

One of the most perfect achievements in etching
From a proof in the Victoria & Albert Museum.

$11\frac{1}{8} \times 6\frac{15}{16}.$

the great cathedral, but marred by the sky; and *La Morgue*, which epitomizes the whole outlook of the artist's life (**Plate 103**). It is a work which, in my judgment, approaches as nearly to perfection as is possible. *L'Abside* was, I believe, the later plate, and both Sir Frederick[1] and Mr. Dodgson[2] acclaim it as the finest of all the " Meryons."

Mr. Dodgson has even departed from his custom of ignoring the commercial side of collecting, and by doing so somewhat weakens the value of his praise : " Then follows *L'Abside*, the justly famous masterpiece for which higher sums are paid to-day than for any other etching except some of Rembrandt's." We all know how little current prices may have to do with merit.

Personally I find that the band of clouds which passes across the whole length of the sky are not only badly drawn and bitten, but ruin the whole arrangement of the plate by carrying the eye along the top of the composition instead of allowing it to sweep down from the towers of the cathedral to the bridge below and the distant buildings beyond it. However fine the rest of the etching, if this criticism be admitted, one cannot call the plate a perfect work. Whether there is a trial proof without the clouds, as I strongly suspect—these being an obviously right attempt to break the unfortunate contour of the houses beyond the bridge—I have not discovered ; but it should be very wonderful.

Another reason for my special preference for *La Morgue* is that it seems most typical of Meryon's personality. It sums up what was begun in *Le Petit Pont* and continued in *La Galerie*. It is indeed one of the most perfect pieces of self-expression in the world of Art.

There are three more plates which I wish to mention, not because they are in any way equal to the greatest, but because they are interesting to the student. First : the apparently strong Italian influence shown in a plate of the very same year as those last discussed, 1854 : *L'Entrée du Couvent des Capucins à Athènes,* but which must have been etched from an early drawing. Second : the particularly beautiful *Tourelle de la rue de l'École-de-Médecine*, the sky of which, in the early states, shows how delicately Meryon could etch clouds.

His Power of Portraiture.—Last of all : the great power of expressing individual human character demonstrated by the portrait of 1861—the date also of *La Tourelle*—L. J-Marie Bizeul being the sitter's name (**Plate 104**). It may not be an original work, but is none the less fine.

Death.—Both these plates show how far from mad the artist was during the period between his two confinements in the asylum, i.e. between 1859-1866. There—at Charenton—he died.

His Printing and Legacy to Whistler.—Meryon was one of the first—perhaps *the* first—to make use of variously tinted papers to aid the impression he wished to convey in any particular plate ; and his practice has been followed by most of the moderns.

His printing (or Delâtre's, who must have been kept in check by

[1] " Etchings," p. 42, where the dates vary from Mr. Dodgson's.
[2] " The Etchings of Charles Meryon," p. 18.

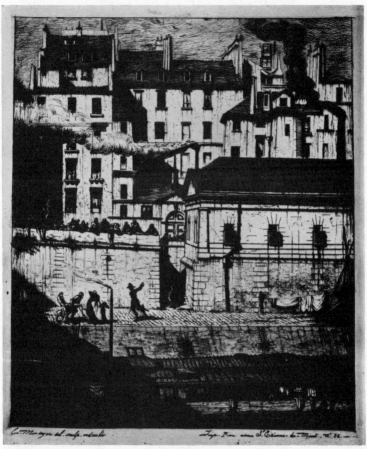

Etching. 9¼×8¼.

Plate 103

LA MORGUE. Meryon.

In most ways the artist's supreme expression of his attitude towards life. Note the Callotesque
figures derived through Zeeman & the astonishing solidity & dignity of the buildings.

From a proof in the Victoria & Albert Museum.

279

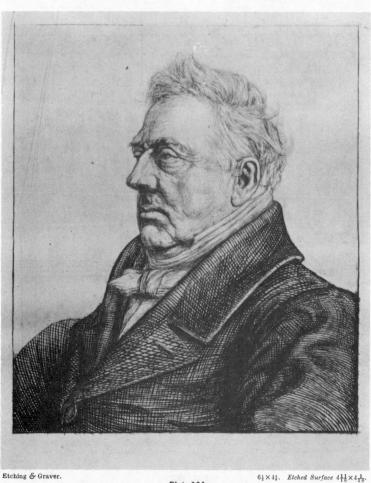

Etching & Graver. $6\frac{1}{2} \times 4\frac{1}{2}$. *Etched Surface* $4\frac{11}{16} \times 4\frac{1}{16}$.

Plate 104

L. J-MARIE BIZEUL. Meryon.

This plate, so searching & matter-of-fact & showing such a grasp of character, was executed between the artist's first and final confinements in the asylum. There is considerable burin work in the coat.

From a proof in the British Museum.

him)[1] was very simple and fairly clean in wiping, though quite a heavy tone is left on the surface very frequently. This was probably the result of using a very thin (perhaps unburnt) oil. Such an oil, we know, was employed by Delâtre, long after, when printing with Whistler. Hence we find that Whistler owed the delicacy of his printing directly to Meryon, whom he affected to despise !

Of Meryon's three great contemporaries—Jacque, Bracquemond and Legros—who all contributed to the French revival, Legros, I think, stands easily first, though Jacque was the pioneer and, in that sense, equally important in history.

Jacque (1813–1894).—Charles Jacque did some remarkably fine work and, though never attaining to the heights reached by Legros, must have the honour of being the first Frenchman of importance (who lived and worked in France) to take up etching and drypoint seriously. Many of the most beautiful plates of his large output are scarce and seldom seen, having been printed in very small editions, and justice has hardly been done him ; perhaps for that reason. Many of the plates are common enough, but they are mostly late and not usually good ones. He was a magnificent draughtsman of animals, and apparently much influenced by Rembrandt's night pieces. His own are full of feeling and observation, and the forerunners of Clausen's similar plates.

A very beautiful example of this manner is *Le moulin*, with its tenderly luminous sky (**Plate 105**). This sky is largely " printing "[2] and, of course, impressions may vary enormously ; but a proof to which one may refer is in the Scottish National Gallery, though the impression here illustrated is far richer. The early states of some of the drypoints are very much simpler and better than the later, but much rarer.

One of his most perfect interior studies of sheep in a barn is the *Intérieur de Bergerie* (1st state, B 447). How big and luminous also is *La Vachère*. Both are drypoints. It is interesting to find Jacque deliberately lifting the composition of one of his cattle pieces from Claude. Hence we have the Rembrandt and Claude schools united in him. We must remember that Jacque's original plates began at least a decade before Meryon's *Petit Pont*, and one of the best I know—a little *etching*—is dated 1840. Jacque undoubtedly influenced the young Whistler enormously, to say nothing of J. F. Millet, Legros and others.

Bracquemond (1833–1919).—The most memorable plate of Félix Bracquemond's is, I think, his portrait of Meryon (1853) (**Plate 106**). It is modelled rather upon the lines of Van Dyck than of Rembrandt, but with a more intimate understanding of the character of his sitter. There is in the face an almost furtive expression as if Meryon were upon the point of rushing away like a suspicious savage who had first met a white man. Very expressive is the drawing of the hands—without which no portrait

[1] Hamerton informs us (" Etching and Etchers," 1st ed.) that Delâtre could hardly print simply if he tried !

[2] There is a considerable amount of mezzotint in many of these dark plates.

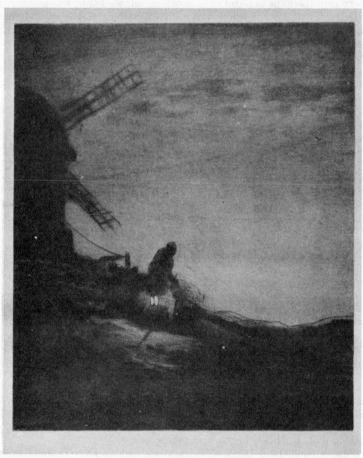

Drypoint & Mezzotint. $4\frac{7}{16} \times 3\frac{15}{16}$.

Plate 105

LE MOULIN. JACQUE.

THE TYPE OF PLATE IN WHICH JACQUE, FOLLOWING REMBRANDT, SAID SOMETHING NEW. NOTE THE EXTREME
BEAUTY OF DESIGN.

From a proof in the collection of E. R. Boase, Esq.

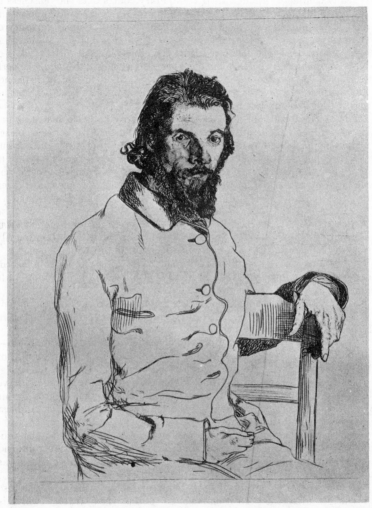

Etching. 9 × 5¼.

Plate 106
PORTRAIT OF MERYON. BRACQUEMOND.

APART FROM ITS VALUE AS A RECORD, THIS PLATE IS NOTEWORTHY FOR ITS FIRM & DIRECT
USE OF THE NEEDLE.

From a proof in the collection of Campbell Dodgson, Esq., C.B.E.

283

is really complete—though their tranquillity contradicts the tenseness of the face. Bracquemond's portrait of his other great contemporary is almost as fine. Here is Legros the visionary ; but again the quality of shyness is so noticeable that one wonders whether his sitters shared it equally, or whether it emanated from the etcher himself. His studies of birds are technically perfect, but such plates as *Le haut d'un battant de porte* —beloved of Wedmore—leave me entirely cold. On the other hand, *Le vieux coq* (of the later manner) is a creation, and has been both father and mother of countless modern works.

Legros (1830–1911).—Alphonse Legros began etching in his teens—at least as early as 1855—just when Meryon had finished the series of plates upon which his fame rests. There is nothing more interesting and curious than the manner in which the art, having taken a fresh lease of life in Scotland, suddenly came to perfect maturity in France through the medium of a man who was half English and half French, and then returned to this country, reintroduced by a Frenchman, Legros, and an American of Anglo-Scottish descent, Whistler.

Although Legros worked and lived in London, never for a moment was he anything but French. In actual technique he was extraordinarily limited, considering the huge extent of his output—about 700 plates, I believe—and yet he expressed himself with that simple, mannered, diagonal shading (suggesting the earliest Italian engraving) in a wide range of subjects and with deep humanity.

In the course of his long life he naturally produced very many indifferent plates, and many of these, instead of being destroyed, were published in huge editions and poorly printed.

It is such impressions—seen in every print-seller's and auction room— which have been responsible for the low estimation in which their author has been held by the average collector and artist.

They are bad plates, often printed long after what burr there may have been had disappeared, and it is a thousand pities that Legros or his publishers issued them to damage the reputation of one of the noblest etchers of the century.

Legros's temperament, like his technique, restricted him to the production of a certain class of work, and that only. He could never unbend and express the sheer joy of living as could Rembrandt. His outlook was often sombre ; always dignified and quiet ; never gay.

In such portraits as that of the " Sculptor Dalou " **(Plate 107)** he rose to a height of serene perfection ; not in such as the " Watts," which is feeble in every way. Again, in the studies of pollard-trees lining the banks of a river **(Plate 108)** his one method of drawing on the copper—the short diagonal stroke—suited his subjects perfectly and they are most masterly in design and luminosity ; while in what Wedmore describes as Legros's " leaning towards the theme of the human derelict " the artist was expressing himself with full conviction, e.g. " Death and the Woodcutter."

Legros, whose manner of expression was so personal, and never varied

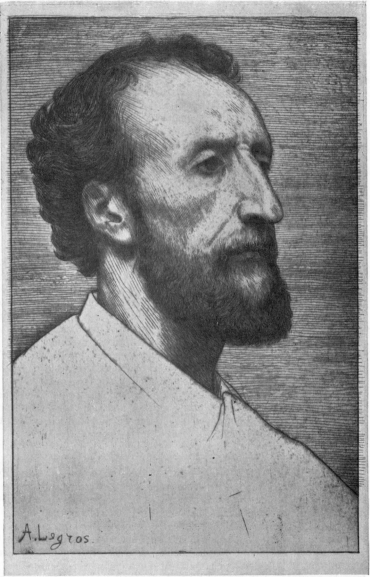

A. Legros

Plate 107

PORTRAIT OF DALOU. LEGROS.

THIS IS ONE OF THE MOST MONUMENTAL OF THE ARTIST'S PORTRAITS. IT COMBINES SEARCHING CHARACTERIZATION
WITH BREADTH OF MODELLING. NOTE THE TYPICAL RAG-WIPED QUALITY OF THE PRINTING (GOULDING'S).

From a proof in the collection of the author.

in accordance with the requirements of his subject, as that of the greatest masters has always done—Rembrandt, Meryon, Hokusai, Turner, for instance—had the usual effect that such men have upon their pupils. Either these broke away altogether, or slavishly followed his mannerisms and failed.

To make my meaning clearer I will analyse that much-illustrated plate *Le mur du Presbytère*. The composition is simple and very dignified in its big masses of tower and trees against the blank sky ; the suggestion of resting horses perfect as far as it goes. Yet the wide, coarse, diagonal shading upon the wall behind the horses is so obvious—so unlike tone, yet equally ignoring the texture of the surface, whether stone or brick one cannot tell—that the eye is inevitably drawn to these drypoint strokes at the expense of the animals in front.

Its result is to make the nearer horse's head appear part of the wall. It is transparent and has no reality or solidity.

Again : even if we grant that it is not of vital importance whether the trees look like any particular species, we still have to ask whether this same diagonal shading does not prevent them appearing like trees at all. We know that they must be trees because they could not be anything else, but not because there is any intimate piece of draughtsmanship to tell us so. They are like the trees of a scenic background where the instructions indicate " Trees here." I am by no means denouncing this method in works requiring such treatment, but I do not feel this to be one of them. Legros rightly ignored all matters which seemed irrelevant. But he carried this too far when the fact that his horses were not solid and his trees not drawn ; that his wall could not be seen for the lines composing it, failed to worry him, so long as his shape was fine, and something of the emotion called forth by the spirit of the place was captured.

And in those things—big things both—he succeeded. On the other hand, it so often degenerated into a mere mannerism when this same treatment was used to express things which do not lend themselves to such a means of expression.

In studying Legros, therefore, it is necessary to select most rigorously, first the plate, and afterwards the impression from that plate.

Corot (1796-1875) : Millet (1814-1875).—I do not propose to say anything of the etched work of either Corot or Millet. Etching was not their business, and nothing either of them did on the copper in any way added new commentary to the truths they expressed in their proper medium.

Rops (1833-1898).—Although a Belgian, Félicien Rops did much of his work in Paris, and his outlook was largely French. He used etching, drypoint and soft-ground with equal facility, and his draughtsmanship was magnificent. The indecent character of much of his work has banned it from this country, but some of his less gross plates are superb. Particularly fine is the study of a youthful couple embracing in a ploughed field, entitled " The End of the Furrow." It recalls Millet, but without Millet's heaviness of handling and sentimentality.

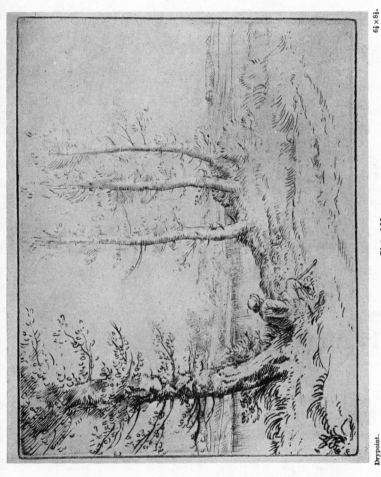

Drypoint.

6⅛ × 8¼.

Plate 108

LE LONG DE LA RIVE. LEGROS.

THIS BEAUTIFUL PLATE IS ONE IN WHICH THE ARTIST'S MANNERISM OF HANDLING IS EXACTLY SUITED TO
THE NEEDS OF HIS SUBJECT.

From a proof in the collection of Campbell Dodgson, Esq., C.B.E.

CHAPTER XXV

HADEN AND WHISTLER

AND now we come to the two men—brothers in-law, and, at the end, totally estranged—who did more than any man, or any group of men, towards creating the revival of etching in nineteenth-century Britain which is in full force at the present time.

Haden (1818–1910).—Sir Francis Seymour Haden's first etchings—six Italian subjects executed in 1843—ante-date the Paris-trained American's by more than a decade, but his great work was produced largely under the stimulus of the younger man's example. By this I am not implying that Haden in any way imitated either the manner or the subjects of his wife's half-brother : merely that, after the long interval of fifteen years he was once more fired by the enthusiasm of the recently arrived American to etch ; and in the first year (1858), Hamerton says, he produced nineteen plates. Between that year and 1875 practically the whole of his significant output was executed.

His Unique Record.—Haden's is one of the most curious records of history. He was born in 1818. He became a successful surgeon and—his tentative early plates apart—did not etch until forty years of age ! In sixteen or seventeen years he had practically finished his *great* work, and yet he lived almost as long after ceasing as before beginning to work on the metal. A man who was born before Meryon and easily outlived Whistler !

It has been the custom to contrast these men, and, of late, to decry Haden's work as second-rate. I certainly have no intention of following that fashion. Both were very great artists, and, of the two, the American was infinitely the more versatile ; but to say that therefore the work of the one was superior to that of the other is only a futility.

Both have had vast influence and will continue to have ; but they were utterly unlike in the finest work of each ; and each had *les défauts de ses qualités*.

In the few plates in which the older man deliberately competed with the younger, he failed ; as for instance in Haden's version of the subject —evidently they worked nearly side by side—which Whistler called " Reading by Lamplight," where the one rendering is expressive, and the other merely matter-of-fact and dull. But Haden had no need to compete with any one. What he had to say was new, and he said it clearly and emphatically. His art was essentially that of suggestion—of the sketch—except in one or two of his very finest plates, such as " Shere Mill Pond " and the " Agamemnon " **(Plate 109)**, and this last is, in my opinion, one of the greatest masterpieces of all etching.

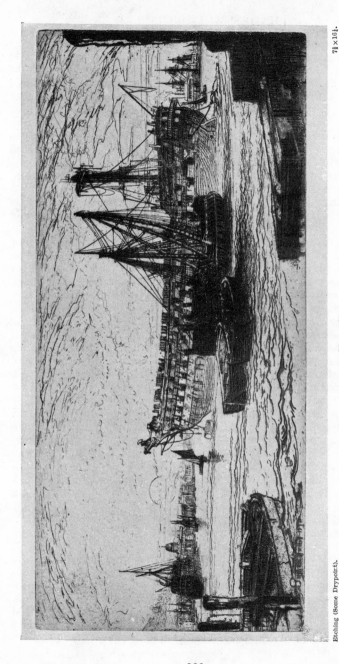

Etching (Some Drypoint).

7⅞ × 16¼.

Plate 109

BREAKING-UP OF THE AGAMEMNON. SEYMOUR HADEN.

THIS IS UNDOUBTEDLY HADEN'S MASTERPIECE & ONE OF THE MASTER WORKS OF ETCHING.

From a proof in the collection of the author.

289

The " Agamemnon."—Here I should like to digress a moment in order to warn both the student and the collector against the foolish practice of prizing early states, as such. In this case, the last or "second published" state is finer than the first published state. The plate was strengthened *and improved* by Haden after a large edition had been issued, yet, merely *because* it is the later issue, it fetches about one-quarter the price, at auction, of the first published state. (These two have nothing to do with the preliminary trials of which there are several "states.") It is just as foolish to pay larger sums for proofs which happen to have been signed by the artist ; especially prints which date from a time—such as these— when the marginal signature was a novelty and not, as it is now, considered an essential part of the issue. This magnificent plate has an interesting history and many absurd statements have been made concerning it. Not the least absurd is Mr. Pennell's, where he makes the author of the plate tell an obviously ridiculous story[1] :

"Apropos, I remember one story he told me in his own house. How he went down to Greenwich, one day, to a whitebait dinner . . . and he saw the subject, and just went and sat on a pile, and pulled the plate out of his dress coat-tail pocket, and etched the ship and forgot the dinner, and then came back next day at sunset and put in the background."

Then follows the obvious gibe as to the size of the pocket in relation to the plate (it measures more than 16 by $7\frac{1}{2}$ inches).

It is sufficiently clear that either Haden had quite forgotten the real facts of the case, as an old man will, or, more probably, he was getting a little of his own back from one who himself can hardly expect us to take his statements too literally. In the same book (p. 4) we find, ". . . Great Britain has never produced a supreme etcher, and I do not believe ever will ; it is not in the nature or temperament of the people " ; while on p. 150, " F. Seymour Haden : ' Sunset in Ireland ' : The most poetical drypoint landscape that exists " ; and p. 149, " far better than any by Rembrandt, far better than any of Whistler's." Again, in speaking of the "Agamemnon " (p. 154), ". . . the hull is the finest thing in line that has ever been done in etching " !

Without subscribing to any of these rather dogmatic utterances, I think that there is little doubt that Haden will go down to posterity as a " supreme etcher."

The real facts concerning the making of Haden's masterpiece are sufficiently interesting and instructive to quote.

Mr. Hamerton, in an article on Haden in " Scribner's Monthly " (1879, p. 582), quotes a letter from the etcher, verbatim, in which the latter says that in that year (1870), believing himself to have lost the power of working upon the copper in the open air, he made, or tried to make, a free-handed drawing of the "Agamemnon," then breaking up opposite Deptford. He offers this plate to Hamerton for the " Portfolio." After speaking of the difficulties he had experienced in the work, he goes on to say that he

[1] " Etchers and Etching," 1920, p. 149.

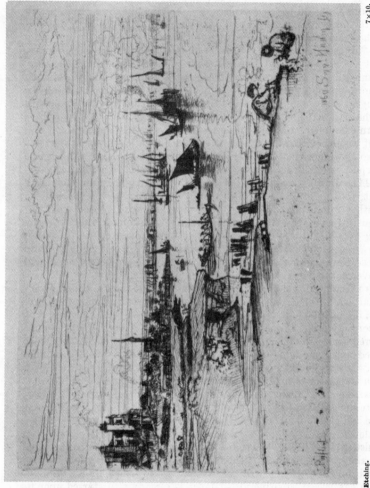

Etching.

7×10.

Plate 110

PURFLEET. SEYMOUR HADEN.

FIRST PUBLISHED STATE.

THIS ZINC PLATE IS ONE OF THE ARTIST'S MOST BRILLIANT RECORDS OF THE LOWER THAMES.

From a proof in the collection of the author.

had thought of making the sun set behind the old hulk and distant Green-wich, as typical of the departing glories of both ; and that he would try to do this if Hamerton would return the plate after using it.[1] He finishes by saying that, as for himself, he is old, blind and unhandy ! The man who had half etched the masterpiece of his life : unhandy ! And he still had forty years to live.

In the same article Mr. Hamerton expresses my view exactly in writing of the " Sunset in Ireland " : ". . . rich in tone but not very luminous, so that the idea of sunset does not occur to us before we read the title. The same subject was afterwards etched in the bath . . . and the etching was more luminous than the drypoint." I saw this second plate at Dr. Harrington's house some years ago for the first time, and felt it to possess just what is so lacking in the drypoint.

As an example of Haden's amazing promptitude in gripping the essen-tials of a subject there is a note in the Drake catalogue of the artist's work to the effect that the five Welsh plates (two of them, at least, are masterpieces—" Kilgaren Castle " and " From the Bridge at Cardigan," **Plate 111**) were all executed, out of doors, upon the same day, 17th August, 1864 !

Another interesting note (this time by the editor of the magazine previously quoted) says that upon the first publication of Haden's *Etudes à l'eau forte* in France—his first issued set—Meryon wrote to the editor of the " Gazette des Beaux Arts " cautioning him against being taken in by these plates, which, he declared, were " not done by Mr. Haden and moreover not in this century " !

This throws a double light upon both Meryon *as a man,* and the very unusual quality of Haden's work for the period in which they were pro-duced, i.e. in 1865.

According to Mr. Hamerton, Haden has left it on record that he much preferred zinc to copper, and certainly the style of work in which he excelled was thoroughly suited to the character of line yielded by that metal. His mordants I have already given in Chapter VI.

As a translator of masses of foliage ; moving water and cloud effects ; vessels silhouetted against luminous skies, etc., into free, vigorously-bitten, definite line, Haden has few, if any, compeers. His printing was always simple and clean, and the work stands upon the merit of the sheer, black line alone.

Whistler (1834–1903).—James Abbott (McNeill[2]) Whistler has received more abuse and, since his recognition, more praise than probably any etcher before or after him. At the time of writing the pendulum of public opinion has ceased to swing up—I fancy is already well started upon its return journey—his finest prints bringing actually less at auction than

[1] The plate was not used, the " Brig at Anchor " being issued instead, but it would be very interesting if a proof of this early state could be found. Dr. Harrington told me that he did not know of such a proof.

[2] McNeill was his mother's name, added by Whistler after coming to England.

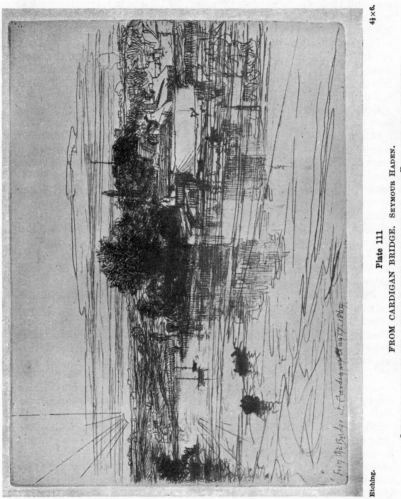

Etching.

Plate 111

FROM CARDIGAN BRIDGE. SEYMOUR HADEN.

ONE OF THE RAPIDLY EXECUTED, BRILLIANT PLATES IN THE PRODUCTION OF WHICH HADEN INVENTED A NEW METHOD—
DRAWING IN THE BATH.

From a proof in the collection of the author.

4½ × 6.

293

those extremely popular ones of Cameron which are enjoying their fullest appreciation in the artist's lifetime. In this respect we are all reaping where Whistler sowed—where Whistler and Haden sowed would be more just—for these two men placed etching, by their actual creative work as well as by their speech and writings, in a position never before occupied in the estimation of the public.

It is by no means easy to appreciate the finest qualities in a Whistler print. It is easier in the case of Haden : far easier in that of Cameron. That is why the majority of those who will " collect " Whistler will do so because he is an established master ; the minority because it really loves and understands his work.

Early Life.—There is scarce need for me to recapitulate the well-known facts of Whistler's career. He was the son of an American engineer holding the rank of Major in the U.S. Army, and while quite a small boy went with his family to Russia, where the Major was engaged in building a great railway. Upon his return to America he entered West Point Military Academy (though how his eyesight was passed is a mystery : no one has mentioned it) ; learnt a certain amount of topographical drawing ; found he was unfitted for a soldier's life ; was engaged for a short time in the Coast Survey Office, where he learnt his etching-craft, and utilized his knowledge of drawing ; and, finally, threw that up also and left America —practically for good—when he was nearly twenty-two, to settle in Paris as an art student. It was soon after this that he must have come under the influence of Jacque. The extraordinary resemblance both in style of technique and in subject between the two Jacque etchings here reproduced and the Whistlers was first pointed out to me by Mr. Martin Hardie, and, I think, is quite conclusive (**Plates 112** and **113**).

And now comes the astonishing fact that, in less than three years, Whistler had completed the first issued set of his etchings, *Douze eaux-fortes d'après Nature*, printed by Delâtre at the end of 1858 ; and that amongst these plates are some of the finest (in my opinion) that he ever executed. It is rarely that a young man's work is taken seriously unless he happen to die young (as in Schubert's case), so that one must either accept him young or not at all ! And Whistler himself disparaged his early plates late in life.

His Early Maturity.—Whistler belonged to the type which develops early and wears itself out rapidly. His zenith was reached in oil-painting before he was forty—the portrait of his mother was begun in 1871 at latest, i.e. when the artist was between thirty-six and thirty-seven years old—and even the Venice etchings (if one accepts them as the culmination of his etcher's career) were produced in 1880.

An Analysis.—Personally, I doubt very much whether posterity will accept the present verdict that the Venice sets are greater than the earliest sets of all. They are more *obviously* original, just as Chopin is more obviously " original " than Beethoven. But is this quality so important as it seems ? No one who knows one note of music from another can

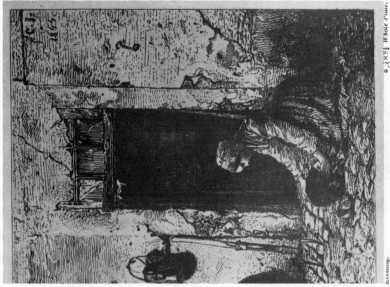

Etching. LA MARCHANDE DE MOUTARDE. WHISTLER. $6\frac{1}{8} \times 3\frac{3}{8}$.

THIRD STATE.

From a proof in the collection of the author.

IT IS INTERESTING TO COMPARE THESE TWO PLATES. NOTE THE TREATMENT OF THE PLASTER, BRICK-WORK, FAN-LIGHT & STILL LIFE APART FROM THE CENTRAL FIGURE, IN EACH.
THE WHISTLER IS BY FAR THE FINER WORK OF ART, BUT IT JUST AS OBVIOUSLY DERIVES FROM THE JACQUE.

Etching. RÉCUREUSE. JACQUE. $5\frac{5}{8} \times 8\frac{1}{4}$ *Whole plate.*

RIGHT HALF ONLY.

From a proof in the Victoria & Albert Museum.

Plate 112

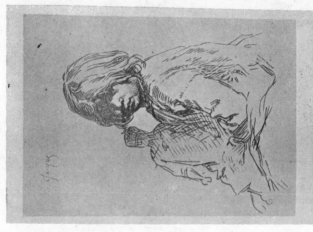

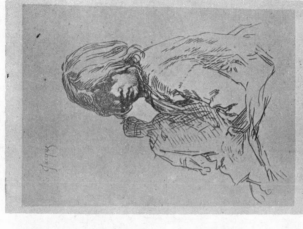

Etching. 5¼×3¾. Plate 113 Etching. 3¼×2¼.

ANNIE, SEATED. WHISTLER. MA PETITE FILLE. JACQUE.

1858–9. 1850.

From a proof in the collection of the author. *From a proof in the Victoria & Albert Museum.*

THESE PORTRAITS SHOULD PROVE CONCLUSIVELY HOW GREATLY INDEBTED WHISTLER WAS TO JACQUE. NOTE EVEN THE PROLONGATION OF THE
FINAL LETTERS OF THE SIGNATURES, &C.

mistake Chopin for anyone else, but it is perfectly easy for the uninstructed to confuse much of Beethoven with several of his predecessors. Why is this ? Why is the man who is not so *obviously* individual acknowledged as the greater artist in spite of this ? There is the same peculiarly individual flavour about the work of many minor—some very minor—artists. To take the first name one thinks of—Beardsley ; and so we are driven to the conclusion that there is something which matters more than this : that the greatest artist must combine this—and, by so doing, hide it to some extent—with some quality which is greater ; something outside himself, universal.

In other words, the greater the artist, the less he thinks about *himself* and the more he is interested in, absorbs and expresses life *outside himself*. It is just this, it seems to me, which allows the greatest artist—the Rembrandt, Michel Angelo, Leonardo—to be appreciated so easily by people in all classes—with little or much education—in all countries. It is because, instead of being exclusively preoccupied by himself, he is in sympathy with, studies, understands and is therefore able to express (through the medium of himself) universal attributes of humanity. People say of such a man, " Why, that's exactly what *I* feel, only I never just put it into words " ; or, " How *easy* it looks ! I feel as if I could have done that myself." Quite so ; everyone feels those things, but only the very few can express them.

On the other hand, none of these remarks are ever made concerning the lesser, " obviously original " artist. Of him people say, " How wonderful ! how brilliant ! how *clever* ! " Last of all, " How original ! "

These remarks have many a time been called forth by the later Whistler prints, but rarely, I imagine, by Haden's "Agamemnon." It is a work containing that universal " something " which everyone feels but none can explain. There is not even a figure in the whole composition, and yet humanity is in it by inference : much more real humanity than in many of Whistler's later figure-subjects. But not more than is expressed by the *young* Whistler.

Early Etchings Compared with Late.—In the early portraits, particularly, where the artist was obviously deeply interested in expressing the character of his sitters rather than in more consciously expressing his own *ego*, one feels this universal quality. " They are not typical Whistlers," says the critic. No, but is the typical Whistler a greater work of art ? Could the early portraits and Thames etchings be attributed to anyone else ? Of course they could not. Why, then, is one set up as typical at the expense of the other ? I am equally justified in saying that the later prints are not typical of the young Whistler ! No, they are both typical, but of different phases of development ; and my own opinion (which I offer with great diffidence for what it may be worth) is that Whistler developed along the wrong lines.

The Venice etchings are exquisite—the last word in that quality—but they are conscious of dexterity ; sophisticated. They were produced by

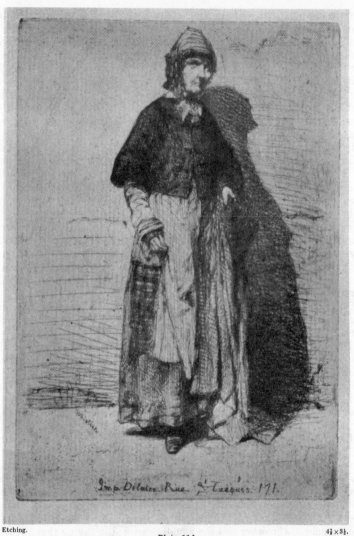

Etching.

4⅞×3¼.

Plate 114
LA MÈRE GÉRARD. WHISTLER.

THIS IS ONE OF THE MOST COMPLETE & BEAUTIFUL OF THE EARLY ETCHINGS—INDEED OF ANY PERIOD.
HERE WHISTLER CHALLENGED REMBRANDT'S SIMILAR WORK.

From a proof in the collection of the author.

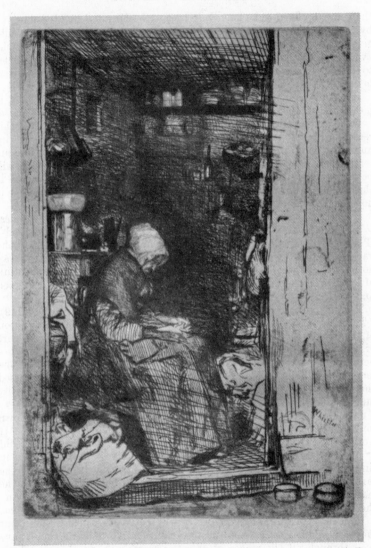

Etching. 8¼×5½.

Plate 115
LA VIEILLE AUX LOQUES. WHISTLER.

THERE IS SOMETHING EXTRAORDINARILY SATISFYING IN THIS WONDERFUL EARLY PLATE.
NOTE THE INTIMACY OF THE DRAWING.

From a proof in the collection of the author.

299

the man who liked to be looked up to as "the Master" by his followers;
by the man who was small enough to act as if he believed everyone should
give way to him, in every particular and upon every occasion. That the
average individual was (and ever is) ready to allow a man like Whistler
to walk over him roughshod is not only pitiable : it is the *greatest curse
to the individual who does the walking*.

It is only an artist who is *arrivé* who tries this, and when he does, it
means that his art is on the wane.

One cannot imagine the greatest artist taking this attitude, for this
reason : that he is far too sympathetic towards, and interested in,
humanity to treat them as if they were of no account. He can lose his
temper with everyone, like Beethoven, but, equally like Beethoven, he will
be the first to admit that he was wrong to do so. Surely the reason is
that, being as *great* as he is, he sees more clearly than anyone that he is
not a god, although fully conscious of his power.

I can imagine Rembrandt full of admiration for plates like *La mère
Gérard* (**Plate 114**), *La vieille aux Loques* (**Plate 115**), "Annie, seated"
(**Plate 113**), *La marchande de moutarde* (**Plate 112**), *En plein soleil*, the
various studies of children, and the old pensioner of Chelsea, to say
nothing of the wonderful Thames plates (**Plate 116**), so searching, so full
of love for the old ships, the older water-way and the men of the dock
and sea.

Turning to the *Rialto* (**Plate 118**), the *Traghetto*, "Turkeys" (**Plate 119**),
"The Bridge" and *San Giorgio* (**Plate 120**), I cannot find that absorption
of the *ego* in the desire to express something which it feels to be part
of, and yet greater than, itself. In these plates I find a conscious art—
very individual ; unmistakable—and yet an art which never for one
moment loses sight of the artist. Nature, now, has to be not only expressed
through, but improved by, the greatest of all her creations—the artist
himself.

I believe that had Whistler developed along the lines first laid down
for himself, he would never have made the name he did make in the Art
world of his time : he would not have cared very much whether he did
or no ; but he might have been one of the "universal" artists, and in
time his work would have been recognized ; just as, in time, I believe the
early plates will take rank with the Rembrandts, and only second to the
mature and loftiest conceptions of Rembrandt and perhaps of Meryon :
the Rembrandt of the Hundred Guilder print and the Meryon of *La Morgue*.

I am fully aware that the majority will scoff at these convictions, but
they *are* genuine convictions, and I am not ashamed to admit that I have
been through all the stages of Whistler worship ; and though I have
always loved the earlier prints, I believed the later work to be far greater.
But I no longer believe it : and I have tried to state my reasons, not,
I fear, as clearly as one might who had practised with the pen, but as
clearly as I can.

His Printing. The Tradition Received and Left.—In printing, Whistler

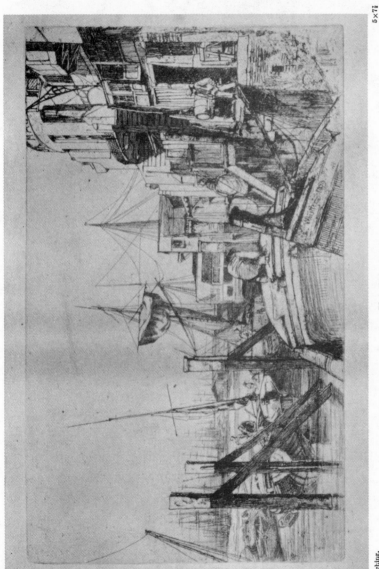

5×7¾

Etching.

Plate 116.

LIMEHOUSE. WHISTLER.

ONE OF THE MOST BEAUTIFULLY DRAWN & COMPOSED OF THE THAMES SET. IT IS CERTAINLY BITTEN IN THE BATH.

From a proof in the collection of the author.

301

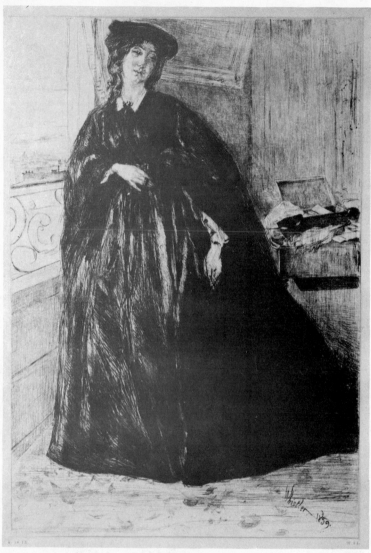

$11\frac{3}{8} \times 7\frac{7}{8}$

Plate 117.

FINETTE. WHISTLER.

SHOWING WHISTLER'S EARLY UNDERSTANDING OF THE PECULIAR QUALITY OF DRYPOINT BURR, & **THE**
RICH VELVETY BLACK OBTAINED FROM IT.

From a proof in the British Museum.

302

set an example which has been the ruin of several of his followers and those who came after.

The early plates he and Delâtre (with the Meryon tradition) printed perfectly. In the later rag-wiping and painting upon the plate—suggested by Rembrandt—Whistler allowed himself to lose his hold upon tradition, and began what was to lead to a decadence in the work of his followers. I said, earlier, that Whistler was *technically* a bad printer, and, in spite of his often wonderful results, that is, I think, a perfectly true statement. I speak only of his later period, of course, and at that time he worked too empirically : with too little reasoning.

He obtained his results—at times—but only at the expense of far more failures than were necessary. His best proofs were often marred by " folds " and also by those marks (referred to in Chapter X) which appear when the paper is too wet.

In his attempts to condemn Meryon for being too faultless in technique, Mr. Pennell implies that this carelessness shows Whistler to have been the greater artist. It shows nothing of the sort. It shows that in that particular Whistler was an artist who had not sufficient control.

Mr. Pennell used to possess an otherwise beautiful *Traghetto*, and to him —so he used to say—these creases made no difference. But to me they make this difference : they prove that the man who did the work was either a " bad printer " because he could not regulate his press, or that he was too lazy to pull another proof and then destroy the spoiled one. We *know* that Whistler was not lazy, therefore the alternative supposition must stand. As the editions of most of these plates were so small, the consequence of this empirical printing is that proofs that are both fine in quality—a quality which *at the time* only Whistler knew how to obtain— and that are not blemished, are very scarce.

There is a trial set of the second Venice etchings (of which I possess half) which was printed by M. Salmon in Paris for Messrs. Dowdeswell ; and it has an extraordinary interest for the student, because, being quite simply hand-wiped, the proofs show the quality of Whistler's clean, delicate line in a way lost altogether by the artist himself in his desire to obtain atmospheric surface-effects by rag-wiping. In doing this, much of the ink was dragged from the lines, which became "thin." His result was a subtle gradation of tone in such plates, e.g. " The Long Lagoon," "*La Salute*— Dawn," obtained at a sacrifice of the line itself : the line, in my own impressions, being of a remarkable strength and precision with no less delicacy, but with little or no gradation of surface tone to help it.

Obviously such a plate as " Nocturne—Palaces " would not exist at all if printed in the same manner—the simplicity of the early Whistlers— but when a plate so perfect in its line as " Turkeys " is proved in this fashion, I, for one, infinitely prefer it to an impression of Whistler's own handling.

Later still, Whistler gave up this rather over-elaborate printing to a large

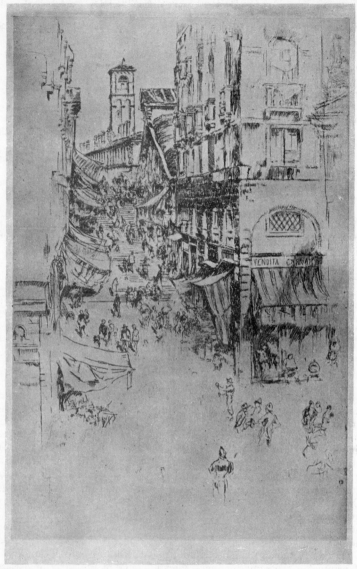

Etching.

11½×7⅛.

Plate 118

THE RIALTO. Whistler.

A TYPICAL EXAMPLE OF THE ARTIST'S EXQUISITE LATER MANNER. NOTE THE "VIGNETTING" BOTH IN
DRAWING & IN BITING.

From a proof in the collection of the author.

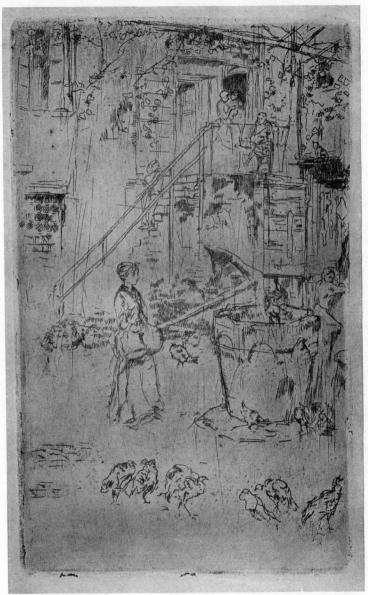

8¼×5¼.

Plate 119
TURKEYS. WHISTLER.

FIRST STATE.

ONE OF THE DAINTIEST & MOST EXQUISITE OF THE VENICE PLATES BUT LACKING THE SOLIDITY & INTIMACY
OF THE EARLY WORK.

From a proof in the collection of the author.

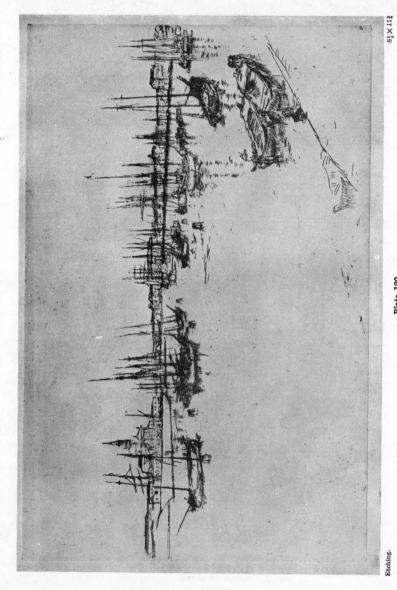

$8\frac{1}{8} \times 11\frac{3}{4}$

Etching.

Plate 120

SAN GIORGIO. WHISTLER.

3RD—4TH STATE.

THIS PLATE IS PARTICULARLY NOTABLE FOR ITS DESIGN & FOR THE RHYTHMIC BALANCE OF THE LINE OF MASTS.

From a proof in the collection of the author.

306

extent, but in his line-work he grew more and more sketchy; less and less intimate.

I hope that, because I am following what I feel to be the truth instead of the fashion, no one will imagine that I am endeavouring to belittle Whistler's later etchings. I do not think anyone can have a keener appreciation of their beauty than I. But although beauty may be one of the qualities of a work of art, it is not the whole of Art. In the narrower sense of the word it is not even a necessity, although a really great work is always *technically* beautiful.

To repeat: I am convinced that the young Whistler, both unsoured and unspoilt, was nearer in spirit—in humanity—to Dürer, Rembrandt and Meryon than the Whistler of the later etchings, though these may be more "beautiful." And does not Humanity count for more than all other qualities put together?

CHAPTER XXVI

THE MODERNS : AND THE REVIVAL OF THE GRAPHIC ARTS IN ENGLAND

IT is difficult for any artist to stand outside his own art as a critic may, and particularly so when called upon to review the work of his contemporaries.

Although practically a truism to say that every artist is biased in favour of his own manner of treating a subject, it is not true of an individual all the time. Contrary to the general belief, it *is* possible for an artist to judge dispassionately, and—it may necessitate conscious effort—to appreciate, fully, another's standpoint, even though diametrically opposed to his own.

I have always loved other people's prints and collected them even when I could not afford it, and I possess examples of nearly every modern etcher since the eighteenth century mentioned in these pages.

Adverse criticism of one's contemporaries—especially of those who are most popular at the moment—is ever looked upon as being the result of professional jealousy. As a matter of fact, I believe it is generally perfectly sincere though often mistaken.

Jealousy *in art* is to me as ridiculous as mock-modesty or conceit, and any one of them implies that the artist is thinking more of himself than his art. It should be, surely, a joy to him to discover great art, whether he himself or another was its creator ?

Jealousy also implies the inferiority of him who is jealous *in his own estimation*, though he will not admit it even to himself.

The only way to do good work is to believe that, sooner or later, you yourself will do the very *best* work ; and he who so believes can never be jealous of anyone.

That there is an amazing revival of fine draughtsmanship in Britain at the present time (1924) should be patent to anyone who has eyes to see. It began before the war with etching and lithography, and since the war has included black-and-white woodcut.

In England, after Whistler and Haden had produced their best work a great number of etchers grew up who followed too closely in the footsteps of one or the other, sometimes both.

These men—I was one of them—believed that everything had to be sacrificed to the inspiration of the moment—the sketch was what it amounted to in most cases—and though much of the output on these lines was vital it was not based on solid foundations, and consequently could not be built upon without sooner or later toppling over.

Following Whistler's later and weaker manner everyone tended to

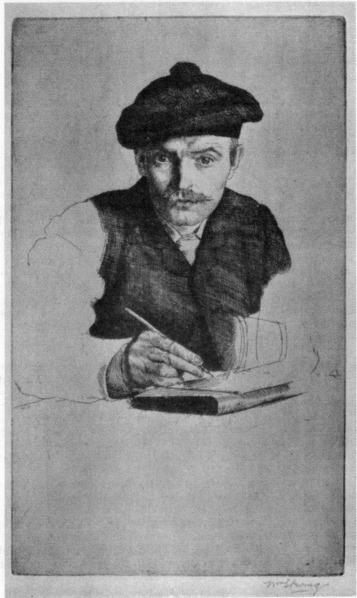

Etching. 7⅛×4⅜.

Plate 121
SELF PORTRAIT. STRANG.
ONE OF THE MOST SEARCHINGLY DRAWN & INDIVIDUAL OF THE ARTIST'S PLATES.
From a proof in the collection of the author.

309

vignette; to indicate; suggest; "feel" for form in a vague indeterminate way; to fear all positive statement, and the carrying through of a drawing upon the copper to the bitter end. It was easy and "artistic," but led to chaos and oblivion as the easy road must.

The inevitable revolt came, as it was bound to come, and a return to individual study of nature and the fundamental laws governing art, rather than nature-study through the medium of Whistler. In other words, men began to look for *themselves*, as Whistler and Haden had done.

This caused a revival of the study of the older masters, and, in etching, Rembrandt again became *the* master, just as in some other mediums the young men reacted to Italian Primitivism, throwing over the Impressionism of Velasquez, who was the master of Whistler and his school.

Men saw also that Impressionism carried to its logical extreme became an absurdity : that a slice cut from Nature was not necessarily art. They cast about for the secret of the bigness of Design shown in the work of the great masters even when their drawing was unrealistic or distorted, and for the moment this distortion in one or two of the masters who showed great power of design—e.g. El Greco—was mistaken for a necessary, integral part of that design.

There is no need to go into the eventual development of this theory of distortion until all idea of making shapes represent anything objective was abandoned and we had the full tornado of Cubism upon us, as etching itself was only very slightly affected by the movement : not in the least in its main evolution.

None of the biggest men went off the track, and it was only natural that some of the beginners should be temporarily upset ; but most artists who wished to express themselves in modern terms took up the wood instead of the metal.

To indicate how "modern" these terms were I should note that some years ago I found in the Tibetan monasteries of Ladak wall decorations showing precisely similar influences ! The only difference between them and the modern European works being that those of Tibet are far more beautiful !

I take it that the reason why so few etchers were included in this movement was that to be a great etcher a man must be peculiarly sane and yet sensitive and alive ; and at the time the great etchers in this country were also the majority of its greatest draughtsmen. Eliminate such names as Bone, John, Brangwyn, Clausen, Cameron, Blampied and McBey, and abroad Bauer, Forain and, in his own line, Benson from modern draughtsmen, and it is a very serious matter indeed. None of these men showed the faintest trace of the modern movement, and every one of them has been—more or less directly—influenced by Rembrandt.

The spirit of unrest had, of course, manifested itself in France (and among the continental peoples generally) before it showed itself in Great Britain, and not by any means only in the Graphic Arts. Whistler's impressionism was but part of a big movement in Paris imported thence

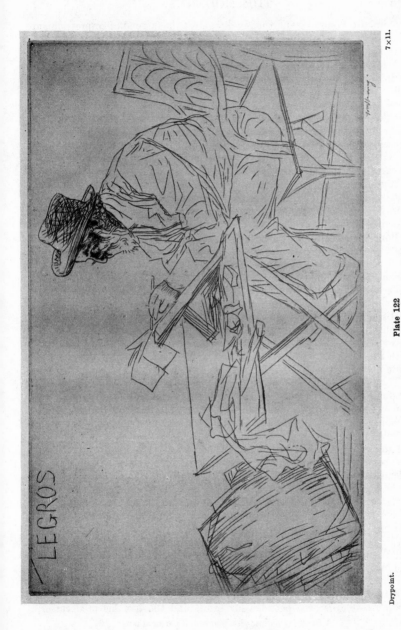

Drypoint.

Plate 122

PORTRAIT OF LEGROS. STRANG.

THIS IS AN EXCELLENT EXAMPLE OF OPEN DRYPOINT LINE.

From a proof in the collection of the author

7×11.

by him into London ; and the revolt against the fag-end of Impressionism abroad was the outcome of the same logical impulse as that against the Whistlerian in this country.

Every phase of artistic manifestation must have its impetuous uprush in infancy ; its vigorous, controlled maturity, and its decadence ; and when the last sets in it is time for the new generation to revolt. It is then only natural that the youthful enthusiasm of the revolutionaries should blind them to anything fine that there may have been in the *maturity* of the last phase, their eyes being fixed upon the immediately preceding *decadence*.

But to return : while the majority of English etchers were endeavouring to carry on the later Whistler tradition—Frank Brangwyn was the notable exception—several Scotsmen were coming to the front, who, though technically influenced by the American, eventually checked the decay. These were Strang—at the time largely under the spell of Legros—Cameron, who founded himself upon Meryon, and Muirhead Bone.

Bone is undoubtedly the supreme master of drypoint, and one of the great etchers in the history of the art. Such plates as the " Demolition of St. James's Hall—Interior " **(Plate 132)**, "Ayr Prison " **(Plate 133)**, " San Frediano, Florence," " South Coast, No. 2," " Leeds Warehouses," " The Shot Tower," to name a few from memory, are masterpieces, and one can say no more of any work.

His drawings—many of them—are equally great, but are not yet " collected," as drawings are not in fashion.

No one—not even Rembrandt—has handled the burr of the medium, with its capability of yielding both extreme richness and delicacy, with more power and certainty.[1]

To my mind, **Strang** did a great deal of spade-work of which others will reap the benefit, but he was rarely himself, though often very nearly so. Some of his portraits of men, however, are very fine indeed, and genuinely personal expressions ; but often his work commands one's respect while it fails to move.

Cameron has probably done more than any man to popularize etching, and some of his architectural plates are very notable. I have already referred to the " Chimera of Amiens " **(Plate 135)**, which, in my opinion, is the best of all his etchings. In it, moreover, one may see most clearly both the strength and the weakness of Cameron's art. Technically it is superb : far finer than its prototype *Le Stryge* : it is beautifully etched and finely spaced. It is also as personal as the Meryon, but it lacks what all Cameron's plates lack—humanity. One feels that the etcher was interested in Etching : not in expressing Life through the medium of etching.

His chief appeal lies in his black-and-white *pattern* (see **Plate 136**) which tells richly when hung in a quiet-toned drawing-room. In this one feels the greatest difference between his prints and those of his predecessor,

[1] See next chapter for plates and personal notes.

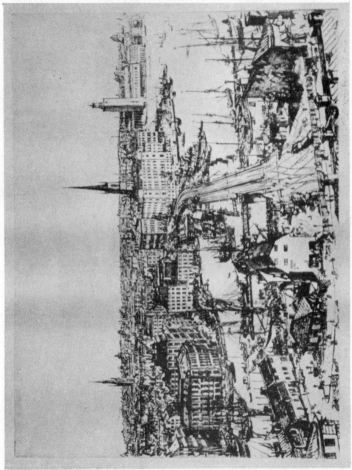

Drypoint.

$8\frac{7}{8} \times 11\frac{7}{16}$.

Plate 123

STOCKHOLM. MUIRHEAD BONE.

THIS IS NOTEWORTHY FOR ITS COMPLETE TECHNICAL MASTERY & BEAUTY OF DRAWING IN THE SHIPPING.

From a proof in the possession of the artist.

Whistler. The average Whistler does not—nor was it intended to—
decorate a wall. At a little distance the delicate expressive lines vanish,
while the black masses of the Cameron—especially the later Cameron dry-
point—tell better than when looked into too closely.[1]

One of the greatest masters of etching—certainly of to-day and, I think,
of all time—is Marius **Bauer.** In this country only the few appreciate him
so far. He is extraordinarily versatile in the treatment of his plates and
can vary his scale with equal facility. For instance, his " Siege of Con-
stantinople " is only 4 inches in length and ⅝ inch in depth, and yet, in
its few delicate lines, suggests the bigness of a mural decoration ; while
his " Porch of a Mosque," a wonderful, rich interior, broadly and freely
etched, is nearly 2½ feet in height and 2 feet broad. It is, in my opinion,
one of the greatest prints since Rembrandt, and a direct descendant of
the "Three Crosses."

Between these extremes of scale there is a wonderful series of plates,
some mere suggestions, like the delicate drypoint "Stamboul Bridge,"
done in a few strokes, of which the subject is not a bridge, but the tired
wayfarers ; others, like the "Amiens Cathedral," having an intricate lace-
like pattern covering the entire surface of the copper. Every one of them
is full of intense human feeling and deep emotion. I think no one living
can approach Bauer in the luminosity and pattern of broad shadows seen
in such monumental plates as " The Entrance to a Mosque," " The Entry
of a Queen " (**Plate 124**) and "A Sultan " (**Plate 125**). " The Entry " has
surely never been surpassed even by Rembrandt.[2]

Another very great foreign etcher, now a veteran, is **Forain.** His later
prints are so different from his earlier that it is like looking at the work
of another man. In his case it is only the late work which is significant,
and some of it is of the very first rank.

He, like Bauer, follows Rembrandt very closely, yet he also resembles
the modern Dutchman in being intensely himself.

He has influenced the younger men in this country very much in recent
years, though one of those who succumbed to his domination was of the
older generation—Strang. His actual style—even more so than that of
Legros—is a dangerous one for another to build upon. The follower is
apt to take hold of the mannerism rather than the truth of draughtsman-
ship which lies beneath. In his plates of the law-courts, Forain is deeply
indebted to his greater predecessor in France, Honoré Daumier, whose
lithographs contained even more dramatic force than the etchings of the
living artist (**Plate 126**).

Forain came entirely into his own, however, in his series of *motifs*
taken from the Life of Christ, and, in them and his remarkable
Lourdes set, carried the art of elimination of unessentials to an
extreme.

Le Retour de l'Enfant Prodigue (4th plate) is one of the simplest and

[1] See next chapter for plates and personal note.
[2] For notes by the artist and further plate see next chapter.

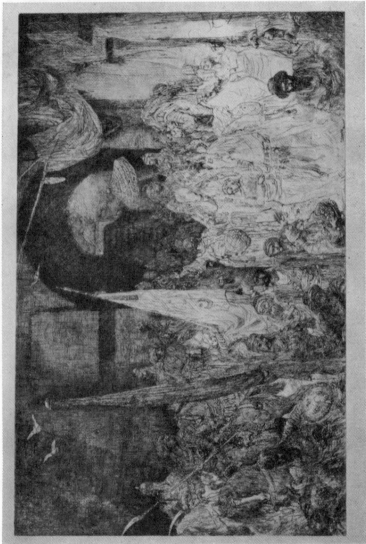

12×18¼.

Etching.

Plate 124

THE ENTRY OF A QUEEN. M. A. J. BAUER.

THIS IS ONE OF THE MOST REMARKABLE OF MODERN PRINTS & ITS DESIGN & REALIZATION OF DETAIL IS STUPENDOUS.

From a proof in the collection of J. D. Pollock, Esq., M.D.

315

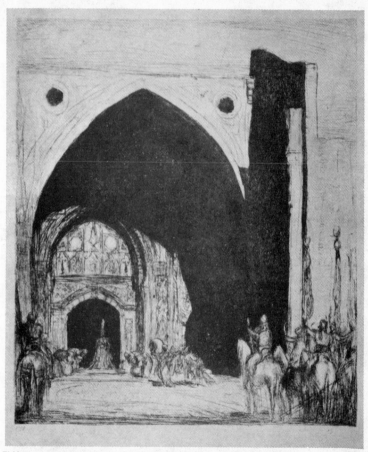

16¼ × 15.

Plate 125

A SULTAN. M. A. J. BAUER.

NOTE THE ORIGINAL USE OF THE GREAT SHADOW IN BUILDING UP THIS IMPRESSIVE DESIGN.

From a proof in the collection of J. D. Pollock, Esq., M.D.

most moving of etchings, and yet in it Forain shows his indebtedness to Rembrandt most clearly (**Plate 127**).

The quality in which he is pre-eminent—I think nowadays without rival —is his sense of the dramatic in human affairs.

I well remember when Mr. Dodgson showed me a number of Forain prints some seventeen years ago that they seemed to me just sketchy Rembrandts. Probably I said as much, and, if so, Mr. Dodgson wisely said nothing. Yet in one—the least important—sense, that was a true criticism. As a student, I was unable to see (as I see now) that one master may obviously found himself upon the work of a greater and yet keep his own individuality and be able to say something for himself.

The youth who is trying to learn *how* to do things is more interested in the *manner* than the matter. But to the man who has mastered his own technique, the technique of others ceases to be of primary importance. *He* can pay more attention to the *matter*. He then realizes that there are other points of view besides his own, all equally right.

" In my Father's house are many mansions." One can forgive a hot-headed student for being dogmatic, and intolerant of work which is expressed in a form unlike that which he is trying to master. But an intolerant, dogmatic old man is very different. He is not only intolerant but intolerable.

There have been many other very good etchers in modern France, but none that, in any work which I have seen, can be ranked with Forain. One can hardly help thinking of **Steinlen** because his work came so near to being first-rate. He may have done an exceptional plate now and then which really lifted him into the first rank, but I have never seen one. The same applies to that most prolific worker **Lepère**. Twenty years ago his work stood out from the average mediocre production, but now he has been easily surpassed by several late comers. Twenty years ago Forain had hardly begun to find himself although already in his sixth decade ; none of the younger British etchers had produced his great work, and Bauer was hardly more than beginning to be known. Forain's name is not even mentioned in the 1st edition (1908) of Mr. Hind's " History," while Bauer has but a meagre five lines. Reputations have changed since then !

Another foreign etcher—a native of Sweden—who has had considerable influence upon all the modern schools is **Zorn.**

Few men create more than a small number of master-works, but in Zorn's case the gap which separates his " Renan " (**Plate 128**) and the relatively small number of really fine works from his average production is to me far greater than in the case of most artists.

I have studied Zorn's etchings for fully twenty years, and I cannot yet feel that many of them are in any way great works of art. To me the majority are intensely clever but entirely superficial. Zorn etched considerably from his paintings, and he thought in terms of brush-marks rather than in line. He skilfully avoided the searching draughtsmanship

Etching.

15¼ × 19¼.

Plate 126

LA FILLE MÈRE. FORAIN.

FIRST PLATE.

THIS PLATE, WHICH SHOWS THE INFLUENCE OF DAUMIER, IS A TYPICAL EXAMPLE OF THE ARTIST'S POWER OF
CHARACTERIZATION EXPRESSED IN A FEW STROKES.

Etching.

Plate 127

LE RETOUR DE L'ENFANT PRODIGUE. FORAIN.

4TH PLATE. 2ND STATE.

THIS MOVING WORK SHOWS THE INFLUENCE OF REMBRANDT MOST STRONGLY & YET IS VERY INDIVIDUAL

From a proof in the collection of Campbell Dodgson, Esq., C.B.E.

11¼ × 17¼.

which is necessary in order to render form with the point, and though he had great vitality, his outlook was usually commonplace.

Having said all this, let me hasten to give him full credit for an undoubted masterpiece—" Renan." It is a work which holds its own by the master-works of any time. In this *tour de force* Zorn must have been moved to an utterance far beyond his normal capability—at least, that is the only explanation I can find—for rarely does he approach this level : hardly even in *L'Irlandaise* and " Mona." An exceptionally fine study of an old man is *Djos Mats*. In such a popular plate as " King Oscar II," Zorn sinks to the level of the snapshot. On the other hand, from a purely technical point of view his plates are very equal, which is also significant.

Brangwyn[1] has already been mentioned as the outstanding Englishman to break away from the Whistler thrall. His huge plates were anathema to the followers of that school, and though I admit I have no great love for the majority of them, it is not on account of their size but because of the way in which they are printed. Almost clean-wiped, I cannot but think they would be very much finer. So printed, without the over-elaborate painting upon the surface, some of these great plates would rank amongst the masterpieces of etching (see **Plate 140**). The splendid arrangement is always visible, but the superb draughtsmanship is, more often than not, obscured. It is the more strange, to me, that this giant among moderns should have failed to realize the value of the unfaked "state of the plate," because he shows how perfectly he understands the quality of the simple line in his magnificent woodcuts.

Clausen[1] is an artist of an older generation who has shown his great individuality upon the copper as well as in paint.

The few plates that I have seen are extremely beautiful, showing his deep sympathy with the worker on the land, and are examples of how even a comparatively elementary technique can express the ideas of a man who knows exactly what he wants to say. One of the finest is reproduced in the next chapter (**Plate 134**).

Of the younger men who showed no trace of the Whistler influence, but on the contrary went directly to Rembrandt, is Augustus **John**.[1]

His self-portrait, *Tête farouche* (**Plate 138**), Jacob Epstein, C. McEvoy (**Plate 139**) and several others are amongst the finest of modern prints and have curiously escaped the booming which many inferior productions have undergone. They are drawn with a delicate, sensitive, Rembrandt-esque line and are very personal ; very beautiful.

Much as I disagree with the dogmatic and partisan utterances of Joseph **Pennell** in print, I admire many of his sayings on copper. Though founded on Whistler, they are yet personal and sometimes very fine indeed. To his work in aquatint I have already drawn attention in the chapter on that method. Pennell's plates must be seen in series to obtain the best from them—his attitude is always that of the pictorial journalist—and that is why most individual plates are a little disappointing. Nevertheless

[1] These artists' personal notes, with the plates, will be found in the next chapter.

Etching.

Plate 128

PORTRAIT OF RENAN. ANDERS ZORN.

THE TECHNIQUE IS TYPICAL OF ALL ZORN'S WORK, BUT THE EXPRESSION OF CHARACTER PLACES THE WORK AMONG THE
MASTERPIECES OF PORTRAITURE.

From a proof in the collection of Campbell Dodgson, Esq., C.B.E

$9\frac{3}{4} \times 13\frac{5}{8}$.

he has done a great work, and a few of his later plates, notably those dealing with Pittsburg with its smoke and dirt, are masterpieces.

Amongst the men who are still actively producing is **McBey**.[1] He early came under the influence of Rembrandt, then of Seymour Haden and Whistler, and finally of Forain, but in all these phases he retained his own individuality ; now more, now less. The war acted upon him as a great stimulus, as upon many others, and during that period he produced some very fine plates : notably the " Sussex " (**Plate 141**). The *motif*—sunset behind the vessel—reminds one inevitably of Haden's masterpiece, but the treatment is his own, and it is a work to live with. There are many prints of almost equal quality of this time ; but not until the artist was sent with the Australian Camel Corps to the desert did he find inspiration for plates fully entitled to rank with the " Torpedoed Sussex."

Such were " Strange Signals " and " Dawn," and in many ways I think they are a more personal expression than anything McBey has given us. " Strange Signals " (**Plate 142**) is a very original design and contains the very essence of the desert, as none knows better than I. It contains also the chief characteristics of the artist : his impulsiveness, his sense of the dramatic, his strength combined with delicacy of handling.

Another man who drew amazing inspiration from the war, and whose sense of the dramatic is second to none, is **Percy Smith**.[1] The present-day public is incapable of judging his " Dance of Death " (**Plates 145** and **146**) purely from the æsthetic point of view. It does not wish to be reminded of the all too recent bitterness of loss, but in time to come these plates will, I feel sure, be looked upon as the most searching commentary on the horrors of the Great War produced in this country : perhaps in any.

Two men who in collaboration produced some very fine plates in the manner of engraving were the brothers **Detmold.** More recently the surviving brother has etched a variety of subjects and in several different styles. By far the finest are those in which the artist is working from actual facts and in the manner adopted originally by the pair. Such is the splendid Dürer-like study of a chained eagle, " The Captive." From his oriental plates, however, it is quite impossible to believe that the etcher knows anything at first hand of the East, though it is presumably hardly from ignorance that he endows the Indian cattle with buffalo horns, makes his elephants thirty feet high and plants banana trees in the desert ! Notwithstanding these " artistic licences," some of these plates have a great deal of feeling and atmosphere.

I have already referred to the very important work in aquatint of John **Everett**[1] (**Plates 151** and **152**) and his pupil (in the medium) Mrs. **Laura Knight**[1] (see Chapters XIII and XXII). In his studies of sailing ships, Everett has struck a new note, and his technical control is extraordinary. Mrs. Knight's figure-subjects, based on the Goya tradition, show tremendous power in design and draughtsmanship and are technically faultless.

[1] These artists' personal notes, with the plates, will be found in the next chapter.

They will probably wait some time for recognition, as their subjects are not likely to appeal to the average collector (**Plates 149** and **150**).

Blampied [1]—a native of Jersey—is one of the most individual draughtsmen now living, and his plates (**143** and **144**)—more especially his etchings than his drypoints—are almost as fine as his pen drawings.

He is largely a specialist, and his study has been horses. Probably no draughtsman knows the horse so intimately as he, and he has the power of expressing that knowledge. But Blampied has also a most intimate understanding of the peasant of his native country-side, and it is his great humanity which appeals so directly and so rightly to the public. His drawing of the " Sick-mother " is one of my most valued possessions, and I only hope he may use the *motif* for interpretation on the copper.

A man whose work is the antithesis of the Whistler tradition, whose technique is superb, and who has something to say with it, is **Griggs.** There is a peculiarly satisfying quality about his best prints—engraver-like though they are—which means that, however much he has elaborated his careful and deliberate work, he has successfully retained his *idea* from start to finish, and this is surely a hall-mark of great work—if the idea is of value in the first place.

Nevinson [1] has done some most interesting work in several mediums and should do still more vital work if he becomes sufficiently absorbed in any one branch of human activity. Some of his plates of the French front during the war showed what he could do when moved. " That Cursed Wood " (**Plate 147**) is a drypoint of distinct personality, and contains something more than a merely objective representation of the battle area. His little etching " In Suburbia " (**Plate 148**) is also full of genuine observation of life.

Among the younger Englishmen, **Wheatley, Rushbury, Brockhurst** and **Nixon** have all done plates which are notable, but all still have their work ahead of them.

Particularly fine is Wheatley's bold, drypoint profile " Old Rogers." Brockhurst is very personal in his etchings of women, though he is still more convincing, to me, in his delightful pencil drawings. Rushbury's " Les Baux, Provence," is a drypoint of great power and points to good things in the future ; while much may be expected from the young artist of the " Italian Fiesta," Job Nixon.

Noteworthy plates have also been produced in recent years by **Malcolm Osborne, J. W. Nicolson, Westley Manning, George Marples, W. P. Robins, Herbert Whydale** and **William Larkins,** whose " Underwood St., Whitechapel," is a fascinating little work.

In France, **Auguste Brouet** must be mentioned as the etcher of a number of interesting plates ; while, judging by the few I have seen, still higher rank must be accorded to the works of the Spanish-born **Pablo Picasso.**

It is difficult for us on this side of the Atlantic to have much knowledge of the American and Canadian etchers : I mean of those men who stay

[1] These artists' personal notes, with the plates, will be found in the next chapter.

in their own land. We know of those who come to Europe : of Pennell and Maclaughlan, but there must be men of outstanding merit who are at present unheard of in this country.

But one at least is well known here, and very justly : Frank **Benson.** Ilis studies of wild-fowl and other birds are wonderful (see **Plates 130** and **131**),[1] and mark him as a man apart, holding a place in the collector's heart which will, I am sure, be permanent. In his best work, both etched and drypoint, Benson is among the great etchers. His feeling for movement is at times astonishing.

A younger American who has done a few remarkably beautiful, pure line plates is Louis **Rosenberg.** His " Isola Tiberina " is an exquisite little etching, somewhat on Whistler lines, yet quite personal.

I don't know anything more distasteful than the making of more or less invidious distinctions between the works of my own contemporaries. One can never pre-judge any artist's life work. Some " find themselves " at the beginning : others not till the end of their lives. I may have over-estimated the work of some : underestimated that of others. Without the time at the disposal of the professed critic one can see but a small proportion of any one man's work, and, the chances are, happen upon the least representative side of it.

Although restricted here to the discussion of etchers only, I should be very sorry to give the impression that the extraordinary revival of Black-and-White in London, of late, has been confined to workers in that medium. Perhaps the most vital movement of all has been that of the woodcut group. Then there has been splendid work done in lithography, and besides, we have magnificent draughtsmen who have taken up no reproductive medium.

I must not mention even a few of the great names connected with these various activities ; but it is a period in which we may well be proud to take some part, though I doubt if many realize how high the general standard of draughtsmanship has been pushed, and how much more severe the appraisement nowadays before a man's work is accepted as of outstanding merit.

I salute all genuine etchers : past, present and to come.

[1] See next chapter for plates and personal notes.

PART IV

CHAPTER XXVII

PERSONAL NOTES BY EMINENT ETCHERS ON THEIR METHODS

THE following personal notes upon their technical practice have been very kindly contributed by the artists expressly for this book. On such a subject a definite assertion by the etcher himself must necessarily be of far more value than suppositions by any one else.

The student will see, at a glance, in comparing the methods of these eminent craftsmen, that there is no " royal road " in etching. One man produces great work by means of methods abhorrent to others of equal authority. It is for the beginner to discover the technique best suited to his own temperament : to what he wishes to express.

In the earlier chapters I tried to show authentic examples of the technical processes reviewed, and therefore relied exclusively upon my own plates, even where this entailed the employment of a method hitherto unfamiliar, e.g. the perchloride-of-iron bath.

Here I have selected some of the best from the *œuvre* of each modern specialist whose technical preferences are given—more or less fully—in the individual's own words

NOTES BY M. A. J. BAUER

Plates.—The big plates are mostly copper, but many of the little earlier ones are of zinc, e.g. " Mecca Pilgrims," " Street in Constantinople," " A Fountain ; Stamboul," " Horsemen under a Gate," " Market Day," " Wall of the Harem," are all zinc.

Ground.—I never use the roller.

Acid.—I always buy salt-petre[1] acid at the chemist's, and generally take one-half water and one-half salt-petre, but not exactly. Sometimes (the acid) nearly without water ; it depends on the etching. I have no regular proportion and strength. I do my biting rather quickly, and prefer to spoil the plate than to do it systematically. It is always a question of feeling.

Method.—I never made any etching from drawings, but make the composition directly on the plate. Usually I begin with one figure and the composition grows little by little, though I have the whole in mind.

No, I never etched out of doors (from nature).

[1] Nitric. See Chapter VI.

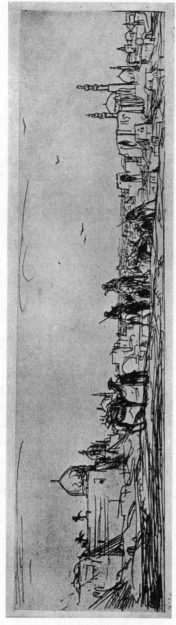

Etching. $3\frac{1}{4} \times 13\frac{1}{2}$. $3\frac{1}{4} \times 13$ *Etched Surface.*

Plate 129

MECCA PILGRIMS. M. A. J. BAUER.

THIS BEAUTIFUL PLATE SHOWS THE ARTIST'S POWER IN THE USE OF SIMPLE, EXPRESSIVE, VITAL LINE AT ITS BEST.
NOTE THE RHYTHM OF THE DESIGN. THE PLATE WAS KING.

From a proof in the collection of J. D. Pollock, Esq., M.D.

Plates.—I use zinc rarely ; copper usually.

Ground.—Sand's[1] ground.

Acid.—I have only used Dutch mordant twice, and find it does not suit my manner of working. I have long given up the bath. I flow the mordant on the plate where I want it with a feather or brush, and, because of the thicker consistency of perchloride, I find I use this generally, though it shows the progress of the work less well than nitric. Sometimes I brighten all the lines with the latter to see where I stand, and finish the heavier parts with this mordant.

[Mr. Benson adds, in the course of his very interesting letter, the following passage, which should be instructive to the genuine student and also to the collector :]

Birds were the passion of my youth, and I drew them until I was middle-aged with no thought that they might prove interesting to others than my sportsmen friends. You will realize that a subject of this nature will hardly ever pose for one, and my pictures of wild-fowl are entirely the result of things seen in nature and drawn from memory. I try to make them part of the landscape in which they occur, rather than to describe them as specimens. The thing that I most enjoy about them is their *wildness*. Once or twice I have drawn captive geese or a tame pelican, but the best results I get on shooting expeditions where I watch for the things that I want and afterwards fix them (or fail to fix them) in drawings.

[1] This is a good old English make of ordinary ball ground. It is used considerably by process etchers.

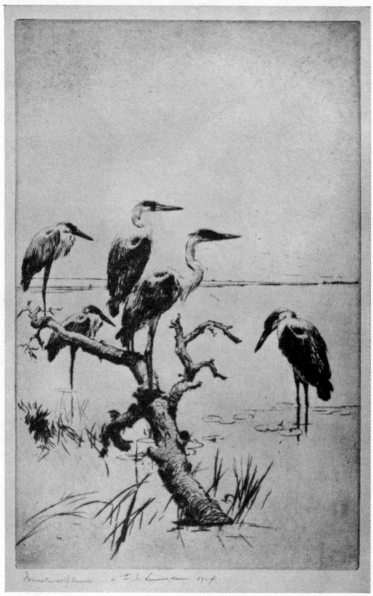

Etching. 11⅞ × 7¾.

Plate 130

HERONS AT REST. FRANK W. BENSON.

A NOTABLE EXAMPLE OF THE ART WHICH BENSON HAS MADE EMPHATICALLY HIS OWN.

From a proof in the collection of the author.

329

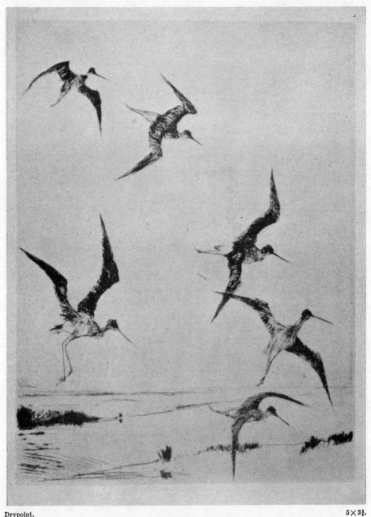

Drypoint. 5 × 3¾.

Plate 131
SUMMER YELLOW-LEGS. FRANK W. BENSON.
THIS EXQUISITE PLATE IS NOTABLE BOTH FOR DESIGN & OBSERVATION.
From a proof in the collection of the author.

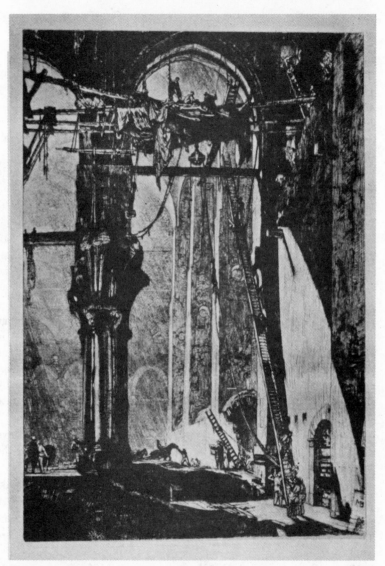

Drypoint. 15¾ × 11¼.

Plate 132

DEMOLITION OF ST. JAMES'S HALL—INTERIOR. MUIRHEAD BONE

TRIAL STATE.

THIS PLATE SHOWS THE EXTRAORDINARY DEPTH & LUMINOSITY WHICH CAN BE OBTAINED FROM THE BURR
OF DRYPOINT IN THE HANDS OF A SUPREME MASTER.

From a proof in the collection of the author.

I have not examined the matter carefully, but I suppose about half my plates have been done straight from nature, and the other half in my studio from drawings. "Ayr Prison" was done in the studio with the help of a slight jotting, but really from memory.

The "Shot Tower" was done leaning on the Thames Embankment wall opposite (and very hard work it was !).

Both the plates of St. James's Hall (Plate 132) are compositions made from sketches ; but most of my country plates have been done direct on the copper from nature, as one works there under comfortable conditions, and the important thing to preserve is the feeling and freshness.

"Orvieto" was done on the spot and finished in the studio ; "San Frediano," "Rainy Night in Rome" and "The Dogana" from drawings. "The Fish Market, Venice, No. 1," was done out of doors ; also the "Somerset House," which is one of the largest plates I have ever done on the spot.

One certainly gets a freshness and vivacity in plates done direct, but it precludes the possibility of carefully digested composition, and it is exceedingly difficult, out of doors, to return to work day after day as one does, say, in the case of an oil-painting. Often, too, one gets a simpler, better statement of the particular sentiment or "theme" of a scene by doing it from memory or a very rough sketch ; and in that case elaborate drawings made from Nature are more often a hindrance than a help.

"Ayr Prison" (Plate 133) was worked entirely with a diamond. I have split many diamonds, and one is particularly liable to do this on the *edge* of the plate.

"The Demolition of St. James's Hall" (interior) was done, I think, altogether with steel.

"St. Peter's from the Pincio" was one of the comparatively few zinc plates. It only gave about three impressions. The others mentioned were copper.

Messrs. Brooker and Co. kindly make up my ink for me, and I thin it when necessary. In inking-up I use the dabber, but it certainly isn't very satisfactory and I must try the roller.

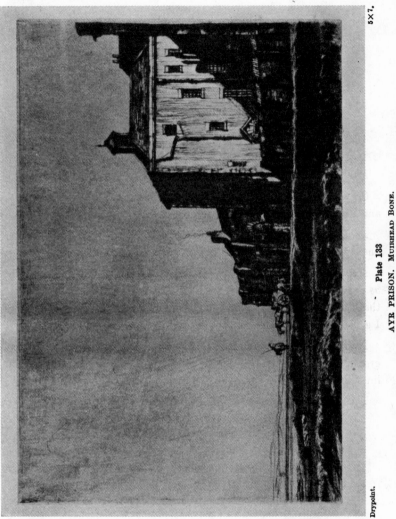

5×7.

Drypoint.

Plate 133

AYR PRISON. MUIRHEAD BONE.

THIS IS UNQUESTIONABLY ONE OF THE MOST PERFECT PLATES EVER EXECUTED IN THE MEDIUM.

From a proof in the collection of E. R. Bacon, Esq.

333

Notes by George Clausen, R.A.

Plates.—I work both on copper and on zinc.

Ground.—I ground the plate with the dabber in the old-fashioned way, and stop-out, etc., in the orthodox manner.

Acid.—A 50 per cent solution of nitric acid for copper, and a weaker one (I am not very exact about these things, I'm afraid) for zinc.

Method.—I always make a drawing and work from that. I like to print *as clean as possible*. I think the visiting card is the ideal of printing, i.e. that the plate *should* give you what you want when wiped clean ; though I generally " drag " the ink a little here and there.

I am so much of an amateur in this work that I've no claim on technical grounds. What I try to do is to get the thing expressive with as few lines, and in as simple a way, as possible.

This plate, " Filling Sacks " (Plate 134), was an old hammered copper.

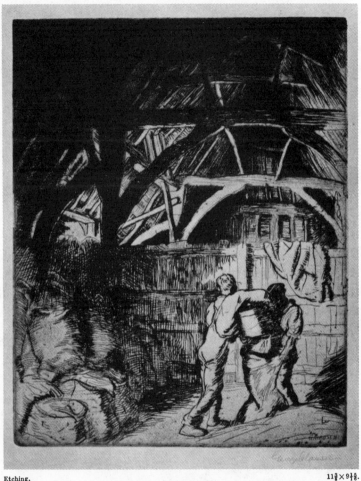

Etching. 11¾ × 9⅛.

Plate 134

FILLING SACKS. GEORGE CLAUSEN, R.A.

IN THIS BEAUTIFUL & INDIVIDUAL PLATE WE SEE THE INFLUENCE OF JACQUE STILL VIRILE.

From a proof in the collection of the author.

Notes by Sir D. Y. Cameron, R.A.

Plates.—I always use copper.

Acid.—The strength of my acid (nitric) is of little interest to me.

I always judge of lines by taking the plates out and examining them.

I have no science whatsoever and no data of any importance for students.

I never use a feather with acid now, and only in my early days did I do so.[1]

[1] This presumably refers to the method of playing the acid on the plate as noted in Whistler's later manner : not to removing bubbles from the lines.

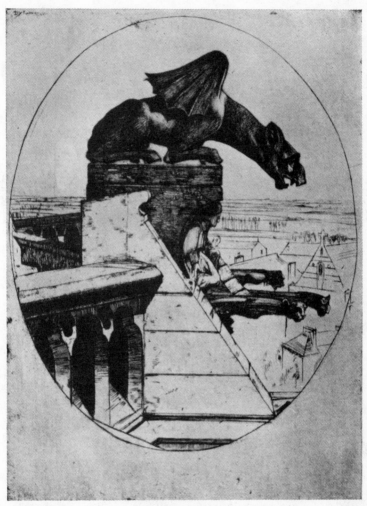

Etching & Drypoint. 9¼×7¼.

Plate 135
THE CHIMERA OF AMIENS. Sɪʀ D. Y. Cᴀᴍᴇʀᴏɴ, R.A.
TRIAL STATE.
Iɴ ꜱᴘɪᴛᴇ ᴏꜰ ɪᴛꜱ ᴏʙᴠɪᴏᴜꜱ ᴅᴇʙᴛ ᴛᴏ Mᴇʀʏᴏɴ, ᴛʜɪꜱ ᴘʟᴀᴛᴇ ɪꜱ ᴠᴇʀʏ ᴘᴇʀꜱᴏɴᴀʟ & ᴛᴇᴄʜɴɪᴄᴀʟʟʏ ꜱᴜᴘᴇʀɪᴏʀ
ᴛᴏ ɪᴛꜱ ᴘʀᴏᴛᴏᴛʏᴘᴇ.
From a proof in the collection of R. K. Blair, Esq.

337

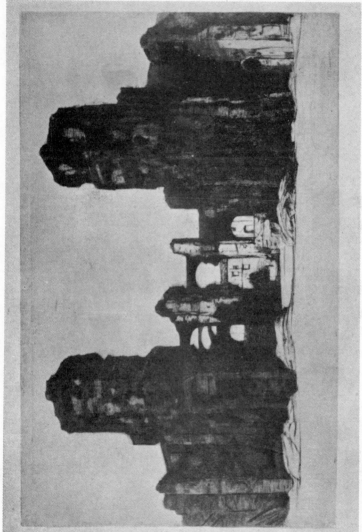

Etching & Drypoint

Plate 136

THERMAE OF CARACALLA. Sir D. Y. Cameron, R.A.

TRIAL STATE.

THIS IS A VERY GOOD EXAMPLE OF THE ETCHER'S DESIGN BY MASS.

From a proof in the collection of the author.

$10\frac{3}{8} \times 16\frac{5}{8}$

"A Span of Old Battersea Bridge." Aquatint.

Plate.—Copper.

Ground.—That of the distance through the span was a spirit-ground to give an air of transparency as opposed to the dust-ground for the bridge, which is more sodden in sympathy with the old timbers.

The bridge part was got on the plate, in the first instance, by biting through bichromated gelatin, using for the transfer by light a chalk-and-wash drawing on thin paper made transparent by varnish.

This was afterwards strengthened by soft-ground and by re-biting with other aquatint grounds—possibly two or three.

The distance was done last by ordinary stopping-out.

Acid.—Perchloride of iron and nitric were the baths used.

(*Continued on the next page*)

"Curfew : Rye."

Plate.—Copper.

First or Line State.—This was drawn from nature, and sand-paper was used a little to cause fouling, in order to suggest the broken quality of the old timbers.

Acid.—$\frac{1}{3}$ nitric to $\frac{2}{3}$ water.

Second or Aquatint State.—A fine resin spirit-ground was laid, and bitten in five gradations with the same acid : one bubbling being sufficient for the first, and the time increased for each successive biting.

A gradation was obtained in the water by dipping the plate in edgeways.

I think the " Whitby Scaur " might be interesting to students. There were two spirit-grounds, that of the mid-distance and foreground being laid with the direction of the grain horizontal ; while that of the sky around the glare of the rising sun was laid with a radiating grain obtained by whirling the plate (in this case upside down) during the process of formation[1] of the ground.

This was done to help the radiation of the light from the sun.

This plate was also bitten with nitric acid.

I have also used the Dutch bath of the usual strength.

[1] i.e. the drying.—E.S.L.

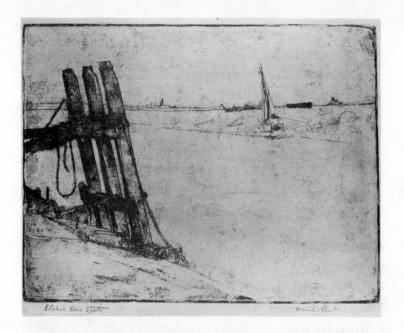

Etched line state

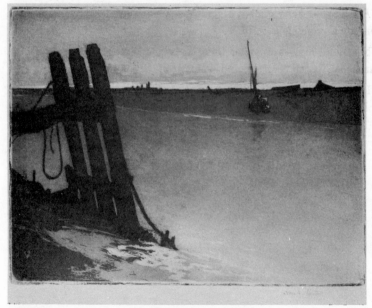

Aquatint. 6 × 7⅞.

Plate 137
CURFEW, RYE. Sir Frank Short, R.A.

These two states show the ordinary procedure of using the etched line as a guide to the tone
process. There is sand-grain fouling upon the timbers in the first state.

From proofs in the Victoria & Albert Museum.

Notes by Augustus E. John, A.R.A.

Plates.—Copper.

Ground.—Rhind's.

Acid.—Nitric and Rhind's " English Mordant."

Nearly all the plates were drawn direct from Life or imagination.

In biting, the plates were mostly submerged.

Printing.—I have printed a great many myself, but have had editions done by a professional printer.

Nearly all my plates suffer from hasty and inaccurate biting. " Tête Farouche " is too coarsely, and " McEvoy " equally under, bitten.[1]

I have rarely used drypoint, and then only by way of reinforcing the etching, and with only doubtful success.

[1] I cannot endorse the artist's opinion of the biting of these two plates.—E.S.L.

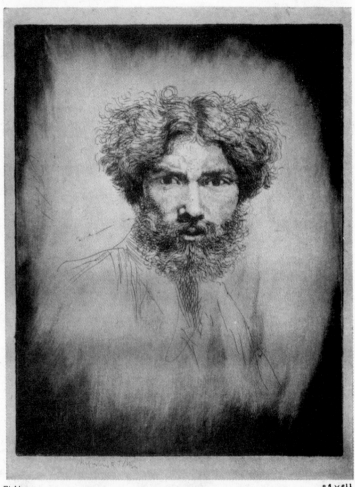

Etching.

Plate 138

$8\frac{4}{16} \times 6\frac{11}{16}$.

TÊTE FAROUCHE. Augustus E. John, A.R.A.

This early self-portrait is certainly one of the most interesting—perhaps the finest—of
the artist's plates. The vignetting is a matter of printing only.

From a proof in the collection of the author.

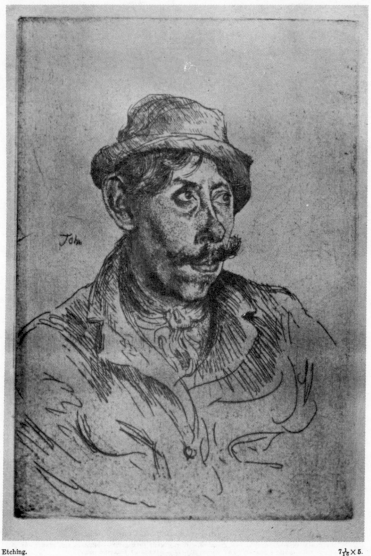

Etching.
7 7/16 × 5.

Plate 139
CHARLES McEVOY. AUGUSTUS E. JOHN, A.R.A.
A TYPICAL EXAMPLE OF THE ARTIST'S DIRECT LINE IN THE REMBRANDT TRADITION
From a proof in the collection of E. L. Allhusen, Esq.

Notes by Frank Brangwyn, R.A.

Plates.—Both copper and zinc.

Ground.—Most of the plates I had coated for me with Rhind's liquid ground.

Acid.—Nitrous—roughly speaking, half-and-half, and I like to bite-in in the summer because it works quicker.

I used to experiment with a white surface by painting over the ordinary ground with several things.[1] I found gum cracked up the ground in drying by its contraction, so I bought some powdered zinc-white and mixed it with yolk of egg as a medium. The egg gave more elasticity and prevented the cracking.

Biting is a matter of feeling, and I have never had any rules. It's a sort of instinct.

The modern soft plates don't seem to be attacked by the acid strongly enough, and sometimes I have used the nitrous neat.

I can't imagine any man whose ideas come quickly—spontaneously—

[1] See Rembrandt's ground, p. 36.

putting up with a slow mordant, and I don't believe Rembrandt bit his plates with a slow acid, as people think.

Some of the big plates were taken out of doors and drawn straight from the model on the spot.

" The Feast of Lazarus." Zinc.

This plate was done direct from the models in the studio and the composition was evolved on the plate. After the first proof, the top part of the composition was entirely changed, and it took a lot of grinding to get it all out before the new work could be etched.

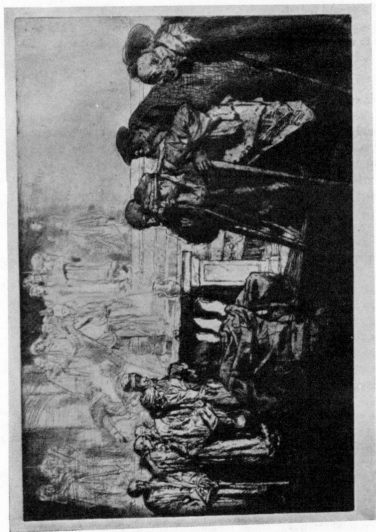

Etching.

.9¼ × 28.

Plate 140

THE FEAST OF LAZARUS. FRANK BRANGWYN, R.A.

THIS HUGE VIGOROUSLY BITTEN PLATE IS TYPICAL OF THE ARTIST'S TREATMENT OF THE MEDIUM.

From a proof in the collection of J. D. Pollock, Esq., M.D.

347

Plates.—All copper.

Ground.—I have never used a liquid ground at any time. I like to be able to vary the thickness of my ground. Generally I make it up myself—

> 2 white wax
> 1 gum mastic

but in cold weather a little more of white wax in proportion.

Acid.—Nitric was, I fancy, used for the " Sussex " (Plate 141), and certainly nitrous on the " Strange Signals " (Plate 142), both as strong as I could safely manipulate them. The deepest lines would not have taken more than twenty minutes. The ground unsmoked.

I pour half my pure nitrous into a large bottle, adding its own bulk of water. The other half I use to keep my acid up to strength, adding as required, preferring a bath which has been used time and again.

No actual bath was used. The surface of the plate was simply flooded with acid, and the stuff pushed about with the help of a feather, a fountain pen filler and saliva.

My Edinburgh plates were bitten with perchloride of iron, but I discontinued it because of the deposit which choked up the lines.

Many of the Aberdeen plates were bitten with the Dutch mordant, but I am not fond of the " thin " appearance it gives. One is inclined to put too much work on a plate. I like the habit nitric and nitrous acids have of biting more vigorously in close-worked parts.

So far as I remember, the " Strange Signals " was very lightly sketched in drypoint on the plate before the wax was laid on. The drypoint was so slight[1] that it was intended to disappear in the subsequent working, being merely a guide to the proportions of the figures, as the needlework was done in the acid.

The " Sussex " was etched in the acid also, without previous drypoint ; but I think the foreground figures were strengthened with drypoint at the last.

Needles.—I used darning needles without any holder for those plates, but I now find gramophone needles, held in an engineer's " pricker," the ideal points. Half a dozen or so are naturally used up in the acid on each plate.

[1] Mr. McBey's memory is a little at fault here as to the "slightness" as there are proofs of both "Strange Signals" and "Dawn" (as well as other plates of the series) in drypoint alone before the etched work.—E.S.L

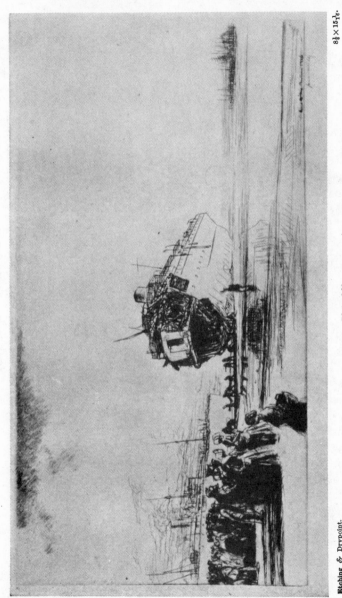

Etching & Drypoint.

Plate 141

THE TORPEDOED SUSSEX. JAMES McBEY.

THIS PLATE RECALLS HADEN'S MASTERPIECE, BUT HAS A PERSONALITY OF ITS OWN, & IS REMARKABLE FOR ITS LUMINOSITY

From a proof in the collection of the author.

$8\frac{1}{8} \times 15\frac{1}{16}$.

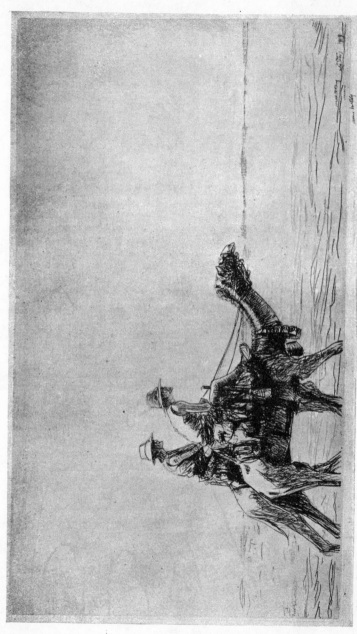

Plate 142

STRANGE SIGNALS. JAMES McBEY.

THE LOW PLACING OF THE FIGURES IN THE DESIGN HELPS TO CONVEY THE SENSE OF THE ILLIMITABLE DESERT.

From a proof in the collection of the author.

$8\frac{1}{8} \times 15\frac{3}{8}$

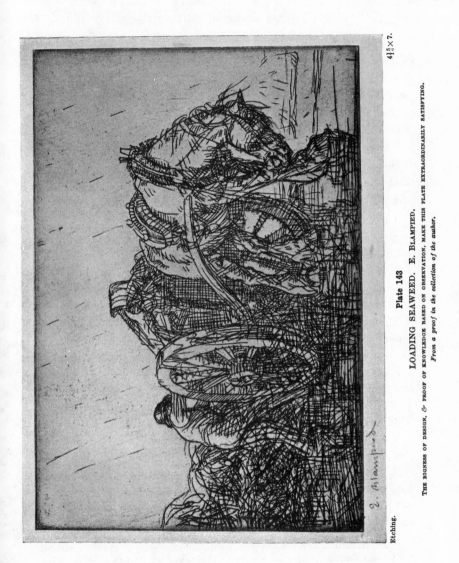

Etching.

E. Blampied

4⅝×7.

Plate 143

LOADING SEAWEED. E. BLAMPIED.

THE BIGNESS OF DESIGN, & PROOF OF KNOWLEDGE BASED ON OBSERVATION, MAKE THIS PLATE EXTRAORDINARILY SATISFYING.

From a proof in the collection of the author.

" Loading Seaweed."

Plate.—Zinc.

Ground.—The plate was prepared for me with a white ground which was not at all reliable. One could only rely on, say, two out of five.

Acid.—Nitric, something like 75 per cent strength, if I remember rightly. There was only one very short biting.

I had only just started and knew nothing about the technique of etching.

Since the war I have used the ordinary dabbed dark ground, and the acid about half-and-half.

I prefer zinc for etching, but all my drypoints are on copper.

I never work on a plate direct from nature.

Drypoint.—I generally choose from amongst my various drawings one which would tend to produce a successful plate.

I do not trace on to the copper, but copy the few important lines of the drawing on to the bare metal with litho-chalk. I then sketch over this with an ordinary sewing-needle and rub in a little black oil-colour.

After this I generally put away the drawing and try to create a fresh interest, as I do not believe in copying, as, in my case, it invariably leads to failure.

From the first my efforts are to improve on the sketch until I consider the plate finished. Directly I think this is the case I remove the ink. In very few cases do I touch a plate after the first proof, so the majority have but one state.

If I am dissatisfied with either the composition or details, I prefer to start afresh upon another plate rather than to make radical alterations.

My conception of drypoint is that it should appear spontaneous, fresh, crisp and without any sign of effort.

" The Stranger " is pure drypoint, but was purposely done upon the back of an old plate.[1]

[1] This refers to the broken heavy tone obtained in printing from such a surface. For another similar example see my own " Cenotaph," Pl. 22, and I believe " The Pianist " by McBey.

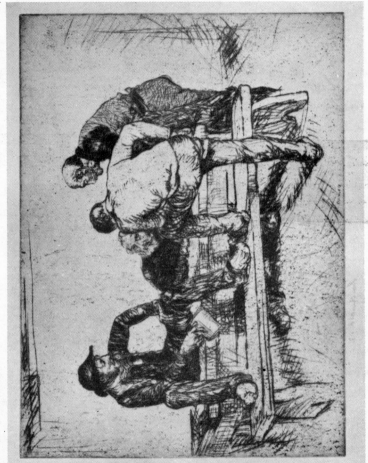

Drypoint.

Plate 144

THE STRANGER. E. BLAMPIED.

THIS IS ONE OF THE SERIES OF STUDIES OF JERSEY PEASANTS WHICH IS A VITAL CONTRIBUTION TO MODERN ART.

From a proof in the collection of the author.

$9\frac{18}{18} \times 12\frac{15}{16}$.

353

Notes by Percy Smith

Plates.—Copper.

Ground.—Rhind's solid, dabbed and smoked.

Acid.—Nitric, a little weaker than half-and-half.

Needles.—I use gramophone needles fixed into a wooden holder with sealing-wax. These points seem ideal : smooth and yet sharp.

" Dance of Death " set : I made small sketches first (1 inch or so), and then full-sized drawings in pen-and-ink or wash.

" Death Marches " was transferred to the plate, as I particularly desired to obtain a certain precision and regularity to help the subject. A clear drawing helped me to express slow and regular movement.

The main lines of the other six were first indicated upon the ground with Chinese white, but the point-work was done quite freely with the studies near me, together with notes of detail made in France. The pen-and-ink drawings were not always followed.

" Death Awed " was etched almost entirely at one sitting.

They were all bitten in the ordinary way in the bath. Some line-work was invariably added while the biting was going on, i.e. in the bath itself.

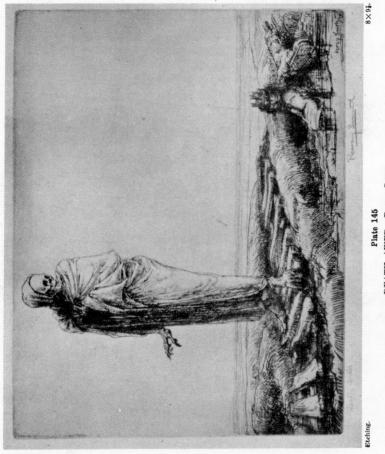

Etching. 8×9¼.

Plate 145

DEATH AWED. PERCY SMITH.

THIS GREAT ETCHING SUMS UP THE WHOLE HORROR OF WAR. IT IS EXPRESSIVE OF NO ONE PERIOD, BUT OF ALL PERIODS.

From a proof in the collection of the author.

355

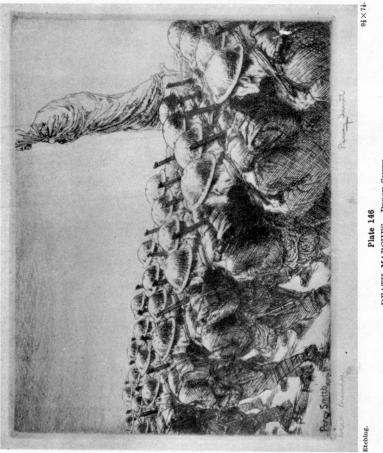

Etching. $9\frac{3}{4} \times 7\frac{1}{2}$.

Plate 146

DEATH MARCHES. PERCY SMITH.

NOTE HOW THE OVERPOWERING SENSATION OF A MOVING BODY OF MEN IS RECAPTURED BY THE ALMOST EXACT REPETITION OF FORM.
THERE IS HERE NO ATTEMPT AT STUDY OF INDIVIDUALS, BUT THE EXPRESSION OF FORCE IN THE WHOLE.

From a proof in the collection of the author.

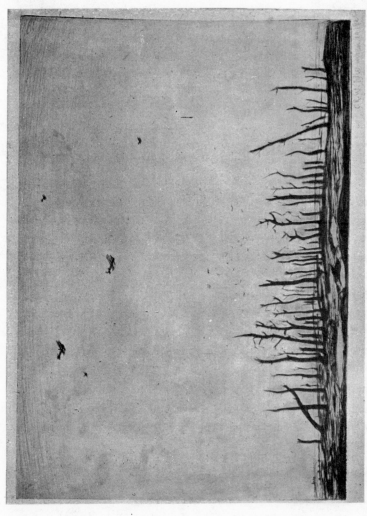

Drypoint.

10⅛×14.

Plate 147

THAT CURSED WOOD. C. R. W. NEVINSON.

THIS IS A NOTABLE WAR RECORD. THE PLACING & DRAWING OF THE PLANES IS VERY SKILFUL.

From a proof in the collection of the author

Notes by C. R. W. Nevinson

Drypoint.—My drypoints are invariably traced on to the surface of a smoked liquid ground : cut through with a ruby point and then the ground cleaned off. After that the ordinary working of drypoint : a well-polished plate and a dirty finger of oil and charcoal to study the lines.

Etching.—I invariably use a thermometer and *pèse-acide.*[1] I then draw a chart with all the various densities and lengths of biting that the density and temperature of acid have produced in other cases.

I find this absolutely essential in aquatint.

I rely upon the temperature of the room as much as possible (generally 60° Fahr. in summer), taking note of a higher temperature and allowing for it. In winter, if necessary, I heat the bath.

Through using this method I never remove the ground in order to see the result.

Afterwards I prefer to strengthen and patch by working with transparent liquid ground. I have sometimes laid twenty of these, and find it much more certain than stopping-out and working in the dark, so to speak.

Acid.—Nitric acid always. I like the bubbles as a guide : also the widening line.

I never work on the spot. I can't compose out of doors.

Really my etching is dependent upon my *pèse-acide* and thermometer. They rid me of all chance biting. The French copper-plate workers always use them in the shops.

[1] Hydrometer. See Chapter VI and foot of p. 366.

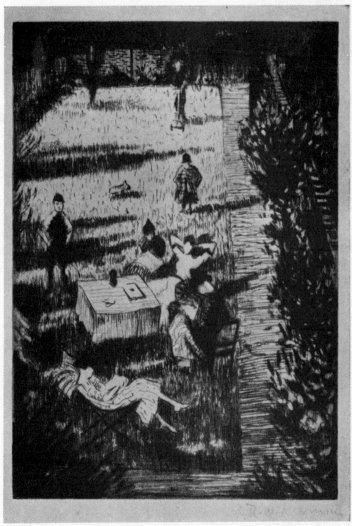

Etching. 7 × 5.

Plate 148
IN SUBURBIA. C. R. W. NEVINSON.

IN THIS LITTLE PLATE THERE IS AN INTIMATE REALISM (IN ITS BEST SENSE) WHICH MAKES IT ONE OF THE
ARTIST'S MOST SUCCESSFUL.

From a proof in the collection of the author.

359

Notes by Mrs. Laura Knight

Plates.—Copper.

Ground.—Rhind's etching ball. I prefer the dabbed ground to the liquid.

For line-etching I use the Dutch mordant, finishing sometimes with nitric; but for aquatint generally nitric alone at rather less than half-and-half strength, but I am rather careless in these matters.

"The Spanish Dancer, No. 2" (Plate 149).

The line-work was first bitten with nitric on a liquid ground. After this the plate was prepared for aquatint with a resin dust-ground sprinkled through several thicknesses of muslin stretched across a common sugar-box which had had the top and one side knocked out. This is my ordinary method.

It was bitten with nitric acid at 20° on the French *pèse-acide*,[1] in three tones. First biting about 25 seconds.

 Second ,, ,, 25 ,,
 Last ,, ,, 50 or 60 seconds in warmish weather.

I have not been doing this work very long, but all the plates have been done from drawings or jottings on the spot.

This particular one was made from a note, but I had a pretty clear idea of what I wanted to do.

There was a little burnishing on the trousers of the dancer; otherwise the plate was untouched.

[1] For this hydrometer see Note by John Everett, p. 366.

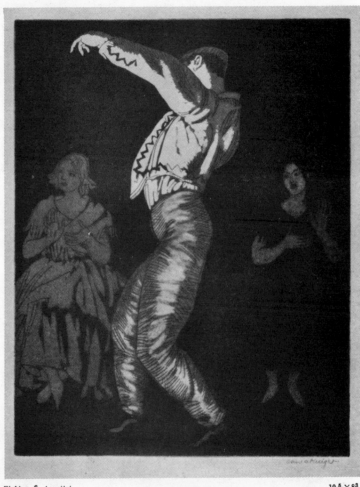

Etching & Aquatint

10$\frac{5}{16}$ × 8$\frac{3}{8}$.

Plate 149

SPANISH DANCER. No. 2. LAURA KNIGHT.

IN THEIR DIRECTNESS & SIMPLICITY—THE RIGHT UNDERSTANDING OF THE MEDIUM—THESE AQUATINTS ARE
AMONGST THE FINEST EVER PRODUCED.

From a proof in the collection of the author.

361

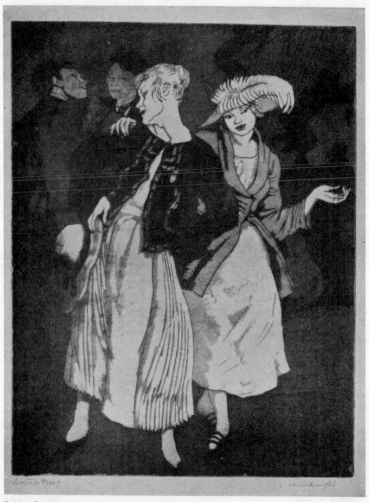

Etching & Aquatint

Plate 150

$10\frac{1}{2} \times 8\frac{5}{8}$.

BANK HOLIDAY. Laura Knight.

Though founded upon the work of Goya, these remarkable plates have their own personality.

From a proof in the collection of the author.

362

Aquatint.

Plate 151

A GREY DAY IN THE CHANNEL. JOHN EVERETT.

THIS PLATE WAS EXECUTED BY THE ARTIST'S OWN METHOD OF USING OIL-COLOUR & RESIN AS STOPPING-OUT MEDIUM.

IT HAS GREAT BREADTH & VIGOUR.

From a proof in the collection of the author.

9¾ × 14.

363

NOTES BY JOHN EVERETT

" Luynes " (Plate 152).

Plate.—Zinc.

Acid.—Nitric, 10° (French hydrometer).

Ground.—Resin dust, hand laid through six muslins. Fine grain show-
ing more resin than metal.

Room temperature, 65° Fahr. Acid, 18° Cent.

Stopped-out with Rhind's varnish and benzol, *vernis mou*, litho-chalk
and litho-ink.

First : high-lights stopped.

3 secs.	Next highest lights—sky and roofs.
3 ,,	,, ,, sky and bits of distance.
3 ,,	All sky except darks feathered with brush and half-and-half nitric.
10 ,,	Shadow on distance : parts of roofs.
10 ,,	All distance : parts of roofs, etc.
1 min.	Parts of middle distance.
1 ,,	,, ,, ,, and castle.
1 ,,	,, ,, ,, ,,
1 ,,	All castle.
1 ,,	Bits of foreground.
1 ,,	,, ,,
1 ,,	,, ,,
1 ,,	Strongest darks.

8 mins. 29 secs.

(*Continued on page* 366)

Aquatint.

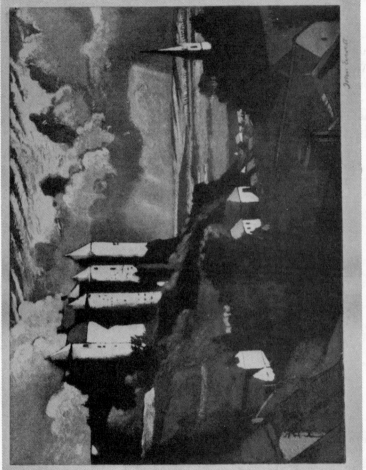

Plate 152

LUYNES. JOHN EVERETT.

THIS DRAMATIC PLATE SHOWS WHAT DEPTH & BRILLIANCE CAN BE OBTAINED FROM THE MEDIUM BY ONE WHO IS SUCH A TECHNICAL MASTER.

From a proof in the collection of the author.

" A Grey Day in the Channel " (Plate 151).

Plate.—Zinc.

Acid.—Nitric 12°,[1] at temperature of 18° Cent.

Ground.—Resin dust, hand laid through three muslins. A very open grain showing more zinc than resin.

With regard to temperature of the bath, I use a French Centigrade thermometer, but latterly I judge by the temperature of the room. 65° Fahr. gives about 18° Cent. in the bath ; 70°=20° in the bath. The *pèse-acide*[1] I use is also French.

Bitings :—

2½ secs.		The whole plate.[2] The sun and high-lights on sea were stopped-out with half-and-half flake-white and resin, laid on with an ordinary hog-hair brush. This method was used throughout.
5	,,	The light round the sun.
5	,,	Next highest lights.
10	,,	Rays and highest lights on sea.
10	,,	All middle light of sky and foam of mid-distance.
20	,,	Most of lower sky except on right.
20	,,	All lower sky.
20	,,	All sky.
30	,,	Distant sea.
3 mins.		Distant sea (bits).
3	,,	All distant sea except on right.
3	,,	Strongest darks.

11 mins. 2½ secs.

[1] Hydrometer. I buy these from Catinels, 150 Blvd. Montparnasse, Paris. Price fr. 2.75.

[2] This plate was bitten to be printed in colour, but the reproduction was not made from a colour proof. The use of oil colour as stopping out medium is Everett's own invention.—E.S.L.

"Meditation" (Frontispiece) Etching. By the Author.

Plate.—Copper.

Ground.—Rhind's, dabbed.

Acids.—Dutch and nitric.

With exception of a very little additional work to the modelling of the face and one or two of the branches above, the whole was executed in one biting.

Time:—

In Smillie's Dutch bath (cold),	5	mins.		Parts of face stopped.		
,, nitric (half-and-half) bath	3	,,		,, drapery stopped.		
,, ,, ,, ,,	$2\frac{1}{2}$,,	Rest of figure, etc., stopped.			
,, ,, ,, ,,	$2\frac{1}{2}$,,	Tree trunk stopped.			
,, ,, ,, ,,	7	,,				

Total . . . 5 mins. Dutch and 15 mins. nitric.

The last and heaviest biting completed the darks of the begging-bowl, necklace and upper part of tree.

The proofs are printed with Frankfurt with a little French-black and burnt umber, thin and a little medium oil, clean hand-wiped with *retroussage*. The plate was not steeled, and the most delicate modelling in the face unfortunately deteriorated before the end of the edition.

INDEX

The principal reference to some of the artists referred to in the following Index are printed first and in black letter.

INDEX

375

Salt and Vinegar (acteic acid), 34, 51, 55
Saltpetre (nitre, pot. nitrate), 50, 51
,, -acid (nitric), 51, 326
Sandby, P., 18th cent., Eng. etcher, 196
Sand-grain aquatint, 119
Schiavone, A, 172. *See* Meldolla
Schöngauer, 15th–16th cent., Swiss engraver, 165, 201
Schools of Art, 19. *See also* College
,, danger of, 21
Scott, Dr. Alex., F.R.S., 156–9
Scraper, 23, 47
how to use, 48
Mezzo-, 135
Screen (light), 63
Seghers, H., Dutch etcher (1590–1645), 110, 172, 239
Sheet copper and zinc, 26
Shellac varnishes, 43, 44
" Short History of Engraving and Etching, A," 1908 (Hind), 119, 165, 176, 187
Short, Sir F., R.A., Eng. etcher (1857–), **134,** 34, 37, 239, 255, 339–41
Size in paper, 138
Sizing paper, 142
Smillie's (Dutch) bath, 52
Smith, Percy, 20th cent., Eng. etcher, **322,** 163, 239, 249, 354–6
Smoking the ground, 42
Snakestone (Water of Ayr), 30
Soda chlorinated, 157
Sodium carbonate, 58
chloride (salt), 34, 50, 51, 55
hydrosulphite, 157
Soft-ground (making), 113
,, etching, 18, 35, 113
Soft-sized paper, 139
Spike oil of lavender, 40
Spirit ground (aquatint), 119
Spirit solvents—
benzol, benzoline, 33, 44
chloroform, 41
ether, 41, 42, 44
methylated, 33, 43, 44
petrol, 33
turpentine, 33, 44
Stapart's ground, 119
Starch (wheat), 139
Starrett Co. (points), 46, 61
Steel, 17
facing, 18, 30
points. *See* " Points."
Steinlen, A., Fr. etcher (1859–1923), 239, 317
Stopping-out varnishes, 43
Stout, for tinting paper, 140

Strang, W., R.A., Scots etcher (1859–1921), **312,** 46, 127, 224, 232, 239, 309, 311
Stretching proofs, 153
Sulphuric-acid, 50, 51

T

Tallow, 44
Tapers (for smoking), 42
Tarnish, removal of, 34
Thymol, 158
Tiepolo, G. B., Ital. etcher (1696–1770), **188,** 232, 239, 242
Tiepolo, G. D., Ital. etcher (1727–1804), **188,** 191, 232, 239, 242
Tools, list of, 59
Torinoko paper, 141
" Touch " in etching and drypoint, 24
" Tower-brand " varnish, 43
Tracing, 80
,, -paper screen, 63
" Traicté des manières de graver " (Bosse), 51
Transferring, 109
Trays for acid, etc., 56
Turner, J. W. M., R.A., Eng. etcher (1775–1851), **255,** 134, 161, 239, 256–7

U

Umber, powder colour for ink, 61, 85, 124
Urs Graf, Swiss etcher (c. 1485–1529), **168,** 169, 239
Urushibara, Y., 20th cent., Jap. wood engraver, 143

V

Van de Velde. *See* Velde.
Van dyck, Sir A., Flemish etcher (1599–1641), **240,** 179, 208, 239, 259, 281
Van Ostade, Dutch etcher (1610–85), **186,** 218, 232, 239
Varnishes, stopping-out, 43
Velarium for picture galleries, 155
Velde, A. van de, Dutch etcher (1635–1672), **186,** 187, 232, 239
Vellum, Japanese (paper), 143
,, skin, 144
Verdigris, 51
Vernis mou (soft-ground), 35, 113
Vice, hand, 43
,, screw (for table), 28
Vinegar (acetic acid), 34, 51, 55
Vitriol, oil of (sulphuric acid), 50, **51**

A CATALOGUE OF SELECTED DOVER BOOKS
IN ALL FIELDS OF INTEREST

A CATALOGUE OF SELECTED DOVER
BOOKS IN ALL FIELDS OF INTEREST

CONDITIONED REFLEXES, Ivan P. Pavlov. Full translation of most complete statement of Pavlov's work; cerebral damage, conditioned reflex, experiments with dogs, sleep, similar topics of great importance. 430pp. 5⅜ x 8½. 60614-7 Pa. $4.50

NOTES ON NURSING: WHAT IT IS, AND WHAT IT IS NOT, Florence Nightingale. Outspoken writings by founder of modern nursing. When first published (1860) it played an important role in much needed revolution in nursing. Still stimulating. 140pp. 5⅜ x 8½. 22340-X Pa. $3.00

HARTER'S PICTURE ARCHIVE FOR COLLAGE AND ILLUSTRATION, Jim Harter. Over 300 authentic, rare 19th-century engravings selected by noted collagist for artists, designers, decoupeurs, etc. Machines, people, animals, etc., printed one side of page. 25 scene plates for backgrounds. 6 collages by Harter, Satty, Singer, Evans. Introduction. 192pp. 8⅞ x 11¾. 23659-5 Pa. $5.00

MANUAL OF TRADITIONAL WOOD CARVING, edited by Paul N. Hasluck. Possibly the best book in English on the craft of wood carving. Practical instructions, along with 1,146 working drawings and photographic illustrations. Formerly titled *Cassell's Wood Carving.* 576pp. 6½ x 9¼.
 23489-4 Pa. $7.95

THE PRINCIPLES AND PRACTICE OF HAND OR SIMPLE TURNING, John Jacob Holtzapffel. Full coverage of basic lathe techniques—history and development, special apparatus, softwood turning, hardwood turning, metal turning. Many projects—billiard ball, works formed within a sphere, egg cups, ash trays, vases, jardiniers, others—included. 1881 edition. 800 illustrations. 592pp. 6⅛ x 9¼. 23365-0 Clothbd. $15.00

THE JOY OF HANDWEAVING, Osma Tod. Only book you need for hand weaving. Fundamentals, threads, weaves, plus numerous projects for small board-loom, two-harness, tapestry, laid-in, four-harness weaving and more. Over 160 illustrations. 2nd revised edition. 352pp. 6½ x 9¼.
 23458-4 Pa. $6.00

THE BOOK OF WOOD CARVING, Charles Marshall Sayers. Still finest book for beginning student in wood sculpture. Noted teacher, craftsman discusses fundamentals, technique; gives 34 designs, over 34 projects for panels, bookends, mirrors, etc. "Absolutely first-rate"—E. J. Tangerman. 33 photos. 118pp. 7¾ x 10⅝. 23654-4 Pa. $3.50

AN AUTOBIOGRAPHY, Margaret Sanger. Exciting personal account of hard-fought battle for woman's right to birth control, against prejudice, church, law. Foremost feminist document. 504pp. 5⅜ x 8½.
20470-7 Pa. $5.50

MY BONDAGE AND MY FREEDOM, Frederick Douglass. Born as a slave, Douglass became outspoken force in antislavery movement. The best of Douglass's autobiographies. Graphic description of slave life. Introduction by P. Foner. 464pp. 5⅜ x 8½.
22457-0 Pa. $5.50

LIVING MY LIFE, Emma Goldman. Candid, no holds barred account by foremost American anarchist: her own life, anarchist movement, famous contemporaries, ideas and their impact. Struggles and confrontations in America, plus deportation to U.S.S.R. Shocking inside account of persecution of anarchists under Lenin. 13 plates. Total of 944pp. 5⅜ x 8½.
22543-7, 22544-5 Pa., Two-vol. set $12.00

LETTERS AND NOTES ON THE MANNERS, CUSTOMS AND CONDITIONS OF THE NORTH AMERICAN INDIANS, George Catlin. Classic account of life among Plains Indians: ceremonies, hunt, warfare, etc. Dover edition reproduces for first time all original paintings. 312 plates. 572pp. of text. 6⅛ x 9¼.
22118-0, 22119-9 Pa.. Two-vol. set $12.00

THE MAYA AND THEIR NEIGHBORS, edited by Clarence L. Hay, others. Synoptic view of Maya civilization in broadest sense, together with Northern, Southern neighbors. Integrates much background, valuable detail not elsewhere. Prepared by greatest scholars: Kroeber, Morley, Thompson, Spinden, Vaillant, many others. Sometimes called Tozzer Memorial Volume. 60 illustrations, linguistic map. 634pp. 5⅜ x 8½.
23510-6 Pa. $10.00

HANDBOOK OF THE INDIANS OF CALIFORNIA, A. L. Kroeber. Foremost American anthropologist offers complete ethnographic study of each group. Monumental classic. 459 illustrations, maps. 995pp. 5⅜ x 8½.
23368-5 Pa. $13.00

SHAKTI AND SHAKTA, Arthur Avalon. First book to give clear, cohesive analysis of Shakta doctrine, Shakta ritual and Kundalini Shakti (yoga). Important work by one of world's foremost students of Shaktic and Tantric thought. 732pp. 5⅜ x 8½. (Available in U.S. only)
23645-5 Pa. $7.95

AN INTRODUCTION TO THE STUDY OF THE MAYA HIEROGLYPHS, Syvanus Griswold Morley. Classic study by one of the truly great figures in hieroglyph research. Still the best introduction for the student for reading Maya hieroglyphs. New introduction by J. Eric S. Thompson. 117 illustrations. 284pp. 5⅜ x 8½.
23108-9 Pa. $4.00

A STUDY OF MAYA ART, Herbert J. Spinden. Landmark classic interprets Maya symbolism, estimates styles, covers ceramics, architecture, murals, stone carvings as artforms. Still a basic book in area. New introduction by J. Eric Thompson. Over 750 illustrations. 341pp. 8⅜ x 11¼.
21235-1 Pa. $6.95

UNCLE SILAS, J. Sheridan LeFanu. Victorian Gothic mystery novel, considered by many best of period, even better than Collins or Dickens. Wonderful psychological terror. Introduction by Frederick Shroyer. 436pp. 5⅜ x 8½. 21715-9 Pa. $6.00

JURGEN, James Branch Cabell. The great erotic fantasy of the 1920's that delighted thousands, shocked thousands more. Full final text, Lane edition with 13 plates by Frank Pape. 346pp. 5⅜ x 8½.
23507-6 Pa. $4.50

THE CLAVERINGS, Anthony Trollope. Major novel, chronicling aspects of British Victorian society, personalities. Reprint of Cornhill serialization, 16 plates by M. Edwards; first reprint of full text. Introduction by Norman Donaldson. 412pp. 5⅜ x 8½. 23464-9 Pa. $5.00

KEPT IN THE DARK, Anthony Trollope. Unusual short novel about Victorian morality and abnormal psychology by the great English author. Probably the first American publication. Frontispiece by Sir John Millais. 92pp. 6½ x 9¼. 23609-9 Pa. $2.50

RALPH THE HEIR, Anthony Trollope. Forgotten tale of illegitimacy, inheritance. Master novel of Trollope's later years. Victorian country estates, clubs, Parliament, fox hunting, world of fully realized characters. Reprint of 1871 edition. 12 illustrations by F. A. Faser. 434pp. of text. 5⅜ x 8½. 23642-0 Pa. $5.00

YEKL and THE IMPORTED BRIDEGROOM AND OTHER STORIES OF THE NEW YORK GHETTO, Abraham Cahan. Film *Hester Street* based on *Yekl* (1896). Novel, other stories among first about Jewish immigrants of N.Y.'s East Side. Highly praised by W. D. Howells—Cahan "a new star of realism." New introduction by Bernard G. Richards. 240pp. 5⅜ x 8½. 22427-9 Pa. $3.50

THE HIGH PLACE, James Branch Cabell. Great fantasy writer's enchanting comedy of disenchantment set in 18th-century France. Considered by some critics to be even better than his famous *Jurgen*. 10 illustrations and numerous vignettes by noted fantasy artist Frank C. Pape. 320pp. 5⅜ x 8½. 23670-6 Pa. $4.00

ALICE'S ADVENTURES UNDER GROUND, Lewis Carroll. Facsimile of ms. Carroll gave Alice Liddell in 1864. Different in many ways from final Alice. Handlettered, illustrated by Carroll. Introduction by Martin Gardner. 128pp. 5⅜ x 8½. 21482-6 Pa. $2.50

FAVORITE ANDREW LANG FAIRY TALE BOOKS IN MANY COLORS, Andrew Lang. The four Lang favorites in a boxed set—the complete *Red, Green, Yellow* and *Blue* Fairy Books. 164 stories; 439 illustrations by Lancelot Speed, Henry Ford and G. P. Jacomb Hood. Total of about 1500pp. 5⅜ x 8½. 23407-X Boxed set, Pa. $15.95

A MAYA GRAMMAR, Alfred M. Tozzer. Practical, useful English-language grammar by the Harvard anthropologist who was one of the three greatest American scholars in the area of Maya culture. Phonetics, grammatical processes, syntax, more. 301pp. 5⅜ x 8½. 23465-7 Pa. $4.00

THE JOURNAL OF HENRY D. THOREAU, edited by Bradford Torrey, F. H. Allen. Complete reprinting of 14 volumes, 1837-61, over two million words; the sourcebooks for *Walden*, etc. Definitive. All original sketches, plus 75 photographs. Introduction by Walter Harding. Total of 1804pp. 8½ x 12¼. 20312-3, 20313-1 Clothbd., Two-vol. set $70.00

CLASSIC GHOST STORIES, Charles Dickens and others. 18 wonderful stories you've wanted to reread: "The Monkey's Paw," "The House and the Brain," "The Upper Berth," "The Signalman," "Dracula's Guest," "The Tapestried Chamber," etc. Dickens, Scott, Mary Shelley, Stoker, etc. 330pp. 5⅜ x 8½. 20735-8 Pa. $4.50

SEVEN SCIENCE FICTION NOVELS, H. G. Wells. Full novels. *First Men in the Moon, Island of Dr. Moreau, War of the Worlds, Food of the Gods, Invisible Man, Time Machine, In the Days of the Comet*. A basic science-fiction library. 1015pp. 5⅜ x 8½. (Available in U.S. only)
 20264-X Clothbd. $8.95

ARMADALE, Wilkie Collins. Third great mystery novel by the author of *The Woman in White* and *The Moonstone*. Ingeniously plotted narrative shows an exceptional command of character, incident and mood. Original magazine version with 40 illustrations. 597pp. 5⅜ x 8½.
 23429-0 Pa. $6.00

MASTERS OF MYSTERY, H. Douglas Thomson. The first book in English (1931) devoted to history and aesthetics of detective story. Poe, Doyle, LeFanu, Dickens, many others, up to 1930. New introduction and notes by E. F. Bleiler. 288pp. 5⅜ x 8½. (Available in U.S. only)
 23606-4 Pa. $4.00

FLATLAND, E. A. Abbott. Science-fiction classic explores life of 2-D being in 3-D world. Read also as introduction to thought about hyperspace. Introduction by Banesh Hoffmann. 16 illustrations. 103pp. 5⅜ x 8½.
 20001-9 Pa. $2.00

THREE SUPERNATURAL NOVELS OF THE VICTORIAN PERIOD, edited, with an introduction, by E. F. Bleiler. Reprinted complete and unabridged, three great classics of the supernatural: *The Haunted Hotel* by Wilkie Collins, *The Haunted House at Latchford* by Mrs. J. H. Riddell, and *The Lost Stradivarius* by J. Meade Falkner. 325pp. 5⅜ x 8½.
 22571-2 Pa. $4.00

AYESHA: THE RETURN OF "SHE," H. Rider Haggard. Virtuoso sequel featuring the great mythic creation, Ayesha, in an adventure that is fully as good as the first book, *She*. Original magazine version, with 47 original illustrations by Maurice Greiffenhagen. 189pp. 6½ x 9¼.
 23649-8 Pa. $3.50

PRINCIPLES OF ORCHESTRATION, Nikolay Rimsky-Korsakov. Great classical orchestrator provides fundamentals of tonal resonance, progression of parts, voice and orchestra, tutti effects, much else in major document. 330pp. of musical excerpts. 489pp. 6½ x 9¼. 21266-1 Pa. $7.50

TRISTAN UND ISOLDE, Richard Wagner. Full orchestral score with complete instrumentation. Do not confuse with piano reduction. Commentary by Felix Mottl, great Wagnerian conductor and scholar. Study score. 655pp. 8⅛ x 11. 22915-7 Pa. $13.95

REQUIEM IN FULL SCORE, Giuseppe Verdi. Immensely popular with choral groups and music lovers. Republication of edition published by C. F. Peters, Leipzig, n. d. German frontmaker in English translation. Glossary. Text in Latin. Study score. 204pp. 9⅜ x 12¼. 23682-X Pa. $6.00

COMPLETE CHAMBER MUSIC FOR STRINGS, Felix Mendelssohn. All of Mendelssohn's chamber music: Octet, 2 Quintets, 6 Quartets, and Four Pieces for String Quartet. (Nothing with piano is included). Complete works edition (1874-7). Study score. 283 pp. 9⅜ x 12¼. 23679-X Pa. $7.50

POPULAR SONGS OF NINETEENTH-CENTURY AMERICA, edited by Richard Jackson. 64 most important songs: "Old Oaken Bucket," "Arkansas Traveler," "Yellow Rose of Texas," etc. Authentic original sheet music, full introduction and commentaries. 290pp. 9 x 12. 23270-0 Pa. $7.95

COLLECTED PIANO WORKS, Scott Joplin. Edited by Vera Brodsky Lawrence. Practically all of Joplin's piano works—rags, two-steps, marches, waltzes, etc., 51 works in all. Extensive introduction by Rudi Blesh. Total of 345pp. 9 x 12. 23106-2 Pa. $14.95

BASIC PRINCIPLES OF CLASSICAL BALLET, Agrippina Vaganova. Great Russian theoretician, teacher explains methods for teaching classical ballet; incorporates best from French, Italian, Russian schools. 118 illustrations. 175pp. 5⅜ x 8½. 22036-2 Pa. $2.50

CHINESE CHARACTERS, L. Wieger. Rich analysis of 2300 characters according to traditional systems into primitives. Historical-semantic analysis to phonetics (Classical Mandarin) and radicals. 820pp. 6⅛ x 9¼. 21321-8 Pa. $10.00

EGYPTIAN LANGUAGE: EASY LESSONS IN EGYPTIAN HIERO-GLYPHICS, E. A. Wallis Budge. Foremost Egyptologist offers Egyptian grammar, explanation of hieroglyphics, many reading texts, dictionary of symbols. 246pp. 5 x 7½. (Available in U.S. only) 21394-3 Clothbd. $7.50

AN ETYMOLOGICAL DICTIONARY OF MODERN ENGLISH, Ernest Weekley. Richest, fullest work, by foremost British lexicographer. Detailed word histories. Inexhaustible. Do not confuse this with Concise Etymological Dictionary, which is abridged. Total of 856pp. 6½ x 9¼. 21873-2, 21874-0 Pa., Two-vol. set $12.00

AMERICAN ANTIQUE FURNITURE, Edgar G. Miller, Jr. The basic coverage of all American furniture before 1840: chapters per item chronologically cover all types of furniture, with more than 2100 photos. Total of 1106pp. 7⅞ x 10¾. 21599-7, 21600-4 Pa., Two-vol. set $17.90

ILLUSTRATED GUIDE TO SHAKER FURNITURE, Robert Meader. Director, Shaker Museum, Old Chatham, presents up-to-date coverage of all furniture and appurtenances, with much on local styles not available elsewhere. 235 photos. 146pp. 9 x 12. 22819-3 Pa. $6.00

ORIENTAL RUGS, ANTIQUE AND MODERN, Walter A. Hawley. Persia, Turkey, Caucasus, Central Asia, China, other traditions. Best general survey of all aspects: styles and periods, manufacture, uses, symbols and their interpretation, and identification. 96 illustrations, 11 in color. 320pp. 6⅛ x 9¼. 22366-3 Pa. $6.95

CHINESE POTTERY AND PORCELAIN, R. L. Hobson. Detailed descriptions and analyses by former Keeper of the Department of Oriental Antiquities and Ethnography at the British Museum. Covers hundreds of pieces from primitive times to 1915. Still the standard text for most periods. 136 plates, 40 in full color. Total of 750pp. 5⅜ x 8½.
23253-0 Pa. $10.00

THE WARES OF THE MING DYNASTY, R. L. Hobson. Foremost scholar examines and illustrates many varieties of Ming (1368-1644). Famous blue and white, polychrome, lesser-known styles and shapes. 117 illustrations, 9 full color, of outstanding pieces. Total of 263pp. 6⅛ x 9¼. (Available in U.S. only) 23652-8 Pa. $6.00